THE ILLUSTRATED HISTORY OF
COLOUR
PHOTOGRAPHY

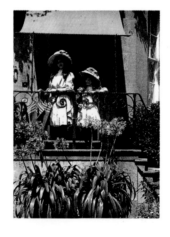

BY JACK H COOTE

Fountain Press

FOUNTAIN PRESS LIMITED
Queensborough House
2 Claremont Road
Surbiton
Surrey KT6 4QU
England

© **FOUNTAIN PRESS 1993**

Art Direction: Nigel Osborne
Design: Sally Stockwell

Reproduction and Printing by
Regent Publishing Services Limited
Hong Kong

Typesetting by Midford Limited

ISBN 0 86343 380 4

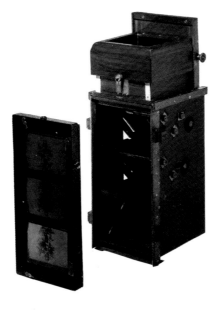

*The picture on the previous page is reproduced from an Autochrome by
courtesy of The National Museum of Photography Film and Television.*

CONTENTS

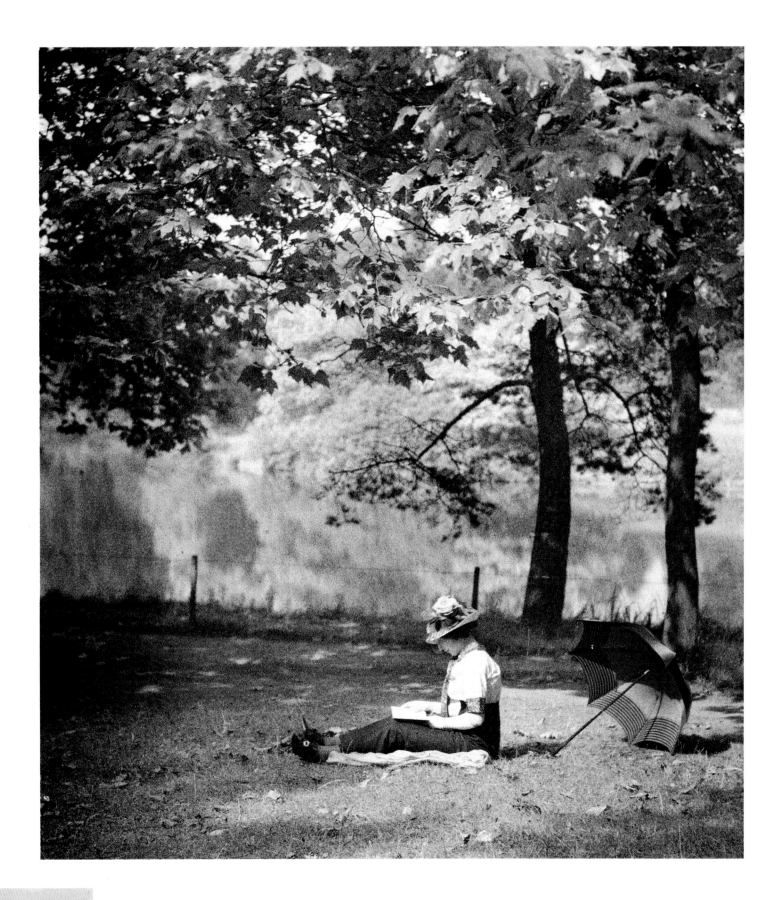

Colour photography covers so many areas of human endeavour that its history is particularly fascinating. A purely physical approach was adopted by Lippmann, who attempted to reproduce the same spectral composition. A physiological approach was adopted by Maxwell, who attempted only to produce colour matches to the eye. Subsequent attempts to make Maxwell's method more convenient led to a wonderful variety of additive systems, some of which are the basis of modern colour television. But colour photography today is almost entirely carried out by means of the subtractive method in the form of the integral tripack, which is a marvel of sophisticated chemistry and engineering. For the successful application of inventions, timing is of the essence. So much of modern systems was foreseen by DuHauron and Fischer decades before the necessary technology was available, and there is a wonderful irony in the fact that it was two professional musicians, Mannes and Godowsky, who were the first to produce a commercially successful tripack. The early days were dominated by motion picture systems, but the reflection print is now supreme. However, it was Evans, who came from the motion picture industry, who solved the difficult problem of printing from negatives by the 'integrating to grey' method. To cover such diversity of material requires a broad approach to the part of the author, and Jack Coote, with his experience both of small enterprises and of major manufacturers is well qualified to cover the ground; furthermore, his knowledge of many of the personalities involved makes his story come to life. History is not, as Henry Ford once said, bunk; any student of colour photography can learn much from its history, and Jack Coote's book will be a valuable aid in this regard, as well as providing an enjoyable experience for the more general reader.

Robert W. G. Hunt

(left) Reading on the bank of Lake Évian, taken by Louis Lumière between 1906 and 1910. (From the Ciba-Geigy collection.)

INTRODUCTION

'When a new idea is first propounded, in the beginning every man objects and the poor inventor runs the gauntlet of all petulant wits, every man finding his several flaws, no man approving it – now not one of a hundred outlives this torture, and those that do are at great length so changed by the various contrivances of others, that not any one man can pretend to the invention of the whole, nor will agree about their respective shares in the parts.'

SIR WILLIAM PETTY. 17TH CENTURY

The two most important histories of colour photography, by Wall and Friedman, were published in 1925 and 1944. When Wall wrote his monumental book, no multi-layer colour films or papers had been successfully realised and when Friedman completed his work, some twenty years later, there was still little evidence that the negative-positive way of working would be adopted universally for both amateur as well as professional photography and cinematography.

Cornwell-Clyne's first edition of *Colour Cinematography*, written while he was still known as A. B. Klein, was published in 1936, when the Technicolor 'three-strip' camera and dye-transfer printing process were beginning to dominate the motion picture industry. Although the third edition of this work was not published until 1951, the author had completed his manuscript in 1946, so that he could only deal with the new Agfacolor motion picture films by means of an appendix and could make no mention of the Eastman Color Negative and Color Print films that were announced in 1950.

There have been several more recent histories, by Sipley in the US, Coe in the UK, and Koshofer in Germany, all of which make use of plentiful illustrations in colour. However, unlike Wall or Friedman, none of these works is a detailed technical history although they are perhaps the more easily read because of that.

It seemed to me therefore that there is now a place for a new history, dealing in a fairly detailed manner with the technicalities of photographic colour processes and emphasising the part that mechanical and electronic engineering have played along the way. Most people relate colour photography with chemistry because of the complex make-up of colour films and papers and their processing and in the second volume of his book *Modern Photographic Processing*, Grant Haist goes some way towards recording the part that chemistry has played in colour photography. Yet precision engineering has also played a most

important part in colour processes ever since the ruling engine invented by Joly to produce his screen-plates in 1894. Equally precise engineering was necessary to produce the Dufaycolor reseau in the 1930s and it was engineering rather than chemistry that enabled Technicolor to design and construct the imbibition-transfer machines and beam-splitter camera with which they achieved their success. Again, if it were not for the advance in multi-layer coating technology, the complex colour films and papers we use today could not be produced and without the electronic engineering incorporated in the printers used for photo-finishing amateur photographers throughout the world could not have the 50 billion colour prints they buy each year.

Another purpose I had in mind was to draw attention to the number of times that chance has played a vital part in the development of a colour process.

For example, how in 1912, Herbert T. Kalmus, an industrial consultant from Boston, was asked by a client to vet an idea for eliminating flicker in motion pictures and then persuaded that client to invest in an additive colour system that eventually led to the Technicolor subtractive process.

How, in 1922, the introduction by Professor Wood of Leopold Mannes to Dr. C. E. K. Mees of Eastman Kodak led, via a two-colour process, to multi-layer Kodachrome.

How, in 1928, Dr. D. A. Spencer, a consulting chemist working for Colour Photographs (British and Foreign) Ltd, quickly abandoned a process using diazo-sensitized Cellophane in favour of a version of the trichrome-carbo process to be called Vivex.

How, in 1935, Wilhelm Schneider saw the possible connection between the way in which he was able to retain dyes in an anti-halation layer with the requirements of the multi-layer colour film that became Agfacolor.

How, in 1951 while Dr. Edgar Gretener was working on the additive lenticular system, his assistant, Dr. Armin Meyer, investigated the silver dye-bleach process in an attempt to obtain a fine-grain high-resolution monochrome image, and this in turn led to Ciba's work on the Cibachrome process.

How, in 1955, Theodore Russell of Eastman Kodak, without being able to explain the phenomenon, discovered and patented a 'method of simultaneously applying thin coatings of a plurality of collodial material onto a web support in distinct layer relationship'; thereby showing the way to high speed multi-layer coating.

These and many other examples serve to remind us that planned research alone is seldom able to predict the path to commercial success.

In the preface to his *History of Three-Color Photography* Wall feared that – 'The inclusion of many patents, particularly those dealing with cinematography in colors, may lead some critic to look upon these as so much padding.' Wall was writing at a time when additive processes were still important and practical subtractive materials had not been realised. For my part I need have no such reservations since the advent of the subtractive processes has shown that there are usually no great differences between products intended for cinematography and those required for transparencies or prints. As examples it should be remembered that both Kodachrome and Agfacolor were first launched as films intended for making motion pictures. Therefore I have made no attempt to deal separately with colour cinematography but have simply included it as part of the whole story.

Not many of the very many colour processes that were proposed and patented during the past hundred years ever prospered commercially, but behind those few that did there are some interesting stories. So here and there I have, as it were, taken time out to relate separately and in some detail, the course of events that led to the success of a particular process.

DIRECT PROCESSES

'The experiments I have done up till now make me believe that, as far as the principal effect, my process will work well; but I need to arrive at some way of fixing the colour: This is what is concerning me at the moment, and it's the thing which is the most difficult.'

FROM A LETTER FROM NIECÉPHORE NIÈPCE TO CLAUDE IN PARIS, DATED APRIL 1816.

'M. Daguerre has succeeded in fixing on his chemical substance some of the coloured rays of the prism. He has already collected four and is working to unite the other three in order to obtain the seven primary colours. But the difficulties which he encounters grow in proportion to the changes this same substance must undergo in order to retain several colours at the same time . . . After what he told me he has little hope of succeeding . . . My process seems to him preferable, more satisfactory from the results I have achieved . . . He wants me to make some experiments with coloured glass, in order to see if the impression produced on my material is the same as his.'

FROM A LETTER SENT BY NIÈPCE TO HIS SON ISIDORE AFTER A VISIT TO DAGUERRE IN SEPTEMBER 1827.

PHOTOCHROMY

These two quotations show that even before the public announcement of the Daguerrotype process in 1839 both Nièpce and Daguerre had been searching for some way of reproducing colours as well as light and shade.

Sir John Herschel, who saw some of the earliest daguerrotypes in Paris in May 1839, immediately wrote to his friend, Fox Talbot, saying – 'they surpass anything I could have conceived as within the bounds of reasonable expectations.'

Herschel too, must have believed that some form of photography (a word he coined) might be found that would allow colours to be reproduced by direct exposure, because in 1840 he reported that he had – 'been able to produce red, green and blue colours on silver chloride paper that corresponded with the colours of the spectrum to which the paper had been exposed.' However, Herschel was cautious about the value of his experiments and warned: 'at present I am not prepared to say that this will prove an available process for coloured photographs, although it brings the hope nearer.'

With men like Herschel working on the problem of direct heliochromy it was not surprising that many others hoped that they might find the answer. Even before Herschel, the physicist Seebeck of Jena had observed that silver chloride when exposed to a range of spectrum colours, tended to produce similar hues.

Soon after Herschel had reported his findings Becquerel also prepared a sensitive layer of silver chloride which – 'under the influence of coloured glass or the spectrum, takes on the impression received and which retains this colour as long as subsequent light action is avoided.'

There was the rub, and it is therefore rather surprising to learn from Eder's History of Photography (4th ed. 1932) that a heliochrome made by Nièpce de Saint Victor in 1867 and given to

Eder, still – 'presents unchanged a remarkable liveliness of colour after sixty years.' However, it is probable that the photograph had been carefully stored in the dark because Eder adds – 'This at the time established the fact that direct heliochromes on silver subchloride do not fade by themselves, although they turn grey rapidly in light; they cannot be fixed.'

So tempting was this dream of direct colour photography throughout the last half of the century that many honest optimists and some charlatans periodically claimed success.

One of them, the Reverend Levi L. Hill, of Westhill in the State of New York, was seen by some as a genuine experimenter and by others as a crook. In 1856 Hill, after three years of promises, published a booklet entitled *A Treatise of Heliochromy* which he had pre-sold by subscription. Samuel Morse, remembered for his telegraphic code, set up a daguerrotype studio on the roof of New York City University, where he was a professor of drawing, and became an enthusiastic supporter of Hill's claims.

In 1921, writing in the *British Journal of Photography*, E. J. Wall somewhat belatedly considered Hill's book and felt that – 'His notes on the natural and artificial colorific agents are decidedly good reading and he seems to be fairly well acquainted with the action of light on the silver salts.' Wall added – 'In chapter 14 he described in full his process and it would seem to me that it really deserves to be rescued from the class of swindles and placed amongst the true heliochrome processes.'

The opposite view was expressed by a correspondent in the same journal immediately after publication of Wall's review, who drew attention to *Harrison's History of Photography* (1888) where Hill's process was included under the heading 'Pretended Discoveries in Photography.'

In his *History of Photography* Eder also dealt severely with Hill – 'The Reverend Levi Hill sold in America licenses for the use of a process invented by him of daguerrotype in natural colors, the Hillotype, which turned out to be nothing but painting over the daguerrotype.'

Evidently Hill did manage to produce some kind of result because a Hillotype entitled 'Landscape with a Farmhouse' formed number 1 exhibit in the 'Colour as Form' exhibition at the International Museum of Photography in Rochester, NY in 1982.

Some of the pros and cons of this long running argument about an unimportant process have been included as an early reminder that during the development of such a complex field of activity as colour photography, it was inevitable that there were many disputes and uncertainties that sometimes preclude the historian from being as sure about things as he would wish to be.

HAND-TINTED DAGUERROTYPES

While experimenters throughout Europe and the US were busy seeking a way to record colours directly, many practising photographers did not wait; they simply decided to supply their customers with the colours they wanted by adding them to the surface of their daguerrotypes. It is not easy to colour the non-absorbent surface of a metal-based image, and in 1842 the London-licensed daguerrotypist Richard Bird obtained a patent in which he disclosed several methods of tinting, the simplest of which involved – 'stippling dry colours onto different parts of the picture and then setting the colours by breathing on them.'

The popularity and commercial success of the daguerrotype process only lasted for about twenty years and after 1860 the wet-collodion process took over, to be replaced in turn by gelatine dry-plates during the last quarter of the century. During that same period there was growing acceptance that 'indirect' three-colour methods would eventually provide solutions to the photographic reproduction of colours.

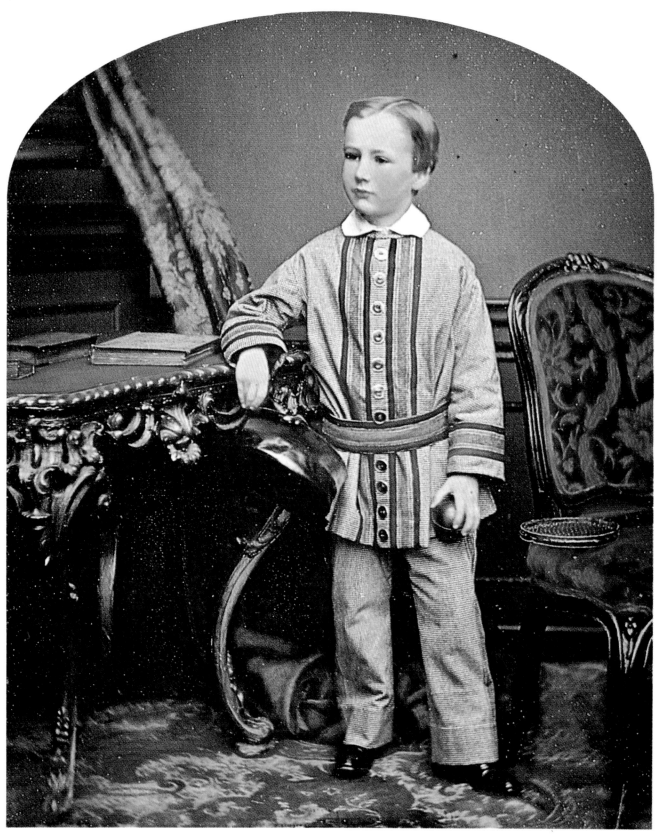

Thomas Richard Williams (1825-71), British. Portrait of a young boy c. 1855, handtinted daguerreotype (half of a stereograph) 5.6 x 6.8 cm (Collection & Copyright © Stefan Richter.)

THE LIPPMANN PROCESS

However, one technically sound 'direct' process of colour photography was announced in Paris in 1891. In January of that year Gabriel Lippmann, a professor of physics at the Sorbonne, presented a paper to the Academy of Sciences in which he described how colours can be reproduced by recording standing waves formed within an emulsion layer by the interference of direct and reflected light.

Briefly, when light waves pass through transparent emulsion and are then reflected from the surface of a layer of mercury, these waves will, on their return, engender a number of stationary waves when they meet other incoming waves. Whenever these reflected waves meet incoming waves of the opposite phase a trough will be filled in and there will be no effect on the silver halide, but when the incident and reflected waves meet in the same phase they will be intensified and have a strong effect on the adjacent silver halide.

When a Lippmann plate has been exposed, developed and fixed, its gelatine layer will contain a series of layered silver deposits, the distance between them being in strict proportion to the wavelength of the light which caused them. If the processed Lippmann plate is then viewed by reflected light at a suitable angle, colours corresponding to the original will be seen.

Some daguerrotypes, because of their polished silver backing, may also display traces of natural colours when held at a certain angle, but it remained for Lippmann to understand and refine the system.

Although the interference process is generally attributed to Lippmann, he referred in his paper to earlier theoretical work by Zenker and practical demonstrations by Weiner. Becquerel too claimed to have had success with a similar procedure, but in fact he used dry plates coated electrolitically with silver chloride in a crystalline form which allowed the formation of a pattern of stationary waves. Becquerel could neither fix his images nor prevent them from disappearing if exposed to light. Nièpce de Saint Victor and Poiteyin met the same difficulty and although Saint Victor did display some of his heliochromes at the World Exhibition in Paris in 1867, he had to keep them in subdued light and replace them frequently.

The announcement of Lippmann's process caused a stir in both the scientific and the popular press and in 1908 Lippmann was awarded the Nobel Prize for physics for his invention. From the beginning however, this elegant answer to the quest for direct colour photography was destined to have little practical use.

The first essential requirement when recording colours by the interference method is that the light sensitive layer, which must be panchromatic, is practically transparent and yet capable of recording some 7,500 line pairs per millimetre. Such an emulsion will obviously depend upon extremely small grains of silver halide – somewhere around 0.04 micro-metres in diameter. This in turn means that exposure in a camera will seldom be less than a minute, even under favourable conditions.

The second requirement is that the sensitive layer must be in perfect optical contact with an efficient reflecting surface when it is exposed. In practice this was usually achieved by use of a special dark-slide into which mercury could be poured so as to be in contact with the emulsion surface during exposure. Mercury was not an ideal answer since it tends to desensitise silver halides. Herbert E. Ives son of Frederick Ives later suggested using a silver-coated foil applied to the emulsion layer but this must have involved a complicated preparatory procedure.

Penrose in England and Zeiss in .Germany made special mercury-holding darkslides and the latter also produced hand-held viewers and an arc-light projector. Practical work on the

(left) Before any form of colour photography was possible, daguerrotypes were being hand-coloured or tinted. The practice was popular with some photographers and many of their customers; but others condemned the practice, claiming that it was akin to 'illuminating an engraving by Rembrandt'.

(right) Penrose made special darkslides to contain the mercury that was used to provide the reflecting surface needed when making a Lippmann interference photograph.

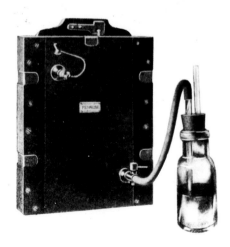

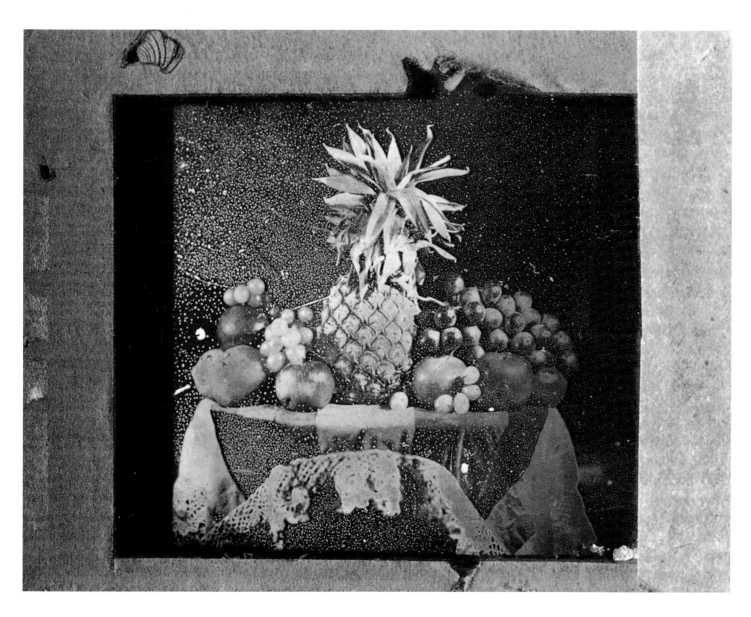

Reproductions of a still-life (above) and a spectrum (right) made from Lippmann interference photographs by Neuhauss and Lehmann

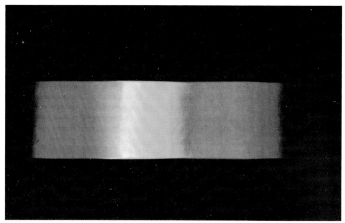

interference process was done by Lippmann in France and by Neuhauss and Lehmann in Germany. Dr. R. Neuhauss was probably the most active and successful practitioner, producing some 2,500 Lippmann photographs in the decade between 1894 and 1904.

The Lumière brothers, who backed several different colour systems before conceiving their Autochrome process, fostered Lippmann's interference method with enthusiasm, not only making the special emulsions but also projecting the images with arc light.

Viewing a Lippmann photograph was not straightforward because reflections from the front of the glass plate tended to interfere with the colour image. This problem was largely solved in 1899 by Professor Weiner (who had previously demonstrated the practicality of the process) when he cemented a shallow angle (10 degrees) glass prism to the front of a processed Lippmann plate.

Most photographic museums have at least one example of a Lippmann photograph but the finest collection is probably that held by the Preus Fotomuseum at Horten in Norway.

Even though the process could not be commercialised, the technology used to produce the extremely fine-grained emulsions required for interference photography proved to be indispensible to a new generation of photographers working on reflection holography more than half a century later.

LANCHESTER MICRO-DISPERSION PROCESS

There is another way to reproduce colours by a single 'direct' exposure. The microdispersion method of colour photography is often attributed to Lanchester, who certainly obtained a patent protecting his version of the system in 1895. However, other workers, including Rheinberg and Lippmann, also contributed to the understanding and practice of this prismatic dispersion method of reproduction.

Lanchester's patent explained his procedures:

'I arrange a grating consisting of a number of parallel opaque bars, between a photographic camera and the object to be reproduced and as close to the latter as possible, the said bars being preferably fixed at an equal distance from one another and leaving spaces between of less width than the bars themselves. The camera is of ordinary construction and a prism is arranged in front of or behind the lens with its axis parallel to the bars of the grating the dispersion of the said prism being such that when the camera is focussed on the grating the images of the slots form a series of spectra on the focussing screen or plate.'

After exposure (which will inevitably be a long one because the emulsion would be fine grained and very slow) the negative image is processed and a positive is made from it by contact printing onto another glass plate. If the positive is then placed in exactly the same position as the negative occupied during exposure, and is then illuminated with white light, an image of the object in colour will be visible via the optical system.

Like the Lippmann process, Lanchester's prismatic dispersion method of colour photography was ingenious and elegant but impractical, because of its restrictive conditions for viewing and consequently, Lanchester is more likely to be remembered for his motor car than for his contribution to colour photography.

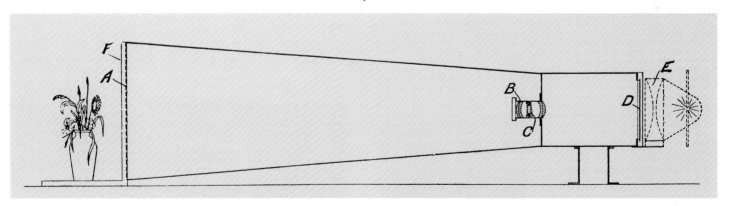

Lanchester's microdispersion method of 'direct' colour photography, required a grating of about 200 lines to the inch with the opaque lines being wider than those transmitting light. The grating (A) was placed close to the object being photographed and an image of the two was formed by an objective (B) which also incorporated a dispersing prism (C) so that a parallel series of tiny spectra was recorded on a panchromatic plate at the focal plane (D). A positive, contact printed from the processed negative, was then placed in the focal plane (in exactly the same position as the negative when exposed) and its image projected back through the system to form a reconstituted colour image on a screen (F).

EARLY CONCEPTS AND PROCESSES

WEEKLY EVENING MEETING,
Friday, May 17, 1861.
The Duke of Northumberland, K.G. F.R.S. President,
in the Chair.
Professor J. Clerk Maxwell,
On the Theory of Three Primary Colours.

'Three photographs of a coloured ribbon taken through the three coloured solutions respectively, were introduced into the camera, giving images representing the red, the green and the blue parts separately, as they would be seen by each of Young's three sets of nerves separately. When these were superposed, a coloured image was seen, which, if the red and green images had been as fully photographed as the blue, would have been a truly-coloured image of the ribbons. By finding photographic materials more sensitive to the less refrangible rays, the representation of the colours of objects might be greatly improved.'

EXTRACT FROM THE REPORT OF CLERK MAXWELL'S LECTURE 'ON THE THEORY OF THREE PRIMARY COLOURS', AT THE ROYAL INSTITUTION ON FRIDAY, MAY 17TH 1861.

Most historians agree that colour photography as we now know it, really began with a lecture before the Royal Institution in London on the 17th of May 1861, during which James Clerk Maxwell demonstrated that photographic records could be used to first analyse and then synthesize the colours of a scene by means of red, green and blue light.

In fact, Maxwell had suggested that photography might be used in this way in a communication to the Royal Society of Edinburgh six years earlier. In that paper he acknowledged that Thomas Young, the celebrated physicist and mathematician, had been first, in 1801, to put forward the hypothesis that our ability to perceive colour depends upon the presence in our eyes of three different types of nerve fibres, sensitive to reddish, greenish and bluish light respectively and that the variety of sensations we call colours, all result from the stimulation of those three types of nerve to different extents.

In his Royal Institution paper, Maxwell was at pains to explain that – 'The sensation of each elementary nerve is capable only of increase or diminution, and of no other change.' He then went on to describe his possible system of colour photography –

'This theory of colour may be illustrated by a supposed case taken from the art of photography. Let it be required to ascertain the colours of a landscape by means of impressions taken on a preparation equally sensitive to rays of every colour.

'Let a plate of red glass be placed before the camera and an impression taken. The positive of this will be transparent wherever the red light had been abundant in the landscape and opaque where it has been wanting. Let it now be put in a magic lantern along with the red glass and a red picture will be thrown on the screen. Let this operation be repeated with a green and a violet glass, and by means of three magic lanterns let the three

(right) At a meeting of the Royal Institution in London May 17th 1861, Professor J. Clerk Maxwell described and demonstrated the principles on which all subsequent processes of colour photography were based.

(far right) The lantern plates used by Clerk Maxwell to demonstrate three colour additive photography are in the Cavendish Laboratory at Cambridge. This plate represents the blue record of the famous tartan ribbon.

images be superimposed on the screen. The colour at any point on the screen will then depend on that of the corresponding point of the landscape and by properly adjusting the intensities of the lights etc, a complete copy of the landscape, as far as visible colour is concerned, will be thrown on the screen.'

MAXWELL'S DEMONSTRATION

Several things about Clerk Maxwell's demonstration were puzzling; for instance, Thomas Sutton, his assistant, reported that he also made a fourth exposure through a yellow filter, the purpose of which was never made clear.

The filters used for the experiment were specified as being glass cells containing solutions of ferric thiocyanate, cuprammonium sulphate and cupric chloride, information that was to be quite important a hundred years later when the experiment was repeated. The wet-collodion plates that Maxwell had to use were

'colour blind' in the sense that they were really only sensitive to ultraviolet radiation and blue light. Sensitivity to blue-green light was very slight and there was no sensitivity at all to red light. Maxwell himself later admitted that very long exposures were required through all except the blue filter.

Sutton, who carried out the practical work, left a detailed account of the demonstration:

'A bow made of ribbon, striped with various colours was pinned upon a background of black velvet, and copied by photography by means of a portrait lens of full aperture, having various coloured fluids placed immediately in front of it, and through which the light from the object had to pass before it reached the lens. The experiments were made out of doors, in a good light, and the results were as follows: 1st. A plate-glass bath, containing the ammoniacal sulphate of copper, which chemists use for the

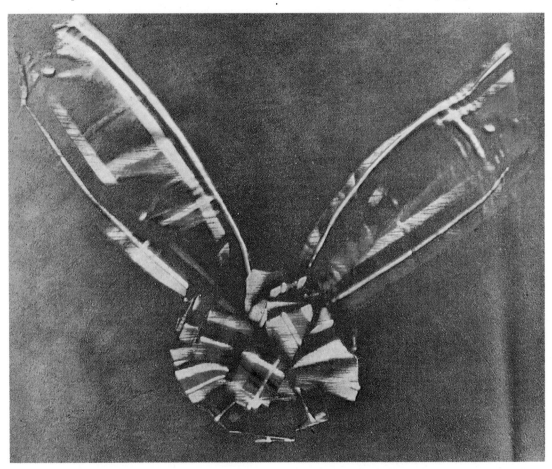

When in the 1930s, D. A. Spencer learned that the actual positive plates used by Maxwell for his demonstration to the Royal Institution still existed in the Cavendish Laboratory at Cambridge, he arranged to make copy negatives from them. From those negatives he made a colour print by the Vivex process, which has been used for the many subsequent reproductions of the famous tartan ribbon.

blue solution in the bottles in their windows, was placed immediately in front of the lens. With an exposure of six seconds a perfect negative was obtained. 2nd. A similar bath was used containing a green solution of chloride of copper. With an exposure of twelve minutes not the slightest trace of a negative was obtained although the image was clearly visible on the ground-glass. It was therefore found desirable to dilute the solution considerably; and by doing this a tolerable image was eventually obtained in twelve minutes. 3rd. A sheet of lemon-coloured glass was next placed in front of the lens, and a good negative obtained with an exposure of two minutes. 4th. A plate-glass bath, similar to the others, and containing a strong red solution of sulphocyanide of iron was next used, and a good negative obtained with an exposure of eight minutes.' Sutton continued: 'The negatives taken in the manner described were printed upon glass, and exhibited as transparencies. The picture taken through the red medium was, at the lecture, illuminated by red light – that through the blue medium, by blue light – that through the yellow medium, by yellow light, and that through the green medium, by green light: and when these different-coloured images were superimposed upon a screen a sort of photograph of the striped ribbon was produced in the natural colours.'

However, according to Maxwell, only red, green and blue light was used. But how was it that any kind of colour photograph was seen – when the iodized collodion emulsion could have recorded no red light?

The mystery seems to have escaped the attention of early historians, who could perhaps be excused because of the evidence that the demonstration was at least partially successful.

THE DEMONSTRATION REPEATED

It was not until a hundred years later that Ralph Evans of Eastman Kodak decided to simulate the Maxwell experiment. Using Thomas Sutton's notes, Evans obtained an emulsion with the same spectral sensitivity as the collodion plates used in 1861 and also made filters with the same transmissions as Sutton's liquid filter cells. By superimposing the transmission curves of the red, green and blue filters on the sensitivity curve of the emulsion, Evans revealed the explanation for the apparent success of the original experiment.

The limit of sensitivity of the collodion emulsion in the visible spectrum was about 425 nanometres, or just into the blue-green region, but the solution of ferric thiocyanate that was used as the red filter, not only transmitted red light, but also passed appreciable amounts of ultraviolet radiation – to which the collodion plate was sensitive. Following this lead, Evans looked at the reflection characteristics of a number of red fabrics and found that they often reflected ultraviolet rays as well as red light.

Evans, having found a likely explanation for the apparent success of Maxwell's experiment, confirmed his theory by using a blue-sensitive emulsion to photograph a sample of red cloth through red, green and blue filters adjusted to require the same ratios of exposure as Sutton had used. By these means Evans obtained negatives from which he was able to reproduce a reasonably good red.

So it was ultraviolet reflection together with the reflection of blue and green light from the tartan ribbon that had made it seem to Maxwell and his audience that he had demonstrated the practicality of three-colour photography.

Maxwell's lecture and demonstration came at a time when many people still believed that some direct way of recording colours would be found and it is not clear who was aware and impressed by Maxwell's disclosure and who was unaware or unconvinced by it.

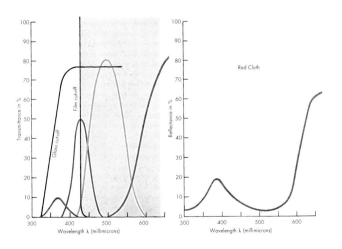

(far left) The shaded area encloses those wavelengths that could not have been recorded by Maxwell's plates.

(left) Reflectance curves of a sample of red cloth showing significant reflection of ultra-violet rays.

SUBTRACTIVE SYNTHESIS

Although he seems not to have visualized any connection between the additive and subtractive methods of colour synthesis, Maxwell did know that a wide range of colours could be obtained by appropriate mixtures of the subtractive primaries, because at the commencement of his lecture he said:

'It is found that by using three pigments only we can produce all colours lying within certain limits of intensity and purity. For instance, if we take carmine (red), chrome yellow, and ultramarine (blue), we get by mixing carmine and the chrome, all varieties of orange, passing through scarlet to crimson on the one side and to yellow on the other; by mixing chrome and ultramarine we get all hues of purple, from violet to mauve and crimson.'

It is particularly interesting to note that Maxwell clearly understood the importance of describing two of the subtractive primary colours as carmine and ultramarine, rather than using the less precise red and blue. It was not until much later that the words magenta and cyan began to be used, and even in 1911, Mees was still referring to 'yellow, red and light blue'.

For centuries before Maxwell's demonstration it had been discovered that a wide range of colours could be matched by mixtures of red, yellow and blue pigments applied to paper and other white surfaces.

JACQUES CHRISTOPHE LE BLON

Le Blon, who was born in Frankfurt in 1670, came of a family of copper-plate engravers and artists and worked as a miniature painter in Zurich, Rome and Amsterdam before coming to London in 1722. By that time he had devised a method of colour printing in mezzotint from three plates, using only red, yellow and blue inks. Le Blon disclosed his method in a book entitled *Il Coloritto or the Harmony of Colouring in Painting*. He claimed that:

'Painting can represent all visible Objects, with three Colours. Yellow, Red and Blue; for all other Colours can be compos'd of these Three, which I call Primitive; for example.
Yellow and Red make an Orange Colour
Red and Blue make a Purple and Violet Colour
Blue and Yellow make a Green Colour.
And a mixture of those Three Original Colours makes a Black and no other colours whatsoever.'

The method worked well in the hands of le Blon and those artists/printers he trained; but when the companies he formed came to depend upon less skilled operators the quality of results deteriorated and the businesses failed. Nevertheless le Blon was correct in claiming that a wide range of colours could be matched by the superimposition of three inks – his problem was that the proportion of each colour could not yet be determined by photography, but had to remain a matter of individual judgement.

LOUIS DUCOS DU HAURON

Louis Ducos du Hauron was undoubtedly first to recognize and describe the 'subtractive' method of colour photography by which it is possible to obtain colour prints on paper. So important were du Hauron's contributions that it is interesting to speculate briefly on how he came to formulate his ideas.

In his Maxwell Centenary Discourse to mark 'The First Hundred Years of Photography', D. A. Spencer expressed the opinion that Louis Ducos du Hauron had no knowledge of Clerk Maxwell's experiment. But one Frenchman who almost certainly did know of

Louis Ducos du Hauron (1837-1920), can fairly be described as the father of colour photography. In a patent he was granted in 1868, he forecast almost all the processes that were subsequently used.

Maxwell's work was Michel Chevreul, who was a member of the Royal Institution of London.

In the very same year as Maxwell's demonstration, and almost two centuries after Le Blon, Chevreul sent a memoire to the Académie des Sciences describing the work he had done to produce 1,440 different colours by mixing different proportions of red, yellow and blue pigments.

In a biography of du Hauron, Georges Potonniée expresses the opinion that du Hauron's – 'deductions must have been drawn indirectly from the experiments of Chevreul.'

Perhaps it is not very important to decide whether it was knowledge of Maxwell's lecture and demonstration that triggered du Hauron's ideas, because the fact remains that the young Frenchman undoubtedly did predict most of the practical ways of reproducing colour by photographic means.

Du Hauron, who was born on December 8th 1837 in Langon, Gironde, filed a British Patent in 1876, which for its foresight and comprehensiveness must be unequalled in the history of photography.

Throughout his youth du Hauron was delicate and more interested in the arts than the sciences, studying music and painting and becoming an accomplished pianist by the age of fifteen. It was not until 1859, a couple of years before Clerk Maxwell's famous demonstration, that du Hauron began to interest himself in the practical problems of colour photography. In 1868 he obtained a French patent entitled *Les Couleurs en Photographie – Solution du Probleme* in which he described both a three-plate 'one-shot' colour camera and a 'mosaic' filter additive screenplate. The paper was sent to a friend, M. Lelut, a member of the Académie des Sciences, with a request that it be read before the Académie; but Lelut decided not to submit the paper because du Hauron could offer no proof of the correctness of his argument. It was not until ten years later in 1876, that Alcide du Hauron, a

A.D. 1876, *22nd July.* N° 2973.

Photography in Colours.

LETTERS PATENT to William Morgan-Brown, of the Firm of Brandon and Morgan-Brown, Engineers and Patent Agents, of 38, Southampton Buildings, London, and 13, Rue Gaillon, Paris, for the Invention of " IMPROVEMENTS IN PHOTOGRAPHY IN COLOURS, AND IN THE APPARATUS FOR THAT PURPOSE." A communication from abroad by Louis Ducos Duhauron, of Agen (Lot and Garonne), France, Chemist.

Sealed the 17th November 1876, and dated the 22nd July 1876.

COMPLETE SPECIFICATION filed by the said William Morgan-Brown at the Office of the Commissioners of Patents on the 22nd July 1876.

5 WILLIAM MORGAN-BROWN, of the Firm of Brandon and Morgan-Brown, Engineers and Patent Agents, of 38, Southampton Buildings, London, and 13, Rue Gaillon, Paris. " IMPROVEMENTS IN PHOTOGRAPHY IN COLOURS, AND IN THE APPARATUS FOR THAT PURPOSE." A communication from abroad by Louis Ducos Duhauron, of Agen (Lot and Garonne), France, Chemist.

GENERAL DESCRIPTION OF THE SYSTEM.

10 The problem of photography in colors such as I express it does not consist in submitting to the luminous action a surface prepared in a manner to appropriate and preserve at each point the colouration of the rays which strike it. What I ask is that the sun avails itself judiciously of an invariable palette, to which it is trusted. It must be that he only charged with the choosing and the mixing of the

15 colours furnished to him will obtain incomparable copyist the most learned and the most authentic of the representations of nature. The problem being defined in these terms, an observation that I have checked by numerous experience has served for the point of departure to resolve it. That observation is this : In opposition to the colors of the spectrum, the scale of which is formed of innumerable shades, and

20 allows of our distinguishing and naming seven principal ones, the coloring substances which serve to express them are reduced to three; red, blue, yellow. This triplicity of colors has been of long date experimentally but confusedly recognised ; if it had been verified beyond possibility of doubt it would have long since been an axiom,

[*Price 8d.*] A

(above) This patent, the first to be granted in Britain on the subject of colour photography, should be required reading for any student of photographic history. In it, du Hauron forecast almost all of the processes of colour photography that were subsequently used.

(right) 'Still-Life With Butterfly'; a colour photograph taken and printed by Ducos du Hauron circa 1875.

more forceful character, described the work of his brother in a book entitled – 'La Triplice Photographique des Couleurs et l'Imprimeur'.

Modern patent specifications are often notable for what they omit rather than what they reveal, but that criticism could never be levelled at the seventeen pages of E.P.2973 of 1876 in which du Hauron disclosed his many ideas on colour photography.

The specification commences by dismissing the prospects of recording colour by the direct action of light along the lines pursued by Seebeck, Herschel, Becquerel and Saint Nièpce:

The problem of photography in color (sic) such as I express it does not consist in submitting to the luminous action of a surface prepared in a manner to appropriate and preserve at each point the coloration of the rays which strike it. This point of departure thus fixed, I will explain by what reason I have arrived at this system of heliochromy. If it is true that three colors produce, by the mixture that results from their superposition, all the colors, it follows, per contra, that any picture ... may in the mind decompose itself into three pictures, the one red, the other blue, the third yellow, the superposition and incorporation of which reconstitute the same picture.'

There surely, we have the basis of all subsequent subtractive colour processes.

But making colour separation negatives in 1876 involved sensitizing wet plate emulsions to green and red light to augment their native blue sensitivity and, characteristically, this prophetic Frenchman goes into a detailed description of his procedures for obtaining each colour record. He acknowledges Vogel's discovery of the green sensitizing powers of aurine, but in his typically reserved manner, adds:

'I have notably experimented with the leaves of the red beetroot, the sensitive plate impregnated with an alcoholic solution of the said leaves, has given rapid impressions with green light. This is only a first point ascertained, I should not dare to guarantee complete regularity of the results'.

For his red record du Hauron depended upon the earlier discovery by Becquerel, that chlorophyl could be used as a red sensitizer. The procedure du Hauron followed was to:

'collodionize and sensitize the plate with the collodion and the silver bath common to all three negatives. I wash it in distilled water to free it from the excess of nitrate of silver, then immerse

it in a bath of rectified alcohol so as to substitute this alcohol for the water which the layer has retained, and the better to ensure the penetration of this layer by the solution of chlorophyl.' To obtain the solution of chlorophyl – *'I fill a flask with the fresh gathered leaves of the ivy cut into small pieces with scissors. I put in it rectified alcohol 40, so as to cover the ivy and leave it to infuse. At the end of 3 or 4 days the beautiful green shade which the liquid acquires little by little will have acquired its intensity and the solution will have arrived at its maximum photogenic power.'*

From all of which it can be seen just how formidable a task it was to produce a set of colour separation negatives at a time when the individual exposures were likely to have taken 10 to 15 seconds in sunlight with a doublet lens at about f/8. All the more surprising then, that in this same patent, du Hauron proceeds to define the principles – 'upon which a triplicate camera should be constructed, furnishing at once a simultaneousness of the three exposures, lineal identity of the three proofs and the power of giving them any dimension whatever.' In other words, the dual concept of a one-shot camera and enlargement of the negatives made with it. The layout of the chromographoscope, as the camera was called, is better understood from the diagram and photograph than from a description.

Next the patent deals with the 'printing and superposition of the monochromes' and after mentioning several alternatives, including chemical toning, du Hauron says: 'I will limit myself then to show, as an example, how the bichromated gelatine, or carbon process, may be applied to heliochromy.' He continues characteristically, with detailed instructions for making and sensitizing carmine, prussian-blue and chrome yellow pigment tissues and using sheets of glass treated with ox-gall as temporary supports for the relief images before transferring them in register onto a final paper support.

The accompanying illustration is from a print made by these means in the 1870s.

Not all of his contemporaries understood or agreed with du Hauron's ideas and Frederick E. Ives in particular was critical of his proposals, declaiming as late as 1902, that – 'such loose methods may serve as playthings, but they no more represent scientific trichromatic photography than a child's use of a sixpenny prism represents the science of spectrum analysis.'

However, later authorities had no doubts about the value of du Hauron's contributions, as Wall made clear in his *History of Three-Color Photography,* declaring that – 'du Hauron's methods were in close accord with the most successful of present day practice.'

Du Hauron never managed to gain any commercial benefit from his inventions and he died a poor man in 1920 having been helped in his later years by the Lumière brothers of Lyons.

In 1897 du Hauron received belated recognition by the Academie des Sciences in his own country and by the award of its Progress Medal by the Royal Photographic Society of Great Britain in 1900. In 1912, he was made a Chevalier of the Legion d'Honneur.

HERMANN WILLHELM VOGEL

In his patent of 1876 du Hauron refers to Vogel's disclosure, made only three years earlier, that the dye coralline could be used to extend the sensitivity of silver halides into the green region of the spectrum. Vogel, who had made his discovery by chance, described what happened in 1863:

'I obtained from England some collodion – bromide dry plates prepared commercially by Wortley, who used a process some

In 1873, Vogel caused considerable controversy claiming that a silver bromide emulsion could be rendered sensitive to a wide range of colours by the inclusion of certain dyestuffs. He was proved right and optical sensitization soon became accepted practice.

details of which are kept secret. I exposed these plates to the spectrum and found to my surprise that they were more sensitive in the green, ie. the E line, than in the blue, ie. the F line.'

The dye had been added to the emulsion of the plates to reduce halation, although Vogel did not know that at the time. The remarkable discovery was of course widely reported, but the claims immediately met with much disbelief and some ridicule. Even men like Eder questioned Vogel's findings although Becquerel, who had already found that chlorophyl imparted sensitivity to red, did support him.

Most of the failures that resulted from early attempts to confirm Vogel's findings were caused by the use of too high a concentration of dye; for as Vogel pointed out – 'In a tinted film each bromide particle is surrounded with colour and if the concentration of dye be too great, the rays are absorbed so efficiently that they cannot reach the grain itself.'

The editor of the *British Journal of Photography* disagreed with this explanation and argued that – 'if it is true that the less the dye concentration, the stronger the sensitizing effect, then would not the maximum effect be obtained if the dyes were omitted altogether?'

Such fallacious arguments must have exasperated Vogel, who nevertheless kept his cool and continued with his work, at one point saying: 'First executed, next banished; fortunately I have suffered both proceedings without any inconvenience or damage, and have even as an executed exile, the impudence to continue my experiments.'

Once Vogel's work had been confirmed and the principles of optical sensitization adopted, progress towards the discovery of new and more effective dyes was rapid. Eder, who had scorned

Vogel at first, found in 1884 that erythrosin imparted excellent yellow and green sensitivity and its use led to the first commercial orthochromatic plates.

Adolphe Miethe and Arthur Traube obtained a patent in 1903 for ther use of the dye ethyl-red which was used by the Perutz Company in Munich to produce the first panchromatic plate, but adequate red sensitivity was not achieved until Benno Homolka, a chemist at the Lucius and Bruning dye works at Hoschst, discovered pinacyanol in 1906.

Panchromatism was of course most important to the pioneers in colour photography who, until the early years of this century, had to accept very long exposures to obtain a red record negative and modify the exposing light by the use of yellow or orange filters to suppress the inherent blue-sensitivity of the emulsions used for the early screen-plate additive processes.

As du Hauron made clear in his 1876 patent, an emulsion can be rendered colour sensitive by bathing the coated plate in a solution of an appropriate dye, but he also said in an interview in 1907, that: 'Colouring matters were little known at that time and I had to give almost incredibly long exposures, by green or red light, to emulsions scarcely sensitive to those colours.'

In the early days of colour sensitizing, manufacturers often met difficulties in producing reliable sensitized plates and some photographers found it necessary to sensitize ready coated emulsions by bathing and drying them just prior to exposure. This inconvenient way of obtaining colour sensitive film was still in use when Kinemacolor and even the first Technicolor films were shot.

CHARLES CROS

In February 1869, the year after du Hauron had obtained his first patent or *privilege*, Charles Cros published a paper in *Les Mondes* with the title: 'Solution generale du probleme de la photographie

des couleurs.' Cros had in fact, as seems to have been common practice in France at that time, deposited a sealed package with the Academie des Sciences containing a report of his work on colour photography by means of separation negatives. It was only when he learned of du Hauron's work along parallel lines that Cros decided to reveal what he had left with the Academie in 1867.

It is remarkable, but there seems to be no doubt that neither du Hauron nor Cros was aware of the other's simultaneous attempt to solve the problems of colour photography. Furthermore, it is pleasant to find that all but one of those who have written on this remarkable coincidence agree that these two Frenchmen working just before the Franco-Prussian war, readily acknowledged each other's findings without any trace of jealousy. As we shall see from many later controversies colour photography did not throw up many inventors who were ready to share credit with others.

The two were vastly different men, one a provincial from Bordeaux and the other a dilletante who moved among the Parisian intelligentsia.

Cros was a man of many parts; a poet, a scientist, and artist. He tended to be a theoretician rather than a practical worker explaining that he had neither the means of carrying out his ideas nor the desire for commercial exploitation, being content with the honour of discovery. His ideas for a phonographic disc, rather than the cylinder chosen by Edison, were contained in another paper he deposited with the Academie that was opened in 1877, but he never actually made a sound recording.

In his several patents, du Hauron made it clear that he knew how to produce colour prints on paper and it was the fact that he had submitted two or three colour prints in support of the paper he sent to the Société Francais de Photographie in 1869 that gave his submission precedence over that read by Charles Cros on the same day.'

Nevertheless, making colour prints from separation negatives in the 1870s was extremely difficult, and we should remember that throughout the latter half of the nineteenth century stereoscopic photographs were extremely popular and to a large extent satisfied public interest in photography. For instance, the London Stereoscopic Company, whose slogan was 'No Home Without a Stereoscope', offered a choice from more than 100,000 scenes.

This widespread use of the stereoscope probably encouraged du Hauron and Cros and then Ives, to devise instruments in which positive images printed from three separation negatives could be optically combined to produce a colour photograph without the need for either projection or printing.

Although, as already mentioned, it was not forwarded to the Academie des Sciences in 1862 as du Hauron wished, the famous paper he had sent to his friend M. Lelut was eventually published in 1897 and it contained a drawing and description of the very first photochromoscope. The instrument du Hauron proposed was to be used to combine red, green and blue positive images obtained by making glass diapositives from three separation negatives.

As part of his presentation to the Société Francaise de Photographie, Cros also described a photochromoscope and although he provided no drawing, he did explain how to set up the elements of the instrument as it were on a bench:

'Print separately the three clichés on glass – so as to have the three positives. Coat the positive obtained with the red frame with the same varnish which was used for the glass of the frame. The same for the other two positives, of which the first will be covered with yellow varnish, the second with blue varnish. This done, take two clean glasses. Mount on five independent supports, at the same height, the two white glasses and the three positives coloured as has already been described. Finally, try to make coincide the

images of two of the three positives formed in each of the transparent glasses with the third positive which one looks at direct through these glasses. it may be convenient to illuminate the positives by mirrors.'

By 1876 when his first British patent was granted, du Hauron could clearly see that a photochromoscope could fairly easily be

adapted to become a colour camera. In fact, before the end of the century, he did design and build several different dual purpose instruments, one of them being made by Lesueur in 1899 and called the Melanchromoscope.

It is clear from the patents and writing of the time, and from colour photographs of the Chromographoscope of 1879 and the Melanchromoscope of 1899, that du Hauron and others, including

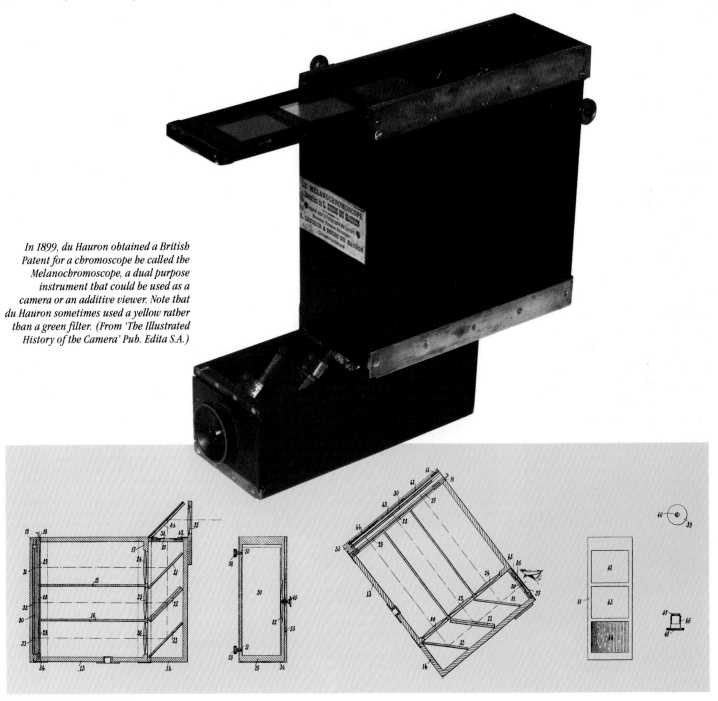

In 1899, du Hauron obtained a British Patent for a chromoscope he called the Melanochromoscope, a dual purpose instrument that could be used as a camera or an additive viewer. Note that du Hauron sometimes used a yellow rather than a green filter. (From 'The Illustrated History of the Camera' Pub. Edita S.A.)

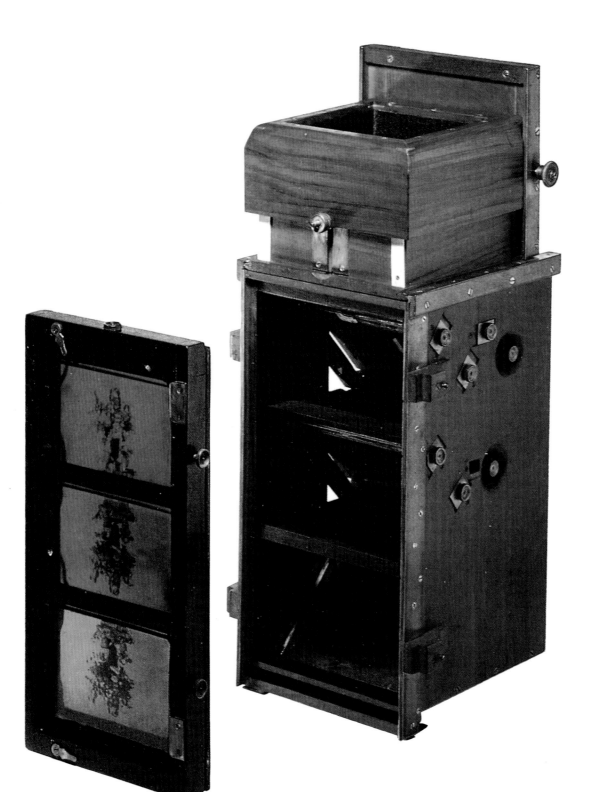

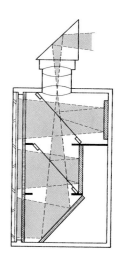

Du Hauron invented his Chromographoscope
in 1874. It could be used either as a camera or
an additive viewer. (From 'The Illustrated
History of the Camera', Courtesy Edita S.A.)

Cros, McDonough and Lumière, were not sure whether a yellow or green filter should be used together with orange-red and blue-violet filters to effect three-colour analysis.

Ives subsequently noticed this uncertainty and derided du Hauron by saying: 'Du Hauron had not even selected the correct "primary" colours but assumed that red, yellow and blue were the "primaries".'

FREDERICK EUGENE IVES

Ives was the next man to take the stage, and remain there for almost fifty years. Frederick E. Ives, who was born in Litchfield, Connecticut in 1856, first worked as an apprentice to a local printer but by 1874 he was a photographer in a studio in Ithaca, NY. In 1878 he set up a photogravure printing company in Philadelphia and was granted his first patent in 1880, not for colour photography, but for an improvement in half-tone screening. Prior to Ives' patent a pair of screens was used for colour work. Ives introduced the single cross-line screen that became the norm thereafter.

Throughout his life Ives was involved in arguments and litigation concerning his rights in the half-tone screening process and similar disputes followed much of the work he subsequently did on colour photography.

In his *Autobiography of an Amateur Inventor*, Ives stated that he had no knowledge of Clerk Maxwell's 'proposed method of color reproduction', although he surely must have been aware of Maxwell's work by the time he applied for U.S. Patent No. 432,530

in 1890, for it includes this:

'My plan, based upon the above theory, may be described as follows: Three photographs are to be made from each subject to be reproduced in such a manner that each photograph represents by its light and shade the degree to which light coming from different portions of the subject excites a single primary color sensation in the eye.'

From the outset of his involvement with colour photography, Ives tended to belittle the work of du Hauron and Cros, claiming that their suggestions 'did not lead to the production of any convincing results', but failing to acknowledge the advances that had taken place in colour sensitizing since their experiments.

In 1892, some fourteen years after Mackenstein had made du Hauron's Chromographoscope, Ives devised a camera with which he could simultaneously make three exposures through colour filters, in trefoil pattern on a single plate. Ives admitted that this first camera was 'somewhat complicated in optical construction', as also were the viewing instruments he made to superimpose optically the three filtered positive images made from the colour separation negatives.

By 1895 Ives had improved both his cameras and the viewers that went with them, which were either intended for direct vision or projection. This time the three separation negatives were exposed side by side on a single plate, thereby anticipating du Hauron's Melanchromoscope of 1899.

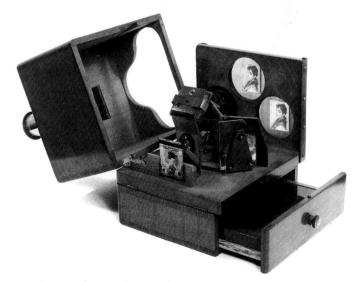

Ives first colour camera used a system of mirrors to divide the beam from a single lens into three paths so as to make simultaneous exposures on a single plate.

A similar optical system (in reverse) was used in the Ives chromoscope viewer to recombine red, green and blue images of the three separation positives.

THE KROMSKOP

Ives chose the name Kromskop for his various additive colour systems, perhaps influenced by George Eastman's double use of the letter K in Kodak. The triple-lens Kromskop was used for projecting enlarged images and the table-top transmission Kromskop for direct viewing of either monocular or stereo colour images. Ives, who was an extremely energetic man, travelled to Europe in 1898 to obtain photographs of landscapes with a stereoscopic colour camera fitted with a sliding back. The negatives he produced were used to make sets of positives which could then be sold to owners of Kromskop viewers to augment their collections. (This idea was resurrected in the 1970s when GAF promoted world-wide sales of the popular View-Master discs and stereo viewers. By that time it was possible to use 16mm Kodachrome to record the stereo pairs.)

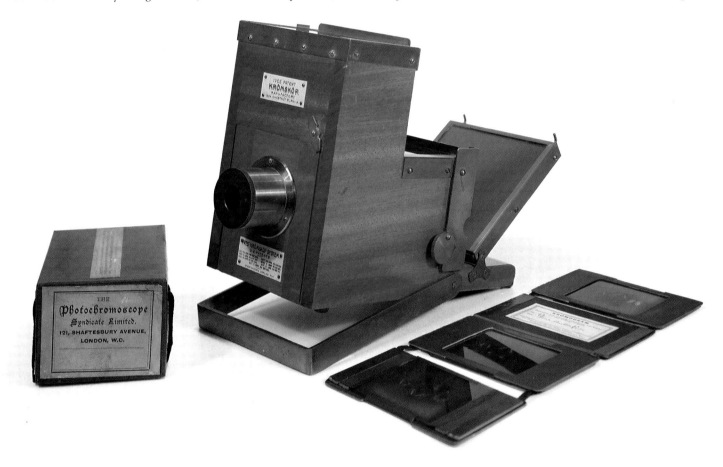

(above and right) The Ives Junior Kromskop was used with Kromograms comprising three separation positives taped together so that they would be inserted into the viewer in the correct positions.

Frederic Eugene Ives was born in the US in 1856 and between 1892 and 1937, when he died, he worked continuously on processes and apparatus related to colour photography.

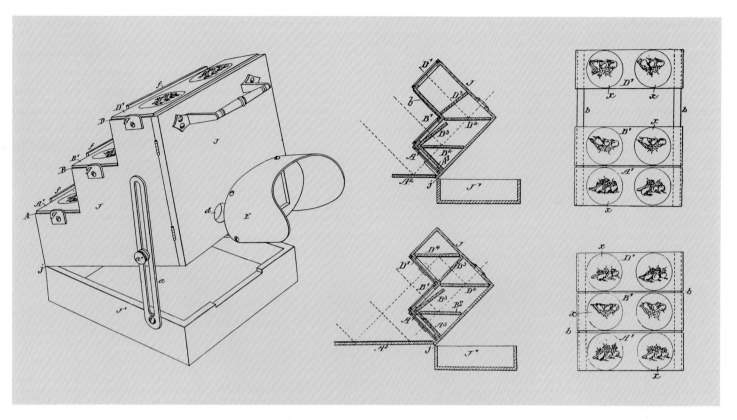

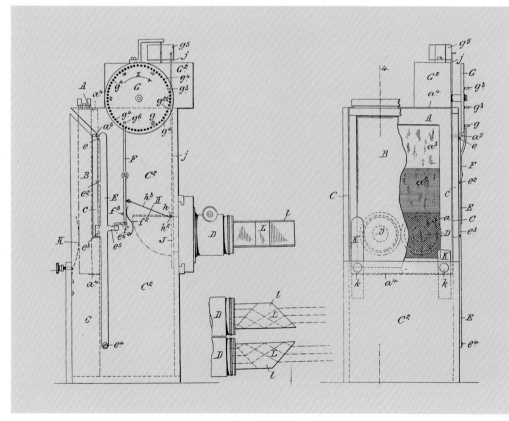

For the Ives' Stereo Kromskop, the three pairs of glass positives comprising each colour stereogram were made by contact printing from original separation negatives taken on a single plate in a twin-lens stereo camera fitted with a sliding back. In order to obtain the necessary pairs of colour separation negatives, Ives designed and patented an ingenious gravity operated repeating back with which the three exposures could be individually adjusted and automatically given.

The device may never have been built, for there is evidence that in practice, Ives used a simpler camera made for him by Sanger Shepherd, but still operated by gravity.

Ives also gave frequent lectures and demonstrations to learned societies, including the Society of Arts in London in 1897, when Sir William Abney said:

'coming next to Mr. Ives, not everyone in this room may be aware of my opinion of that gentleman's process. It is the acme of perfection, showing what can be done if you take the trouble to use three plates in a scientific manner.'

In 1900, again in London, Ives gave the Traill Taylor Memorial Lecture before members of the Royal Photographic Society in Russell Square.

Although none of them was used as widely as the Kromskops, there were several other manufacturers of photochromoscopes,

including Bermpohl in Germany, Lesueur in France and Watson in England.

It was Watson who made the Kromaz viewer, based on a patent by C. S. Lumley, T. K. Barnard and F. Gowenlock, who in 1899 patented the idea of achieving stereoscopic three-colour photography with only two pairs of stereograms. They depended upon the human brain's ability to combine a red and green right-eye image with a blue and green left-eye image. The four negatives were taken in pairs in succession, using a simple sliding back fitted with one red, one blue and two green filters.

It is undoubtedly true that remarkably convincing colour reproduction was possible via the three-plate additive method, and for some years Ives remained hopeful that his Kromskops would become popular as educational tools as well as for entertainment.

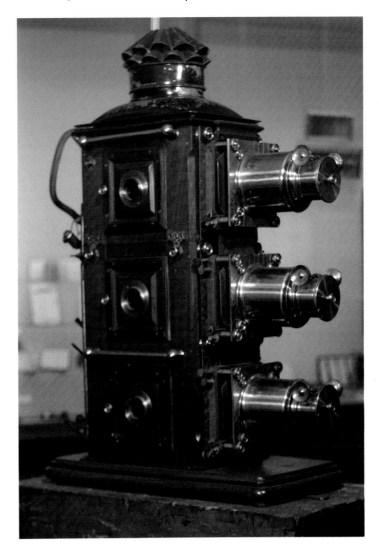

The company he formed in Philadelphia produced a catalogue of prepared medical specimens in the form of Kromograms, and in 1898 a company called the Photochromoscope Syndicate was formed in London to promote the sales of Kromskop projectors and viewers. But in the end Ives was forced to admit that the future of colour photography did not lie with the additive method of synthesis based on three separate records. Even in his *Handbook of the Photochromoscope* published in 1894, Ives was prepared to write:

'It is true that this is not exactly the kind of color photography that the world has been looking for ... because it does not produce fixed color images which can be framed and hung upon the wall. Fixed color prints can be made from the Kromskop negatives, but only by so greatly complicating the process as to make it comparatively impracticable.'

Ives did make colour photographs by the subtractive method – usually in the form of lantern slides that could be projected in a normal single lens projector. He described his earliest method in an article in the *Journal of the Camera Club of London* in 1889:

'Bichromated gelatine films on clear celluloid were exposed (from Kromskop negatives) from the back by electric light, developed like carbon prints, and each image dyed to a suitable depth by immersion in a solution of its proper printing colour. These prints were superimposed in register between glasses to make lantern slides.' But Ives admitted there were problems: *'the film had to be sensitized the night before printing, the development was slow, the dyeing was even slower and never under very perfect control, the gelatine prints did not dry very sharply unless wetted and redried two or three times, and the*

(left) This triple projector would have been similar to the one used by Ives for his demonstrations of additive colour photography in the 1890s.

relief was so high that it was necessary to cement them up with Canada balsam for satisfactory use in the lantern. It required a day's time from start to finish.' Ives claimed to have: *'taught the process to Sanger Shepherd who was employed as my assistant in London, and he afterwards exploited it commercially as the Sanger Shepherd Process.'*

Whatever the truth of this, during the early years of this century Sanger Shepherd certainly was advertising a dyed gelatine relief process as well as a colour camera with which to obtain separation negatives of live subjects.

It had already been realized by a number of workers including Sanger Shepherd that colour separation negatives could be conveniently exposed in succession by means of a sliding triple plate holder containing the necessary plates and colour filters. The sets of stereo separation negatives made by Ives during his European tour of 1898 were made with a twin-lens camera fitted with a repeating back.

The realization by Ives that his Kromskops would not provide a satisfactory answer to the popular expectations for colour photography simply meant that he turned his attention to finding other ways of solving the problems. His attempts to do this continued until he died in 1937. Among his later work were ideas for a single exposure tripack for use in ordinary cameras and simplified methods of making colour prints.

SERGEI MIKHAILOVICH PROKUDIN-GORSKII

It is not well known that photography was extremely popular in Russia during the second half of the nineteenth century and up to the Revolution in 1917. From time to time collections of historic records come to light, usually in the form of monochrome prints; but one very different collection of nearly 2,000 colour separation

negatives taken between 1909 and 1915, is now in the possession of the Library of Congress in Washington, USA.

The story behind the collection is the story of Sergei Mikhailovich Prokudin-Gorskii whose name repeatedly crops up in the patent literature of colour photography and cinematography until the late 1920s. Prokudin-Gorskii, a chemist by training, had met Professor Miethe while working in Germany and was therefore well versed in the techniques of colour photography, particularly colour sensitizing. For a time after returning to Russia in 1893, Prokudin-Gorskii edited a photographic magazine, but he also formulated a grand scheme to record life throughout the Russian Empire by means of colour photographs. He proposed to use the additive system, exposing his 9in x 3in Ilford Red Label plates with a sliding or repeating back of the type designed by Miethe and constructed for him by the Berlin camera maker, Bermpohl. To project the positive plates made from the separation negatives, Prokudin-Gorskii would use a modified Ives projection chromoscope.

However, before he could undertake such an ambitious scheme, he needed the support and authority of the Tsar. Through the good offices of the Grand Duke Aleksandrovich, who was the Honorary Chairman of the St. Petersburg Photographic Society, Prokudin-Gorskii managed to arrange demonstrations; first to the mother of the Tsar, and then to Tsar Nicholas II himself. The Tsar was greatly impressed and asked: 'What do you have in mind for this beautiful work?' This was Prokudin-Gorskii's chance to explain his idea, and he seized it. The upshot was that the project took on the authority of an Imperial Commission and within a short time Prokudin-Gorskii was presented with a Pullman railway car that had been fitted out for his photographic work and an order stating that the Tsar considered the mission of such importance that all officials should render whatever aid was necessary for the successful

completion of the project – 'at any place, at any time'.

The job was begun in 1909 and continued until 1915. It was not easy, for as Prokudin-Gorskii said:

'I worked from early in the morning to late in the afternoon hours, shooting pictures of different places from several positions. To do this I had to take my equipment from place to place, often up and down hills. I worked late into the night to see if the pictures were any good. If not, then I took them over again.'

After the Revolution, Prokudin-Gorskii and his family moved to Norway, then England and then France, where he died in 1943. Fortunately, his sons, who remained in Paris, held on to the large collection of negatives, which were eventually acquired by the Rockefeller Foundation who brought them to the attention of the Library of Congress, where they are now.

A book entitled *Photographs for the Tsar* was published in 1980, in which 120 of Prokudin-Gorskii's colour separation negative sets were used for reproduction on paper for the first time after 70 years. The illustrations were made directly from black and white contact prints printed from the original glass negatives. Bearing in mind that in some cases the emulsion was beginning to peel away from the glass, the results were remarkably good. When his scenes included live subjects, particularly animals such as camels, we are reminded that he needed several seconds in which to record all three negatives and any movement during that time inevitably resulted in colour fringing when the positive images were combined.

In 1918, a year after the Revolution, Prokudin-Gorskii was granted a British patent for a colour camera that would have greatly reduced the effects of time parallax, but it is unlikely that the camera was ever built because Prokudin-Gorskii left his homeland in 1918, never to return.

(right) While travelling through the Russian Empire during the years from 1909 and 1914, Prokudin-Gorskii used a camera fitted with a repeating back to obtain his separation negatives. Whenever a live subject such as a camel was included in the photograph there was a risk that movement would result in colour fringing.

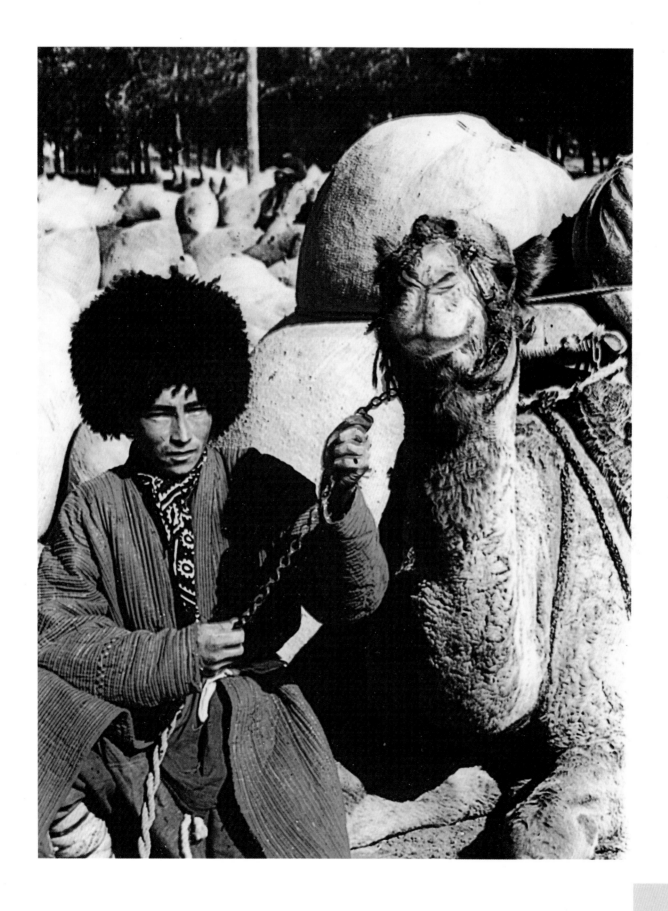

SCREEN-PLATE AND LENTICULAR PROCESSES

'Of all the chapters in the story of photography perhaps that which relates to the evolution of the colour plate as we know it at the present day is the most crowded with the results of technical investigators. The foundation of this branch of photography was laid years before this time. We must go back in fact, to the year 1861, in which the Cambridge professor Clerk Maxwell, established the system of three-colour photography in which three separate records are made, one of the blueness, another of the greenness, and a third of the redness of a coloured object. Nevertheless, within eight years of Clerk Maxwell's work, the conception of a single plate containing within itself in minute subdivision the three separate records originated in the mind of the French worker Louis Ducos Du Hauron.'

'THE BRITISH JOURNAL OF PHOTOGRAPHY', OCTOBER 2ND 1914.

Just before the turn of the century several people worked on an idea that du Hauron had propounded in his French patent of 1868.

'Enfin, il existe une derniere methode par laquelle la triplice operation se fait sur une surface. La tamisage des trois couleurs simples s'accomplit non plus moyens de cerres colores, mais au moyen d'une feuille translucide recouverte machaniquement d'un grain de trois couleurs.'

which Wall translated as:

'Finally there is another method by means of which the triple operation may be effected on one surface. The separation of the three elementary colors may be effected no longer by three colored glasses, but my means of one translucid sheet covered mechanically by a grain of three colors.'

In several articles published in 1869, du Hauron made it pretty clear that 'It is a matter of absolute indifference for the optical results obtained, whether the screens be composed of straight lines or of some geometrical divisions', but on balance he did seem to have it in mind to use parallel lines alternately coloured red, green and blue.

In 1894 John Joly, a professor of physics at Trinity College, Dublin, picked up this idea and in the patent he was granted, he tells how he would: 'obtain by means of a single photographic image of an object, a representation of this object in its natural colours, or in colours seeming such to the eye.'

As du Hauron had done before him, Joly described several different ways in which a pattern of tricolour filter elements might be formed on a glass plate, but he clearly preferred the idea of using parallel lines. From the amount of detail in the patent, it is

A schematic illustration showing how additive screen-plate processes work.
1. *Green light affects only the silver halide immediately behind green filter elements.*
2. *Removal of the resulting silver deposits leaves residual silver halide behind all the red and blue filter elements.*
3. *A second stage of development causes silver to be deposited behind those filter elements so that only green light is transmitted.*

clear that the inventor had already designed or even built the 'dividing engine' or ruling machine that he describes in even greater detail in a second patent, EP No. 17,900, granted in 1897.

Joly's investment of time and money in the design and construction of such an elaborate ruling machine was the first of many examples of the dependence of colour photographic technology on precision engineering.

A general view of the way in which Joly's ruling machine worked can be gained from the detailed drawings and explanations that accompany his patent; although the complexity of the operation is also conveyed by one or two details from the text of the specification. For instance:

'To guard against the ink flowing too freely and gathering until a drop is formed, thin folded plates of platinum or copper foil are inserted vertically in the fountain box so as by the close juxtaposition of their surfaces to render surface tension of the ink sufficient to retain the ink in the box', or: 'In the process of ruling plates it is often found desirable to maintain the ruling table warm during the ruling operation. For this purpose tubes, Fig. 2, heated by hot water or air circulating through them may be provided beneath the table.'

Joly used dyed gum or gelatine to rule lines at a frequency of 200 per inch on glass plates that had been previously coated with a thin layer of gelatine. The resulting screen-plates, as they came to be called, were produced in two forms, 'taking' screens and 'viewing' screens. A taking screen would be placed in a darkslide with its ruled surface in contact with an orthochromatic plate (the term panchromatic was not yet in use); the glass side of the screen plate facing the lens of the camera. After exposure and processing the resulting negative was used to produce a positive by contact printing and that positive was then placed in contact with a 'viewing' screen bearing exactly the same pattern of red, green and blue lines as the taking screen. The only difference between taking and viewing screens was that colours of the screens used in the camera had wider transmission bands than the narrower cutting dyes used for viewing screens.

There was every reason to use diluted colours for the taking screens because the fastest orthochromatic emulsions of that time required exposures of at least one second, even in bright sunlight when used behind a Joly screen.

At the same time as Joly, and probably prompted like him by du Hauron's ideas, an American, James William McDonough of Chicago, became interested in additive screen-plate processes.

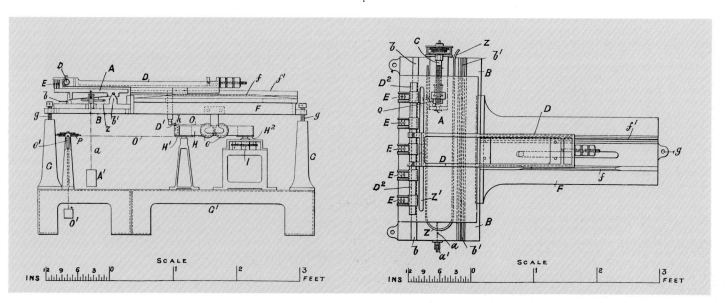

In order to obtain a screen-plate consisting of a regular pattern of very fine red, green and blue lines, Joly designed, and in 1894 patented, a precision ruling machine. A plate to be ruled with lines was carried on a sliding table (A), which was moved in one direction to rule a set of three lines and then moved at right angles a distance exactly equal to the width of the three lines formed by the ruling pens (E). Then on the return stroke, the pens would rule a further set of three lines on a fresh surface of the plate adjacent to the lines already there. The pitch of the lines on a Joly plate was 1/200th of an inch, and as can be imagined, the yield of usable plates was very low because of the many things which could go wrong.

McDonough's first idea was to produce a random patterned mosaic filter by using finely divided particles of 'glass, transparent pigments, gelatine, resin or shellac, stained by analine dyes.'

Although his patent of 1892 largely anticipated the very successful Autochrome plate that followed a few years later, McDonough seems to have had no luck with it, because he soon turned his attention to producing lined screens of the same type as Joly. McDonough must have been aware of Joly's progress, because by the turn of the century the rights to Joly's process and machine had been acquired by a Chicago syndicate called The International Color Photo Company.

The American company decided that 200 lines per inch was not fine enough and they set about producing plates ruled with 300 or even 400 lines to the inch. To do this they abandoned Joly's ruling pens and used tiny bevelled wheels instead. Nevertheless, serious production problems meant that they were only able to rule about three successful 30in x 24in plates each day, and even by charging eight shillings for a dozen quarter plates (4-1/4in x 3-1/4in) they were losing so much money that they soon went out of business.

Despite their commercial failure the efforts of both Joly and McDonough did subsequently encourage a host of other people to produce other forms of screen plates, some of which, Autochrome and Dufaycolor in particular, did eventually achieve success.

In a paper read before the Royal Photographic Society in 1910, when the interest in screen-plate processes was reaching a peak, C. E. K. Mees and J. H. Pledge examined all the colour plates invented up to that time and classified them under these headings:

1) Ruled lines
2) Dusting-on methods
3) Methods depending upon the properties of bichromated gelatine

4) Screens made by section cutting
and 5) Mechanical printing or a combination of printing and dyeing.

The two best known ruled line processes have already been considered and the next method to receive attention was the Lumière brothers' dusting-on process, Autochrome, which was also the first practicable 'coated' screen plate.

THE LUMIÈRE BROTHERS

Antoine Lumière, father of Auguste and Louis, began producing dry plates in Lyon in 1882 because he believed there would be a market for plates with better reliability and consistency than those on offer at that time. The firm prospered under the direction of the two sons, their 'Etiquette Bleue' plates became famous and the company became the largest photographic manufacturer in Europe. The Lumières were well aware of du Hauron's work and in fact towards the end of that famous man's life it was largely they who took care of him.

Following the principles laid down by du Hauron for making colour prints on paper from separation negatives, Louis Lumière produced a series of prints that were exhibited at the Paris Exhibition of 1900 where they 'set a standard that far exceeded any previous work.'

The Lumière company also made the special 'grainless' emulsions required for the plates used for the Lippman interference process.

Hoping to widen the scope of three-plate photography, the Lumières patented a 'crossed-mirror' one-shot camera in 1904, but by then they must have decided to change direction because in that same year they patented the idea of an additive screen-plate filter mosaic comprising dyed grains of starch.

(left) A monochrome enlargement from a Joly ruled-line screen-plate of about 1895.

THE AUTOCHROME STORY

It is probable that some 20,000,000 Autochrome plates were exposed during the first third of this century; certainly 6,000 a day were being produced in 1913, and the process remained popular from 1907 until the mid-1930s. Yet despite the fact that thousands of Autochromes remain in museums and private collections throughout the world, it is unlikely that more than one in a thousand present-day photographers has ever seen an original Autochrome transparency. The reason for this is the difficulty and inconvenience of viewing glass plate transparencies that may vary in size between 4.5 x 6cm and 18 x 24cm. Most of them cannot be projected and to make things worse, none of them will transmit more than about 10% of incident light.

'Autochromists', as the early enthusiastic colour photographers were called, often used a simple daylight viewing device known as a 'diascope', while those who were into stereoscopic photography could use one of the many forms of stereoscope around at that time.

The origins of the Autochrome process are very interesting and while the writer hesitates to question anything on the subject written by E. J. Wall in his authoritative *History of Colour Photography*, he was surprised to find the view propounded that Louis Ducos du Hauron, in his all-embracing patent of 1868, 'conceived the idea of applying the principle of a particular school of French painters known as *pointillistes*'. This seems to me to be unlikely, since it was not until 1882 that Seurat began to develop his Neo-Impressionist 'small-dot' technique, utilizing the optical mixture of juxtaposed colours.

Nevertheless, there is no doubt that it was du Hauron who first saw the possibility of obtaining the necessary red, green and blue records of a subject on 'une seule surface', rather than by using three separate plates.

Perhaps sometime during the first few years of this century either Auguste or Louis Lumière was prompted by the paintings of Seurat and Signac to consider using a random distribution of red, green and blue elements to form a filter mosaic, rather than the regular geometrical patterns of alternating red, green and blue lines that had already been used by those earlier inventors – Joly and McDonough. In any case, McDonough had previously patented the formation of a three-colour mosaic using a layer of finely ground particles of red, green and blue dyed shellac; but there is

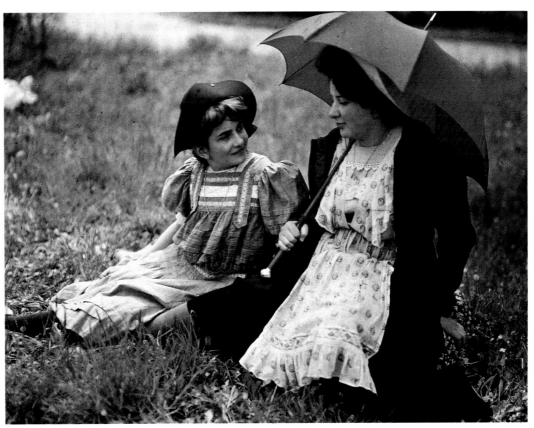

Reproduced from an Autochrome that was probably exposed by Louis Lumière himself, who often included a red parasol in his photographs.

THE AUTOCHROME STORY

no evidence that any commercial use was made of his idea and it remained for the Lumière brothers to use dyed grains of starch to obtain the first successful random patterned filter mosaic.

It was one thing to have the idea of using dyed starch grains as the filter elements in a screen-plate, and quite another thing to make such a system work. First of all, if the individual screen elements were not to be visible at normal viewing distances, then they would have to be extremely small and not vary much in size.

It was claimed by the Lumière company that the grains they used varied between the narrow limits of 0.01 and 0.02mm, but Mees and Pledge, after making many measurements of finished plates, found that the size of individual filter elements ranged between 0.006 and 0.025mm. The starch powder or 'fecule' was obtained from la Feculerie Brueder in the Haute-Saone, and it consisted of the tiny particles that remained suspended in the wash water used in the preparation of starch which had to be recovered by centrifuging.

SELECTION OF GRAINS

The range of particle sizes supplied was too great for Lumière's requirements and so they had to devise a way of extracting only those grains within the size range they required. At first an attempt was made to use a sieve created by etching appropriately sized holes in a 0.01mm thick copper sheet. Unfortunately the minute holes quickly clogged and that method was abandoned.

The final answer was found in the process of elutriation (separating the lighter from the heavier particles of a pulverulant mixture by washing). This meant devising suitable equipment and in the end a battery of 25 elutriation units was employed.

Two stages of separation were involved. First, a 9 kilogram batch of the starch powder obtained from the supplier was soaked in 10 litres of water for several hours before being thoroughly stirred and

Nº 22,988 A.D. 1904

(*Under International Convention.*)

Date claimed for Patent under Patents Act, 1901, being date of first Foreign Application (in 17th Dec., 1903 France),
Date of Application (in the United Kingdom), 25th Oct., 1904
Accepted, 8th Dec., 1904

COMPLETE SPECIFICATION.

Improvements relating to Sensitized Plates for a Process of Color Photography,

We, La Société Anonyme des Plaques et Papiers Photographiques A. Lumière et ses fils of 21 to 25 Rue Saint-Victor, Lyon-Monplaisir, France, Manufacturers, do hereby declare the nature of this invention and in what manner the same is to be performed to be particularly described and ascertained in and by the following statement:—

The present invention has for its object the preparation of sensitive plates, giving colored pictures, by means of simple manipulations, analogous to those which are practically effected in ordinary photography in black. These plates are characterized by the interposition between the sensitive coating and the glass which serves as its support, of a screen coating, formed of colored grains and prepared in the following manner.

The colored grains are grains of starch, ferments, leavens, bacilles, pulverized enamels or other pulverulent and transparent materials, they are colored by means of colors also transparent, in red, yellow and blue. The grains of these different colors are mixed in the state of dry powder, as intimately as possible and in such proportion that being applied on the glass as is about to be described, they do not communicate to the entire surface of the plate any appreciable coloration.

The accompanying diagrammatic drawing considerably enlarged shows the mode of application of this mixture.

On one of the faces of the glass *a* is spread a coating of pitchy matter on which is projected the mixture of colored grains which is brushed in such a manner that the grains which remain fixed thereon touch each other without being superposed and form a layer *c* as uniform as possible.

A second coating of pitchy material is then spread upon which is projected, in the same conditions as the first, a second coating *d* of colored grains; the whole is finally covered with a varnish. This varnish, as well as the pitchy matter in which the grains are contained, should have an index of refraction as near as possible to that of the colored particles, in order that the light may pass through the screen coating without being diffused.

The screen coating thus obtained is composed of an infinity of small elements the color of which depends on the chance of the superposition of colored grains in the two coatings *c* and *d*. these elements will be red, yellow or blue every-

[Price 8d.]

(above) *It will be noticed that this patent protecting the Autochrome plate, lists red, yellow and blue as the colours of the three filter elements. There was some confusion among inventors around the turn of the century regarding the best triad of colours. In fact all Autochrome plates used red, green and blue filter elements.*

(left) *This portrait of Louis Lumière, was taken on one of his 13 x 18cm plates in 1910. It is likely that the exposure required was several seconds, because Autochrome plates were some 30 times slower than a typical black and white emulsion of those days.* (From the Ciba Geigy Collection)

THE AUTOCHROME STORY

distributed between the 25 treatment units. Water was then run through each of the systems at the rate of 500ccs in 45 seconds. At this rate of flow, all the small and mid-sized particles were carried up to an overflow that fed them into a continuously running centrifuge for recovery. After about 35 hours, no particles were left in the overflow and the grains in the centrifuge were removed and dried. The large grains left behind in the system were either discarded or resold.

The combined small and medium particles, now amounting to about 5 kilos, were removed from the centrifuge and dried ready for the second stage of selection.

The 5 kilos of grains were soaked in 10 litres of water for 48 hours and then thoroughly stirred before being distributed once again between the 25 elutriation units. This time the rate of flow was lower, about 500ccs in 1 minute and 45 seconds, but the period of treatment was longer, about three days. During that time all the small grains were washed out in the overflow, leaving the required medium sized particles to be collected by centrifuging the residue in the system.

The final yield of usable grains was about 3 kilos.

THE DYES

None of the relevant patents disclosed which dyes were chosen to colour the starch grains, but working instructions revealed by Ilford Photo SA in 1987, show that in 1929, Lumière were using a mixture of erythrosine, tartrazine and rose bengale for the orange, tartrazine and blue carmine for the green, and violet crystallene for the blue-violet filter elements. These dyes and any others that may have been used earlier, have proved to be remarkably stable, as so many excellent images continue to testify after seventy or eighty years.

Three equal quantities of selected grains were dyed appropriately and then filtered and dried before being placed in turn in a rotating barrel together with 1.5 litres of spirit to each kilo of powder. The tumbling process continued for several hours, during which most of the grains became separated from any aggregates that were formed while they were being dyed. Even so, the mixture was drained from the barrel through a perforated disc in order to retain any remaining clumps.

Predetermined proportions of the dried three-coloured grains were then thoroughly mixed in a rotating drum. Exactly equal quantities of each colour were not necessarily used and in 1929, the ratio was 1kg orange; 1.2kg green; and 0.8kg of blue-violet.

Ideally, the three coloured elements needed to be perfectly evenly distributed over the plates, but in practice, despite thorough mixing, some 'clumping' of grains of the same colour inevitably occurred. The chances of the dyed grains forming groups of the same colour were calculated by Mees and Pledge, and according to the laws of probability, they forecast that:

'if counters of three different colors are placed in a bag and two are withdrawn, then the probability that two will be the same color is 1 in 3; the chances that three withdrawn counters will be the same color are 1 in 9, and four, 1 in 27; while the chances that twelve will be the same color will be about 1 in 120,000.'

Mees and Pledge therefore estimated that since there are some 4,000,000 filter elements to the square inch of an Autochrome plate, the probable number of clumps of twelve elements of the same colour being found in an area of one square inch of a transparency would be 4,000,000/120,000, or 33.3:1. They went further and forecast that within one square inch one would expect to find 11 instances of thirteen red, green or blue grains clumped together, 4 groups of fourteen and 1 clump of fifteen or more.

Ball mills and filters were used to separate the dyed starch grains before mixing and applying them to glass plates.

THE AUTOCHROME STORY

(above) An Autochrome still-life taken in 1912 (from Ciba-Geigy collection).

(right) Alvin Langdon Coburn, a young American living in England before the First World War, used Autochrome plates for several portraits of George Bernard Shaw. Shaw himself was a keen 'autochromist' as colour enthusiasts were called at that time. (Courtesy of Royal Photographic Society)

THE AUTOCHROME STORY

Fortunately, in practice this problem of clumping did not prove to be as serious as might have been expected and certainly did not diminish the popularity of the process.

Just how the dyed starch grains were applied to the glass plates was not made entirely clear, the original patent merely stating:

'on one of the faces of the glass is spread a coating of pitchy matter on which is projected the mixture of coloured grains which is brushed in such a manner that the grains which remain fixed thereon touch each other without being superimposed and form a layer as uniform as possible.'

In practice, the coloured grains were fed onto the tacky varnished surface of 20cm x 84cm plates as they moved along a track at the rate of 1 metre in 20 seconds. Immediately after application of the powder, soft badger hair brushes reciprocated across the surface of the plates about 2000 times a minute to remove any grains that were not firmly attached to the varnish.

A filter mosaic formed in this manner would present a serious practical problem because the gaps between the individual grains would pass so much unfiltered light as to ruin any chance of accurate colour reproduction. This snag was solved initially by filling the interstices between the filter elements with an opaque powder such as carbon black. This expedient reduced the effective speed of the plate and it was not long before it was discovered that the spherical starch grains could be made to spread and fill most of the gaps between them if they were subjected to very high pressure. At first, pressure amounting to 5,000 kilos per square centimetre was applied through a sandwich of a thin steel plate and a rubber blanket, but later it was found more effective to use a small diameter steel roller and a pressure just short of that required to break the glass.

After flattening, the filter mosaic needed to be protected and isolated from the layer of panchromatic emulsion that would cover it. A varnish had to be found with the same refractive index as the starch grains; that would not melt under the heat from a projection lantern and could be dispersed in a solvent that would not affect the filter dyes.

It should be remembered that fully colour sensitive emulsions were rare at the turn of the century, when there was a very limited choice of sensitizing dyes. These difficulties were made worse for the Lumières because of the special properties their emulsion had to have when used for a screen plate. First, the emulsion had to be as fast as possible and yet very fine grained – two conflicting requirements even today. Second, its colour sensitivity needed to be as uniform as possible throughout the visible spectrum and finally, the coating weight had to be kept as low as possible in order to minimise scatter with its consequent degradation of colours. (The sensitizing dyes used in 1929 were orthochrome, erythrosine and ethyl violet).

The outcome of these difficult and conflicting requirements was an emulsion that had an overall speed of about 1 H&D; colour sensitivity that remained predominantly blue and required correction by filtration and an emulsion layer thickness of only about 6 micro-metres. This very thin emulsion sometimes revealed defects in the form of 'judder' lines of uneven density across the direction in which the plate moved on the coating machine. These faults were particularly noticeable in uniform areas of density such as skies.

Autochromes, like all screen-plates, were exposed with the uncoated side facing the camera lens, which meant that the ground glass focusing screen of the camera had to be reversed.

An idea of the 'slowness' of Autochrome plates will be gained from the fact that an exposure of one or two seconds at f/8 would

The red, green and blue starch grain filter elements of an Autochrome plate were randomly distributed.

In order to fill in the interstices between the individual grains, they were flattened under pressure to spread them and any remaining gaps were then filled with carbon black powder.

The machine used to flatten the mosaic of starch grains by subjecting them to extreme pressure rolling. The plates were held by vacuum on a traversing table.

THE AUTOCHROME STORY

be required for an outdoor subject around midday in midsummer sunlight. Clearly a tripod was essential!

Estimating exposures for Autochrome plates must have been very difficult because there were no exposure meters of the kind we know today and yet exposure of any reversal transparency material is always far more critical than exposure of a negative.

Basically, processing an Autochrome plate was very simple: 1) development of negative image; 2) removal of developed silver; and 3) development of residual positive image. But autochromists, all of whom had to weigh and measure all the components of their solutions, had been used to developing plates by inspection and were quite unaccustomed to handling panchromatic emulsions in complete darkness. To meet them half-way as it were, Lumière published these recommendations:

'Development must begin out of reach of the light of the lantern, which should be fitted with "Virida" paper; but after 10 or 12 seconds, the plate may be rapidly examined.'

Nor was the importance of developer temperature fully appreciated in 1907, and Lumière in those same processing instructions wrote loosely of working at – 'about 60° to 65°F.'

Despite their extremely low speed and the relatively high risk of failure, Autochrome plates became extremely popular from the day they were launched in 1907. Shortly after the plates went on sale in

France, this comment appeared in *The British Journal of Photography*:

'The demand in France has been so great that there has been no chance of any plates reaching England yet, but as the makers are doubling their output every three weeks it will not be long before plates can be obtained commercially in England.'

The Autochrome plate caused a sensation when it was introduced and all the reports were wildly enthusiastic. Alfred Steiglitz, who was in Paris at the time the new process was announced, wrote to his friend Steichen saying:

'The possibilities of the new process seem to be unlimited. It is a positive pleasure to watch the faces of doubting Thomases – the painters and art critics especially – you feel their cynical smile. Then showing them the transparencies, one and all faces look positively paralysed, stunned. In short, soon the world will be color-mad, and Lumière will be responsible.'

World-wide adoption of the process was rapid and for twenty years or more after the plates were introduced, the *British Journal of Photography* published a continuous stream of articles on the exposure and processing of Autochromes. Typical topics were: *The Manipulation of Autochromes when Travelling*; *Flash Powders for Autochrome Work*; *Instantaneous Portraiture with*

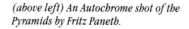

(above left) An Autochrome shot of the Pyramids by Fritz Paneth.

(below left) An enlarged area to show the random pattern of coloured starch grains. (From Royal Photographic Society collection.)

THE AUTOCHROME STORY

Autochrome plates; A New Method of Developing Autochromes and *Duplicates of Autochromes*.

All this enthusiasm was in spite of the very low effective speed of the plates, which almost always meant using a tripod. Up to the First World War most amateurs used plate cameras on tripods anyway and all they had to do when exposing Autochrome plates was to reverse their ground glass screens.

Quite soon after the War, however, the use of roll-films in hand-held cameras rapidly increased and it became obvious to the Société Lumière that they would have to find a way of producing a version of the Autochrome process on a film base.

Working out a method of distributing dyed starch grains on to a wide band of film and then, after compressing the grains to close the gaps, coating the film with emulsion, must have posed many problems. Somehow they were solved and in 1932 Lumière replaced their glass-plate Autochrome process with Filmcolor. The new film still required the use of an orange filter on the camera lens to balance the colour sensitivity of the emulsion, but within two years Filmcolor was replaced by Lumicolor, which incorporated the necessary correction filter and could be used without a lens filter.

The film versions of the Autochrome process were faster than the plates had been because it became possible to dispense entirely with the carbon black that had been used to fill in the interstices between the dyed grains. With film as a base it was possible to increase the pressure used to flatten the grains so that they were squeezed into intimate juxtaposition. All of these changes took place at about the same time as Eastman Kodak introduced Kodachrome, the first multi-layer subtractive colour film. Although Lumière continued to produce additive films until after the Second World War, even introducing a new version called Alticolor in 1952, there was no longer a future for additive processes – except in television.

(above) This portrait, made on an Autochrome plate by J W Allison, was exposed by using 15 grammes of flash powder 7 feet from the sitter with a lens aperture of f6.3

(right) In order to make it easier to view Autochrome plates, many people used a simple device called a 'diascope' with which light from a window (or lamp), would illuminate the transparency, the image of which could then be viewed via a mirror.

(far right) Pêcheur (fisherman) 1907. (Autochrome from the Ciba-Geigy collection.)

THE AUTOCHROME STORY

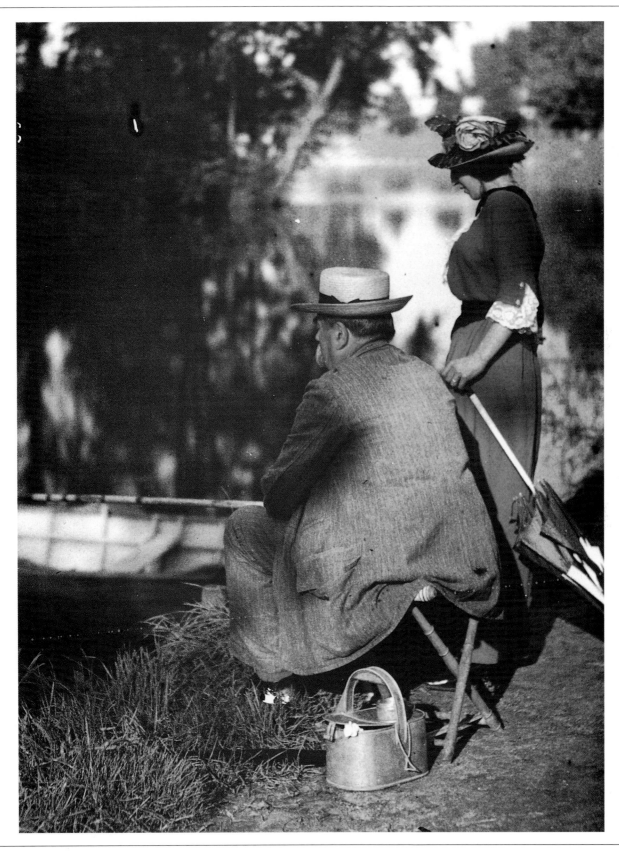

OTHER ADDITIVE PROCESSES

The rapid world-wide success of the Autochrome process led several other Frenchmen to try to emulate the Lumière achievement.

Du Hauron was quite an old man when in 1905 he returned to France after living in Algiers for many years, but together with his nephew, Raymond de Bercegol, he set to work to apply one of the ideas for a screen-plate that he had outlined in his patent of 1868. As an alternative to dyed grains of starch, they decided to produce a tricolour mosaic or reseau with a regular rather than a random pattern.

The French patent granted jointly to du Hauron and Bercegol in 1906 describes a method of mechanically ruling a gelatine-coated plate with a set of transparent, greasy ink lines coloured blue-violet, then dyeing the intervening spaces yellow before ruling another set of blue-green ink lines at right-angles to the first set. This resulted in the formation of green rectangles wherever the cyan lines crossed yellow area. A final immersion in a magenta dye converted the remaining unprotected yellow area into orange-red elements. This rather ingenious procedure shows what a good understanding du Hauron had of both the additive and subtractive principles of colour mixture.

The plates were made and coated by Jougla at Joinville-le-Pont and were named Omnicolore. However, a few years later the Jougla company joined forces with Lumière and that was the end of the Omnicolore plate.

The next Frenchman to enter the field was Louis Dufay, who obtained two patents in 1908. According to the second of these two specifications, a gelatine-coated plate (or film) was sensitized with bichromate and exposed through a line screen before being rolled-up with a layer of opaque greasy ink which adhered only to the hardened areas. The spaces between the ink lines were then dyed red. Next, the whole surface of the plate was coated with a layer of varnish that adhered to and protected the dyed area, but elsewhere could be dissolved and removed together with the underlying greasy ink. Then a new set of greasy ink lines was applied at right-angles to the first set and the unprotected areas between the resist were dyed blue-violet, before the plate was again coated with varnish. By now, one third of the surface of the plate was coloured red and one third blue-violet in the form of alternating rectangles. Finally, the layer of varnish was dissolved together with the greasy ink so that the intervening lines could be dyed green, to complete the mosaic.

Dufay enlisted the co-operation of the Guilleminot company to produce his plates which were sold under the name Dioptichrome. For a while, Dioptichrome plates were offered either pre-coated or as taking screens to be used with separate panchromatic plates. The taking screens were supplied in metal frames which could be used again to combine a positive plate with the screen for viewing the finished colour transparency. There were advantages in using screen plates with some form of regular geometric pattern. On the one hand, if produced accurately enough, they allowed the use of separate taking and viewing screens, which made for easy duplication. Also, the whole of the surface of the plate was covered by filter elements with no intervening spaces to be filled in with carbon black as had to be done with the starch grains of an Autochrome plate. Consequently, it was estimated that a Dufay Dioptichrome plate would transmit some 20% of the light reaching

it while an Autochrome plate would only pass about $7\frac{1}{2}$% of incident light. Another advantage of regular over random filter elements is the avoidance of the clumping of elements of the same colour that occurs in the latter, giving them a much more mottled appearance. These advantages of using a geometric pattern of filter elements rather than randomly dispersed starch grains, with their unavoidable interstices, must have tempted the Lumières to consider a change of direction, because in 1908 they patented a method of producing a screen which Louis Dufay considered he had anticipated in his earlier patent. Correspondence exists which indicates that Louis Lumière acknowledged Dufay's priority. Nevertheless, there is no doubt that the Autochrome 'starch grain' process was more successful than any other screen-plate and for that reason its story has been told separately. (p. 36).

A number of British inventors also obtained patents on various ways of making screen-plates, among them: C. L. Finlay (1908) and G. S. Whitfield (1912). Both of these systems involved the use of separate taking and viewing screens, the one based on Finlay's patent being made and sold by the Thames Colour Plate Company, while Whitfield's patent was taken up by the Paget Dry Plate Company. The Thames and Paget plates had only modest success before the outbreak of war in 1914 and after the war, in 1920, the Paget plate was renamed Duplex under which name it was sold for a few more years.

A company was formed in the UK in 1929 to reintroduce Finlay's process under the inventor's name and during the early 1930s the National Geographic Magazine regularly used Finlaycolor originals to illustrate their stories, and continued to do so until the mid 1930s when Kodachrome replaced all screen plate processes.

AGFACOLOR MOSAIC SCREEN PROCESS

In 1932, I. G. Farbenindustrie (Agfa), introduced a mosaic screen additive process that was similar to Autochrome in some ways but significantly different in others.

Instead of being composed of dyed starch grains, the Agfa mosaic filter layer was formed from a mixture of three solutions of dyes in colloidal suspension. The elements in suspension were immisible but would coagulate, so that when they were coated on glass or film and allowed to dry, the dyed droplets formed into individual red, green and blue filters. Furthermore, because the elements dried in close contact with each other, there were no interstices to be filled in with carbon black as was necessary with Autochrome plates. In fact, it was claimed that whereas some 92% of incident light was absorbed by the filter layer of an Autochrome plate, only 86% was absorbed by the Agfacolor mosaic. Consequently, Agfacolor and Agfacolor Ultra, the film based product that was sold between 1934 and 1938, were appreciably faster than Autochrome; allowing — 'instantaneous exposures of 1/25th of a second in brilliant midsummer sunshine'!

By 1920 Louis Dufay was concentrating on the manufacture of a film-based reseau, no doubt with the rapidly expanding motion picture business in mind. Because it was quite important, the story of the Dufaycolor process is related separately. (p 46).

Dufay was not the first to produce a film-based additive screen process. In 1910, the Neu Photographische Gesellschaft of Berlin introduced a line screen roll-film based on one of the patents of Robert Krayn. The Krayn process deserves mention because it must have been the first time a colour negative image was specifically intended to be used for contact printing on a similar material.

Three different French companies produced screen-plates during the first decade of the 20th century. Lumière made the Autochrome plate, Jougla produced the Omnicolore plate invented by du Hauron and Bercegol while Dufay's Dioptichrome plates were made by Guilleminot.

THE DUFAYCOLOR STORY

THE DUFAYCOLOR STORY

Although it did not always bear Dufay's name, the process he invented in 1907 was pursued in modified forms and under various names for over forty years – covering much the same period as the Autochrome process.

Louis Dufay, son of the notary in the small town of Baume les Dames near Besançon, was born in 1874. After studying law and working in a practice in Chaumont, he somehow became interested in colour photography and then conceived, and in 1907 patented, a method for producing a geometric filter reseau for a screen-plate. In his patent, Dufay described this procedure at some length.

Briefly, a transparent support, having been coated with a thin layer of gelatine, was covered by a pattern of parallel greasy ink lines to serve as a temporary resist. The gelatine between the ink lines was then dyed red. The surface of the plate was then coated with a varnish that adhered to and protected the dyed areas but elsewhere could be dissolved and removed together with the underlying greasy ink. Next, a new set of greasy ink lines were printed at right-angles to the first and the unprotected areas between the resist dyed blue-violet. The whole surface was again varnished and the resist removed. By now one third of the surface was coloured red and one third blue-violet in the form of alternating rectangles, while the remaining third of the area, represented by parallel lines, was dyed green to complete the mosaic.

This may seem to be a very complicated way of forming a mosaic of red, green and blue filters, and in fact the method was simplified later, when Dufaycolor was produced on film-base.

There is evidence that in 1908 Dufay tried to interest Lumière in his patent, but by then that company was probably quite happy with their method of producing a random screen pattern. He had more luck with Guilleminot, a plate and paper manufacturer with a factory at Chantilly, where Dufay and his family went to live in 1909.

A company name la Société des Plaques et Produits Dufay was formed with a capital of 420,000Frs. and the plates were called Dioptichrome. They were on sale for only a few years, the most successful of which was 1911, when 40,000 plates were sold.

Because there were no gaps to fill between the filter elements as there were with the dyed starch grains of an Autochrome, Dufay Dioptichrome plates were faster and the results more transparent than the Lumière product. But the resolution of an Autochrome was far superior to a Dioptichrome transparency because the filter reseau of the latter only contained about 40,000 elements to the square inch compared with the millions of starch grains covering each square inch of an Autochrome.

However, things did not go smoothly and there were many difficulties and disputes, so that by 1914 the company was dissolved

(left) From a 13cm x 18cm Dioptichrome transparency, circa 1912. The subject is Simone, daughter of Louis Dufay. (Courtesy of Jean-Luc Dufay.)

(right) In the early 1920s, Louis Dufay briefly established a portrait studio in Paris, where he proposed to use a negative/positive version of the Versicolor additive process. This portrait of Louis Dufay himself is from one of the colour prints of that time, although it is not certain how it was made. (By courtesy of Jean-Luc Dufay.)

THE DUFAYCOLOR STORY

Film moved through the Dufaycolor bleaching and dyeing machine as follows: with resist side uppermost it was carried over rollers through a hot box (14) and over a suction table (15), just ahead of a roller (16) which applied a protective layer to the back of the film.

The film could now be bleached, dyed and cleaned without affecting the side not being treated.

Bleaching was effected in bleach bath (20) and then dyed in dye tank (40). On leaving the dye tank, excess dye was removed by air squeegees and the film was then dried in a drying box (44). The film now had the required lines on it, but also the resist lines and the protective layer. These were both removed by passing the film through a solvent contained in a series of tanks (46), so arranged that new solvent was fed into the last tank to cascade through the intermediate tanks and overflow to waste from the first tank.

The film was then dried in a drying box (70) and re-wound ready for the next operation.

Dufaycolor Reseau: 1. A thin layer of collodion was applied to the film base and then dyed blue, before being imprinted with a pattern of parallel greasy lines;

2. The unprotected areas of the collodion were then bleached;

3. The bleached areas were dyed green;

4. The greasy ink lines were then removed and another set printed at right angles to the original pattern;

5. The areas between the protected lines were then bleached;

6. Finally, those bleached areas were dyed red.

THE DUFAYCOLOR STORY

– possibly because the war made it impossible to continue. After the war, Dufay renewed his efforts to promote his process, this time concentrating on production of film rather than glass-based products, no doubt with cinematography in mind.

In 1920 another company was formed, this time called la Société Versicolor, with a capital of 2,900,000Frs. By now Dufay was offering not only the attraction of a film for the cinema, but also a negative/positive paper print process based on an additive screen-plate colour-negative, but requiring the prints to be made via three film-based positives obtained by making separate exposures from the colour-negative through red, green and blue filters. The three positive images were converted into subtractive primary colours (presumably by dye or chemical toning), and then superimposed to form the colour print.

A portrait studio was opened in la Place de la Madeleine in Paris. For reasons that should have been obvious, even at the time, the print process was unsuccessful and was soon abandoned. Once again there were production problems and financial difficulties so that by 1926, Versicolor must have been relieved that they managed to interest Spicers, the large paper-making company in the UK.

Spicers used the services of Thorne Baker as an expert to advise them on the potentialities of Dufay's process and he must have reported favourably because several thousands of feet of experimental colour negative film were shot in the South of France from which prints were made and shown at the Pavilion Theatre in London in 1928.

At that time the ruling of the reseau was still very coarse – only 8 lines per mm – and image resolution would have been very poor. Nevertheless, the results must have been good enough for Spicers, because in 1932 they invested more than £500,000 in a new company called Spicer-Dufay Limited. Soon after this, Ilford Limited joined forces with Spicers, after which another company –

Spicer-Dufay (British) – was formed and by the end of 1935 Ilford was in control.

The first high-precision resist printing machine to be installed by Spicer-Dufay at Sawston in Cambridgeshire was used to produce continuous rolls of 22ins wide cellulose acetate film bearing a mosaic of red, green and blue filter elements. Later, another machine was installed that was capable of printing 42ins rolls at 10ft per minute, the resist lines being spaced 20 to the millimetre.

The sequence of printing, dyeing and bleaching operations went as follows:

1. A roll of acetate film already coated with a thin layer of blue-dyed collodion was printed with a set of parallel greasy ink lines angled at 23° to the edge of the film.

2. The printed film was then passed through a bleach bath so that the spaces between the resist lines were decolourized.

3. The film was then treated in a bath of green dye, after which the film carried a pattern of alternating blue and green lines.

4. Next, the residual ink lines were removed and a new set printed on the film, this time at right-angles to the first set.

5. The film was again treated in a bleach bath to leave a pattern of green and blue rectangles with clear lines between them.

6. The film then moved through a bath of red dye to colour the bleached areas.

Removal of the residual resist lines was followed by the application of a thin layer of protective varnish to imprison the dyes and to prevent them from reacting with the emulsion coating that followed. In fact, the emulsion was not applied at Sawston, but by Ilford Limited in their factory at Brentwood in Essex.

Even though Ilford used their fastest 'Hypersensitive' panchromatic emulsion to coat Dufay reseau, the speed of the film was only Weston 6, but this made it possible to use 1/25th second at f8 on a bright day. The reason for the low sensitivity, common to all

THE DUFAYCOLOR STORY

additive processes, was that more than 75% of the light reaching the film was absorbed by the filters. The reseau filters not only reduced the speed of the emulsion, but it also meant that very powerful light sources were necessary when it came to project an additive transparency.

Despite all these limitations, so urgent was the need to have some form of colour photography that allowed the use of ordinary cameras, that professionals and amateurs alike were prepared to tolerate the shortcomings. At that time the only alternative systems involved making separation negatives, either successively or by means of special 'one-shot' cameras, and then to produce a colour

print on paper or film by some kind of lengthy and complicated assembly process such as trichrome-carbo or dye-transfer. In particular, the motion picture industry was looking for some alternative to the dominant Technicolor system, with its special 'three-strip' cameras and the necessity to have all release prints made by Technicolor's imbibition transfer process.

King George V's Silver Jubilee was photographed in Dufaycolor by Movietone News in 1935 and 150 copies were distributed to cinemas on the following day. At that time the only way of making copies was to use the same type of reversal film and processing as had been used for the original, but the results were not very good.

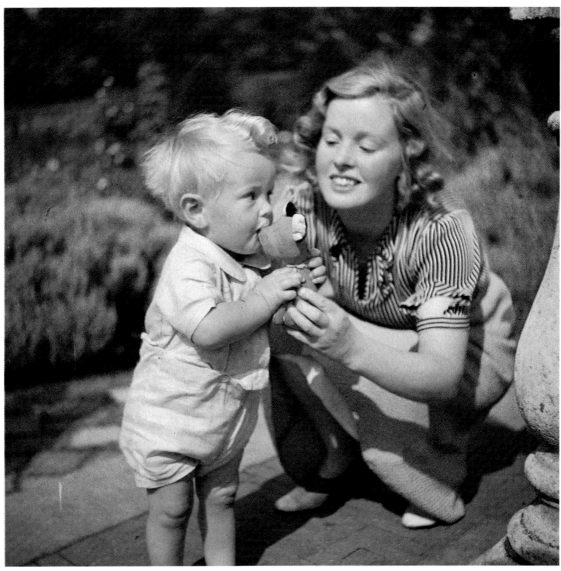

In the 1930s, many amateur photographers with hand-held roll film cameras were able to use the Dufaycolor process to obtain colour snapshots for the first time.

A colour printing service using an 'assembly' process was available for a while, but results were not good and the service was soon discontinued.

THE DUFAYCOLOR STORY

In the late 1930s Dufaycolor became popular in 16mm format for amateur cinematography, and for this application it was quite satisfactory to process the original film by reversal, and such a service was offered by Ilford.

However, it was realized that a much better way of proceeding in professional cinematography would be to process the original as a colour negative and then print it by contact to produce positives. But there were two problems to be solved before this method of working could be successfully adopted. First, some way had to be found to avoid the moiré effects that resulted from the interaction of the two reseau patterns. Second, it was necessary to prevent the serious degradation of colour that resulted from the scattering of printing light as it passed through the two reseaux.

Some very well-known experts in the field of colour photography applied their minds to these problems and came up with solutions. Dr. D. A. Spencer devised a 'depth' developer that ensured the silver image remained very close to the filter reseau and therefore resulted in less scattered light when the negative was printed. Dr. G. B. Harrison, together with R. G. Horner and S. D. Threadgold of Ilford's Research Department, devised improvements to the illumination system used in the contact printing machines and so managed to eliminate moiré patterns.

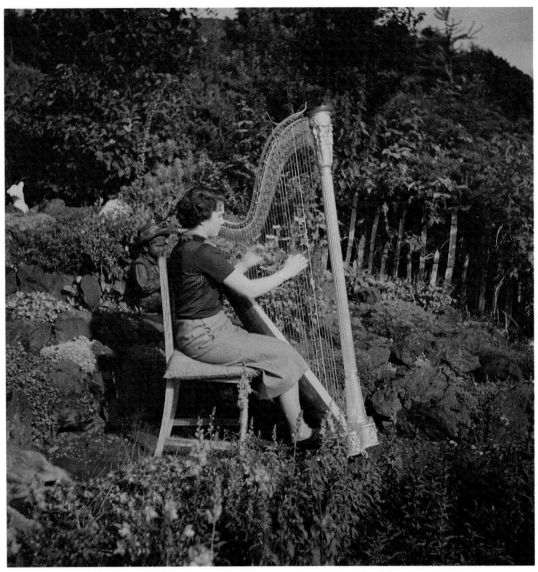

In 1936, portraits on Dufaycolor film were often taken in the garden, in order to have enough light. This one was by C. Leslie Thomson, who devised substitute formulae to enable amateurs to process their own colour films before the manufacturers released the information.

THE DUFAYCOLOR STORY

The problem was to destroy the identity of the negative reseau by the time the printing light reached the positive reseau. This was done by placing the negative and positive films front to back; separating them by the thickness of the positive base so that the printing light passed through the positive reseau before reaching the positive emulsion. By using a source of light of finite size as opposed to a point source, the projected image of the negative reseau was diffused, thus avoiding the formation of moiré patterns.

The improvement in quality that resulted from using the negative-positive system meant that a film made on Dufaycolor of George VI's Coronation in 1937 was a considerable success and led to a number of other short films being made by Pathé, including *Trooping of the Colour* and *Royal Naval Review*.

Processing and printing facilities were established in Paris, Geneva, Rome, Johannesburg, Bombay and Barcelona, while Dufaycolor Inc. was formed to promote the process in the US However, in 1938 Ilford Limited decided (probably with an eye on the new Kodachrome process) that the future of colour photography was more likely to lie with subtractive rather than additive systems and they sold their holdings in Dufay-Chromex Limited, a company that had been formed by Spicers Limited and Ilford Limited in 1936.

Ilford did continue to coat Dufaycolor reseau at Brentwood until after World War II, but by then it had become obvious just how much progress had been made on the development of multi-layer materials in both the US and Germany, so both technical and financial interest in additive processes quickly declined.

Louis Dufay died in 1936, while on a visit to the Cote d'Azur.

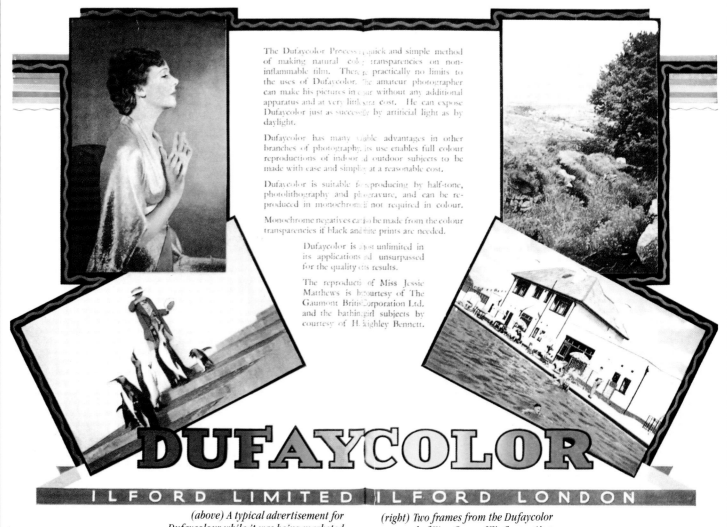

(above) A typical advertisement for Dufaycolour while it was being marketed by Ilford Limited in the 1930s.

(right) Two frames from the Dufaycolor newsreel of King George VI's Coronation in 1937.

THE DUFAYCOLOR STORY

EASTMAN KODAK

According to Jenkins in *Images and Enterprise*, George Eastman was becoming quite concerned by the end of the century that Kodak would be left behind in the search for a viable colour process. At about that time Eastman employed a Bostonian, Joseph Thatcher Clarke, as a kind of roving technical expert with the task of reporting on new products and patents – particularly those related to colour photography. In 1904 Eastman put it to Clarke in these rather quaint terms that: 'If we could achieve a practical color process, it might have quite a vogue.'

First, they looked at a process developed in Chicago by J. H. Powrie and his partner Florence Warner from the earlier work of Joly and McDonough, but after a month or two it was decided not to exercise an option. Next, Eastman became interested in a patent by Carl Spath who had devised a way of making a filter reseau by dyeing film base rather than using glass – a prospect that would have appealed to Eastman because Kodak had just begun to produce cellulose acetate base for films. Again, despite the fact that work was done on the Spath process at both Harrow and Rochester, nothing came of it.

So keen was Eastman to find a way of obtaining an additive process that would allow him to use film-base, that he also made an attempt to simulate the Autochrome process by using a method invented by J. H. Christensen. The idea was to dye three coloured solutions of dextrin or gum before emulsifying them to produce minute droplets which could then be suspended in a solvent such as benzene before being applied to film already coated with a thin layer of rubber. The rubber, having been softened by the solvent, would swell and become tacky so as to hold the lower level of coloured particles while the excess ran off. According to Mees:

'some work was done on this process in the Kodak research laboratories in 1913, but it was eventually abandoned, though it was taken up later by the Agfa Company in Germany, for the manufacture of the first Agfacolor film which gave results comparable with the Autochrome plate.'

Despite all of these attempts Kodak never did produce an additive screen-plate or film.

LENTICULAR PROCESSES

There is yet another way in which colour photographs can be obtained by additive projection, usually known as the 'lenticular' process because it depends upon the use of tiny lenticulations embossed on one side of a film. According to Douglas Collins in *The Story of Kodak*, George Eastman had a dream in which he foresaw the lenticular process that was later launched as Kodacolor, while on a ship in the Red Sea in the Spring of 1926. What Eastman saw was – 'the sort of dream, at once technological, commercial and artistic, that could have come only to a man of Eastman's vision and experience.'

This revelation seems surprising in so far as Collins also acknowledges that the technology dreamed up by Eastman was not new, since the additive lenticular method of producing colour photographs had been patented by Berthon in 1909. This fact must have been known to members of Eastman's research staff, one of whom, Glenn E. Matthews, later recorded in a paper published in the *Journal of the Motion Picture and Television Society* that:

'In 1925 rights were acquired by the Eastman Kodak Co. from the Société du Film en Couleurs Keller-Dorian to adapt the additive color process of R. Berthon, a French inventor, to amateur cinematography.'

Photomicroographs (50X) of some regular and some random patterned screen-plates. (Courtesy R. C. Smith, FRPS)

Autochrome 1907

Omnicolore 1909

Paget 1913

Finlay 1929

Dufaycolor 1935

Agfacolor Ultra 1934

In fact Berthon was not the first to conceive the idea of using a banded tricolour filter on the lens of a camera in conjunction with some means of forming myriad tiny images of that filter on a sensitive surface.

Friedman points out that in 1896 Liesegang outlined the use of a banded tricolour filter on a camera lens together with a cross-line screen to act as a multitude of pin-hole lenses. Like so many others at that time, Liesegang thought that yellow, red and blue would be the correct 'primary' colours, but as Friedman says – 'this error in the choice of colors does not mitigate against the soundness of his engineering and optical procedures.'

In his patent of 1909, Berthon described:

'A process for obtaining photographic prints capable of projection and reproduction in colours by means of photographic plates, films or bands carrying on one side a sensitized panchromatic layer and on the other side lines of a transparent embossed striated or grained surface in combination with a three colour screen of the fundamental colours arranged in the objective.'

Drawings accompanying the patent make it quite clear that Berthon foresaw the possibility of using either tiny spherical or parallel cylindrical lenses and in fact both configurations were subsequently used commercially.

The relative positions of the necessary optical elements required for the lenticular system to work are shown. A banded three-colour filter is located either just in front of the camera lens, or within the lens itself, as Berthon suggested in his patent. Each of the lenticulations on the film, which must face the camera lens, will form an image of the filter on the emulsion surface and the amount of silver exposed behind each sector of each image of the filter will depend upon the colour of the corresponding area

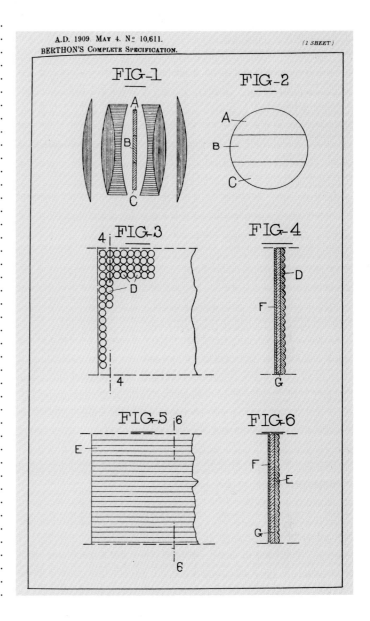

(above) Berthon's 1909 patent showing his method of using lenticulations in a system of additive colour photography, shows two forms of lenticulation. One comprising a regular pattern of tiny spherical lenses and the other depending upon parallel cylindrical lenses.

(left) The Kodacolor lenticular process, launched in 1928, depended upon the use of a banded three colour filter placed in front of an f1.9 lens, which always had to be used at full aperture.

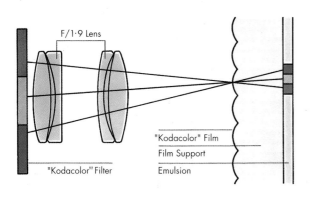

F/1·9 Lens

"Kodacolor" Film
Film Support
"Kodacolor" Filter Emulsion

of the subject. If, after exposure, the panchromatic emulsion layer is processed by reversal to produce a black and white image, then the resulting positive can be used to recreate the colours of the original simply by projecting it, in reverse as it were, onto a screen through a lens and another banded filter. In his patent Berthon said that he would form his lenticulations by rolling sheets of gelatine or celluloid at an appropriate temperature 'between a smooth cylinder and a cylinder carrying in intaglio the engraving of the embossing to be formed.'

At that time Berthon was thinking of producing separate embossed sheets that could subsequently be laminated to glass, because in 1909 plates were still being used by all serious photographers. However, by the outbreak of World War I, the Kinemacolor process had been successfully demonstrated in England and the prospects for an alternative additive motion picture process must have looked good – provided lenticular film base could be produced in long lengths.

A. Keller-Dorian, another Frenchman, obtained the first of his many patents on the lenticular process in 1914, protecting a method of producing continuous lengths of embossed film. The earliest film made by Keller-Dorian's method bore fifty-two embossed lenses per square centimetre, but as time went on he managed to reduce the size of the lenticulation until there were twenty-two lenses to each square millimetre.

After the War Berthon joined forces with Keller-Dorian to form an organisation called the Keller-Dorian Berthon Company, and the first motion picture to be made with their process was shown in Paris in December 1922. There is little doubt that the film that was projected was the one used in the camera, after being processed by reversal. This would have avoided the many problems that bedevilled all later attempts to make satisfactory copies from lenticular originals.

As already noted, the Eastman Kodak Company bought rights from the Société du Film en Couleurs Keller Dorian to manufacture 16mm lenticular film, which they decided to call Kodacolor. No doubt Kodak realised that they would not be much troubled by the problem of duplication, since for the most part amateurs need only one copy of their films. This requirement could easily be satisfied by offering a black and white reversal processing service — which they were already doing for their ordinary 16mm black and white films.

THE FIRST KODACOLOR PROCESS

Just before the new process was launched Kodak decided to use parallel cylindrical lenses rather than discrete spherical lenses. They also had to make available several other elements of the system before the amateur could use it. For example, a Ciné Kodak camera with a fixed wide aperture (f1.9) lens had to be used together with a banded tri-colour filter. Then, because in those days it was not possible to make and coat panchromatic emulsions with precisely uniform characteristics, a segmented diaphragm 'cap' or mask had to be provided with each different batch of film to compensate for differences in speed and colour sensitivity. A conversion kit also had to be provided for existing 16mm Kodascope projectors whose owners were not prepared to buy the new 'Model 13' Kodascope designed for use with either Kodacolor or black and white.

The complete Kodacolor system was launched in 1928 and after limited success, was withdrawn in 1937 two years after the introduction of 16mm Kodachrome.

In Europe it was Agfa who fostered the lenticular process for both amateur movies and for still photographs taken with the Leica camera. The principal difference between Agfa's film and Kodacolor was that the German product was based on

(left) Both the Kodak and Agfa lenticular processes required the correct banded filter to be used with each different batch of panchromatic film. These two filters were for different batches of Agfacolor used in a Leica camera.

(right) Kodacolor lenticular film, showing the effects of its embossed surface. The enlargement is from a 16mm frame.

lenticulations 0.028mm in width as against 0.043mm for the American film.

Between the 1930s and the 1950s repeated attempts were made to use the lenticular system for the production of 35mm entertainment films. In Germany, Siemens and Halske of Berlin together with Perutz in Munich formed a company called Opticolor A.G., and a short film was produced in 1936; but World War II brought an end to all European work on the process. In the US in 1930 Keller-Dorian Berthon entered into an agreement with both Eastman Kodak and the Paramount Picture Corporation to carry out further research on the process, but by 1936 Paramount had pulled out.

After World War II, Kodak joined forces with Twentieth Century Fox in yet another attempt to establish the process in the motion picture field, but again no films were produced and in the early 1950s, soon after the introduction of the Eastmancolor negative/positive process, the lenticular process was finally abandoned, apart from an attempt by Eastman Kodak in 1956 to use it for recording television programmes.

Between the 1920s and the 1950s very large sums of money were invested in the lenticular system and no less than 250 British patents related to the process were granted during that period, for, as Adrian Clyne said in 1936:

'*Most physicists would consider the lenticular process as the most elegant solution of the problem of motion picture in colour so far discovered. Yet with all its theoretical perfection this system has certain defects that must have been overlooked by the pioneers of the method.*'

Clyne then suggests two of those reasons:

1) Marginal rays, which have excessive circle of confusion are focused on more than one lenticule with consequent colour errors such as de-saturation
2) Necessity of using nearly maximum aperture, with resulting poor depth of field, results in the focus for many planes of the subject occurring in front of the focal plane and thus covering more than one lenticule.'

If we then add to these shortcomings the insuperable difficulties related to duplication, and the inevitable loss of light within any additive system, it is easy, with some hindsight, to understand why the lenticular system was never commercially successful.

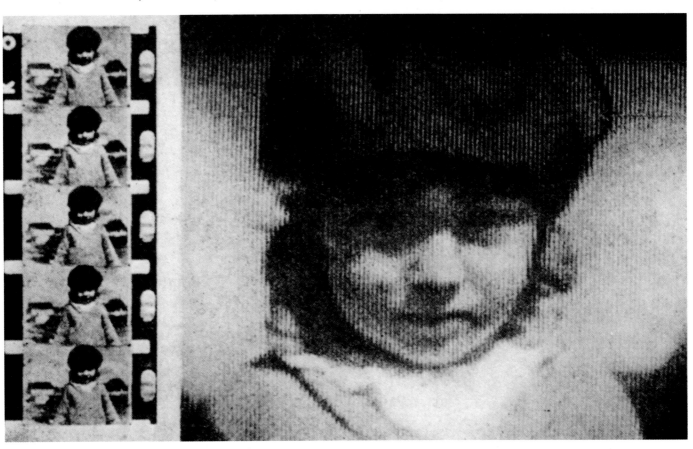

COLOUR CINEMATOGRAPHY BY ADDITIVE METHODS

'It appears that while G. A. Smith was working on Kinemacolor at Brighton, Friese-Greene had been experimenting on two-colour persistence of vision principles also, but instead of projecting through a rotating colour disc he stained each frame of a completed black-and-white print alternatively red and green. A film of Friese-Greene's was being exhibited at a theatre in Brighton, and a Mr Lyons, who held certain Kinemacolor rights in Brighton, persuaded Kinemacolor to bring an action against the Friese-Green theatre to prevent the showing of the picture. F. S. Edge, a well known racing car expert, financed the Friese-Greene defence, Kinemacolor lost the action and appealed, winning their appeal. The case was then carried to the House of Lords, and the judgement reversed in favour of Friese-Greene. This litigation ruined Kinemacolor financially.'

A. CORNWELL CLYNE. 'COLOUR CINEMATOGRAPHY' 1951.

It was the greater convenience of a directly viewed colour transparency compared with the awkwardness of adjusting and viewing a composite image from three positives in a photochromoscope viewer or projected on a screen, that made the screen-plate processes so popular, even though viewing a screen-plate, image was never very convenient.

But in the final decade of the last century a new kind of photography was emerging in which projection was both essential and acceptable – the cinematograph. The Lumière brothers are generally considered, at least by the French, to have invented the motion picture in that they were first to project moving pictures before an audience. Yet, despite their work on the Autochrome process, they did little to achieve cinematography in colour.

The first British patent describing a system of colour cinematography was granted in 1899 to Turner and Lee, two men who, according to Frederick Ives, had been assistants in his London workshop. Ives went further and in a paper published in the *Transactions of the Society of Motion Picture Engineers* in 1926, he claimed that: 'the two young men, with my consent patented a scheme *which I disclosed to them* but which I told them was of more theoretical than practical interest at the time.'

THE KINEMACOLOR STORY

D. B. Taylor, author of *The First Colour Motion Pictures*, believed that Turner was a technician while Lee was his backer, and a breeder of racehorses – he was certainly described as a 'gentleman' in their joint patent. The idea was to use a camera fitted with a rotating filter-cum-shutter wheel geared to the film transport so that a repeating sequence of exposures was made through red, green and blue filters. However, when it came to projection, Turner rejected the possibility of projecting each set of images simultaneously, which would have meant moving the film on by three frames at a time, and instead decided on a much more complicated system. Each frame of the positive film was to be projected three times, first through the upper lens, then through the one in the middle, and finally through the lower lens. The filter sections of the shutter wheel bore concentric bands of colour arranged so that any red-record frame on the film would be projected through a red filter whichever lens it happened to be behind.

As might have been expected, bearing in mind the crude standards of perforating at that time, accurate registration of the three projected images proved to be difficult if not impossible. Furthermore, since taking and projecting was carried out at only 16 frames per second, colour flicker and fringing must have resulted. In 1901 Lee withdrew his support, after which Turner approached Charles Urban, already a prominent and successful figure in the growing motion picture business, producing films through the Warwick Trading Company of Warwick Court off Wardour Street.

Urban agreed that Warwick Trading would back Turner for six

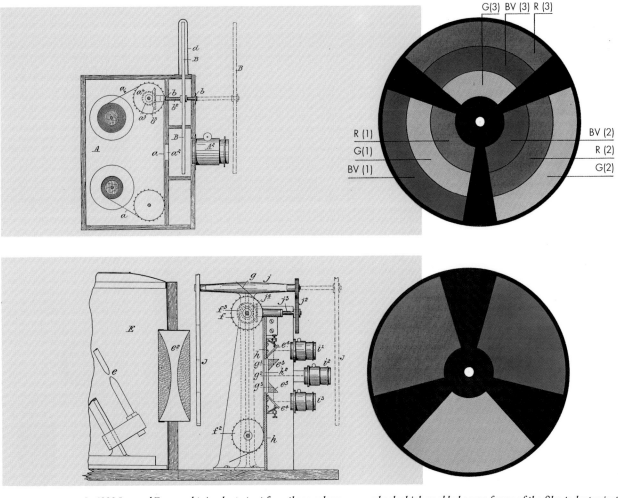

In 1899 Lee and Turner obtained a patent for a three colour process of cinematography requiring a single lens camera (above left) making a recurring sequence of red green and blue exposures through a rotating filter cum shutter. Their projector (lower left) used three lenses and a special filter wheel which enabled every frame of the film to be projected three times in succession through the appropriate filter as it passed through the triple frame projector aperture. Although it eventually led to the Kinemacolor two colour process, the Lee and Turner patent was not successful.

THE KINEMACOLOR STORY

months, a decision that would eventually lead to the Kinemacolor process. After spending £500 – a quite useful sum at that time – Warwick Trading pulled out, but Charles Urban himself continued to back Turner.

For some reason Turner was using a film width of 1½ inches when Edison's 35mm (1⅜in) had become the standard. He also continued to face the insuperable problems of obtaining registration of the three projected images. Perhaps these and other difficulties became too much for him, because one day in 1902 he was found dead in his workshop at Warwick Court. The original triple lens projector is now in the collection of the National Museum of Photography at Bradford.

Urban, by now not only financially involved, but intrigued by the prospect of finding a practicable colour process, had to find someone else to continue the technical work. George Albert Smith had been a photographer in Brighton before turning to making films for the Warwick Trading Company and becoming the leader of what came to be known as the Brighton Group. Smith also had a scientific bent that Urban must have noticed because, after acquiring Lee and Turner's patent rights from Turner's widow, Urban joined with Smith in an attempt to bring the earlier work to fruition. Most of the construction work on cameras and projectors was done by Darling, who also lived in Brighton. One of the first things the new partners decided was to adopt the standard 35mm film gauge, thereby making it more likely that existing projection equipment could be used without too much modification.

For a while an attempt was made to tint successive frames of each print with red, green and blue dyes so that no filter disc would be necessary, the only special requirement being to run the projector at three times the normal speed, which was asking a lot of the fragile film-base of that time.

By the end of 1905 the outlook was unpromising and the project

seemed likely to founder, when efforts were switched from three- to two-colour photography and the project took off. The way in which this change came about is amusing, if the explanation given by Terry Ramsaye in *A Million and One Nights* is to be believed:

'Urban was in Paris when, with the color problem uppermost in his mind, a street vendor of novelty postcards arrested his attention. These cards it must be blushingly admitted, were Parisian. They were in two transparent packs, one red, and the other green. Either, viewed alone, presented a commonplace view of scenery. When superimposed and held to the light they presented not scenery, but obscenery. Urban invested a franc in the cards and, hurriedly and furtively concealing them in his inside coat pocket, wondered whether they might somehow relate to the problems that puzzled them at Brighton.'

What Urban did not know was that in 1891 Louis Ducos du Hauron had patented the idea of producing a three-dimensional effect in a print by superimposing two records taken by a stereoscopic camera, one coloured red and the other blue-green, and then viewing the combined images through spectacles having one red and one blue-green lens. So, once again, this time indirectly, du Hauron influenced the development of colour photography.

The new two-colour process was first tested in July 1906 when Smith photographed his two children playing in their garden at Brighton. Within a couple of hours Smith had developed the negative and made a print from the 50 feet of film. He then projected it and Urban subsequently described the momentous occasion:

'Even today – after seventeen years, I can feel the thrill of that

A schematic series showing how the two-colour Kinemacolor additive motion picture process operated.

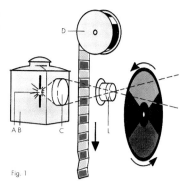

Fig. 1

Fig. 2

Fig. 3

THE KINEMACOLOR STORY

moment, when I saw the result of the two-colour process – I yelled like a drunken cowboy – "We've got it – We've got it." '

A patent protecting the new process was granted to Smith in 1906 and in rather imprecise terms that were to cause him trouble later on, he describes his procedure:

'an animated picture of a coloured scene is taken with a bioscope camera in the usual way, except that a revolving shutter is used fitted with properly adjusted red and green colour screens. A negative is thus obtained in which the reds and yellows are recorded in one picture and the greens and yellows (with some blue) in the second, and so on alternately throughout the length of the bioscope film. A positive picture is made from the above negative and projected by the ordinary projecting machine which, however, is fitted with a revolving shutter furnished with somewhat similar coloured glasses to the above, and so contrived that the red and green pictures are projected alternately through their appropriate colour glasses. If the speed of projection is approximately 30 pictures per second, the two colour records blend and present to the eye a satisfactory rendering of the subject in colours which appear to be natural. The novelty of my method lies in the use of two colours only, red and green, combined with the principle of persistence of vision.'

The use of the word 'bioscope' probably springs from the fact that before he formed the Warwick Trading Company, Urban had been extremely successful at selling a hand-driven projector he called the Urban Bioscope. The word caught on and for some years it was used to denote any form of motion picture.

Neither Smith nor Urban could know that the motion picture industry would still be using two-colour processes forty years later,

albeit with the subtractive rather than additive method of synthesis.

It is easily forgotten that at the time Kinemacolor was shown to be a workable process, no commercially available 35mm film was panchromatic. In order to obtain the essential red and green record negatives, Smith had first to sensitize all his camera film to render it sensitive to those colours as well as to blue. Sensitizing was usually done by winding unperforated film, spiral fashion, on to pin frames and immersing it in a solution of sensitizing dyes, then drying it on a rotating drum and finally perforating it, all of which had to be done in complete darkness in contrast with the normal practice of working under yellow safelight. The sensitizing dyes of those days came from Germany and it is probable that Smith used ethyl red – discovered by Miethe and Traube in 1902.

Even after being sensitized, the film was very slow and because he was at first shooting at 30 and later 32 frames a second, Smith often found that the only way he could obtain adequate exposure was to dilute the colours of the taking filters – no doubt with a consequent deterioration in colour rendering. When it came to projection, balanced illumination was achieved by adjusting the density of the green filter with an extra thickness of filter placed over part of the green sector, varying its area until the light on the screen, with no film in the gate, appeared to be a yellowish white.

The first public demonstration of Kinemacolor was made on May 1st 1908 in Urbanora House, an impressive new building in Wardour Street that Charles Urban erected after he had left the Warwick Trading Company.

The demonstration led to a contract with the Palace Theatre in Shaftesbury Avenue under which Kinemacolor films would be regularly shown at the theatre. The first programme was shown in February 1909 and Kinemacolor films were then projected daily for the next eighteen months.

After exposure, films from the Kinemacolor cameras were developed by hand on 'pin-frames' and then dried on large rotating drums.

THE KINEMACOLOR STORY

In 1909 Urban formed a new company called the Natural Color Kinematograph Company to handle the production and distribution of Kinemacolor films. Smith sold his interests in the process to Urban for £5,000 but remained a consultant at a fee of £500 a year.

In those formative days of the motion picture, short, disparate subjects were used to make up a programme. A typical collection shown (after a full theatrical performance) at the Palace Theatre during one week in 1910 included: *Paris, the Gay Life; Choosing the Wallpaper; Arrival of Lord Kitchener at Southampton; Mr Graham White's Great Aeroplane Flight;* and *Punchestown Races.*

A Kinemacolor film of the funeral of Edward VII in 1910 was the first news reel scoop to be shot in colour and it was shown in several provincial towns as well as in London. Then, in 1911, Urban took a lease of the Scala Theatre, off Tottenham Court Road, so that he could present a complete programme of Kinemacolor films without additional vaudeville acts. It was at the Scala in February 1912 that the epic 16,000 feet Kinemacolor film of the Delhi Durbar of 1911 was first shown.

The 'Durbar' was the greatest success ever achieved in Kinemacolor and at the time the *Morning Post* wrote: 'It is quite safe to say nothing so stirring, so varied, so beautiful, so stupendous, as these moving pictures, all in their natural colours, had ever been seen before.'

Understandably, Urban attempted to repeat the British success in other countries, but for several different reasons, failed to do so. A theatre he leased in Paris was not well sited and only remained open a few months. In the USA, the successful showing of Kinemacolor at Madison Square Garden, was followed by a sequence of private demonstrations during 1920, including one at

KINEMACOLOR
URBAN-SMITH PATENTS

THE ONLY PROCESS IN EXISTENCE SHOWING MOTION PICTURES IN THE ACTUAL TONES, TINTS AND HUES OF NATURE

"THE GREATEST ADVANCE IN THE HISTORY OF KINEMATOGRAPHY."—*Vide, European Press.*

KINEMACOLOR RESULTS ARE REPRODUCED BY MEANS OF ONE LENS, ONE FILM AND THE STANDARD PROJECTOR (WITH SLIGHT ADDITIONS TO THE MACHINE)

"KINEMACOLOR IS REVOLUTIONIZING KINEMATOGRAPHY."
--*Vide, London Press.*

ADDRESS ALL COMMUNICATIONS TO CHARLES URBAN, URBANORA HOUSE, WARDOUR ST. W., LONDON, ENG.

(above) A page from a Kinemacolor programme in 1912.

(left) A hand-coloured lantern slide used to promote the Kinemacolor process in Paris around 1912/13.

THE KINEMACOLOR STORY

the Massachusetts Institute of Technology in Boston, that was almost certainly attended by Herbert T. Kalmus, future chief of Technicolor, who was an Associate Professor of Physics at the Institute at that time.

While demonstrations were being made in America, the Kinemacolor Company in the UK was busy filming the Coronation of King George V, using twenty-three colour cameras. The finished film ran for nearly two hours and when released in the US, it was described by the *Motion Picture World* as 'the greatest achievement that the world of Motion Pictures has yet known.'

With prospects looking good, Charles Urban sold the US rights in Kinemacolor to a group of business men, in 1911 for $80,000. The new company established grand headquarters in New York and several production companies in studios on Long Island and in Hollywood. However, problems were already looming, one of which was that an exhibitor had to hire a special projector to show Kinemacolor films and yet retain a black and white projector because the supply of colour films was insufficient to make up complete programmes. Another difficulty resulted from restrictive practices among those who rented black and white films to exhibitors.

Despite attempts and promises from Kinemacolor to satisfy the demand for more colour productions, it proved impossible for them to fill the gap and by 1919 interest had begun to decline. So, although a quarter of a million feet of film had been shot with nine Kinemacolor cameras and nearly a hundred projectors had been rented, the process was a commercial failure in the US.

Nevertheless, Kinemacolor did make money in the UK, where their total receipts between April 1911 and March 1914 were some £400,000 against an expenditure of about £260,000. The Scala Theatre alone took in £65,000 during its two-year run.

As was to happen repeatedly to other ventures throughout the history of colour photography, patent litigation bedevilled the Kinemacolor project. To some extent this was because Smith's original specification had been very loosely drawn, and had no accompanying drawings, but it was also because William Friese-Green claimed that he had anticipated Kinemacolor by a patent granted to him in 1898 – a year before Smith. In fact Friese-Greene's patent, although it described a rotating filter wheel, related to a method of producing lantern slides in colour and not motion pictures.

Backed by a financier, F. S. Edge of racing car fame, and a company called Bioschemes Limited, Friese-Greene protested that Smith's patent was not sufficiently detailed in that it did not state what colour red or what colour green filter should be used on either camera or projector and that no method of colour sensitizing the film was described.

The petition was heard in August 1913 and the judge dismissed it. Bioschemes then appealed against the decision and the Court of Appeal reversed the first judgement; the appeal judge saying:

'The patentee says his process will reproduce the natural colours or approximately so. Blue is a colour. He says: Drop the tricolour blue; do not employ the blue end of the spectrum – blue or approximately blue will still be reproduced. It will not. The patent is consequently invalid.'

The Natural Color Kinematograph Company took the case to the House of Lords, where the decision of the Court of Appeal was upheld and Smith's patent No. 26671 of 1906 was revoked on April 26th 1915.

LIMITATIONS OF SUCCESSIVE FRAME ANALYSIS

There are a number of serious limitations inevitably associated with any two- or three-colour additive process of colour cinematography that depend upon successive exposures. Time parallax is the term used to describe the cause of the differences there will always be between the content of two or three successively recorded images of a moving subject. This bugbear affected many of the processes – not only in cinematography but also when two or three colour separation negatives were taken of a live subject for a still photograph.

A most striking example of time parallax can result from a flock of pigeons flying into a scene that is shot at two or three times normal camera speed through a sectored filter wheel. The resulting multi-coloured birds will surely hold the attention of any audience, no matter what else is happening in the scene!

Another serious disadvantage was that twice as much negative and positive film stock had to be used for a successive frame two-colour process and because of the higher running speed, wear and tear on cameras, projectors and films was increased. Loss of light, often amounting to 75%, through both camera and projector filters was also serious; on the one hand because it was difficult to obtain sufficient exposure except in brilliant sunlight, and on the other hand, because much higher powered projection lamps were required to provide adequate screen brightness. Finally, the repeated projection of alternating red and green images very near the threshold frequency for persistence of vision, often caused discomfort and headaches.

To avoid the effects of time parallax some way must be found to make the two or three necessary exposures simultaneously, and of course, from exactly the same viewpoint.

One of the first people to achieve this with a motion picture camera was William Buchanan-Taylor in 1914 when he invented a three-colour beam splitter camera incorporating a 45° reflector. Buchanan-Taylor would use a bi-pack in one gate and a single film in the other – a device that was later to become an indispensable part of the Technicolor three-colour system.

Many other inventors had patentable ideas based on the use of optical systems that would avoid time parallax, by involving the use of non-standard camera and projector lenses, while some necessitated unusual image formats or even double-width film.

Among these systems, spread over a quarter of a century, were: Gaumontcolor (1913); Cinechrome (1915); Prizmacolor (1917); Technicolor (1917); Biocolor (1924); Morganacolor (1932); Raycolor (1933) and others.

Few of these optical solutions to the problems resulted in anything more than demonstration films, although the first Technicolor process, a two-colour additive system, was used to make a full length feature film called *The Gulf Between*.

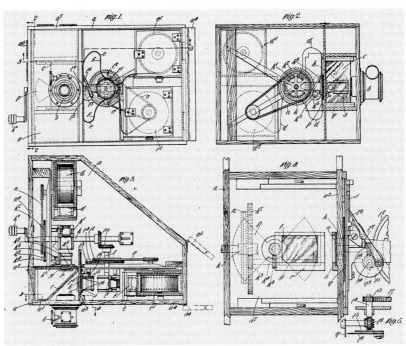

In 1914, when he was granted this patent, Buchanan-Taylor was in fact anticipating the procedure adopted by Technicolor, when they also decided, some twenty years later, to use a 'bi-pack and one' combination of films in their camera.

SUBTRACTIVE 'ASSEMBLY' PROCESSES

'I feel that the use of a triple lantern and three transparencies with colored light-filters will not be the method of the future . . . The superimposition of three-color films, produced by means of the carbon process, is I am afraid, not at present a thoroughly practical method, though successfully done by Mr. Ives, but in this lies the future.'

E. J. WALL, 'PENROSE'S ANNUAL' 1896

Wall was quite right in his forecast, because for almost another half a century, subtractive 'assembly' processes provided the only way of making colour prints.

In his remarkable 17-page British Patent of 1876 (and a corresponding French patent of 1869) du Hauron had shown how colour prints could be made by superimposing three complementary coloured pigment images obtained by contact printing from red, green and blue separation negatives.

It was a difficult and lengthy process that very few people mastered, although some of the results that were obtained have remained hardly changed after almost a century. Du Hauron's disclosure explained in great detail how he managed to sensitize wet collodion plates to green by using eosine obtained from Professor Bayer of Strasburg, and to red by using an alcoholic infusion of ivy leaves to extract chlorophyl. He also tells how the necessary separation negatives could be exposed, either by using a camera with three lenses 'acting simultaneously' (which would have been suitable only for landscapes and may well have been used for the historic view of his home town, Agen, taken in 1877), or by making a sequence of three exposures with a 'multiplicating slide' – later to be called a repeating back.

The fact that du Hauron left the description of his 'triple camera' until the end of the lengthy patent specification might have meant that he was well aware of the many difficulties he would face in making and using such a camera at that time. It is likely that the low emulsion speed and colour sensitivity of any available plates would have meant that exposure through the red filter would be so long as to make it impossible to record live subjects – the only reason for using such a complex instrument. Characteristically, du Hauron admits the problem when he says:

'What matter if the three negatives of a heliochromic portrait are

taken successively and with a single lens if three additional operations do not notably exceed the time of an ordinary exposure?'

REPEATING BACKS

Despite the fact that time parallax must always result in some degree from making a sequence of exposures of any moving subject; sliding, dropping, or rotating backs of many kinds were used right up to World War II. Selle obtained a patent in 1897 for a simple manually operated sliding triple plateholder that incorporated the necessary red, green and blue filters with the plates.

In 1899 A. J. Lege and W. H. England patented a three-colour back that operated in a vertical plane by gravity, movement of the back, and operation of the lens-mounted shutter being controlled in unison by means of a pneumatic bulb. Adolfe Miethe also devised a vertical, gravity operated back that Bermpohl began to produce in

Germany around the turn of the century. Some versions of the Miethe design incorporated a pneumatic dashpot to eliminate jerk.

During a tour of Europe in 1898 Ives used a repeating back subsequently used to produce the slides he needed for his subsequently used to produce the slides he needed for use in his Kromskop viewers. It may well have been that his camera back was made for him by Sanger Shepherd in London, since that company seems to have been the first to produce such equipment in the UK and Ives subsequently claimed that they worked together. There seems to be no evidence that Ives ever used or even made a clockwork-driven repeating back to the design he patented in 1897. This was an ingenious arrangement, automatically linking the changing of plates with any pre-elected set of exposures between 15 seconds and three minutes.

Several more complicated ideas were patented with the intention of reducing the overall time required to complete the three exposures. Typical were the patents of Chenhall in 1906 and

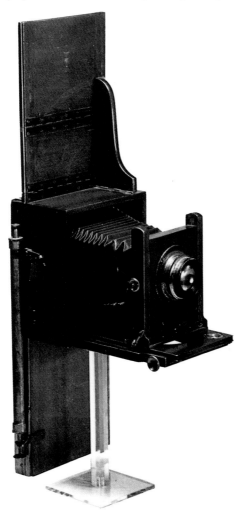

(left) Many different devices have been designed to enable three exposures to be made in rapid succession through red, green and blue filters. One of the first, designed by Miethe and made by Bermpohl in Germany, worked by gravity; the triple plateholder being allowed to fall from one position to the next between exposures.

(above) In England during the early 1900s, Sanger Shepherd made a range of repeating backs which were moved manually in a horizontal direction.

Lechner in 1912. The Chenhall design incorporated a clockwork-driven plateholder that rotated in the focal plane of a camera, the movement of the plates being synchronized with the operation of a lens-mounted shutter. The Lechner back was a box in which three plates, arranged on a rotating drum, would move through 120 degrees between each exposure, operation of the back again being linked with the shutter by twin cables. There were other ideas but not many of them ever achieved commercial production.

By far the most successful repeating back was patented by L. W. Oliver in 1930. Oliver worked for Colour Photographs (British and Foreign) Limited, who operated the Vivex print-making service, which is described separately.

Returning to du Hauron's patent, he goes on to explain how his separation negatives (heliochrome clichés) were used to produce three positive images in pigmented gelatine and how these images could then be superimposed to form a colour print.

Acknowledging that Sir Joseph Swan (who later invented the carbon filament lamp) had discovered the use of bichromated gelatine/carbon paper as a silverless but extremely stable printing material in 1864, du Hauron goes on to describe how an amateur could make his own tricolour carbon printing papers: 'one coloured with carmine, one with Prussian blue and one with chrome yellow.'

The coloured papers, or tissues as they came to be called, were sensitized in an alkaline solution of potassium bichromate before being dried in the dark. Then, after each dried sheet had been exposed to daylight in contact with the appropriate negative, they were immersed in water and brought into contact with sheets of glass that had been prepared with a coating of ox-gall. Du Hauron continues:

'The paper and the glass were lifted out together, the gelatine side of the paper applied against the face of the glass coated with the gall; they drain for a few moments, then the glass being placed on a horizontal surface the excess of water is driven out by the friction of the hand, several sheets of blotting paper being interposed. 5 or 10 minutes after this, the adherance being complete, the glass and paper united are immersed in a dish of moderately hot water; the paper soon detaches itself, and the image is apparent adhering to the glass.'

There follows a detailed description of how each image is successively transferred in register from its glass support onto a sheet of paper to produce the final colour print. Only someone who had frequently done all of these things himself could possibly describe each stage so accurately.

In fact du Hauron's description of his three-colour carbon printing process would have served almost as well half a century later, the only difference being that by then the pigment images would have been obtained via bromide sheets and waxed celluloid or Perspex sheets would have been used in place of glass.

It is the practical understanding and uncanny foresight displayed in this remarkable patent – the first to be granted in Britain on any aspect of colour photography – that justifies the special attention it has been given.

In 1876, when photographers had to sensitize their plates and make their own pigment papers for printing, there was little chance of making a business out of the three-colour carbon process. Nevertheless, du Hauron recognised several alternatives, saying:

'We can choose between the pigment process, Woodburytype, collotype, the dusting-in process or the silver-chloride method with the use of suitable toning baths.'

Sanger Shepherd, who worked for a while with Frederick Ives in London, later formed the first British company to specialise in the supply of materials and equipment for colour photography.

PHOTOMECHANICAL PROCESSES

It was the photomechanical route that appealed to du Hauron, who bought a collotype press and taught himself how to use it. A photomechanical process offered the advantage that once the make-ready and registration of the three printing plates was completed, large numbers of full colour reproductions could be produced relatively cheaply.

Du Hauron exhibited a number of excellent collotype proofs at the Universal Exhibition in Paris in 1878 and in 1883 he established a three-colour printing plant in Toulouse in collaboration with a collotype printer, Andre Quinsac. Unfortunately a fire destroyed the printing works a year or so later, but not before the establishment could have claimed to be the first to print book illustrations by the three-colour photographic method. By now, du Hauron's original French patent was soon to expire and in 1884 he joined his brother, Alcide, in Algiers where he remained for several years, never having benefited from any of his inventions.

EARLY ASSEMBLY PROCEDURES

Even before the turn of the century several other people had devised ways of making three-colour subtractive transparencies or prints by somehow combining the necessary cyan, magenta and yellow positive images.

Ten years before they invented their Autochrome screen-plate process, the Lumières were producing excellent colour prints on paper by superimposing three dyed gelatine/glue relief images, transferred individually from paper to glass and back again, onto paper. Describing the process, Konig said:

'Very beautiful results are unquestionably given ... Unfortunately the method is extremely subtle, and requires so much skill and perseverence that the average amateur, and still more the professional photographer, who cannot spare the necessary time, will be hopeless about it.'

SUBTRACTIVE TRANSPARENCIES

It was a good deal easier to put together a transparent colour photograph by combining three subtractive coloured images than it was to make a colour print on paper, because of having to transfer three images in register onto an opaque reflecting support. Consequently there was for a time some interest in making colour lantern slides by the subtractive process.

In 1895 B. J. Edwards proposed to avoid the problems of making colour prints on paper, by using his colour camera not only to expose separation negatives, but also as a photochromoscope in which positives made from the negatives could be viewed in superimposition through red, green and blue filters. Edwards even suggested that three light sources could be attached to the camera to enable superimposed images to be projected on a screen – just as Clerk Maxwell had done thirty-four years earlier.

Under the same number as his 1897 colour camera specification, Bennetto also patented a method of making transparent colour photographs. He proposed to use:

'A web of paper coated with three parallel bands of gelatine, coloured respectively with the three subtractive primary colours. The gelatine is then sensitized with bichromate of potash. Suitable lengths of the tricolour web are cut off, and three prints made on the three colours from the three negatives obtained in the camera. The prints are developed as in the carbon process and transferred to a transparent support. The two side prints are then folded over the middle so that all three are superposed in correct register.'

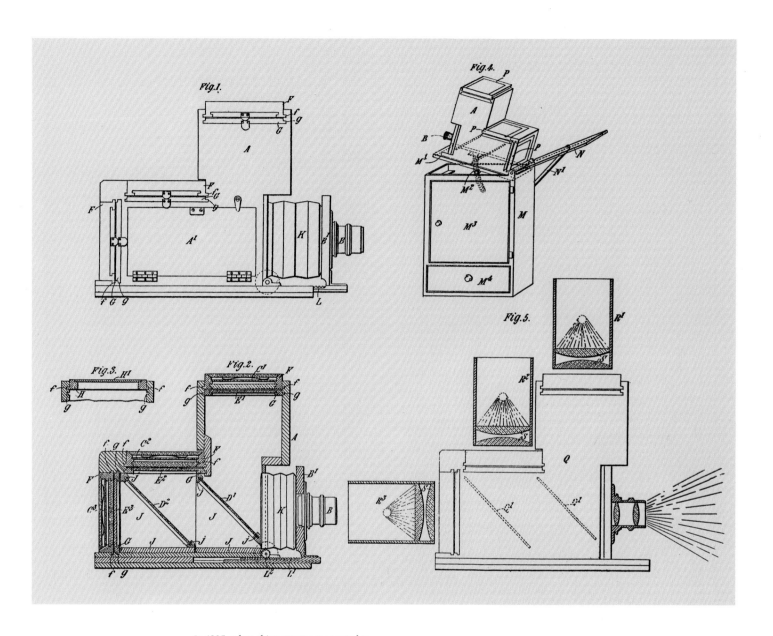

In 1895, when this patent was granted to Edwards, single-exposure colour cameras could also be used as photo-chromoscopes for direct viewing in daylight. Although covered by the patent, it is unlikely that they were ever used for additive projection.

An impression from the pen of GEORGE E. BROWN, Esq., F.I.C.
Editor of "The British Journal of Photography."

Natural - Colour Photography

AT THE ST. JAMES' STUDIO,
THE CORNER, 45 OLD BOND ST., W.

Proprietors—The Rotary Photographic Co., Ltd., London, E.C.

A NEW and important step is being made in colour photography by the opening in London of the first studio for regular photographic portraiture in natural colours. The occasion does not denote simply commercial enterprise. It also marks advances in colour photography, which remove it from a place among amateur pastimes and promote it to a position among the applied arts, if not among the fine arts.

The Studio, which is the scene of the new process, is in a large new building at the corner of Piccadilly and Old Bond Street. It is approached through a suite of rooms, in which is displayed a collection of examples of the process. Colour photography, it should be explained, has been practised for some years past by a few skilled amateurs, and the particular products employed in the making of portraits in colours are well known to these daring and patient workers as the "Carbon Films" of the Rotary Photographic Co. The task of the Company, however, in conducting a studio for the photography of sitters in the regular way is a far more exacting one. For a photograph in colours three negatives must be taken, and each is made through a coloured screen, blue, green or red, which obstructs a large proportion of light. Hence the difficulties of the colour-photographer in diminishing the time during which the sitter must remain still, greatly exceed those of the ordinary maker of photographs, whose work is done through an unscreened lens, and who has to obtain but one negative.

In The St. James' Studio the demands of colour photography have been satisfied by the provision of the most rapid lenses it is possible to procure, by the manufacture of coloured screens of new composition, and by the employment of new sensitive plates, which, before use, are bathed in dyes and dried, whereby their sensitiveness is many times increased. Each of these essentials to the process has involved months of research before things arrived at the stage when a sitter could be asked to seat herself before the camera. The fact that the process is now in working order, is due to the simultaneous perfection of the three factors. In the new studio this realization is seen in practice. The only difference which the non-photographic person is likely to notice is the black frame which projects from each side of the camera — the repeating back it is called — which carries the three plates. In this frame the plate-holder slides, as one exposure is dexterously made after another, whilst the sitter remains seated for a time which is very little longer than many photographers would consider necessary for an ordinary portrait. The studio is provided with arc lighting, probably the most powerful photographic installation in London, which permits of the process being carried out irrespective of time or weather.

As in ordinary photography, the negatives are but the means to an end. The colour photograph is obtained by printing from each one by a modification of the well-known carbon process. The prints from the three negatives have to be brought together on one surface, and the result is the complete portrait in colours.

The activities of the new undertaking are not to be restricted to portraiture. In fact, it seems possible that the largest part of its immediate work will be in the reproduction, in colours, of works of art, objects of vertu, and specimens from the fields of natural history, geology, mineralogy, botany, etc. In fact, the demands for work of this kind by wealthy collectors is already sufficient to keep the present staff of the Studio busy, and there seems little doubt that when the fact is realised that a speedy and certain process of real photographic reproduction of colours is available, many scientific and public bodies, as well as private collectors, will find themselves turning to the new enterprise for a record of their possessions.

In 1906 colour portrait prints were made for the St. James' Studio from negatives exposed in a repeating back. The process was based on carbon stripping films made by the Rotary Photographic Company. George E. Brown, editor of the British Journal of Photography considered that the enterprise marked – 'advances in colour photography, which remove it from a place among amateur pastimes and promote it to a position among the applied arts, if not among the fine arts.'

In 1903, B. Jumeaux and W. N. Davidson patented, and Sanger Shepherd subsequently promoted and sold, a fairly simple procedure by which a red record negative was used to produce an iron-toned blue-green image on a lantern plate and green and blue record negatives to produce magenta and yellow dyed images on two sheets of film coated with bichromated gelatine. The patent concluded by saying that 'the three prints are clipped, fastened or cemented together.' (This patent may have been the first in which the word magenta was used in connection with colour photography).

EARLY COLOUR PORTRAIT STUDIOS

That there was, nevertheless, a latent desire for colour photographs on paper can be seen from an advertisement in Wall's 1906 translation of Konig's book *Natural Color Photography*, describing the first studio to be opened in the UK for 'photographic portraiture in natural colours'. The organization behind this bold project was the Rotary Photographic Company, an offshoot of the Neue Photographishe Gessellschaft of Berlin.

ST. JAMES' STUDIO

The St. James' studio was located at the corner of Old Bond Street and Piccadilly, in one of the most fashionable parts of London. The procedures followed at the studio included the use of arc lighting and 'new sensitive plates, which, before use, are bathed in dyes and dried, whereby their sensitiveness is many times increased.' The studio camera was fitted with a wide-aperture lens and a repeating back – 'in which the plate holder slides, as one exposure is dexterously made after another, whilst the sitter remains seated for a time which is very little longer than many photographers would consider necessary for ordinary portraits.'

The *British Journal of Photography*, reporting on the new studio, was rather more realistic in its estimate and reckoned on – 'exposures being cut down to as little as ten seconds for all three exposures.'

ROTARY STRIPPING FILMS

The Rotary Photographic Company had a factory at West Drayton, just outside London, where they coated bromide, and chloride papers as well as the pigmented gelatine films that were used to make colour prints for the St. James' Studio. Just before use the films were sensitized by bathing them in a solution of bichromate just like carbon tissues, and after drying and exposure in contact with the appropriate negatives, relief images could be developed in warm water before being transferred directly and in sequence on to paper.

Rotary colour stripping films were also sold to individual photographers to make their own colour prints of still-life subjects – a complete outfit containing taking filters, panchromatic plates and a packet of $8\frac{1}{2}$ x $6\frac{1}{2}$ inch pigment papers, costing £1.3s.2d.

If exposures in the studio were as long as 10 seconds, not many of the colour portraits would have been free from colour fringing due to movement of the subject. Perhaps it was because they could see a way of overcoming this problem that another company opened a competing studio just around the corner in Dover Street, in 1911. This time a single-exposure camera was used so that exposure times could be shortened and because any movement of a subject would be recorded equally on all three negatives, no colour fringing would result.

DOVER STREET STUDIOS

The man behind the Dover Street studios was an entrepreneur named Aaron Hamburger and the camera he used was derived from a design that had been patented by J. W. Bennetto in 1897. Although

three separation negatives were obtained at a single exposure, the camera only required two dark-slides; one of them containing one plate and one film with their emulsion sides in contact.

EARLY COLOUR CAMERAS

Lieut. Commander H. E. Rendall, D.S.O., R.N., a dedicated colour worker who managed to make colour prints in his cabin while serving aboard his ship *'Atlantis'* during World War I, described the Dover Street whole-plate (8½ins x 6ins) camera in a paper he read on one-exposure tricolour cameras at the Seventh International Conference of Photography held in London in 1928:

'Mr. Hamburger's Polychromide camera, I should think is the most rapid camera ever made, though of course it required specially prepared plates. The single reflector is of semi-platinized glass, reflecting 50% of the incident light. On the top

plane there is a pack of a plate and a film, the plate being non-colour sensitive, the film green sensitive. The plate being exposed through the back gives a reversed image, as in the ordinary camera and the film image is direct, so it has to be placed face upwards in the printing frame to give a non-reversed print. At the back there is a red filter in front of a panchromatic plate. The ordinary plate (of the bi-pack) may be strongly stained with auramine, which acts as a filter for the plate or film.'

During 1910 there was a lot of somewhat acrimonious correspondence in the *British Journal of Photography* between Frederic E. Ives and Otto Pfenninger as to who really invented the single reflector three-colour camera. Ives' interest was no doubt prompted by his intention to launch the single-mirror Hi-Cro camera and Hichrome printing process in the U.S.

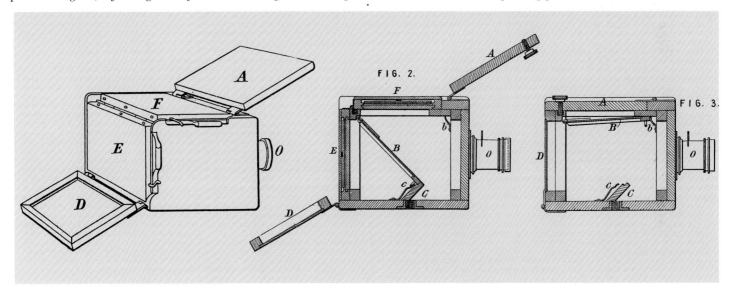

(left) This portrait, from negatives exposed by A. C. Banfield in 1907, was probably printed with the Rotary (carbon) process.

(above) In 1897 Bennetto invented the idea of using a bi-pack of two plates together with a third plate to obtain three colour separation negatives at a single exposure. The camera he patented could also be used to expose a single plate for black and white photography.

The 8¹/₂ x 6¹/₂ inch wooden colour camera used for portraiture in the Dover Street Studio in 1906, together with cast alloy 3¹/₂ x 2¹/₂ inch Devin camera made in the US around 1936 (from The Royal Photographic Society Collection).

It is doubtful whether anyone could now be quite sure how the Polychromide process was operated at Dover Street, but in a lecture before the Royal Photographic Society in 1914, Hamburger said that the yellow image was formed on paper by converting monochrome silver image into – 'a complex of silver, iodine, chromium and mercury', while the red (magenta) image was an alizarin lake, used as carbon paper, and the blue (cyan) image was a silver image toned with the usual cyanotype bath. How the magenta and cyan images were transferred in register on to the paper bearing the yellow image was not made clear. Whatever method was used to make the prints, Hamburger, who was a great publicist, let it be widely known that among the famous sitters who had visited the Dover Street studio were Princess Alexandra of Teck, Lord Esher and Mme Pavlova.

IVES ON COLOUR PRINTS

Ives was somewhat ambiguous in his views on colour prints. In 1910, in answer to the question 'What do you think of the future of colour photography for the amateur?', he replied:

There are several processes he can use, if he will. But he won't. They are all too complicated and dainty in operation. The professional uses them but little because of the expense attached which makes it impossible to do as the average sitter expects – make half a dozen negatives and give her a choice! But any system of colour photography which depends upon pigments on paper, no matter how applied, is at least but a compromise. The only absolutely truthful colour process is my old "Kromskop" process, and the "man in the street" called that a fake!'

Again, in the autobiography he published in 1928, Ives wrote:

'I made color prints from my monochromoscope negatives from the start, but mostly lantern slides . . . I taught the process to Sanger Shepherd who was employed as my assistant in London, and he afterwards exploited it commercially as the "Sanger Shepherd process", but I did not attempt to exploit it myself . . . Beautiful color prints have been made on paper both by the imbibition process and the superposition process of my US patents; but although beautifully standardised, these processes are not sufficiently simple and cheap to popularize in this age of hurry.'

In an attempt to simplify things, Ives finally turned to a two or 'two and a half' colour process he introduced in the 1930s and called Polychrome. The simplicity came from two features: first the use of a bi-pack of two films in an ordinary dark-slide and second, the cementing together of two film-based positives, one blue-green and the other orange/magenta, to produce a colour print.

From the orange-red record negative an iron-toned (blue-green) print was made using Defender Ivora, a bromide emulsion coated on a white pigmented acetate base. To this image was cemented a red/magenta positive printed from the blue-green record negative on to Kodak Wash-Off-Relief film. The gelatine relief image was dyed with a mixture of orange and magenta dyes which tended to produce yellowish highlights that favoured flesh colours and shadows that remained reasonably neutral.

THE RAYDEX (OZOBROME) PROCESS

In 1905 Manley patented the Ozobrome process, by which a pigment image could be obtained via the silver image of a bromide print – thereby making it possible to obtain carbon images without being restricted to contact printing.

Trichrome Printing
=== *by the* ===
Autotype Carbro Process

■

*T*HE AUTOTYPE COMPANY LTD. *invite all those interested in* TRICHROME WORK *to apply for a copy of Brochure No. 970 which contains clear working instructions for the production of Three-colour Prints and Transparencies by the Carbon and Carbro Processes. The list also contains particulars and prices of all requisites.*

You are requested to call at the Company's London Showrooms, where interesting examples may be inspected.

■

The
Autotype Company Ltd.
"Albion House," 59 New Oxford St.
London, W.C.1
Works: West Ealing

Thirty-two Prize Medals & Diplomas for excellence of products

Samuel Manners, a skilled colour worker, took over the Ozobrome process in 1913 and promoted it in the U.K. under the name Raydex, making the somewhat optimistic claim that:

'Once the bromide prints are made the process becomes automatic, as everything is so systematized that only ordinary care and a little practice are required to produce satisfactory results.'

In the 1920s Manners moved to the USA, where he made his own pigment tissues for a while. Later, Devin, who built one-shot cameras, and McGraw also produced tri-colour pigment papers for what became known as the carbro (carbon-bromide) process.

THE CARBRO PROCESS

However, most of the pigment tissues were made in England by the Autotype Company of Ealing, who continued to promote the Trichrome Carbro process until after World War II. Several people achieved recognition as expert carbro workers, among them Frank Newens in the UK and Victor Keppler in the US, both of whom wrote books that included detailed instructions on the process.

One of the most important features of the carbon and carbro processes has always been the extreme permanence of the resulting images. In 1989 this feature led to the re-emergence of the carbon process in California, where Charles Berger operated a system that resulted in prints that he claimed would remain unchanged for 500 years! The process used pigment sheets coated on a film base by Polaroid, and these were printed in contact with screened separation negatives made via a scanner. However, by far the most successful version of the three-colour carbro process was introduced in 1928 as the Vivex process and that story is told separately (page 78).

(above) The Autotype Company had a factory at Ealing in West London, where they coated 'carbon' tissue papers for the three-colour carbon and carbro processes.

(right) Charles Berger assembling the pigment images used to produce a 'Permanent-Color' print. (By courtesy of Henry Wilhelm)

THE PRINCIPAL STAGES OF THE TRICHROME CARBRO PROCESSES
(FROM 'THE EIGHTH-ART' BY VICTOR KEPPLER)

1) Bromide paper enlargements made from three colour separation negatives.

2) The bromide prints after being bleached while in contact with three carbon tissues.

3) The cyan, magenta and yellow gelatine/pigment relief images after being developed in hot water while supported on sheets of celluloid.

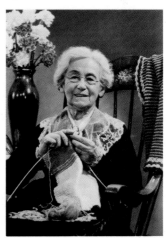

4) A sheet of temporary support paper squeeged into contact with the cyan pigment image.

5) First the magenta and then the yellow pigment images are super-imposed in register onto the cyan image on the temporary support.

6) The combined three colour image is transferred to a final support paper and now appears the correct way round.

7) The final print.

THE VIVEX STORY

Ninety per cent of the colour prints made in the UK during the years just before World War II were produced by the Vivex process – a derivative of trichrome carbro. The company operating the process, Colour Photographs (British & Foreign) Ltd, originally had a portrait studio at Wilton Place, Knightsbridge and a commercial studio at Duke Street, Grosvenor Square. There was also a works at Albion House, New North St, WC, and later a factory at Willesden.

The company was formed in 1928 to acquire and develop the British and foreign rights in a process of colour photography based on two patents granted to Dr. Michael Martinez – a man whose name appeared frequently in the patent literature of that time. The patents related to a tri-pack for obtaining separation negatives and a printing process based on the formation of complementary coloured images by direct printing on to 'sensitive layers that print out in red, blue and yellow respectively'. All of which must have sounded rather easy.

However, the directors of the new company tried to play safe by seeking the opinion of a well known expert; T. Thorne Baker, who was director of research at the Imperial Dry Plate Company and author of *Photographic Emulsion Technique*.

Thorne Baker reported favourably, saying, among other things:

'The method as a whole provides an easy and satisfactory means of taking photographs in natural colours with ordinary cameras and ordinary photographic appliances, and the characteristics of the process are such that it can be readily applied to roll-film photography.'

One of the directors of the company was Joseph Hill, managing director of the Imperial Dry Plate Company – 'with whom arrangements had been made to manufacture negative materials according to the company's requirements.'

There is some evidence that a large-format tri-pack was used for a while by the company in their Wilton Place studio, because a reporter from *The British Journal of Photography*, writing in 1930, gave it as his opinion:

'that a tri-pack method can be successfully combined with a practical colour printing process has been demonstrated by Colour Photographs Ltd., whose results, including studio portraits, are of a very high order of attractiveness and technical merit.'

Whether the tri-pack was based on the Martinez patent seems doubtful because in 1928, Thorne Baker himself assigned to the company a patent protecting a tri-pack using a different combination of three films.

The Martinez printing process also may have been used for a short while, for according to the reporter from the *British Journal of Photography*, he saw:

'extremely thin cellulose tissues being sensitized for the production of the necessary component images which, after being printed directly from the appropriate negatives, were cemented together in register to yield a finished print.'

Yet in a lecture given to the Royal Photographic Society in 1930, L. W. Oliver of Colour Photographs Ltd., spoke of – 'our old process in which we used alloxan red, Prussian blue and silver yellow images', thereby suggesting that the Martinez procedure had already been abandoned. Certainly the company sought outside help, because before the end of 1928, Dr. D. A. Spencer, a partner in a firm of consulting chemists, Murray, Bull and Spencer, had joined Colour Photographs Ltd.

This advertisement appeared in 1930 and was the first one to offer a colour print making service to professional photographers.

THE VIVEX STORY

At the 1928 International Congress of Photography, Spencer presented a paper on Printing in Colours with Diazo Compounds in which he proposed the use of impregnated sheets of Cellophane as supports for the three component images.

Then, in 1929, Spencer assigned a patent to Colour Photographs Ltd. protecting the use of Cellophane as a temporary support for a pigment relief image formed by the carbro process. It was the flexibility of registration that resulted from the use of Cellophane that became one of the most important features of the Vivex process because it made it possible to adjust locally the component images while they were being superimposed. This meant that any small mis-matching of the images resulting from subject movement during the three exposures could be corrected by manually stretching or squeezing the Cellophane.

This facility to achieve good registration was particularly impor-tant to Colour Photographs Ltd. because at the outset they had no 'one-shot' camera to offer customers who needed to photograph live subjects. Instead, they depended upon a mechanized repeating back designed and patented by Oliver and constructed by H. G. Eckert.

An unusual combination of emulsions was used for the three quarter-plates (4¼ins x 3¼ins) in the Vivex repeating back. They were: an Ilford Soft Gradation panchromatic plate behind a red filter, an Agfa Isochrome plate behind a yellow filter for the green record and another Isochrome plate behind a magenta filter for the blue record. This arrangement meant that each negative had to be developed for a different time to yield equal gammas, but the combination was found to be significantly faster than using three panchromatic plates with tri-colour filters.

Spencer claimed that besides producing three critically sharp negatives, the new 'back' could do so in as short a space of time as

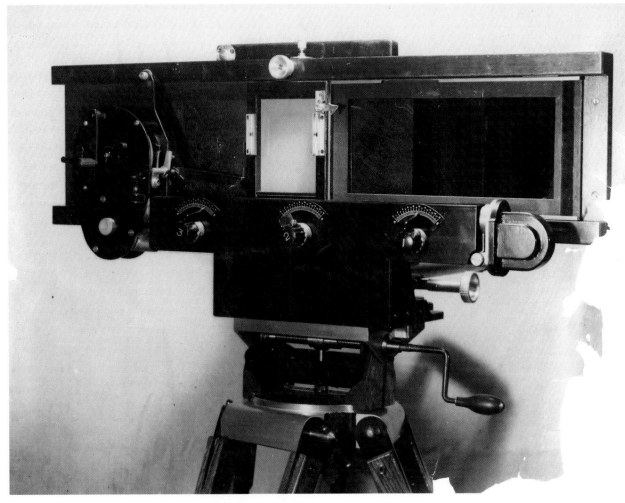

This clockwork driven 'Vivex' repeating back was used to expose three colour separation negatives in rapid sequence. The actual times of exposure could be regulated individually. The back, which took 4¼ x 3¼ inch plates could be attached to any plate camera.

THE VIVEX STORY

two seconds. This may have been optimistic, but the fact remained that many first-class colour prints were made with the Vivex back by some of the foremost photographers of that time, including Noel Griggs, Walter Bird and Madame Yevonde. Clearly the company no longer had faith in either Martinez' or Thorne Baker's tripacks and in 1930 Spencer publicly listed the main objections to them:

1. Lack of sharpness
2. The fact that the cyan printer, responsible for 'drawing', is most diffused
3. Lack of exposure latitude

Besides the use of Cellophane, Spencer introduced several other improvements and modifications to the Trichrome Carbro process, including a new single bath sensitizer and mechanical devices and procedures that ensured uniform and consistent processing of the bromide prints and the pigment images.

A very complete description of the process including formulae was given by F. W. Coppin and D. A. Spencer in a paper they presented to the Royal Photographic Society in 1948, almost a decade after the company had ceased operations.

Among the features contributing to the success of the Vivex process was an insistence on measurement and control. This began with the grey-scale and colour chart that was requested always to be included near the edge of the photograph, thereby enabling bromide print exposures to be based on density measurements rather than judgement of the printer.

In this connection an amusing story is told that because some of the photographers using the Vivex service failed to comply with the request to include a test chart, the factory decided to demonstrate the dangers of not correctly identifying separation negatives. So they made a proof print using incorrectly matched negatives and pigment colours. The result was awful, but the

response from Madame Yevonde was – 'don't correct anything! Just print!'

All three prints were made side by side on the same length of bromide paper, so that they would receive exactly the same development, fixing and washing. Thoroughly washed prints are essential in the carbro process and this was achieved by suspending the triple image sheets in a special clip that allowed water to flow down both surfaces of the paper.

A single bath, containing potassium ferricyanide, potassium bromide and chromic acid, was used to sensitize the three tissues and this sensitizer could be replenished about ten times without any significant differences resulting.

Sensitized pigment tissues were laid face-up on a sheet of duralumin and brought into contact with the bromides in a mechanical squeegee or mangle.

After ten to fifteen minutes the bromide print was stripped off and could be re-developed for further use, although this was not normally done.

A thoroughly wetted Cellophane sheet was now lightly squeegeed to the surface of the pigment sheets before the assembly was placed in a drying chamber.

Next, the combined Cellophane/pigment-tissue/duralumin 'sandwich' was lowered with the Cellophane facing down, onto a sheet of celluloid immersed in water contained in a special developing machine. The water was maintained at between 41°C and 43°C, and was continually circulated within the tank. After one end of the Cellophane sheet had been clamped to an edge of the celluloid, the duralumin sheet was gently lifted off and the backing papers removed from the three tissues. The leading edges of both the celluloid and Cellophane sheets were then attached to a slot in a drum which was then rotated in the hot water for three minutes, during which all the soluble pigmented gelatine was

The machine designed by Vivex for 'developing' pigmented gelatine relief images.

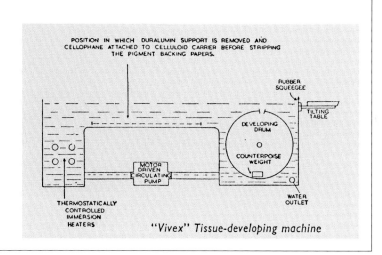

THE VIVEX STORY

removed from the carbro images. After development, the Cellophane/pigment sheet was dried before the individual cyan, magenta and yellow images were cut apart.

The yellow image was transferred to paper first, with the aid of a gelatine cement. After the paper/image/Cellophane sandwich was partially dried, it was placed for about ten minutes in a stripping bath containing formalin, after which the Cellophane support could be stripped off. The magenta and cyan images were assembled in register on the yellow image to complete the print.

THE VIVEX ONE-SHOT CAMERA

At first, Spencer was critical of one-shot cameras, saying in 1930 that – 'no one-exposure camera is optically perfect, we have not seen one which gives three mathematically exact images.' Perhaps at that time he did not fully realise that with the Vivex process he had the key to solving this problem with the flexibility of registration that came from the use of Cellophane.

Anyhow, by 1934 Spencer had changed his mind, and in an article in the *Photographic Journal* he reported that Colour

PURPOSE-BUILT EQUIPMENT USED TO MAKE VIVEX COLOUR PRINTS DURING THE 1930s

1) Pigment sheets were sensitized in a tray suspended from the roof so that the solution would be kept moving. The sheets were held down with rubber covered weights.

2) Special clips were used to ensure that both sides of the bromide prints would be thoroughly washed.

3) A domestic wringer was used to combine the sensitized pigment papers with their respective bromide prints.

4) The developing drum and hot water tank was located alongside a tilting table on which the developed relief images were drained and then coated with gelatine.

5) Superimposition of the three images was done manually and registration could be adjusted slightly by stretching the Cellophane locally.

THE VIVEX STORY

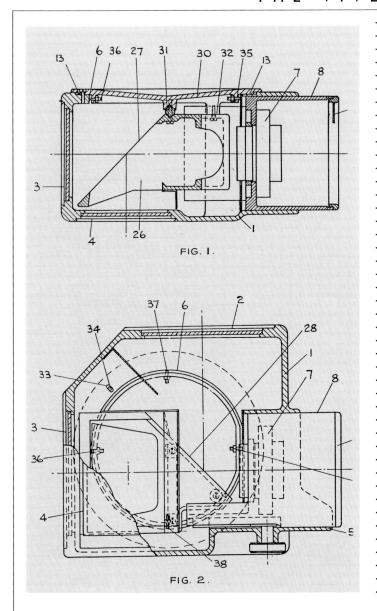

FIG. 1.

FIG. 2.

Photographs had constructed a colour camera to a design by Major Adrian Klein (later Cornwell Clyne), and that the new camera would use pellicle reflectors. Then, in the *Penrose Annual* at the end of that year, he expounded the merits of yet another new camera built for the company by Taylor, Taylor Hobson.

The disposition of the three exposure apertures in the new camera was the same as that patented by Nachet in 1895, the novelty being in the arrangement of reflectors which resulted in one image being recorded on top of the camera, a second at the back and the third on one side. This arrangement made it possible to use an $8^{1}/_{4}$in lens with a 9cm x 12cm format, a much wider angle than had previously been used and although the consequent refraction resulted in negatives that did not exactly match for size or shape, the problem was not considered important because it could be corrected at the printing stage.

The camera was patented in the name of William Clifford and was known as the Vivex No. 2 camera. The body was cast from a light alloy and its reflectors were mounted on an optically worked cast frame that could be adjusted from the side of the camera. The camera was balanced for use in daylight and it was claimed that exposures of 1/50th second could be made in summer sunlight.

While the Vivex camera was somewhat smaller than other 9cm x 12cm colour cameras, it would not be considered small by today's standards, having outside dimensions of $5^{1}/_{2}$ x $9^{1}/_{4}$ x 11 inches and weighing 12 pounds!

Colour Photographs (British & Foreign) Ltd. were only in business for a decade, but during that time they established the first professional colour printing service and produced some of the best colour prints made by any assembly process.

Dr. D. A. Spencer, the moving spirit behind the enterprise, joined the Research Department of Kodak Limited in 1939 and later became managing director of that company.

(above) The Vivex 'one-shot' camera was able to accommodate a relatively short focal length lens because of the compact arrangement of reflectors – one forming an image at the top of the camera and the other at one side.

(right) This drawing shows how the light beam was divided in the Vivex 'one-shot' colour camera.

THE VIVEX STORY

(above) A Vivex print made from 4$^{1}/_{4}$ x 3$^{1}/_{4}$ inch negatives exposed in a Vivex repeating back. There was slight movement of the girl on the left that could not be completely corrected when the print was made.

(left) Madame Yvonde holding the 9cm x 12cm Vivex single exposure colour camera, with no plate holders in position. The camera was considered small by comparison with other colour cameras, but still weighed 12 pounds!

THE PINATYPE PROCESS

Although both Edwards in 1874 and Cros in 1880 had observed the effect on which this process is based, its introduction is usually attributed to the Frenchman, Leon Didier, an associate of du Hauron, who interested Dr. Kronig of Lucius and Bruning in the idea. The German dye-stuff manufacturer named the process Pinatype and patented it.

Their British patent of 1905, describes a process:

'in which are used certain dye-stuffs that have the property of dyeing unchanged gelatine while they leave undyed gelatine that has been hardened by exposure to light.'

As usual the gelatine was sensitized with bichromate.

George Brown, in the 1913 edition of *Photo Miniature*, gave a brief description of the procedure:

'In Pinatype we do not assemble three separate films of gelatine or celluloid. Instead, we start with a blank sheet of gelatine coated paper, the coating on which is caused to absorb successively yellow, red and blue images from "print-plates" – that is from negatives, the images in which are formed in soft unhardened gelatine, which absorbs a suitable dye and yields it up again to the gelatine-coated paper on contact of this latter with the "print-plate".'

Brown also commented on the quality of the resulting prints by saying – 'Pinatypes . . . are somewhat deficient in intensity or depth, due, no doubt, to the lesser "body" of the dyes as compared with the pigments used in carbon printing.'

Wall in his *History*, devoted a good deal of space to a detailed description of the Pinatype process, but also made the point that the process might be termed 'zeitraubend', or tedious, as – 'one has to make three constituent negatives, three transparencies from the same, and three plates from the latter.'

Although it offered the advantage that a number of prints could be obtained from the same set of print-plates, the Pinatype process was never as popular as Trichrome carbo.

THE DUXOCHROME PROCESS

A successful type of coloured relief image film was patented and introduced by Johannes Herzog & Co. of Hamburg, in 1929. This process known as Duxochrome, used three different films, each coated with silver halide emulsion coloured with a non-diffusing cyan, magenta or yellow dye. The films were exposed through their base to the appropriate separation negatives, and then, after development in a pyro or pyrocatechin tanning developer, three coloured relief images could be obtained by treatment in hot water. The residual silver was removed in a bleach/fix bath and, because the film base had not been treated with a substratum, the three relief images could easily be transferred in registered super-imposition onto a final paper support.

The Duxochrome process became very popular in Germany and besides supplying materials to individual users, the Herzog Company offered a professional print making service that ran parallel to the Vivex service of Colour Photographs Ltd. in the UK.

RELIEF IMAGES

Pinatype print-plates were planographic in the sense that there was no significant difference in thickness between those parts of the gelatine layer that absorbed dye and those that did not. Another, and as it proved, a better way of obtaining an image by transfer of dye from a gelatine print-plate or matrix to a second gelatine surface, depends upon the formation of a 'relief' image which will

absorb dye in direct proportion to the thickness of gelatine at any given part of the image.

One of the first to recognize this possibility was E. Sanger Shepherd who, together with O. M. Bartlett, obtained a patent in 1902 in which they described a process for the production of colour prints on paper from three colour records:

'We prepare a positive from each negative as follows: that is to say, we coat a sheet of thin celluloid or other suitable support with a film of gelatine sensitized with a dichromate salt after the manner well-known in producing carbon prints. The dried film is exposed to light under the negative through the support and subsequently developed with warm water. In order to keep the relief as low as possible, it is desirable to add a colouring matter or preferably bromide of silver to the gelatine solution, as the latter may be easily removed after printing, by a solution of hyposulphite of sodium. The resulting low reliefs in insoluble gelatine are next stained up in dye-baths of greenish-blue, pink and yellow respectively. In order to combine the coloured impressions corresponding to the reliefs upon one surface such as a sheet of paper, the said surface, previously coated with a film of soft gelatine is wetted and the reliefs are successively laid upon it in proper register, each relief being allowed to remain for sufficient time for the colour to be absorbed by the softer gelatine.'

Although the process would have worked, it was never successfully promoted, perhaps because Sanger Shepherd could find no one to coat the film.

In 1914 Ives obtained a US patent that also protected a gelatine relief process for dye imbibition printing, a procedure whereby a gelatine relief image is used to absorb dye before being brought into intimate contact with a plain gelatine layer to which the dye transfers by imbibition. A non-actinic dye would be incorporated in the bichromated gelatine layer and the film would be exposed through the base. In order to avoid premature transfer of dye while registering one image on another, Ives proposed to apply the dyed relief image to the final support in dry state, and then to introduce moisture by means of blotting paper saturated with water and placed under pressure.

THE JOS-PE PROCESS

Jos-Pe was an abbreviation of the name Josef-Peter Welker, a financier, who in 1924 formed a company in Hamburg to promote a process that G. Koppmann had patented in 1916 and subsequent years. The company was the first to offer a complete system of colour photography by including a one-shot colour camera as well as the print making process. According to Friedman, Koppmann's several patents added little to Warneke's invention of 1881, in which the idea of using a tanning developer to produce a gelatine relief image was first disclosed.

Like Pinatype, the Jos-Pe process was mainly used in Germany, although some Jos-Pe cameras were sold in several other countries.

METALLIC TONING PROCESSES

Throughout the 1920s and '30s the conversion of silver images into coloured metallic salts of one kind or another provided inventors with several ways of producing two-colour motion picture prints. Typically a silver image obtained from a red record negative would be converted into a blue-green cyanotype image consisting of ferric ferrocyanide; sometimes called Prussian or Berlin blue. A second silver image, usually on the other side of a double-coated film, might be converted into a reddish one consisting of uranium ferrocyanide.

For a three-colour process, yellow images, albeit rather opaque, could be obtained by converting silver into salts of vanadium or cadmium. However, no satisfactory three-colour toning process was possible until a way was found to produce a reasonable magenta component. This happened in 1933 when Anton Jasmatzi patented the use of dimethyl-glyoxime to convert a nickel image to a magenta colour. This invention allowed F. H. Snyder and H. W. Rimbach to devise the Chromatone system of colour printing by converting three images on thin stripping films, into iron (cyan), nickel (magenta), and cadmium (yellow) images.

THE CHROMATONE PROCESS

The Defender Company, later part of DuPont, promoted the Chromatone process, selling kits of stripping papers and processing chemicals. The sensitive material was based on Defender's Velour Black bromide emulsion coated on a tough thin (0.001in) collodion film, secured to a paper base by a soluble substratum. After exposure by contact or by enlargement, followed by development and fixing, the three separation positives were bleached and then toned in the appropriate baths to produce yellow, magenta and blue-green images.

The toned collodion films were then superimposed in register with the yellow component at the bottom because of its opacity. While drying, the assembled print was taped to a stiff board in order to resist curling.

The Chromatone process was easy to operate, taking less than an hour to complete a print, but it did not produce high quality images – simply because none of the toners yielded colours as satisfactory as the dyes or pigments used for dye-transfer or carbon processes, and highlights were always slightly degraded by the combined density of the three collodion films.

THE WASH-OFF RELIEF PROCESS

By the 1930s Eastman Kodak had been producing special films for Technicolor for more than a decade, among them films used to make matrices and 'blank' films to receive transferred dye images. Ives challenged Technicolor over the infringement of certain of his patents relating to dye-transfer techniques – particularly the use of an acid in dye baths to control contrast and the use of mordants in the gelatine of an image-receiving layer to improve sharpness.

Kodak apparently did a deal with Ives, and by 1935 were free to introduce a method of making colour prints on paper which they called the Wash-Off Relief process.

For reasons that are not obvious, Kodak decided to obtain the relief images by using an ordinary metol/hydroquinone developer and a non-hardening fixer, followed by an acid bichromate bleach. This tanning bleach procedure produced a softer gelatine relief image than a tanning developer such as Technicolor used, and ten years later when a new version of the process was introduced and its name changed to Dye-Transfer, Kodak reverted to a tanning developer.

The emulsion of Wash-Off relief film contained a fugitive yellow dye and the film was, of course, exposed through its base, but also

(left) Reproduced from a Chromatone print made from separation negatives exposed in the author's home-made single mirror camera, using Defender films. (circa 1938)

through a blue-violet Wratten No. 35-D filter, to produce a shallow relief. At that time the film base was cellulose nitrate and not really dimensionally stable; this fact, together with an awkward and unreliable method of registering one image on another, often resulted in un-sharp prints. The procedure originally recommended for registration involved inserting a thin sheet of Kodaloid between the matrix and transfer paper while obtaining registration, followed by removal of the Kodaloid and squeegeeing to commence dye transfer.

Transfer times could be as long as 20 minutes for each colour and this to a large extent nullified the fact that any number of prints could be obtained from a single set of matrices.

Altogether the process could not be considered a success in its original form. So when, in 1940, Mees learned that a couple of photographers in New York, Louis Condax and Robert Speck, had simplified the process in a number of ways and were using a tanning developer and a better set of dyes, he recruited them to join the laboratories in Rochester.

THE DYE-TRANSFER PROCESS

The new process, called Dye-Transfer, was launched in 1945 when Mees claimed it had been speeded up so that only three minutes were required to transfer each dye and the whole process could be completed in half an hour.

Improvements were also made to the registering techniques. The three matrices were taped in register on a light box or table so that two corresponding edges of all three films could be trimmed with a knife and a steel straight edge. The trimmed edges were then used to locate each dyed matrix in turn against thin register discs on a fixed but flexible transfer 'blanket' with which to lower each matrix into contact with the transfer paper.

After Eastman Kodak had taken a licence from DuPont in 1955

THE PRINCIPAL STAGES OF THE DYE-TRANSFER PROCESS

1) The three matrices are immersed in the appropriate yellow, magenta and cyan dye solutions.

2) After dyeing, the magenta matrix is rinsed in dilute acetic acid to remove surplus dye.

3) A sheet of gelatine coated transfer paper is squeegeed onto the surface of a polished granite transfer table.

4) Register holes punched in one edge of the matrix are located over corresponding pins let into the surface of transfer table.

5) The magenta matrix is rolled into contact with the transfer paper.

6) After about two minutes, dye transfer is complete and the matrix is removed.

7) The yellow image is transferred.

8) The cyan image is transferred.

9) The completed print.

(right) 'Crested Dwarf Iris' by Eliot Porter. The original was shot on cut-sheet Ektachrome, from which separation negatives were used to make dye-transfer prints. (Courtesy of Amon Carter Museum, Fort Worth, Texas)

to produce Estar film base, it was possible almost entirely to eliminate any problems caused by matrices changing size during processing or storage. This improvement, together with more precise means of mechanical registration, meant that extremely sharp prints could be made.

The improved system of registration depended upon the use of a precision punch with which to insert coincident registration holes in all three matrices, used in conjunction with a corresponding pair of register pins mounted on a board or cemented into a transfer table made from polished granite.

In Japan, the Fujicolor Service Co. operated a print making service using their version of dye-transfer which they called Fuji Dyecolor. In the early 1970s, S. Taguchi and others obtained a US patent protecting the rehalogenisation of the silver contained in a relief image as a means of controlling the contrast of the transferred dye image.

PAN-MATRIX FILM

In 1949 Eastman Kodak introduced a Panchromatic Matrix Film intended for use with Ektacolor negatives, so that a set of three matrices could be obtained by red, green and blue filtered exposures made directly from a colour negative.

Although there was nothing particularly novel about either the Wash-Off or the Dye-Transfer processes, the fact that Kodak promoted them provided a far greater impetus than any other company could have given. As a result, the Dye-Transfer process was still being worked, albeit by decreasing numbers, in 1990, more than half a century after the Wash-Off process was introduced. Furthermore, this imbibition process was capable of yielding some of the best colour prints ever made, and was used by such famous and meticulous photographers as Eliot Porter.

DYE-TONING

Dye-toning, or dye-mordanting, depends upon the conversion of a silver image into some compound such as copper ferrocyanide, a thiocyanate or silver iodide, which will serve as a mordant for basic dyes like auramine, rhodamine or methylene blue.

In his 'History', Friedman dealt in great detail with the many ways in which a mordant image can be obtained via one of silver. Although his priority was contested on the grounds that the idea had already been published by Namias, the fact remains that A. Traube was the first to make commercial use of a dye-toning process. He called it Uvachrome and introduced it in Germany in 1922. Traube used copper ferrocyanide as his mordant and he described a quite simple procedure in his British patent:

'a silver image which has been copper-toned is further toned by treatment with a solution of a basic dye-stuff, about five minutes in a bath of 1/1000 strength being generally sufficient; the excess of dye is removed from the gelatine by a short washing in water. The transparency of the dyed copper picture is very high and may be still further increased by the removal of the silver ferrocyanides contained in it by treatment in a weak fixing solution. A large number of basic dyes are suitable for use in this process, so that almost any desired tone can be obtained.'

The Uvachrome process used film-based materials for the original positive images, and was intended for making transparencies that required much lower levels of viewing or projection light than any of the screen-plate processes of that time. The resolution of a dye-toned subtractive image would have also been superior to the additive processes. But Uvachrome seems not to have been used for colour print making – probably because of

(left) Reproduced from a Dyecolor print made by the Fujicolor Service Company, using their version of the dye-transfer process. (Courtesy of Fujicolor Service Co. Ltd.)

(right) A Tri-Tone (dye toned) print made by the author from separation negatives in 1940.

the lack of any suitable material with which to make and superimpose the component colour images, although Traube did suggest that a stripping celluloid could be used.

One of the principal difficulties in adopting the dye-toning process to make colour prints was to find a suitable sensitive material on which to print the necessary positive silver images before they were toned and transferred to a final paper support.

In 1920 J. F. Shepherd patented a hybrid process that used Transferotype paper for two of the three images, but nothing seems to have resulted from his proposal. Transferotype was a product that Kodak originally produced to make the paper negatives that were used in the very first Kodak cameras. This paper, which Kodak continued to make until after World War II, carried a normal silver bromide emulsion of enlarging speed, but also had a soluble layer of gelatine between the emulsion and the paper base. This meant that the image could be transferred to another support, simply by squeegeeing it to the new surface, letting it become partially dry and then removing the backing paper in warm water.

So far as the writer is aware, no further mention was made of Transferotype paper for colour work until 1937 when he first used it to make dye-toned prints for professional photographers by the Tri-Tone process.

The procedure was quite simple and owed something to the carbro process in that Perspex (Plexiglass) sheets were used as temporary supports for the monochrome images while they were being toned. The separation positives were made on Transferotype paper in an enlarger and the prints were developed and fixed in a non-hardening fixer. After washing, but without drying, the prints were squeegeed onto Perspex sheets and after a short while the backing papers could be removed in warm water, leaving very thin gelatine layers carrying the silver images.

Toning was done with a silver-iodide hydrosol, a mordant discovered by Traube in 1907 but improved and patented by Miller in 1915. The advantage of this particular mordant was that it is almost completely transparent.

After being treated in an iodine/iodide bath, the bleached images were immersed in solutions of rhodamine (magenta), thioflavine blue (cyan), and thioflavine T (yellow) dyes. After rinsing to clear dye from non-image areas of the gelatine layers, the three images were transferred in sequence and in register from the Perspex support to a gelatine-coated paper. The extreme thinness of the hardened emulsion layer of a Transferotype print ensured that even when the three images were superimposed, the highlights remained quite clear.

Although it was not in use for more than a few years, the Tri-Tone process was reliable and capable of making high quality prints.

3M ELECTROCOLOR

In 1965 the 3M company disclosed a process for obtaining colour prints by an unusual assembly method. They called the process Electrocolor, because it depended upon the sequential electrolytic deposition of subtractive coloured dyes onto a conductive surface. The 'plating' equipment was quite complex and although prints could be made in about five minutes and were of high quality, the system never achieved any commercial success.

A patent granted to D. K. Meyer, A. G. Ostrem and G. J. Pollman in 1964, included a drawing (right) which explained the process.

3M's Electrocolor prints required no silver-halide materials, because their composite colour images were built up by the successive electrolytic deposition of yellow, magenta and cyan dyes onto a photoconductive sheet.
(Courtesy of 3M Company)

FIG. 7

(top left) The combined optical and processing machine used for the 3M Electrocolor system. The diagrammatic illustration shows a frame 10 upon which is mounted a projector 12 a movable support platen 14, dye tanks 16 mounted on a carriage 80 movable horizontally over rollers 82 so as to place the tanks 16 in position 1a directly under the support platen 14 with the motor 84 driven rack 86 and gear 88 assembly. The support platen 14 is lowered into tank 16 with the motor 90 driven rack 92 and gear 94. Deposition of the image takes place while the support platen 14 is immersed in the dye tank 16. The support platen 14 is raised and the tank is moved horizontally. The support platen 14 is then lowered in a wash position adjacent to the dye tanks 16. Water knives 20 are used to apply a nonabrading uniform flow of water to the support platen 14 and photoconductor sheet 28. The wash water is caught in pan 96. The support platen 14 is raised during which time the air knives 22 are used to apply a non-abrading stream of air to the photoconductor sheet 28 so as to remove water from the photoconductor sheet 28 and restore uniform photosensitivity to the photoconductive coating. The photoconductor sheet 28 is clamped in place by fingerstock 98 fastened to arm 100. Air knife 22 at the top of the support platen 14 is employed to apply air of the desired humidity to the photoconductor sheet 28.

SINGLE EXPOSURE COLOUR CAMERAS

'The production of a really efficient one-exposure colour camera depends upon the solution of a large number of problems, the majority of which are quite unsuspected by inventors who claim to have solved the problems of colour photography by devising new ways of splitting up light between three plates. Wall's History of Three-Colour Photography is packed with descriptions of such devices, most of which are now little more than curiosities.'

D. A. SPENCER, 'PENROSE ANNUAL '1934.

In tracing the development of 'one-shot' cameras, it is necessary to differentiate between early suggestions for such cameras and proposals for photochromoscopes intended only for the additive viewing or projecting of colour separation positives.

DU HAURON'S COLOUR CAMERA

As with so many other aspects of colour photography, the first idea of exposing three negatives simultaneously in a special camera belongs to Louis Ducos du Hauron. In his 1876 patent, frequently referred to already, he described a camera that would use three lenses with reflectors placed between them and the subject. This arrangement would make effective use of available light, but only at the expense of a complex and bulky instrument and it is doubtful whether any camera was made to this design.

In his all-inclusive patent du Hauron also discussed the use of a partially silvered reflector to control the ratio of reflected to transmitted light and explained the limitations of using three separate lenses placed side by side, pointing out that such an arrangement should only be used for objects beyond a certain distance, because of stereo-parallax. This clear warning did not deter numerous subsequent inventors from persuading themselves and others that the viewpoints of their individual or partitioned lenses were sufficiently closely spaced to avoid serious parallax.

IVES' FIRST COLOUR CAMERA

Du Hauron's next proposals for a colour camera were disclosed in a patent he obtained in 1899, but in the meantime Frederic E. Ives had entered the field in the US with a patent granted in 1892 describing means for 'introducing two or more images identical in perspective on one plane from one point of view at one exposure.'

The negative images obtained with this camera were disposed in a trefoil pattern on a single plate and a positive printed by contact

In 1876, du Hauron described a single exposure three-colour camera requiring mirrors to be placed in front of three separate lenses. It is doubtful whether such a camera was ever constructed.

O(1) O(2) Reflectors
F(1) F(2) F(3) Filters
P(1) P(2) P(3) Plates

from such a composite negative could be viewed through tricolour filters in a chromoscope, to obtain the colour reproduction. Although a few of these early cameras were produced, Ives admitted that they were 'somewhat complicated in optical construction.'

OTHER IVES CAMERAS

Ives' next step, in 1895, was to patent and manufacture his Kromskop camera with a quite different optical design that produced three separation negatives alongside each other on a single plate.

This was a most productive period in his career and within a

few years Ives had invented several other types of colour camera.

In 1899 he obtained a patent for a three-colour single-exposure camera using a novel optical layout that depended upon 'reflectors placed on opposite sides of the light-admitting aperture.' There is no evidence that Ives ever produced a camera to this design but he was very upset when, in 1925, Jos-Pe Farbenphoto patented and produced similar cameras in Germany. In fairness to Jos-Pe they did acknowledge Ives' prior patent and only secured limited protection on a method of moving all three plateholders in unison to focus the camera without disturbing the lens. In fact, Jos-Pe were not alone in 'borrowing' Ives' idea, since in 1904, two other

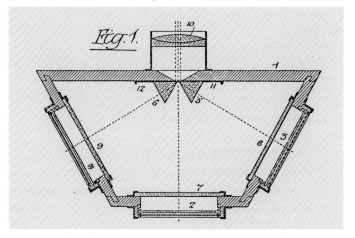

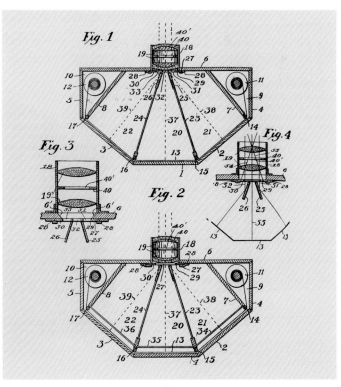

(above left) Ives' colour cameras, patented in 1895 and 1900, both enabled three separation negatives to be exposed adjacent to each other on a single panchromatic plate; the earlier design using mirrors and the other prisms.

(above right) The light dividing system used by Jos Pe for the cameras they made during the 1920s, had been previously patented by Ives in 1899.

The idea had also been adopted by O'Donnell and Clinton (right) in 1904 although they used mirrors instead of prisms to split the beam.

Americans obtained a British patent for much the same kind of camera, except that it was intended for use with roll-films instead of glass plates.

In 1900 Ives patented a camera that certainly did go into production, since a number of examples still exist in collections and museums in the US and the UK. The idea of this particular design was to:

'divide the rays from the viewpoint . . . with transparent bodies (prisms) of more highly refractive substance (glass) than air, interposed in the path of the longer rays to equalise images which are on the same plane but at different distances from the viewpoint.'

Ives obtained still more patents on colour cameras in 1901 and 1902 and on a partial reflector for a camera using a pattern of silvered and unsilvered areas; an idea subsequently patented by Lumière in 1904 and D. F. Comstock of Technicolor in 1914.

IVES AND SANGER SHEPHERD

It is not clear what arrangement, if any, there was between Ives and Sanger Shepherd that led to the latter advertising and selling colour cameras in the UK that seem to have been based on a British patent granted to Ives in 1900, some months earlier than Sanger Shepherd's own camera patent. In fact, Sanger Shepherd's design was basically quite different from that of Ives, using as it did, a sliding arrangement of reflectors to make a rapid sequence of three exposures rather than a single exposure. However, rather strangely,

the specification also included an alternative design, using two double-reflecting prisms instead of the mirrors, so that the three images could be simultaneously recorded in the same plane at the back of the camera – almost exactly the same as the arrangement patented by Ives earlier that same year. In effect, Sanger Shepherd had been granted two patents in one; probably because of the limited experience of the examiner at that time.

Ives' next step to market a colour camera came in 1916 when, backed by the steel magnate Hess, he promoted the Hess-Ives Hi-Cro cameras. The US patent under which the cameras were made was granted to Ives in 1911 but it had been anticipated in a UK patent that W. N. Davidson obtained in 1901. Hi-Cro cameras, which exposed three plates in 'bi-pack and one' combination, were made in a variety of sizes and a few were in the form of a 'back' that could be attached to an ordinary studio camera – exactly as Davidson had envisaged. Other, small versions of the cameras were made for the Hess-Ives Corporation by Eastman Kodak's Hawkeye Camera Works, and examples can still be found in many collections.

NACHET

In 1895 the Frenchman C. Nachet protected two designs, one of which employed a straightforward grouping of two reflectors placed behind the lens at 45° to the axis in the horizontal plane, and the other, close behind it at 45° in the vertical plane, thereby producing one image at the top, one at the side and the third at the back of the camera. The Vivex camera, made some forty years later, bore testimony to the ingenuity of this early design.

Both du Hauron and Cros were granted patents for colour

This Jos Pe camera of 1925 was the first to be constructed in metal rather than wood.

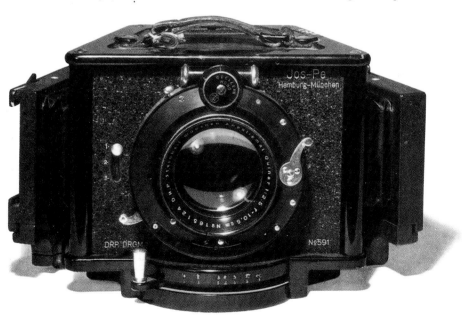

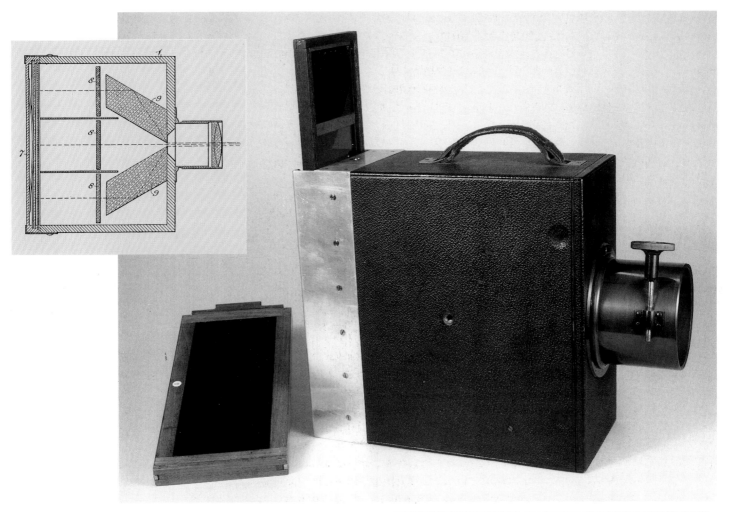

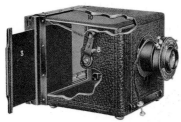

(above) Sanger Shepherd made both repeating backs and colour cameras during the early 1900s. The camera shown here contained a pair of rhomboidal prisms to divide the beam and was based on a design patented by Ives in 1900.

(right) Several versions of the Hess-Ives Hicro camera were made around 1914, some of them by Eastman Kodak's Hawk Eye Camera works in Rochester.

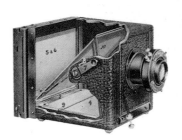

cameras in 1889. Du Hauron's instrument was constructed by Lesueur and called the Melanchromoscope. Its design was similar to the Ives Kromskop camera in that it produced three negatives alongside each other on a single plate. The Melanchromoscope could be used either as a camera or an additive viewer.

The Cros patent was for an ingenious, if cumbersome, camera, using a rotating reflector to intermittently deflect light from a single lens to two of the three separate exposing positions, an idea that was subsequently patented by Dourien and Chertien in 1919 and by A. J. Ball and P. A. Brewster for motion picture cameras in 1929 and 1930 respectively.

In the UK, colour cameras were designed and patented by W. White in 1896, B. J. Edwards in 1899 and E. T. Butler in 1905. All three of these designs used two internal reflectors, but only White's camera had them placed at right-angles to each other, thereby allowing the use of a lens of slightly shorter focal length.

BUTLER'S CAMERAS

Butler, whose first patent for a colour camera followed Bennetto's within a week, originally chose to use three plate-holders and two coloured glass reflectors – a basic layout that began with the photochromoscopes and continued to be used by many other colour camera makers. A few years later, Butler patented a second camera in which differently coloured and more efficient glass reflectors were used and by 1906, this camera was being distributed by Penrose, a well-established supplier of photo-engraving materials and equipment. Judging by the number of Butler cameras that are now in collectors' hands, Penroses did a fairly good job.

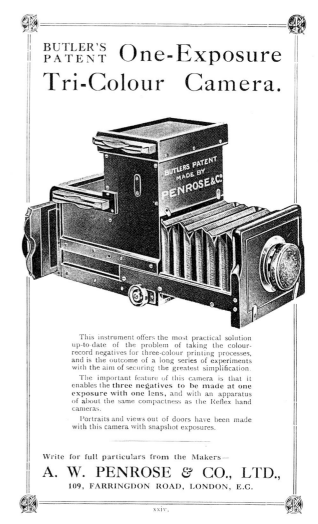

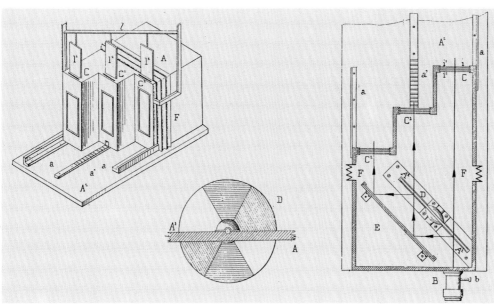

A patent granted to Cros in 1889 protected the idea of using a sectored rotating reflector (centre) to alternately reflect and transmit (right) the beam of light from a lens to three equidistant plates (left). The rotating mirror idea was subsequently used by Brewster in 1929 and Ball in 1932.

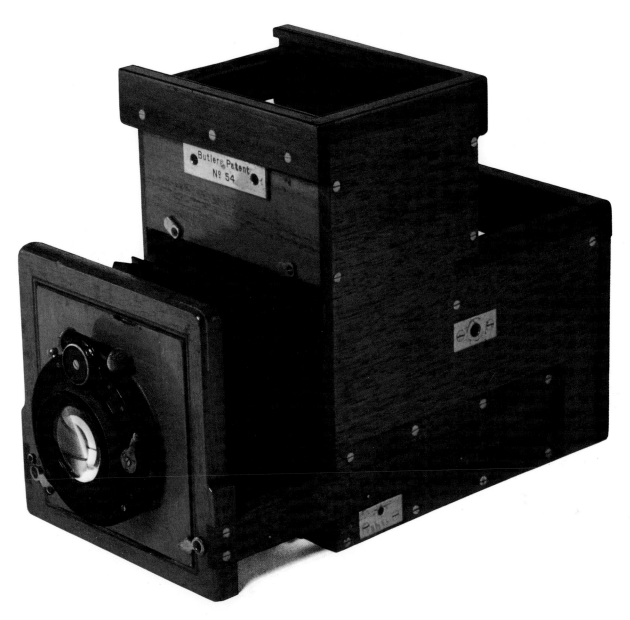

The Butler camera was patented in 1905 and before World War II was distributed by Penrose and Co. who claimed (see advertisement left) that – 'views out of doors have been made with this camera with snapshot exposures'. (From 'The Illustrated History of the Camera', Pub. Edita S.A.)

Dawson patented a camera in 1912 that resembled White's earlier design except that the angle of the second reflector was changed in relation to the first, so that it was at an angle of more than 45° to the axis of the lens. This idea was patented some years later by Reckmeier, who claimed the use of one reflector at an angle of more than 45° to avoid direct marginal rays reaching the side record.

THE BERMPOHL CAMERA

The cameras that W. Bermpohl made and sold between 1929 and 1936 also used reflectors that presented an angle greater than 45° to the lens, and may have owed more to Reckmeier than Miethe.

The Bermpohl, and all other cameras made before 1930 (except the Jos-Pe), were made in wood and represented the very highest standards of craftsmanship, so that they are still highly valued by collectors. Prior to the Reckmeier camera, glass was used for reflectors and this fact had been a constant source of controversy because of refraction and double reflections.

It is, of course, well known that rays of light passing from one medium into a denser medium are subject to refraction and because of this it was often stated that it would be impossible to employ glass reflectors in a colour camera and still obtain a set of negative images of identical size and shape.

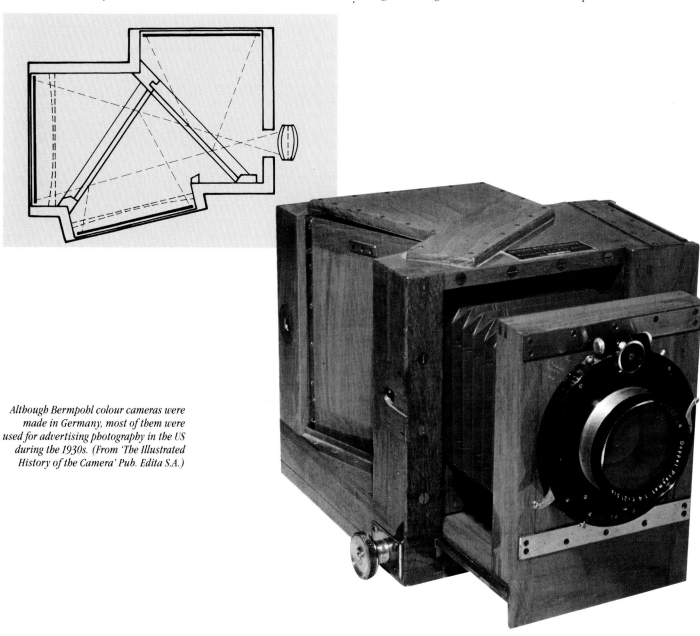

Although Bermpohl colour cameras were made in Germany, most of them were used for advertising photography in the US during the 1930s. (From 'The Illustrated History of the Camera' Pub. Edita S.A.)

In particular, Otto Pfenninger studied the problem and in the preamble to a patent granted to him in 1906, he declared that:

'In 1897, Bennetto invented his camera . . . enabling the simultaneous exposure of three plates. Not much was heard about the work accomplished with this admirably conceived idea, the reason most likely being that Bennetto was not able to alter his idea, so that three pictures of equal size were produced. In Butler's 1905 patent I cannot find any other difference to Bennetto's, and Davidson's camera is the same thing in a collapsible form.'

Pfenninger's patent goes on to propose several solutions to the problems caused by refraction, including the use of wedge-shaped glass corrector plates.

In Bermpohl cameras double images were avoided by coating the rear surfaces of the two reflectors with minus colours of the filters to which the light is reflected, an idea that is attributable to Ives. The effects of refraction were counteracted to some extent by increasing the thickness of the individual colour filters in accordance with the distance travelled through glass by each beam.

PELLICLE REFLECTORS

A means of avoiding all the shortcomings of glass reflectors in colour cameras was quite clearly disclosed by Geisler in 1910, but, possibly because his patent was grouped with Optical Systems and not under Photographic Cameras, it was entirely overlooked until Wall mentioned it in his *History* in 1925. Even then the reference takes the form of a footnote to the chapter on colour filters. L. Geisler described the manufacture, use and advantages of his thin membranes, when stretched over optically flat metal frames. Such thin reflectors subsequently became known as pellicles.

E. Reckmeier was probably aware of Geisler's patent but argued in his own specification, granted in 1930, that 'skin-mirrors', as he called them, are only useful in a colour camera if they can be made to reflect and transmit the required ratios of light. This he proposed to achieve by the deposition of a non-oxidizing metal by electrode atomization or by an evaporation process.

Neither Geisler nor Reckmeier stated the thickness of their pellicles, but in general they probably came out at something between a half and one thousandth of an inch thick.

H. O. Klein outlined the history of pellicle mirrors in an article in the *British Journal of Photography* where he explained that they were first used in two instruments designed by his namesake, A. B. Klein (later Cornwell-Clyne). One was the Chromoscope and the other the Mutoscope and both were intended for quickly changing the colour schemes of textiles or wallpapers by means of a plurality of slides and colour filters. It seems that H. O. Klein made pellicles for a colour camera designed by A. B. Klein in 1929/30, which led to its short-term use by Colour Photographs Ltd. when it was known as the Vivex No. 1 camera. H. O. Klein, who had worked for Adam Hilger, the scientific instrument makers, did not reveal how he made his pellicles, but it was generally believed that he poured collodion on to the surface of a pool of mercury in which he had already placed an optically worked metal frame on which to support the pellicle when it had toughened.

F. Twyman of Adam Hilger had previously patented a method of making pellicles by coating a thin layer of collodion on to the polished surface of a slab of rock salt, so that the hardened film of collodion could then be made to adhere to a metal frame before the salt was simply dissolved away.

Whatever the method used to form these very thin membranes, they were used in most of the colour cameras made after 1930, particularly those produced in the US.

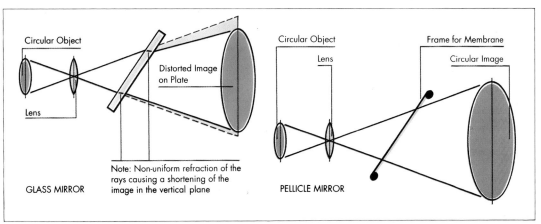

Schematic illustrations showing the distortion of an image by the interposition of a glass reflector in the light beam and the elimination of this effect by using a pellicle reflector.

*The Reckmeier camera was made in
Bremen Germany, during the 1930s and
was the first single exposure colour
camera to use a one piece cast metal body
and pellicle reflectors.*

THE RECKMEIER CAMERA

When the Reckmeier camera was introduced in Germany in the mid-1930s it was sponsored by the printing firm of Schuenemann of Bremen, an indication that at that time, colour photography was still largely confined to the commercial and advertising fields. Because he was Jewish, Emil Reckmeier met with many difficulties but his was the first production camera to use pellicle reflectors, it was also the first to be constructed from a patented one-piece metal casting. These improvements meant that no more colour cameras were made of wood or used glass reflectors.

AMERICAN COLOUR CAMERAS

Having returned from a visit to Europe in 1935, Barker Devin set out to manufacture colour cameras in New York. While in England he had obtained a licence from H. O. Klein to produce pellicle reflectors. The Devin camera resembled the Reckmeier in many ways, but did incorporate two novel features. One was the addition of rising and swinging movements to the lens. The other was a method of precisely positioning the three plates by using special darkslides to enable the corners of all the plates to touch adjustable register points in the camera body itself.

The Devin 5in x 7in model was a success and by 1938, the company could claim an impressive list of users including such famous photographers as Nickols Murray, George Hurrell, Victor Keppler, Anton Bruel and H. I. Williams.

Following the success of the 5in x 7in camera, Devin introduced a smaller (6cm x 9cm) version, intended for use by both professionals and keen amateurs. The effective speed of the small camera was only Weston 6, roughly equivalent to ISO 8! The camera had a simple rangefinder, a 140mm f4.5 Goerz Dogmar. This focal length was long in relation to the image format, but it did make the camera suitable for portraiture.

SINGLE REFLECTOR CAMERAS

There were two other colour camera manufacturers in the US: Thomas S. Curtis in California, and LeRoy (later National Photocolor) in New York. The Curtis 2½in x 3½in Color Scout camera was novel in that it used three film packs instead of darkslides, making it more convenient for anyone working away from the studio.

Besides making double mirror cameras these two companies also produced single mirror cameras and camera 'backs' using a combination of three films in a 'bi-pack and one' combination.

It is likely that Technicolor's success with this arrangement in their cameras prompted film manufacturers like Eastman Kodak and Defender (later DuPont) to make similar films available for still photography.

Plates had been used in the earliest single-reflector camera patented by Bennetto in 1897 and in the 12in x 10in portrait camera used in the Dover Street studios in 1911. Most of the single-reflector three-colour cameras sold in the US were intended for use with films supplied by the Defender Company and known as Tri-Color Combination. The three films divided into a bi-pack for the blue and green records and a separate red record. This arrangement resulted in a sharp cyan printer. The two emulsion surfaces of the bi-pack were pressed into contact in a special spring-back darkslide.

There is no evidence that single-mirror cameras were used for professional work, but for a few years they did provide the keen amateur with a relatively cheap way of obtaining separation negatives of live subjects. However, even the smaller models made by Curtis were still large and heavy by comparison with the cameras used for black and white photography. Several people in Europe recognised this fact and set to work to produce a small, modern colour camera.

THE MIKUT CAMERA

One of them was Oscar Mikut who had been granted a German patent in 1936 and then obtained Government funds to establish a factory in Dresden. The patent disclosed a camera that in principle resembled earlier designs in that it divided the rays entering the objective into three parts. However, in other respects the Mikut camera was a radical departure from any previous design and represented an attempt to produce a colour camera with many of the features of the 'miniature' cameras that were appearing at that time. The camera was small (8in x 5in x 4in), light, and easy to handle with its incorporated split-field rangefinder and a 13cm f4 lens in a Compur shutter.

The negative format was 5cm x 5cm and all three images were recorded side by side on a 15cm x 5cm plate. The camera was part of a complete Mikut system, including a projector with which additive colour images could be obtained on a screen via the same kind of optical system as the camera. The necessary positives were made quite easily by contact printing on to a single plate.

Very few colour cameras were made after World War II and probably no more than a thousand were ever made. Despite the fact that many fine colour prints were produced from separation negatives exposed in cameras like the Devin or Reckmeier, they were cumbersome instruments and professional photographers were uncomfortable with them just as much as cinematographers disliked Technicolor cameras.

The era of the colour camera came quickly to an end as soon as it became clear that multi-layer colour films like Kodachrome and Agfacolor could be used in any kind of camera. Perhaps the most significant event was when Eastman introduced their first version of Kodacolor negative film in 1942, a product that was initially intended only for amateurs, but which really heralded an entirely new way of making colour prints.

In 1936, Oscar Mikut patented a colour camera that bore some resemblance to the 35mm 'miniature' cameras that were becoming popular at that time. The camera was part of a system of colour photography which included a projector using a replica of the camera optics to obtain an additive colour image on a screen.

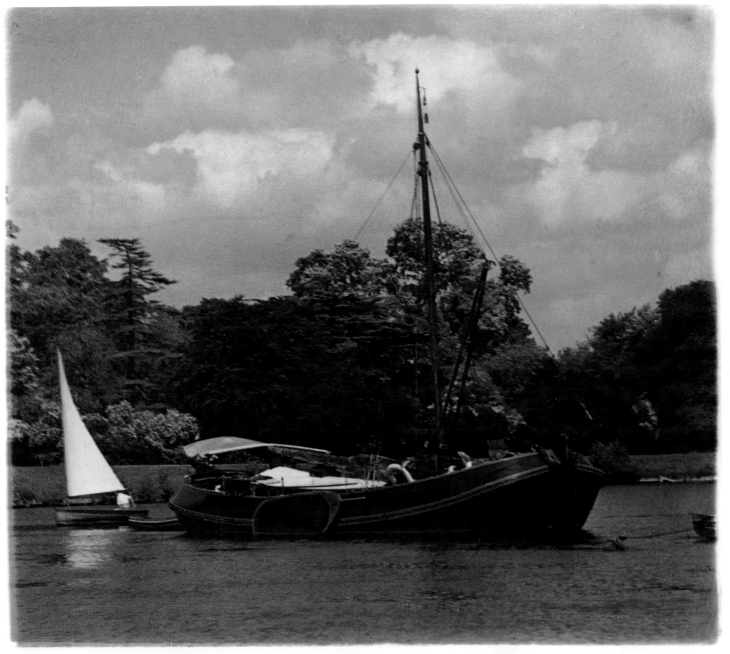

(above) a dye-transfer print made from separation negatives exposed in a Mikut colour camera.

(left) This set of positive images on a single glass plate were made by contact printing from separation negatives exposed in a Mikut camera. The positives could be used in the Mikut projector to produce an additive colour photograph on a screen.

TRI-PACKS AND BI-PACKS

'There is no need here to examine at all closely the various efforts made in the past to produce tri-packs which would meet the cardinal objections just stated. One and all, they have been subject to some drawback or other which rendered them practically useless in everyday circumstances. Consequently nothing marketable was produced until 1927, when William Thomas Tarbin, of Manchester, applied for a patent for a trifolium or tri-pack on new lines, the application being granted in January 1928, and made later the basis of the process exploited by Colour Snapshots (1928) Ltd.'

CAPT. OWEN WHEELER, 'COLOUR PHOTOGRAPHY' 1929.

Long before integral multi-layer reversal or colour negative films became a reality, there had been many proposals and some limited success for the idea of using a separable tri-pack of films or plates in an ordinary camera to obtain three separation negatives.

DU HAURON'S POLYFOLIUM

It was du Hauron who conceived the idea of using a tri-pack rather than a beam splitting colour camera. In his *La Triplice Photographique* published in 1897, he described what he had in mind:

'Apparatus with a single dark-slide and with a single objective procuring the simultaneous obtainment of the three phototypes; in other words, dialytic selection of the light rays by an alternation of colour filters and plates or sensitive films, formed like the leaves of a book or polyfolium.'

Although du Hauron patented 'the industrial making and manufacture of the constituent elements of the polyfolium chromodialytique', there were no suitable colour-sensitive emulsions available in 1895 and the idea was not realised at that time.

Despite many subsequent proposals along similar lines, it was not until thirty years later that the first separable tri-pack was used commercially – and even then not very successfully. As early as 1903, J. H. Smith who had a plate and paper coating plant in Zurich and later worked on the Utocolor bleach-out process, had the idea of coating the three necessary emulsion layers in superposition with thin layers of collodion between them so that after exposure, the individual layers could be stripped and transferred to other supports before being processed. Unfortunately Smith encountered great difficulties in coating three layers one

upon the other, and his tri-pack was never produced commercially.

In 1916 Ives introduced a form of tri-pack he had patented in 1909 and called it the Hi-Block. It comprised two plates, with a thin film bearing the third emulsion sandwiched between them, all three elements being held together by binding their edges with paper tape, a method that had been patented by J. H. Smith in 1904. Several other inventors turned their attention to ways of ensuring intimate contact between the elements of a tri-pack. The simplest solution was to use a plate or film holder with the three elements sandwiched between a glass plate and a spring-loaded pressure plate. Other ideas included the use of a vacuum plate holder and the application of a layer of transparent adhesive between the elements.

The problem becomes even more serious when roll-films are used to enable a number of exposures to be made on the same spool. The solution chosen by Colour Snapshots in 1928 was to supply a pressure plate (costing sixpence) to be inserted in the back of the camera to press the three films together.

However, the real problem with separable tri-packs of any kind is the poor definition that results from the light scattering caused by image-forming rays having to pass through one or two layers of emulsion, and their supports. With the usual sequence of recording – blue, green and then red – this problem is particularly serious because it results in an unsharp cyan printer – the component that provides much of the 'drawing' in a colour photograph.

COLOUR SNAPSHOTS (1928) LTD

This limitation led one or two people to protect ideas for obtaining the red record at the front of, or in the middle of, a tri-pack. W. T. Tarbin, who appears to have been a newcomer in the field, obtained a patent in 1927 that was acquired by a company called

In 1929, Colour Snapshots Ltd. attempted to produce colour prints from separation negatives obtained from roll-film tri-packs exposed in ordinary cameras. The prints were made by an 'assembly' process similar to Pinatype, but the company only survived for about a year.

Colour Snapshots (1928) Limited, with the intention to bring colour photography to the man in the street.

Tarbin's patent described a tri-pack characterized in that:

'the layer of light-sensitive composition which is selectively sensitive to the rays situated towards the blue end of the spectrum is located in making the exposure to obtain the negative images farthest from the source of light.'

In 1928, a year after Tarbin had obtained his patent, A. Klein, (later known as Cornwell-Clyne), a consultant to Colour Snapshots, was granted a patent that would place the green-recording layer in front of the pack with the red record in the middle and the blue record at the back.

T. Thorne Baker, another of the experts involved in the Colour Snapshots project, was granted a US patent which also placed the red recording element at the front of a tri-pack, but in his British patent of 1928, he describes the normal arrangement of films.

J. S. Friedman, in his *History*, dismisses the idea of a tri-pack with the blue record at the back, arguing that for a satisfactory red separation to be obtained, the blue sensitivity of the front element would have to be less than one tenth of its sensitivity to red. If this were to be achieved by the addition of sufficient yellow dye to the front emulsion, then there would not be enough blue light transmitted to the rear element to record a satisfactory image.

Just how Colour Snapshots dealt with these difficulties is not known, but they may have decided to accept imperfect colour separation. Certainly the *British Journal of Photography* were rather cautious when assessing the quality of prints made from the tri-pack; saying that:

'It would be possible to pick holes as regards their fidelity of colour rendering in certain respects. What we can definitely say is that they are photographs in colour, of pleasing character in themselves and broadly reproducing the colour scheme of the original scenes.'

Despite scepticism voiced in the trade press, Colour Snapshots (1928) Limited was easily able to raise the £350,000 called for in an optimistic prospectus. However, they only managed to survive for a little over a year, and another quarter of a century was to pass before the amateur would be able to use an ordinary camera to obtain his colour snapshots.

A roll-film tri-pack, similar to that of Colour Snapshots, was produced by Agfa Ansco in the US under the name of Colorol and in Germany in 1932, a company in Hamburg introduced a tri-pack called Amira 3-Pak. Both companies had to offer processing and print-making service based on some form of assembly process and neither of them had any more success than Colour Snapshots in the UK.

DEFENDER AND DUPONT TRI-PACKS

In America during the 1930s and '40s Defender and then DuPont produced tri-packs in sheet film sizes. The first version, known as Tri-Pak, was marketed around the time that Defender were promoting their Chromatone print making process. The pack was a straightforward assembly of three films, so that the red-sensitive layer was separated from the other two emulsion layers by the thickness of a film base – an arrangement that inevitably led to an unsharp red record negative, and to Defender advising users to choose a large negative format.

In 1947, after DuPont had taken over Defender, an improved form of tri-pack was launched with the name S.T. Tripac. The new product comprised two film supports carrying three emulsion

No. 280. VOL. XXIV. FEBRUARY 7, 1930.

THE BRITISH JOURNAL OF PHOTOGRAPHY

MONTHLY SUPPLEMENT

ON

Colour Photography.

CONTENTS.

COLOUR PHOTOGRAPHY IN 1930.

OWING to the failure of a loudly trumpeted system to realise over-sanguine expectations, last year was in some ways one of the most disappointing in the history of colour photography. There is no need here to emphasise the various accompaniments and consequences of this fiasco, but undoubtedly a certain prejudice against photography in colour has been created, and some time may elapse before it is completely removed. Incidentally, it is instructive to specify one of several reasons why the system in question broke down when the acid test of commercial practice on a large scale was applied to it. The promoters were in too great a hurry, and, if they did not actually begin their operations at the wrong end, they did not take sufficient trouble to " mak siccar," as the Scots say, before proceeding to divest the public of its money. No popular system of colour photography can hope to succeed unless not only the method of producing the three " separation " negatives, but also that of printing from them, is placed on a sound commercial basis. That negatives yielding fairly good colour prints can be made from tripacks, if the latter are exposed under satisfactory conditions, has been demonstrated before and since the enterprise under allusion came into existence. But a long and difficult path beset with obstacles has to be travelled before decent colour prints can be produced singly to sell to the public at a shilling each. Where dozens, or even half-dozens, are concerned, the problem is not so difficult, but, of course, repeat orders are not always forthcoming even when the proof copy is satisfactory, and selling proof copies at a loss can be very bad business indeed when numbers run into tens or hundreds of thousands. That seems to have been one of the rocks on which a ship carrying a very large amount of the public's money has split.

That a tripack method can be successfully combined with a practical colour printing process has been demonstrated by Colour Photographs, Ltd., whose results, including studio portraiture, are of a very high order of attractiveness and technical merit. But in this case commendable caution has been observed in making any public appeal, and from the standpoint of price no bid has been made for the favour of the multitude. In other cases good work in colour is being done, and facilities are being offered, but at prices which only the well-to-do can afford to pay. Two or three one-exposure cameras for making the three separation negatives simultaneously and, under favourable conditions, instantaneously, are on the market, but the size of the cheque necessary for the acquisition of any one of them is sufficient to deter any but wealthy amateurs or very enterprising professionals. In the matter of colour-printing, again, practically all the available processes, trichrome carbon and Carbro, Pinatype, Dyebro, and others, have the disadvantage that, while the cost of materials may be relatively small, a considerable amount of time and skill is needed to produce good results, and the methods are too uncertain for any but specialised commercial practice. Trichrome Carbro is probably the most satisfactory chemical colour-printing process that has as yet been brought forward, but the multiplication of copies by this method is tedious, and, when worked by skilled professionals, it cannot be cheap. Where more than one or two copies are needed, and time is a consideration, a resort to dye-printing by imbibition, as in Pinatype and Jos-Pe, seems to be indicated, but here again skill is required for the preparation of satisfactory print-plates, and in this country, at any rate, neither of the processes mentioned has achieved any general popularity. Dyebro, which is now being put on the market by the Auto-type Co. as a supplement to their staple process, trichrome Carbro, is a neat combination of Carbro and dye-printing, but makes little or no appeal to the professional.

What now seems specially desirable, and what, perhaps, 1930 may produce, is a clearer adjustment and co-ordination of the relative positions of tri-colour negative making and tri-colour printing by methods of which either the average professional or the average amateur can more or less readily avail himself or herself. The most hopeful approach to this seems to be in a sounder appreciation of the difficulties surrounding any attempt to throw colour photography on paper open to any but workers of some intelligence, experience and skill. Also for the present it seems likely that the making of " colour snapshots " will have to be restricted to those able to afford the outlay—running sometimes into three figures—upon a one-exposure camera. But there is no reason why portrait negatives should not be made in a good light out of doors or even, with the aid of the new " soft " panchromatic plates, in a studio, if one of the available devices for quickly changing filters and plates or films is employed. Exposures could probably be reduced, at any rate, to about 15 seconds, which a good sitter should be able to endure for the sake of being effectively photographed in colour. Incidentally, the negatives properly made in this way would obviously be superior to any obtainable by a tripack method in which at best only an approximation to absolute correctness is obtainable.

As regards printing there will always, let us hope, be amateurs desirous and capable of making their own colour prints from their own sets of separation negatives. But for both amateurs and professionals a central commercial establish-

In 1930 the British Journal of Photography made these comments on the Colour Snapshots (1928) Ltd debacle.

layers. The front film was coated first with a yellow dyed blue-sensitive layer, then with a thin synthetic polymer layer and finally with a green-sensitive emulsion. The rear film carried only the red sensitive layer. The two films were exposed, emulsion to emulsion, in a dark-slide with a pressure back. Both films were developed and fixed normally, and then the front element was immersed in an aqueous solution of aluminium chloride, alcohol and acetic acid, which softened the polymer layer and made the green record layer tacky so that it could be transferred simply by rolling a gelatine-coated film on to its surface and stripping it away.

As can be imagined, DuPont did not carry out the necessary experimental work on their stripping tri-pack with only cut-sheet customers in mind. They were more interested in the much larger motion-picture market and in 1949, the same year that Kodak announced their Eastman Color negative and positive films, DuPont announced a 35mm version of S.T. Tripac for the film industry. There is no record of any producer ever having made a film using DuPont's S.T. Tripac.

EASTMAN 35mm STRIPPING FILM

Because the Technicolor cameras were so unwieldy and expensive to hire, several attempts were made to find a way of obtaining three colour separation negatives from a single 35mm film used in a normal motion picture camera. In other words, a tri-pack that would be integral at the time of exposure, but could then be made to yield three sharp and separate negatives.

John Capstaff of Eastman Kodak was the man behind the most successful of such schemes and his approach was to use a multi-layer film from which two of the three emulsion layers could be 'wet' stripped onto special 35mm transfer supports. Work on the emulsion assembly began in 1941, first by means of experiments with a two-layer material and a separate film, and later with the

three-layer integral pack. The final product, called Eastman Multilayer Stripping Film, had a total thickness about the same as a standard 35mm film and its speed was about ASA 8.

The two stripping layers placed between the three emulsion layers were made from hydrolysed cellulose acetate, which had the property of adhering to the emulsion while dry, but readily coming apart when wetted with water.

Capstaff decided that it would be preferable to postpone processing the three image layers until after they had been transferred, since he was then able to develop each layer differently if required.

All three emulsion layers were necessarily very thin, in particular the blue-sensitive emulsion had an extremely low coating weight in order to minimize the scattering it would cause. In fact that layer contained so little silver that it could only yield a negative with a gamma of 0.30, so that it had to be intensified before it could be used alongside the other two records.

A special machine was designed and constructed to effect the stripping and transfer of the two outer emulsions in one continuous operation. In use, an exposed multi-layer film and a transfer film were immersed for about 10 seconds in warm water before being rolled into intimate contact between rubber-covered rollers. The perforations of the two films coincided accurately because they were being driven by a specially designed sprocket which corrected any lack of registration as the films passed over it before the bond between the two gelatine surfaces had become

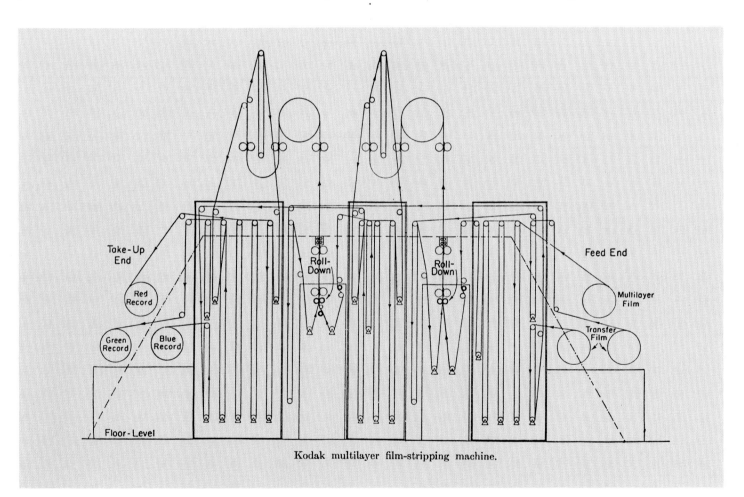

Kodak multilayer film-stripping machine.

In 1947, when many film producers were protesting about the virtual monopoly enjoyed by Technicolor with their three-strip camera, Eastman Kodak made an attempt to solve the problem by introducing a multi-layer stripping film. The purpose of the new film was to enable three separation negatives to be obtained from a single 35mm film after exposure in any ordinary motion picture camera. The schematic drawing shows how two of the three emulsion layers were stripped in succession from the original film and transferred to two perforated blank films. All three negative records were then processed separately.

complete. After about 20 seconds in contact, the blue record layer and its adhering support were stripped from the tri-pack and passed into a drying chamber. The original film, still bearing the green and red records, was then re-wetted together with the second transfer film and the two were brought together before the green record negative was stripped off in the same way. All three dried films were then processed normally except that the blue record was intensified to increase its density and gamma.

This method of obtaining a set of original separation negatives while using an ordinary camera may well have become important had it not been for the arrival of multi-layer colour negative film like Eastman Color. As it was, Columbia was the only producer to use Eastman Multilayer Stripping Film, and that was in 1954, for a film entitled *The Stranger Wore a Gun*.

BI-PACKS

As has been noted, many millions of feet of 35mm bi-pack film were used by the motion picture industry before the colour negative/positive system took over. Much of it was exposed on 'Western' type films in normal Mitchell or Bell and Howell cameras to produce two-colour subtractive prints; but a significant footage of bi-pack was also used in Technicolor three-strip cameras.

Not much use was made of bi-packs for commercial still photography, although users of Ives' Polychrome two-colour print process in the 1930s did sometimes depend upon either Kodak's B-Pack or DuPont's cut-sheet films to obtain their negatives.

'MONOPACK'

A bi-pack of a different kind was promoted in the UK just before World War II. The idea was patented by J. S. Friedman and promoted by Hans von Fraunhofer (not a descendant of Fraunhofer of the 'lines') and was a way of obtaining three separation negative records from only two films. The bi-pack, trial coatings of which were made by several companies, including Ilford and Gevaert, comprised a front element coated first with a yellow-dyed blue-sensitive emulsion, and then with a green-sensitive layer. The second, rear element, carried the red-sensitive layer.

After exposure through the base of the front element, the two films were developed normally, but instead of being fixed, they were treated in an iodizing bath to convert the unused halides into silver iodide, after which they could be exposed to white light. Now the two processed films contained silver images embedded in yellowish silver iodide and the double-coated film would display two different images according to which side was being viewed. In other words, a blue record negative image would be seen through the film base, while a red record would be seen from the emulsion side.

To make prints from the three negative images it was necessary to use reflection printing and that represented the most serious limitation to the process, because it meant that there was practically no exposure latitude and only subjects with a limited brightness range could be correctly reproduced. Monopack was used experimentally by a number of portrait and theatrical photographers in London but it was never a commercial success.

This idea for obtaining three separation negatives from two plates (or films), was tried in 1938, but it required positive images to be obtained from the negatives by reflection printing – which seriously restricted exposure latitude in the camera.

A. Blue-record seen through the base of the front element.
B. Red record seen from emulsion side of the front element.
C. Green record seen from emulsion side of the rear record.

COLOUR CINEMATOGRAPHY BY 'ASSEMBLY' METHODS

'Supposing that we obtained simultaneously the three-colour record negatives on one or three films, is it possible to utilise one of our present printing processes so as to obtain on one film a series of pictures, each of which shall be itself a perfect colour picture that could be projected in any existing cinematograph lantern.'

E. J. WALL,' THE BRITISH JOURNAL OF PHOTOGRAPHY '1916.

The relative simplicity of a two-colour process compared with any three-colour subtractive process tempted many people to accept two colours rather than none.

George Eastman, who together with his scouts and research staff had searched far and wide for an additive screen-plate process during the early years of the century, decided in 1914 that a two-colour process invented by Capstaff was worth backing instead.

TWO-COLOUR KODACHROME

John Capstaff was one of the several Englishmen who joined Dr. C. E. K. Mees to form his research team in Rochester. Like Mees, he had worked for Wratten and Wainwright at Croydon, but had also been a portrait photographer, and an experimenter. Glen Matthews has told how Capstaff came to know about the tanning-bleach effect he used for his two-colour process. Apparently, in 1910, while he was still in England, Capstaff was doing some work on an idea for making carbon prints without having to expose bichromated gelatine layers directly (Manly had invented the Ozobrome process in 1905). In order to improvise a safelight screen he bleached and dyed an old glass negative, only to find that he was left with a dye image. No further use was made of the discovery until 1914, by which time Capstaff was in Rochester, working for Eastman Kodak.

The new process, which was named Kodachrome, required a red and a green record negative, either exposed in a camera with two lenses, or in rapid succession with a repeating back. Very high powered studio lighting was also necessary.

Capstaff worked out two alternative methods of producing finished transparencies – either by utilizing the original negatives themselves, or by making duplicates from them. In either case, the negatives to be converted to colour images were developed and washed normally before being bleached in a ferrocyanide/bromide/

bichromate solution to harden the gelatine in proportion to the silver present. This treatment enabled red and green positives to be formed simply by immersing the bleached plates in suitable dye solutions. Bonding the two positives (one of them having been reversed left to right) together in register provided the finished two-colour transparent image.

The process worked fairly well for portraiture, whenever the absence of blues was not too serious, but the fact that results were in the form of transparencies rather than prints must have limited their appeal. These doubts were expressed by the *British Journal of Photography* who, reporting on the process, said:

'In the past it has undoubtedly been difficult to make business in colour transparencies, however good . . . It remains to be seen whether the portrait transparency will strengthen its position through the vehicle of Kodachrome.'

In the event it did not, for the first Kodachrome transparency process lasted only a few years.

TWO-COLOUR PROCESS IN THE CINEMA

However, Capstaff's process had never really been intended for still pictures, for, as Matthews states – 'from the beginning the process was regarded as one to be developed for color cinematography.' So keen was George Eastman on using Kodachrome for movie making that, after tests using a double pull-down camera with two lenses, it was decided to produce a private film. It was shot in July 1916, at George Eastman's home (now the International Museum of Photography) and on the roof of the Kodak research building.

This modest production, entitled *Concerning $1,000*, may have been the first to be made using a two-colour subtractive system; although credit must certainly be given to Hernandez-Mejia who

had devised and patented a complete two-colour subtractive system as early as 1912. Hernandez-Mejia's ideas included using a beam-splitter camera and double-coated print stock, which he hoped to obtain from Germany. Unfortunately, although a company was formed in New York to exploit his Colorgraph process, it seems not to have managed to operate commercially before the death of the inventor in 1920.

Nothing more was done with Kodachrome until 1926, by which time Technicolor were having some success with their two-colour process, and Capstaff was sent to Hollywood to make tests with his system. In 1924, Twentieth Century Fox became sufficiently interested to rename the process 'Nature Color', build a processing laboratory at a cost of a million dollars, and make a few test films.

The camera for shooting Nature Color also used two lenses, with all the disadvantages that this entails. In a somewhat naive guide to cameramen, the studio acknowledged the problems but offered only partial solutions. For instance:

'If two pictures are taken of subjects close to the camera and the two are placed over each other, a sort of fringe is seen around the subjects caused by the difference in the two pictures. This fringe is called parallax and appears on the screen in this process as a colored border around subjects. In order to be able to take close-ups it is therefore necessary to have some means of photographing the subject as though the pair of lenses were one single lens.'

To do this the beam-splitter was added in front of the two lenses causing a 50% loss of light. Since the basic filtered optical system already required eight times more exposure than normal and that when using specially hypersensitized film, the levels of studio lighting must have been very uncomfortable.

When it came to printing, the Capstaff process required negative images to be bleached and dyed, so intermediate positives had to be made from the original camera negatives. These were used to expose opposite sides of a double-coated print film, using a special optical printer designed by Eastman Kodak at the time the process had been used in Rochester.

This list of problems is perhaps enough to explain why the Nature Color process never prospered and why no more was heard of the original Kodachrome process.

Despite their limited palette, two-colour processes offered greater simplicity than any three-colour system, whether additive or subtractive, and during the 1920s and 1930s this was enough to persuade many inventors, investors and producers that money could be made from two-colour movies.

In 1918, Technicolor, whose story is told separately, abandoned their two-colour additive system and began to work on the two-colour subtractive process with which they made *The Toll of the Sea* in 1922.

For the next decade Technicolor made two-colour release prints for feature films produced by all the major companies in Hollywood, until, in 1930, Dr. Kalmus considered that 'In Warner's *The Mystery of the Wax Museum* and Goldwyn's *Whoopee*, the Technicolor two-component process may have reached the ultimate that is possible with two components.'

The first Kodachrome process was invented by John Capstaff in 1914. It was used to produce large format two-colour transparencies on glass plates. This portrait is a typical example. In a modified form, the process was subsequently used to produce motion pictures.

THE TECHNICOLOR STORY

For almost half a century, from 1912 until his retirement in 1960, the story of Technicolor was also the story of the vision, persistence and persuasion of Herbert T. Kalmus. Few people realise that during that period four different Technicolor processes were used. Kalmus, who was born in 1881, might have been a musician but for a finger he broke while playing baseball. Instead, he attended the Massachusetts Institute of Technology and obtained a BSc in 1904.

In 1905 Kalmus, together with Daniel Comstock, a fellow student from M.I.T., went to Switzerland where they both obtained doctorates before returning to the US. After a short spell of teaching in Canada, Kalmus returned to Boston and in 1912, together with Comstock and Burton Westcott, a brilliant engineer, formed a partnership of industrial consultants.

Later that same year a client wanted advice on an invention intended to remove flicker from motion pictures. The idea was not successful, but Kalmus persuaded the client, William H. Coolidge, to invest instead in a new system of colour cinematography.

Kalmus would have been aware that the first Kinemacolor film had been shown in New York in December 1909 and that the Kinemacolor Company of America had been formed in 1910. It also seems pretty certain that he would have attended the Kinemacolor demonstration given at the Massachusetts Institute of Technology in Boston in December 1910, since he was an Associate Professor of Physics at the M.I.T. at that time.

He was also aware that the Kinemacolor system of making alternating exposures through red and green filters inevitably led to colour fringing whenever the subjects moved rapidly, because he remarked that 'it was nothing for a horse to have two tails, one red and one green.'

With the solution of this particular problem in mind, he decided that the necessary red and green exposures would have to be made simultaneously through a single lens.

TECHNICOLOR PROCESS NUMBER ONE

Comstock therefore designed and patented the first of Technicolor's prism-block beam splitting cameras which was completed in 1916. The basic design of the camera depended upon an arrangement of prisms with a partially reflecting surface to divide the beam from a single objective to form two standard format images on the same 35mm film, but spaced two frames apart to allow projection through two separate lenses. This meant that the film was transported two frames at a time, but no film was wasted.

Comstock's patent (applied for in 1915) related to the use of a grid or random pattern of fully reflecting areas interspersed with fully transmitting areas at the dividing interface of a prism.

Preliminary tests must have impressed Coolidge, because he and a partner, C. A. Hight, put $10,000 into the project and a year later the Technicolor Motion Picture Corporation was formed with Kalmus as President and Comstock as Vice President. The name Technicolor was chosen as a tribute to M.I.T.

However, Kalmus, who was to meet the problem many times, could not persuade any established producer to make a film in colour and the Technicolor Corporation decided to go it alone with a production they would call *The Gulf Between*. A railway carriage was purchased and its interior fitted out as a self-contained processing and printing laboratory. Perhaps Kalmus knew that in Russia in 1909 Prokudin-Gorskii had used a Pullman coach fitted out for processing his still colour photography. There were several reasons for having a mobile laboratory, not least of which was to be able to move it south to Florida where there would be enough light to shoot with the slow emulsions of that time. Even so, the film used to obtain the red record would have to be sensitized on location, since there were no manufactured panchromatic films available in 1916.

At about this time, E. J. Wall, by then a highly respected

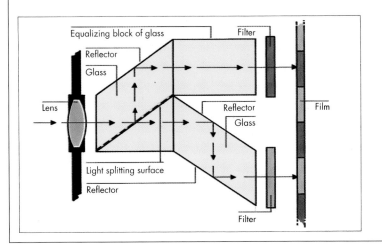

This schematic drawing shows how red and green records were exposed simultaneously in Technicolor's first two-colour camera by using a double-frame pull-down mechanism.

THE TECHNICOLOR STORY

authority on all matters relating to colour photography, joined Technicolor, and one of his first jobs was to help solve problems that were being experienced in colour sensitizing film.

Not long after the production unit had arrived on location in Florida, they ran into trouble with fogged film. The solution to that difficulty led to a joint patent obtained by Comstock and Wall in which they claimed: 'A composition for treating photographic emulsions comprising a color sensitizing dye ingredient and an oxidizing agent to prevent the reduction of the emulsion.'

Westcott, the third partner in the company, realising how unsatisfactory it was to wind unexposed film on to drums in order to dip it into a sensitizing bath, designed and patented a continuous machine with which to:

'sensitize a film after the emulsion has been applied to the celluloid . . . whereby the action of the dye throughout the entire length of the film may be made more uniform whereby a relatively small quantity of dye solution is required.'

The tasks undertaken by Technicolor in their railway carriage were extremely ambitious, including as they did, sensitizing and perforating the camera film, testing it and after exposure, processing and printing it.

The talented team that worked in the mobile laboratory included Dr. Kalmus himself; his wife Natalie; 'Doc' Willat (production supervisor); Dr. Comstock; Dr. Westcott; A. J. Ball (one of Comstock's bright students from M.I.T.); and their new colleague, the Englishman E. J. Wall. L. T. Troland had also joined from M.I.T. but remained in the Boston lab.

Having made prints of *The Gulf Between*, Technicolor faced the problem of projecting them. Unlike Kinemacolor which projected pairs of images in succession through a single lens, Technicolor's

new additive projectors required two lenses so that the pairs of images could be projected simultaneously, thereby avoiding time parallax. But it was difficult to accurately superimpose those images on the screen.

Comstock devised and patented a clever device with which to adjust the projected images to bring them into coincidence, but, having tried it for himself one night in Buffalo, NY, Kalmus made the famous observation that 'such special attachments on a projector required an operator who was a cross between a college professor and a conjuror.'

The first showing of *The Gulf Between* was at the Aeolian Hall in New York in September 1917, and the reviews were lukewarm: the *Motion Picture World* saying:

'Many of the landscapes and water scenes are of a remarkable coolness. The interiors and human elements are not so well done, the men and women in particular having a more or less painted or chromo effect.'

At this point Kalmus, no doubt with the agreement of Comstock and Westcott, decided that a successful future was more likely to lie with a subtractive process. In reaching that decision, Kalmus may well have been influenced by the prior opinion of E. J. Wall, who in 1906 had written:

'What we want is a length of cinematograph film, each picture in which shall be a record of the movement at the instant of exposure and at the same time is in itself a complete colour record.'

By 1920 Mr. Coolidge and his friends had invested $400,000 in Technicolor and now wanted to get out. So Kalmus had to find

The printing and perforating section of the mobile laboratory used by Technicolor while in location in Florida in 1917.

THE TECHNICOLOR STORY

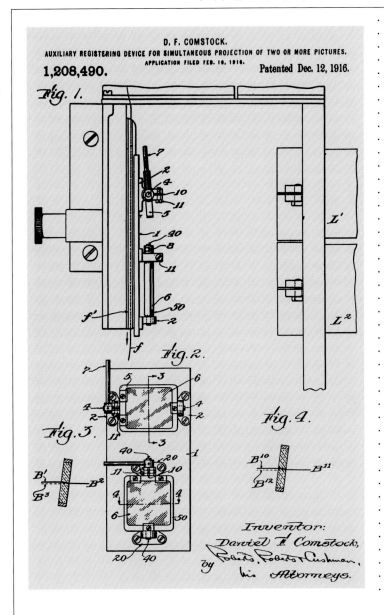

D. F. COMSTOCK.
AUXILIARY REGISTERING DEVICE FOR SIMULTANEOUS PROJECTION OF TWO OR MORE PICTURES.
APPLICATION FILED FEB. 10, 1916.

1,208,490. Patented Dec. 12, 1916.

(above) This was the device that caused Dr Kalmus to decide – 'after one terrible night in Buffalo' in 1918, that – 'such special attachments on a projector required an operator who was a cross between a college professor and a conjuror.'

(right) In order to expose a film through its base to form gelatine relief images, Technicolor decided in 1922 to start with 70mm film carrying four lines of perforations. After printing and processing the relief images, the film was folded and cemented to form a single 35mm length. Then each side could be dyed separately by floating the film across first a red and then a green dye bath.

another backer; which he did in New York by interesting William Travers Jerome, a famous lawyer, who in turn recruited two advertising men; A. W. Erickson and H. C. McCann and some of their clients. With resources renewed, Technicolor then set to work on establishing their second process.

TECHNICOLOR PROCESS NUMBER TWO

Technicolor Process Number Two could have used the original Comstock cameras, but in 1922 a new beam-splitter prism was designed and it was no longer necessary to space the two negative images two frames apart, since only one lens would be used to project the new films.

The new printing process was based on the idea of forming two rows of gelatine relief images on thin, double-width film (supplied by Eastman Kodak and known as 'Kalmus' stock) so that after folding and cementing the two halves together, one row could be dyed orange-red and the other blue-green to form composite colour images on a single 35mm length of film. The idea of using gelatine relief images was patented by Comstock in 1921, although it may have been anticipated by Thornton, a one-time director of Thornton-Pickard, the UK camera manufacturer.

Others, particularly Thornton, had worked on the formation of relief images using bichromated gelatine; but from the outset, Technicolor chose to use tanning development, an idea originally disclosed and patented by Warneke in 1881.

It is not clear whether he was still working for Technicolor at the time but in August 1921, Wall wrote a comprehensive article for the *British Journal of Photography* entitled *Relief Processes for Colour Work*. In his survey Wall acknowledged the work of Warneke and drew attention to the fact that the developer he recommended contained little or no sulphite – a characteristic of all the pyro tanning developers used by Technicolor throughout the next

THE TECHNICOLOR STORY

thirty-five years. Indeed, Clyne has said that 'the first Technicolor patent, granted to Troland in 1922, differed negligibly from Warneke.'

In his history, Friedman, who worked for Technicolor for some years, provides a great deal of information on the chemistry and procedures that were used to produce matrices for motion picture release printing. One interesting point he makes is that Technicolor found that there had to be tight control of the time allowed between treating an exposed matrix film in the tanning developer and forming the relief image in hot water. This was because of the growth of the relief image after completion of development.

After tanning development, and treatment in hot water, the two rows of relief images were combined in register by folding and cementing the film. As they did with all their innovations, Technicolor obtained a patent on the method and equipment used to dye the two sides of the cemented films. The principal novelties were the waxing of the edges of the film to prevent dye from penetrating the perforations, and the use of 'V'-shaped troughs containing the dye solutions. The troughs were filled so that at the

level of the liquid, the distance between the sides was only slightly greater than the width of the film.

The first film to be made with Technicolor Number Two Process was *The Toll of the Sea* produced in Hollywood by M.G.M. and starring Anna May Wong, but all the release prints had to be made in the small pilot plant built in Boston in 1919, and consequently full distribution of the film took many months. After building a second laboratory in Boston, the two-colour subtractive process was used for a production of Zane Grey's *The Wanderer of the Wasteland* in 1924 and *The Black Pirate* in 1925. *The Black Pirate* starred Douglas Fairbanks and was hailed by the press as a triumph, the *New York Times* saying: 'The unrivalled beauty of the shades is mindful of the old masters . . . There is no sudden fringing or sparking of colors.'

But Kalmus knew that they were facing serious trouble because of frequent reports from exhibitors that: 'the film is continually jumping out of focus.' Technicolor tried to deal with the complaints by rushing new prints to the cinemas and bringing the faulty ones back to be 'de-cupped' and reused. By these expensive

These drawings from a patent granted to Technicolor in 1922, show how the two gelatine relief images on opposite sides of a folded and cemented film (Fig 3), could be individually dyed with red and green dyes. After wax had been applied to the area of the perforations (Fig 9), the film was drawn across the surface of dye solutions (Figs 1 and 6) contained in 'V' shaped troughs (Fig 4).

THE TECHNICOLOR STORY

means they managed to keep the show on the road, but Jesse Lasky and Douglas Fairbanks were aware of the problems in the field, and early in 1925, while *The Black Pirate* was still on circuit, they said:

'We have concluded not to do more Technicolor pictures for the present, for two reasons: first, because we have had a great deal of trouble in our exchanges due to the fact that the film is double-coated and consequently scratches much more readily than black and white, and second, because the cost is out of all proportion to its added value to us. We paid $146,000 additional for prints. We understand that you need volume to get your costs down. At an 8 cent price we would be interested to talk volume.'

At that time Technicolor was charging 15 cents a foot for release prints.

It is not clear just when Kalmus and his colleagues decided that they would have to change direction yet again, and work towards an imbibition dye-transfer system. Once more they may well have been influenced in their decision by Wall, who had written a prophetic article in which he described very accurately the process that Technicolor would eventually adopt and with which they would establish a world-wide reputation.

Wall's article appeared in the *British Journal of Photography* in 1916, just one year before he joined Technicolor. In it he made these observations and suggestions:

'Supposing that we obtained simultaneously the three-colour record negatives on one or three films, is it possible to utilise one of our present printing processes so as to obtain on one film a series of pictures, each of which shall be in itself a perfect colour picture that could be projected in any existing cinematograph lantern. At first glance it is at once obvious that we must at once

reject any process in which superposition of stained films is used, for the exposing, printing and staining up of, say, 150 feet of each colour record and superimposing of the same would be a task, in face of which the labours of Hercules would be child's play. The question then remains whether we could use the imbibition process . . . for in these processes we have not the superimposition of three films, but merely the transference of dyes to one film, and it should be possible, though possibly not easy, to obtain accurate register of the matrix film, for this would mean merely accurate mechanical movement, accurate performation, and pressure.'

Another decade was to pass before the Technicolor three-colour process was introduced and operated on exactly the lines foreseen by Wall, but Technicolor Process Number Three was a step in the right direction.

TECHNICOLOR PROCESS NUMBER THREE

The design and construction of a machine to operate the new dye-transfer process was a major undertaking even for Technicolor. In 1923 Comstock had patented a method of cementing a matrix to a thin perforated metal band – surely the forerunner of the 'pin belt' used later.

Use of a large diameter wheel with matrix and blank films wrapped in contact around its circumference had been patented by Thornton in 1912 and Wyckoff and Handschiegl in 1919. The latter patent related to the transfer of dye images from stencils rather than continuous tone photographic records, but the principles were the same.

In 1927, J. A. Ball, together with Gallison and Weaver, patented a wheel with registration pins that could be used either for cementing two films together or as a dye-transfer machine. Such a

In 1912, Thornton patented a method of transferring dye images from a gelatine relief to a blank film by using a large wheel incorporating register pins.

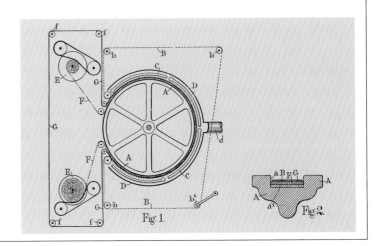

THE TECHNICOLOR STORY

wheel may have been used for Process Number Two, but because of the time required for complete transfer of dye to take place, it is unlikely that a wheel was ever used for imbibition printing. In those early days, matrix and blank had to remain in contact for several minutes and this would have necessitated an enormous wheel for any reasonable rate of production to be achieved.

In 1928 Comstock obtained another patent protecting a system of dye-transfer printing by the imbibition process which in its detailed and comprehensive information was remarkable. Machines to this design were built for Technicolor by I.B. Corporation and the quality of the engineering must have been of a very high order because, after being operated for some years in Hollywood, two of the original two-colour I.B. machines were shipped to England to be used for the three-colour process when it was established there in 1937.

The Comstock patent runs to many pages and contains extremely concise, detailed information, but its content is summed up in this paragraph:

'The apparatus of the invention includes the sequential arrangement of means for effecting the printing of films by imbibition, generally comprising means for wetting or dyeing a matrix film, means for wetting the blank film to be printed, means for effecting intimate contact between the appropriate surfaces of the films (preferably while submerged in a liquid), means for registering said films with respect to each other, backing means for conveying the thus registered films in undisturbed contacting relationship through a prescribed path (such as a continuous metal belt), means for pressing said films together and against the backing, means for conveying the same

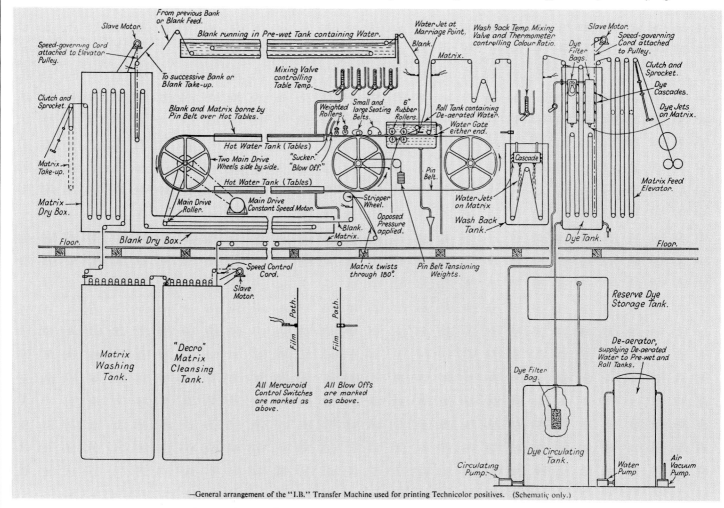

—General arrangement of the "I.B." Transfer Machine used for printing Technicolor positives. (Schematic only.)

A schematic drawing of the I.B. machine used by Technicolor at their Harmondsworth laboratory in the UK.

When the company ceased to use the imbibition process in 1975 the machine was sold to the Republic of China.

THE TECHNICOLOR STORY

in such contacted relationship through an extended path, by means of the backing under controlled and predetermined conditions, means for subsequently separating and drying the printed film, means for separating, decrocinating, rinsing and drying the matrix film, and means for guiding the metallic belt to the origin of its circuit. Means are likewise provided for conveying the matrix and blank films (after separation from the backing) through the apparatus at a suitably regulated rate of speed, so controlled as to provide uniform movement and tension upon the film without disrupting or wearing the same or permitting it to become slack. Means also are included whereby two or more successive printings upon the same film blank may be effected in a continuous series of operations.'

Despite the wealth of information given in most of their patent specifications, Technicolor had a reputation for maintaining strict security within its laboratories. In his book *Glorious Technicolor*, Basten has reported that:

'Very few people were privy to the know-how and workings within the various departments, or to the methods and procedures that were discovered solely by trial and error. Almost no one was allowed to roam at will. It was impossible to gain admittance to the processing lab, for example, without a pass or personal accompaniment of top-level management. Those employees who worked on an operational level were compartmentalized and stayed exclusively within the boundaries of their specialities. Rarely was anyone transferred to another department or division.'

Having designed, built and equipped a laboratory to produce dye-imbibition prints that would be free from the shortcomings of their cemented films, Technicolor, and that meant Kalmus, still had to persuade film producers to use the new process. This proved very difficult in 1927, largely because it could not be proved that the extra cost of shooting in colour could be matched by extra income. The story has it that it was on the advice of Nicholas Schenck, President of Loew's Inc., that Kalmus decided he would have to persuade his directors that Technicolor itself should go into film production:

'not primarily to make money as a producer, but to prove to the industry that there was nothing mysterious about the operation of Technicolor cameras . . . that rush prints could be delivered promptly and economically.'

Once again Kalmus gained the support he needed and during 1927 and 1928, Technicolor made twelve two-reelers from which the knowledge gained was so valuable that Kalmus later said: 'In my opinion Technicolor would not have survived without the experience of this series of short subjects.'

Schenck advised Kalmus to go further and to produce a feature film, which Technicolor did by making *The Viking* in 1929. The venture cost them $325,000, but in addition to gaining valuable experience, they got their money back.

SOUND FILMS

Then came the introduction of sound films and Technicolor found themselves in luck because conversion to imbibition transfer had meant that a high quality silver image sound track could be printed on the blank film before it received its two dye images. Other two-colour processes such as Cinecolor, met considerable difficulties and often had to settle for a less satisfactory iron-toned blue-green track. Troland obtained a

Very few photographs showing the inside of a Technicolor laboratory were ever published. This one is of the take-off end of an I.B. machine in Technicolor's Italian plant in Rome.

THE TECHNICOLOR STORY

couple of patents protecting the combination of a silver track with a dye image.

Meanwhile quality was improving, costs were coming down, and Technicolor was used for sequences in such films as *Broadway Melody* and *Desert Song*. But it was Warner Brothers who finally decided to use the process for a series of more than twenty features, including *On With The Show* (the first all-talking Technicolor film), and *Gold Diggers of Broadway*. By 1929 Technicolor were swamped with work and needed to double their capacity in Hollywood. During 1930 they sensitized, exposed and developed 12,000,000 feet of negative film and made 60,000,000 feet of release prints.

By that time the price of a Technicolor print was down to 7 cents a foot and the company had 1,200 people on its payroll; but once again fortunes changed and by the middle of 1931, Technicolor was employing only 230 people and production in Hollywood was at an extremely low ebb. Probably there were many reasons for the decline, but Kalmus gave some:

'The premature rush to color was doomed to failure if for no other reason because Technicolor was a two-color process. The industry needs all the help it can get, all the showmanship it can summon – it needed sound; it needs color. But color must be good enough and cheap enough. The old, two component Technicolor was neither – hence it failed, but it was a necessary step to present-day Technicolor.'

TECHNICOLOR PROCESS NUMBER FOUR

Kalmus had already made preparations for the switch to Technicolor Process Number Four by adapting a pair of two-colour imbibition machines to produce three-colour prints and by May 1932 facilities were in place in Hollywood to carry out a 'moderate'

amount of three-colour printing at the lowest price yet – 5½ cents per foot. But Kalmus felt that they could not offer the three-colour process to one customer without offering it to all. So they planned to start out by using three-colour printing for a short cartoon film. Here again they met with resistance and it was not until Walt Disney thought he might lose out to a competitor that he signed a two years exclusive contract to use Technicolor for his *Silly Symphonies*. In 1932 the first three-colour cartoon – *The Flowers and the Trees* was shown alongside *Brief Encounter* at Grauman's Chinese Theatre in Hollywood and stole the show.

Although it had been specifically designed to produce three separation negatives of live studio productions, Technicolor's 'three-strip' camera (described later in this section) was first used to photograph a cartoon film for which an ordinary rostrum camera would have served to expose red, green and blue records successively on a single film.

In 1933 John Hay Whitney and some of his associates began to show a practical interest in Technicolor and after many conferences a contract was signed between Technicolor and Pioneer Pictures Inc., which provided for the production of eight pictures – 'superfeatures in character and especially featuring color.'

Pioneer started with a short 'trial' production called *La Cucuracha* – the very first live action film to be shot with the three-strip camera. It was a great success, and in 1935 it was followed by *Becky Sharp*, a full length feature. From then on, Technicolor's business expanded rapidly and besides extending their facilities in Hollywood, they established a processing laboratory at West Drayton in England.

Bearing in mind the company's policy of secrecy, it is the more surprising to find what reads like a first-hand, but unattributed, account of the whole of the three-colour dye-transfer process in Clyne's *Colour Cinematography*. The description relates to the

In 1938, when Troland obtained this patent on behalf of Technicolor, no one knew just where the new sound track would be on the film. It seemed quite likely that a film width greater than 35mm would be used with the track outside one of the rows of perforations. In the event, picture size was reduced to make space for a track inside the perforations, but Technicolor's patent protecting the combination of a picture image in dye with a silver image sound track (either variable area of variable density) remained valid and very valuable.

THE TECHNICOLOR STORY

British (three-colour) plant at West Drayton circa 1940, and takes up some six pages, from which only a few passages have been condensed.

Clyne's informant claims that the dye-transfer machines made by the I.B. Corporation were designed by Mr. 'Mack' Ames, who was the Engineering Authority on both sides of the Atlantic.

The 'blank' film used for the early three-colour process was standard Kodak 1301 positive stock and this was used to provide a silver image sound track. A blank film bearing a sound track and sometimes a light grey 'key' image, was first immersed for about two minutes in a pre-wet bath contained in a long trough situated above the transfer 'table'. From the pre-wet bath, the blank entered a 'roll tank' where it was 'married' with the yellow dye matrix. The two were then seated on a stainless monel-metal 'pin-belt', by means of pressure exerted by four 6in diameter rubber treaded rollers. A jet of de-aerated water was directed at the point of contact between the blank and the matrix. Before the dyed matrix reached the roll-tank, it had passed through a most important 'wash-back' treatment where dye surplus to the amount required was removed by sprays of water, the temperature or duration of which could be rapidly changed and closely controlled.

This idea of always having an excess of dye in a matrix before washing out a controlled amount and then transferring the remainder to a blank film, was patented in 1935 by the I.B. Corporation, builders of the Technicolor imbibition transfer machines. In their specification they explained the reasoning behind the technique by saying that imbibition prints made without the use of a controlled wash-back, 'often prove objectionable due to color cast.' In other words, it was very difficult, or even impossible, to dye a set of matrices repeatedly so that they always produced the same colour balance in the transferred images. In carrying out the invention:

'the amount of dye removed from a matrix may ordinarily be from 15% to 65% of the original dye content, and more commonly, the removed dye content will be over 25% of the original content. When good technique is employed in controlling the exposure in making a set of matrices, the percentage of dye removed from one matrix of the set may not differ by more than 10% of its original dye content from the percentage of dye removed from another matrix of the set.'

The I.B. patent described the use of an automatically controlled sliding hood or shutter to vary the duration of the wash-back and this was the method employed in Hollywood. In the British plant (based on the old two-colour machines) variations in wash-back were achieved by automatically and rapidly changing the temperature of the wash water.

The amount of wash-back applied to each section of each matrix of every print was determined by the viewing room from where colour balance was under continuous control.

The pin belt was 240 feet long and made of monel metal, 35mm wide and about 0.004in thick, with register pins soldered into two rows of perforations. One row of pins fully fitted the corresponding perforations in both blank film and matrix, while the other row fitted longitudinally but not laterally.

The pin belts were driven by frictional contact with 40 inch diameter rubber treaded wheels and some slippage or 'creep' was unavoidable. Therefore, in order to keep the whole system in synchronization, the up and down travel of a constant-speed, sprocket-driven loop in each matrix film was used to speed up or slow down the variable speed motors driving the pin belts. The description and schematic drawing given by Clyne differ from Technicolor's patent specification in that his informant claimed

'Gold Diggers of Broadway' was made by Warner Bros. in 1929, just before the introduction of sound films. The two-colour prints were made by Technicolor's imbibition process from separation negatives exposed on a single film in a beam-splitter camera with a double-frame pull down.

THE TECHNICOLOR STORY

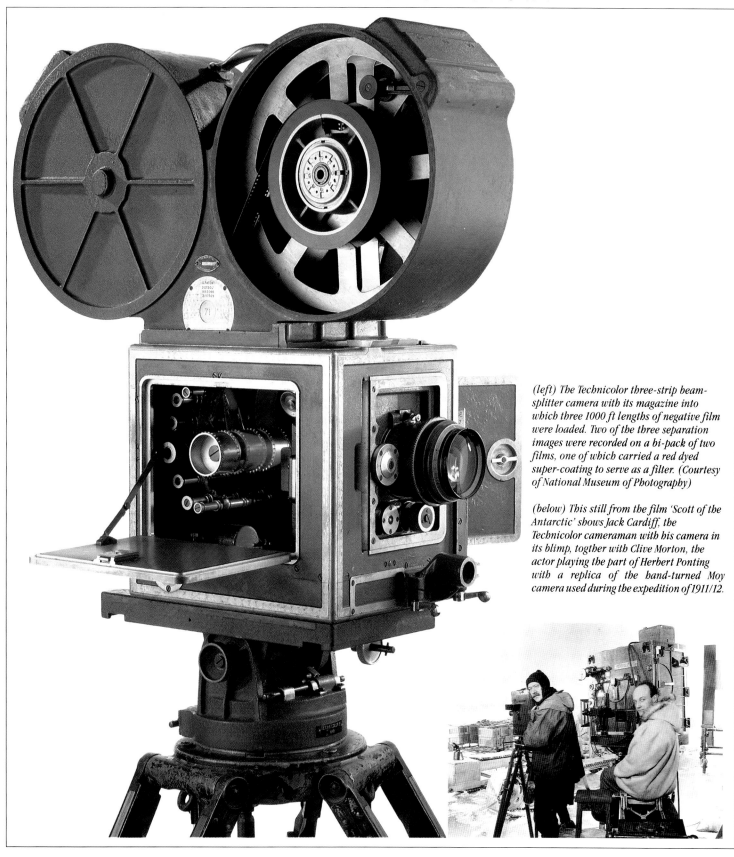

(left) The Technicolor three-strip beam-splitter camera with its magazine into which three 1000 ft lengths of negative film were loaded. Two of the three separation images were recorded on a bi-pack of two films, one of which carried a red dyed super-coating to serve as a filter. (Courtesy of National Museum of Photography)

(below) This still from the film 'Scott of the Antarctic' shows Jack Cardiff, the Technicolor cameraman with his camera in its blimp, togther with Clive Morton, the actor playing the part of Herbert Ponting with a replica of the hand-turned Moy camera used during the expedition of 1911/12.

THE TECHNICOLOR STORY

that the motors driving the matrix films varied in speed to keep in step with the fixed speed drive of the pin belts.

Two small 9 inch and a 7 inch diameter metal belts with associated pressure rollers were used immediately after the roll-tank to ensure perfect seating of the blank and matrix perforations around the teeth of the pin belt and to speed up the rate of dye-transfer. The matrix, blank and pin belt were subjected to controlled heat (110°F) during their time in contact.

At the end of the yellow transfer, the combined blank and matrix films were stripped from the pin belt and then separated. The blank bearing a yellow image then travelled to the next (cyan) transfer stage, while the matrix was passed through a bath of sodium carbonate to remove any residual dye before being dried and held ready for reuse. The cycle continued through the magenta transfer stage to complete the three-colour record.

When the Hollywood machine was first installed at West Drayton, the operating speed was only 20 feet per minute with a transfer time of some 10 minutes, but by 1946, the I.B. machine was running at 150 feet a minute and transfer time must have been down to less than 2 minutes.

It should be realised that when a Technicolor film was being release printed, some 250 copies might be required in the US and another 60 for the UK. This meant that the sequence of operations of dyeing three matrices, transferring the dye images in register on to blank film, re-dyeing the matrices for reuse, all proceeded in a continuous synchronized manner so that at no time, except in emergency or shut-down, did the transfer machine ever stop.

THREE-STRIP CAMERA

A three-colour process requires three separation negatives and after years of working with two-colour records, Technicolor had produced a 'three-strip' camera. They did this so effectively that the basic design remained in service until three-colour cameras were no longer required – more than twenty years later.

The new camera, patented in 1931 and usually attributed to J. A. Ball, was really a modern version of a camera invented by Buchanan-Taylor back in 1914. What he had claimed was:

'A cinematograph camera comprising two film-moving mechanisms, passing three films simultaneously through the said mechanisms so that they are simultaneously exposed through a single lens by means of a transparent reflector.'

In other words, a 'bi-pack and one' arrangement.

During the quarter of a century in which they were used, Technicolor cameras were regularly improved. Some of the more important features included means for easily removing and precisely replacing the prism block, the design of optical systems to allow the use of short focus lenses, and the elimination of problems caused by polarized light.

It was important for a camera operator to be able to remove the prism block from a camera in order to clean the film apertures and gates; but it was also essential that the prism assembly would be replaced precisely in its working position.

The engineering design by which this was accomplished made elegant use of a combination of one line and one point contact.

Despite the obstruction of the prism block, Technicolor, in collaboration with Lee of Taylor, Taylor and Hobson, managed to design a complete range of lenses for the Technicolor camera, including 25mm; 35mm; 40mm; as well as the longer and easier focal lengths.

The problem arising from polarized light manifested itself in the form of spurious coloured highlights resulting from differences

This film transport and prism arrangement remained basically unchanged in all Technicolor cameras between 1932 and 1955.

THE TECHNICOLOR STORY

This mechanical design allowed the prism block of a Technicolor camera to be adjusted so that precisely the same images would be formed at the two exposure apertures and yet allow the prism to be removed for inspection or cleaning and be replaced exactly in its previous position.

between reflected and transmitted rays. The fault was removed by adding a quarter-wave plate to the entrant surface of the prism.

The Technicolor camera, costing $25,000 even in 1935, was necessarily larger than a standard single-film camera and when encased in a blimp, the total volume of the outfit was 16 cubic feet. A loaded magazine containing three 1,000 foot rolls of film weighed 70lbs. These facts did not please production companies any more than did Technicolor's insistence that only their technicians could operate the cameras.

In the early 1940s attempts were made to ease the camera problem by using a version of Kodachrome, made by Eastman Kodak and called Monopack. This multi-layer film had a lower contrast than regular Kodachrome and after processing it to provide a positive colour image, separation negatives were made from which to produce matrices. Monopack was first used in 1942 for the exterior scenes in a film called *Lassie Come Home* and for the complete production of *Thunderhead – Son of Flicka* in 1944.

Although it was much more convenient to use, the colour and sharpness of prints made via Monopack originals were not as good as those made from negatives shot in a three-strip camera.

ANTI-TRUST ACTION

Towards the end of the 1940s, much of the industry felt that Technicolor held a virtual monopoly, and in 1947, this led to an anti-trust suit being brought against both Technicolor, and Eastman Kodak who had been exclusively supplying negative and print films to Technicolor for many years. The case succeeded and among other conditions, Technicolor were required to make a certain number of cameras available for the use of independent studios and producers.

For their part, Eastman Kodak produced a multi-layer stripping film by means of which three original separation negatives could

'Meet Me in St. Louis', featuring Judy Garland, was one of the twenty six feature films printed by Technicolor in 1944.

THE TECHNICOLOR STORY

be obtained after a single film had been exposed in an ordinary motion picture camera. The product was only used for the production of one film which was released in 1953, using prints made by Technicolor.

Enforcement of the anti-trust ruling made little difference to Technicolor's dominance, since there was no other viable three-color process available.

EASTMAN COLOR FILMS

However, in 1950 when Kodak announced their Eastman Color negative/positive system, Technicolor must have realised that their hold on the industry was at an end. In fact it was not long before Technicolor laboratories began to process and print Eastman Color films and in doing so, became just one of the many laboratories throughout the world that were now able to process and print three-colour motion picture films. There was some justice in this because in 1921 Dr. Leonard Troland, Director of Research at Technicolor for many years, had been granted a patent containing 239 claims in which he stated that it would be possible to:

'simultaneously produce at a single exposure a plurality of separate superposed complemental images on a single film adapted to be used in an ordinary still or cinematographic camera.'

Besides their British subsidiary, Technicolor also established laboratories in Paris in 1955 and Rome in 1958. But after the introduction of Eastman Color films in 1950, it was only a matter of time before producers would use colour negative film instead of Technicolor's three-strip cameras and would have their prints made on multi-layer positive film rather than by dye-transfer.

Recognising these trends, Technicolor lost no time before installing colour negative and positive processing and printing facilities in all their plants so that they were able to offer both the old and the new services to the industry. Even so, it was not until 1975 that the last release prints were made on the I.B. machines in Hollywood. Even that did not spell the end of the process, because during the 1970s, Technicolor UK made a new I.B. machine for the Chinese and after they had finished using their own machine, that too was shipped out to China where it was still being used in 1990 to produce the large number of prints required for such an enormous market.

This Tri-Tone print was made by the author from negatives exposed in a Technicolor camera. The film, entitled 'World Garden', was made for the British Council in 1940, directed by Darrel Catling and photographed by Jack Cardiff.

Other companies continued to use two-colour processes up to and even after World War II, albeit mainly for 'Westerns', where the absence of green grass was not too serious. Cinecolor, one of the most successful of the two-colour processes, was still being used in the early 1950s to produce more than a hundred million feet of release prints per annum – probably about half of the annual three-colour footage then being produced by Technicolor.

One of the most important considerations that led to the continued use of two-colour processes even after three-colour Technicolor was well established, was that films could be shot in two-colours with standard cameras loaded with a bi-pack combination.

BI-PACKS

The idea of using two films (or plates) with their emulsion surfaces in contact, to obtain different colour records at the same time dates back to 1903, when Gurtner obtained a patent in which he said:

'Coloured photographs are produced by the superposition of two coloured pictures instead of three. To obtain two negatives, one of the photographic plates is dyed with analine orange and placed in front of the other, thus taking itself an impression and also acting as a screen to the plate behind. The two plates, placed together, film to film, are placed in the camera and exposed.'

This idea was of course a long way from the kind of bi-pack of 35mm films required for two-colour cinematography.

The records indicate that P. D. Brewster may have been the first to use a bi-pack for motion-picture photography, since he described its use in a patent he obtained in 1915, although he would have had to sensitize his own films, since no manufacturer was offering a ready-made bi-pack at that time.

In 1928 DuPont introduced a 35mm bi-pack under the name 'Rainbow Negative' (later to be called DuPack) that could be used in standard Bell & Howell or Mitchell cameras after the addition of new magazines and relatively minor modifications to the film gates. The DuPont bi-pack was used by Multicolor to shoot negatives for a number of colour sequences in black and white productions including *The Fox Movietone Follies of 1929*, but never for a complete feature.

Howard Hughes, who backed the Multicolor process, had built a laboratory costing $1.5 million and after the project failed, Cinecolor Inc. took over the lab and proceeded to operate their Cinecolor process there for another twenty years.

By the 1930s, Kodak in the US, and both Agfa and Gevaert in Europe, had introduced their own bi-packs and shortly after that a multitude of 'new' two-colour processes appeared, some of them truly novel, others using known procedures, but all of them now able to obtain their negatives with standard camera equipment. This meant that most of the earlier optical devices intended to provide two-colour negatives could be bequeathed to museums.

PRINTING FROM TWO-COLOUR NEGATIVES

There are several ways in which orange/red and blue/green images can be combined on a length of motion picture film to produce a two-colour print that can be run through a standard cinema projector.

One way is to start with double width film and print and process the two rows of images alongside each other before folding and cementing the film to bring the pairs of images into registered superimposition, as described in the Second Technicolor Process.

Technicolor were not first to have the idea of using double width film to produce 35mm release prints in colour; Thornton, a

prolific patentee, had proposed a similar procedure in 1911, but it had required Technicolor to put it into practice.

A number of people could be cited as inventors of double-coated or duplitized films intended for recording pairs of differently coloured images on its two sides.

Both Thornton in 1912 and Hernandez-Mejia in 1913, understood the advantages of using a film with emulsion on both sides to produce motion pictures in colour. Both inventors also realised that in order to avoid the penetration of printing light through one emulsion to the other, a light-restricting dye should either be present as a filter layer or incorporated in the emulsions.

George Eastman must have believed that Thornton's patent on double-coated stock was valid because between 1920 and 1930 Kodak paid Thornton royalties (initially at the rate of a halfpenny a foot, and later a farthing a foot) that were amounting to £3,000 a year by the end of the period. What Thornton claimed in his patent was:

'a film coated on both sides with a thin layer of gelatine or other suitable colloid, containing a light-absorbing medium (such as a dye or pigment) capable of being removed by water or chemicals at the last stage of the process.'

Kodak continued to produce duplitized print stock after Capstaff's experiments with Kodachrome in 1916, but having such a film available did not of itself solve any of the problems involved in producing differently coloured images on the two sides of the film. The chemical and mechanical methods employed to do that job were numerous and varied enough to fill a book, but since few of them ever achieved commercial use, most can be forgotten.

It is worth remembering that prior to World War II very little film processing was done on continuous machines. Instead, it was usual to wind lengths of exposed film spiral fashion onto slatted drums that would then be rotated in troughs containing the developer, fixer or wash water. This was probably the procedure used by Capstaff to process his earliest Kodachrome movie films, because in 1915 his British colleague, John Crabtree, devised and patented a wooden processing drum covered with an inflatable rubber envelope so that when — 'the covering becomes inflated and forms its fluid-tight clinging surface against the inner surface of the film convolutions, bulging forth slightly between the latter to lock-off the entrance of fluid at the edges.'

By these means it would have been possible differentially to dye the two sides fo a duplitized film to produce Kodak's short film, *Concerning $1,000* in 1916. But this somewhat primitive method of working (which Wall claimed to have proposed in 1911) only allowed relatively short lengths of film to be processed at one time and by 1920 Capstaff had designed and patented a continuous processing machine for separately dyeing the two sides of double-coated perforated film. The Capstaff machine used:

'a long, narrow trough, provided with a plurality of parallel capillary rollers, which revolved in the dye and carried enough to stain up the positive image as the film passed over them.'

While both the Kodachrome and Technicolor two-colour processes depended upon dyes to form their images, there were other ways of obtaining the necessary blue-green and orange-red components. Metallic toning (the conversion of a black silver dye image into some other, coloured, metallic salt) provided an alternative way of obtaining complementary coloured images on opposite sides of double-coated film. An image of colourless silver iodide could also be used to mordant a basic dye and thereby provide a coloured image.

Crabtree's processing drum with its inflatable rubber covering was probably used by Capstaff to treat the two sides of his duplitized Kodachrome films in 1915.

The procedure adopted for several differently named processes during the 1920s was outlined by a Color Committee of the Society of Motion Picture Engineers in 1931:

'After processing the two (bi-pack) negatives were printed onto opposite sides of double-sided positive film such as Eastman Duplitized Positive or DuPont Duplicoat. Prints were made on Modified Duplex Type Contact Step Printers in which the orthochromatic (green record) negative was placed in one gate of the twin head and printed onto one side of the print film and the panchromatic (red record) negative was placed in the other gate of the twin head and printed on the opposite side of the film.

'The print was developed in a conventional black and white positive developer, fixed, washed and dried. Color was added by toning the side printed from the panchromatic negative blue-green and the side printed from the ortho negative, red-orange. The blue-green image was obtained by floating the print with the side being printed from the red record negative on the surface of a solution containing potassium ferrocyanide and a ferric salt. After washing and fixing, the red-orange image was obtained by immersing the print in an iodide mordanting solution which converted the image from the ortho negative to silver iodide which has the property of absorbing basic dyes. Then the print was washed and floated with the side printed from the green record on the surface of a red-orange dye solution.'

Among the processes worked in this way were: Prizma Color (in its later form); Kesdacolor; Kellycolor; Magnacolor; Multicolor; and finally, Cinecolor. The use of silver iodide as a mordant had been patented by Traube in 1907.

Some two-colour processes obtained their red component by converting the appropriate silver image into one of a uranium, salt; but dye-toning produced a much better and more transparent orange-red.

IMAGE REGISTRATION

The SMPE report refers to a Duplex Contact Step printer, used to print from separation negatives onto double-coated stock. It was of course essential that the two images were printed in precise register, one with the other. The problems that have to be overcome to achieve this, were recognised by Kelly in 1917, when he obtained a patent for use of a fully fitting register pin in combination with a second, reduced width pin on the opposite edge of the films, to accommodate any shrinkage differences between the two films.

This basic idea was subsequently adopted, not only for motion picture colour printing, but also for special effects work and even for making colour prints on paper with the dye-transfer process.

EUROPEAN PROCESSES

Most of the work done on motion picture colour film processes during the two decades preceding World War II, took place in the US. What activity there was in Europe mainly related to continued attempts to solve the optical problems of additive analysis and projection. Processes such as British Raycol (1930); the French Franchita system (1931); and the similar Horst process in Germany were typical.

One of the few two-colour subtractive processes to achieve public showing was British Chemicolor, which had been operated in Berlin from 1932 to 1937 as Ufacolor. Chemicolor was operated from 1937 to the outbreak of war in 1939, by Humphries Laboratories in London, where Agfa bi-pack and duplitized films were used to produce sequences for a film called *Paliacci*, featuring Richard Tauber.

The idea of using a fully fitting register pin in combination with a second, reduced width, pin to print component images in register on perforated film, was patented by Kelly in 1917; although this did not deter others from re-patenting the procedure in later years. The same principle is employed to register successive matrices in the Dye-Transfer process.

Because it was cheaper, the Cinecolor two-colour process continued to be used for some years after Technicolor had introduced their three-colour process. Cinecolor, with its iron-toned sound track was frequently used to produce 'westerns'.

THREE-COLOUR PROCESSES FOR THE CINEMA

Before 1950 no attempt to challenge Technicolor's supremacy in the field of three-colour movies was successful, although several noteworthy efforts were made.

GASPARCOLOR

As early as 1933 Dr. Bela Gaspar, a Hungarian working in collaboration with Agfa, produced the first motion picture films by the silver dye bleach process.

One of Gaspar's most important discoveries was that the silver dye-bleach reaction could be greatly accelerated by the addition of certain organic compounds. It is often mistakenly said that the silver image itself acts as a catalyst in the silver dye-bleaching process, but this is not really the case since the silver is converted by chemical reaction and therefore does not behave like a catalyst. If it had not been for Gaspar's discovery of catalysing compounds, the rate of reaction of the process would have remained extremely low.

Gaspar's motion picture film was coated with emulsion on both sides of the base; a blue-sensitive cyan-dyed layer on one side and a blue-sensitive magenta-dyed layer together with a red-sensitive yellow-dyed layer on the other side. Exposures were made sequentially through separation positives, using red light to expose the yellow-dyed layer. Agfa made the first film of this type, called it Tripo, and supplied it to a company Gaspar had formed in Britain. However, by 1934 Gaspar had transferred his activities to London and Gevaert began making film stock for him which was produced in a laboratory at Thames Ditton near Kingston-upon-Thames.

All the films printed on Gasparcolor material were of cartoon or puppet subjects, since in the 1930s, only Technicolor had three-strip cameras capable of providing separation negatives of live action. Nevertheless, Gasparcolor material was used for several technically successful, short advertising films, some of which are still held in the British National Film Archive.

At the outbreak of World War II Gaspar moved to the US where he made arrangements for processing Gasparcolor motion picture films in the laboratories of the Hollywood Film Company.

Nothing much came of this project and soon after the War he established a company called Chromogen Inc. to operate a print-making service using Kodachrome transparencies as originals. By this time his print material, called Gasparcolor Opaque, was being coated by DuPont.

In the late 1940s Gaspar returned to Europe and entered into an arrangement with Bauchet, whereby the French company produced

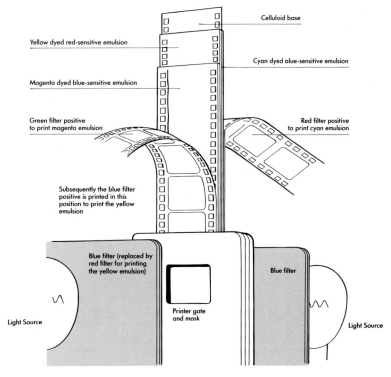

Schematic illustration showing the way in which Gasparcolor print material was exposed using three separation positives.

their version of Gasparcolor Opaque, but only for a short while.

From all of this it will be seen that at one time or another Gaspar managed to persuade many of the major film manufacturers to produce materials based on his patents; nevertheless, apart from his modest success in the UK before the War, nothing much came of the silver dye-bleach process while it bore his name, and it was never again used for motion pictures.

Between 1930 and 1970 nearly every major film manufacturer was granted patents on some aspects of materials or chemistry for the silver-dye bleach process. Before the War Gaspar himself had obtained more than a hundred British patents.

Two companies, Ilford and Ciba, independently at first but then jointly, continued with the development of a version of the silver dye-bleach process that became known as Cibachrome. That story is told separately (pp 183-188).

BRITISH TRICOLOUR

The writer was involved with the only British challenge to Technicolor. The process, originally called British Tricolour, was acquired by Dufay Chromex in 1947 and was renamed Dufaychrome. Perhaps the most important achievement was the design and construction of a beam-splitter camera similar to that of Technicolor, the basic patents on which had expired.

The British Tricolour printing process made use of a basic, blue-sensitive positive film (supplied by Gevaert) containing a substantive magenta coupler. After a latent image had been formed by printing from a green record negative, a second blue-sensitive emulsion layer containing a cyan coupler was transferred to the film from a thin, un-subbed temporary support. After transfer, the new emulsion was exposed behind a red record negative in a step register printer. Finally, another emulsion layer containing a yellow coupler was transferred to the film and exposed behind a blue

(above) In 1944, Warner Brothers patented a beam-splitter camera with which they would obtain three colour separation negatives with only two films. This was possible by using a two frame pull-down, so that the bi-pack was exposed in one gate to provide the blue and red records and the rear film transported through the second gate where its unexposed areas were used to provide the green record. Only half of the front film was exposed.

(right) The author, operating the British Tricolour 'three-strip' camera on location in 1948.

record negative. After completion of the three exposures, the film was processed in a standard colour developer.

This sequence of operations might seem lengthy and complicated, but in fact transferring the two emulsion layers could be done at very high speed after no more than moistening the surface of the receiving layer. The 25mm wide temporary support was very thin, and could be either un-subbed film or paper.

It was realised that the process would not be able to compete with Technicolor when large numbers of release prints were required, but it could be competitive for shorter runs. However, within a few years the advent of Eastman Color films had settled the matter.

In 1947 the British Tricolour camera was tested alongside a Technicolor camera on the production of Michael Powell's *Red Shoes* and in 1948 the camera was used briefly by Consolidated Film Industries in Fort Lee, New Jersey, to provide negatives from which to print on DuPont Colour Print Film Type 275.

DUPONT COLOR RELEASE FILM

This multi-layer positive film was novel in that it used a synthetic polymer (polyvinyl alcohol) instead of gelatine as a binder for the silver halide and colour couplers contained in the three emulsion layers. Printing was done successively from separation negatives through filters to selectively expose the three layers. After exposure, the three component colour images were formed by a single stage of colour development.

No productions were completed with the British Tricolour camera but between 1949 and 1953 one or two films were shot on Ansco Color and Eastman Color negative films to provide the separation negatives required for release printing onto the DuPont positive stock.

It was during the trials with the British Tricolour camera in 1949, that the writer visited Rochester in the company of Cornwell-Clyne and met Donald McMaster, Vice President of Eastman Kodak. When asked what the rumoured Eastman Color Print film would cost, McMaster answered: 'We don't know what it will cost, but we do know what we shall charge – six cents a foot – that's what Technicolor charges!'

What outsiders did not know at that time was that Russell of Eastman Kodak had just discovered the 'slide-hopper' method of multi-layer coating that was to revolutionize the production of colour films and paper.

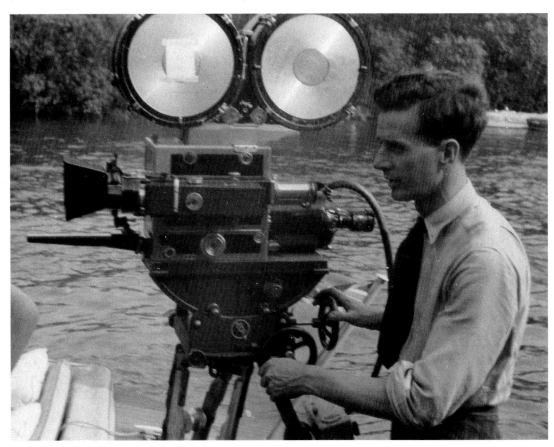

MULTI-LAYER PROCESSES

'It will be clear that we are still far from the ideal process in which the negative is taken upon a single sensitive material without the interposition of separate filters, and from this negative prints are made either in the form of transparencies or upon paper, the prints being permanent, bright and transparent and containing in themselves a perfect reproduction of the colors of the original approaching at least in accuracy that obtained in a black and white print. No process at present in sight approaches these requirements, but it does not follow that it is impossible to work out such a process, and it may be that at some time in the future we may hope to have color photography available in a form as simple as modern photography in monochrome.'

C. E. K. MEES DSc, 'THE PHOTO MINIATURE' No. 183 (1921)

Happily, Dr. Mees lived to see his hopes realised, because by 1960 when he died, negative/positive colour processes were well established in all branches of photography.

It is generally accepted that the turning point between additive and assembly methods of colour photography and the multi-layer processes occurred in the mid-1930s, when both Kodachrome and Agfacolor films were introduced, although the concept of an integral subtractive process had been around for a quarter of a century before that.

KARL SCHINZEL

The first clearly stated proposal to use a self-contained, triple layer material for colour photography will be found in an article by Karl Schinzel entitled 'One Plate Colour Photography' published by *The British Journal of Photography* in 1905.

Schinzel's idea was to coat a plate with alternating layers of silver bromide emulsion and clear gelatine and to have each sensitive layer coloured complementary to its sensitivity – a far-seeing but unachievable aim at that time – and then, after exposure and development to treat the monopack with a solution of hydrogen peroxide in the hope that the dyes would be decolorized wherever there was silver and nowhere else, leaving a three colour reproduction of the subject.

However, Neuhauss was quick to point out that the process was impracticable because the dyes would be bleached out completely and not only where there was silver. Schinzel, whose record over the next thirty years showed that he did not give up easily, acknowledged this fact and later suggested ways of using a catalyst to confine bleaching action to the locality of the silver, thereby anticipating the procedure adopted by Gaspar many years later.

Again without being able to implement his ideas, Schinzel proposed using a single layer of mixed grains of silver bromide

dyed with complementary-coloured sensitizers, an idea that occupied Eastman Kodak researchers for several years during the 1940s and '50s.

UTOCOLOR

Dr. J. H. Smith had a photographic plate and paper coating business in Zurich in the early 1900s and knew something of the problems of emulsion coating at that time. Nevertheless, he became interested in the possibilities of producing a multi-layer bleach-out paper that would enable users to obtain colour prints from additive transparencies like Autochromes by direct action of light. Smith did make such a paper, which he called Utocolor, although in a lecture to the Royal Photographic Society in 1910, while the paper was still on sale, he described the limitations inherent in any direct bleach-out process, particularly when used to obtain prints on paper from additive screen-plate images.

Not least of his several problems was the extremely low sensitivity of Utocolor paper, which needed to be exposed for some twenty minutes in contact with a colour transparency – even in bright sunlight.

Smith also knew how difficult it was to apply multiple layers satisfactorily with the primitive emulsion-coating equipment of that time, saying:

'It is extremely difficult to coat with ordinary coating machinery a solution containing one or more dyes, as the slightest difference in thickness of which would not be observed in the case of silver bromide or plates, will form streaks which must altogether be avoided in the bleach-out process. To coat several layers of differently coloured dye solutions one upon the other so that an evenly colored harmonious surface results, is almost impossible.'

This same difficulty was to influence the direction of many processes for several more decades before efficient methods of multi-layer coating were devised.

BENNO HOMOLKA

It was Homolka, while working for Hoeschst in 1907, who showed that coloured images could be formed by the creation of dyes in combination with silver images rather than by their destruction. He proposed using indoxyl and thio-indoxyl as developing agents that would form blue and red dye images together with reduced silver, that could subsequently be removed. The range of colours Homolka identified was limited and no commercial use was made of his discovery.

RUDOLF FISCHER

As E. J. Wall has noted, it was Rudolf Fischer in 1911/12, who patented the application of Homolka's work and who gave us the terms 'colour development' and 'colour former'. Friedman considered that together, in their articles and patents, Fischer and his colleague H. Siegrist not only outlined the fundamental chemistry involved in colour development but 'left practically nothing to be discovered except tricky and complicated substitutions within the molecules.'

In many ways the Fischer patents were as prophetic as those granted to du Hauron thirty-five years earlier. Like du Hauron, Fischer could not realise many of his proposals, but that does not diminish their historic importance.

In a comprehensive German patent granted in 1911, the Neue Photographische Gesellschaft, for whom Fischer and Siegrist worked, proposed several ways of using colour development. On the one hand they would use it to produce the filter elements for a screen-plate by successively exposing a silver halide layer behind a

This advertisement for Utocolor Paper, appeared in 'The Photo Miniature' No. 128, entitled 'Colour Photography' and published in 1913.

N° 15,055 A.D. 1912

Date of Application, 27th June, 1912—Accepted, 27th June, 1913

COMPLETE SPECIFICATION.

Improvements in or relating to the Production of Photographs in Natural Colors.

I, RUDOLF FISCHER, of Beymestrasse 20, Steglitz, near Berlin, Germany, do hereby declare the nature of this invention and in what manner the same is to be performed, to be particularly described and ascertained in and by the following statement:—

5 My invention relates to the production of photographs in natural colors.

Various methods have been proposed to utilize the oxidising properties of various bodies in connection with the production of coloured photographs. For instance leuco-bodies of organic compounds have been employed in conjunction with one or more nitrogen and oxygen groups which can be readily 10 eliminated, for the production of sensitive layers or coloured photographic images, while coloured prints have been obtained by exposing a chromium di-oxide layer under a negative and developing the image so formed by means of a solution of an alkaline bi-sulphite and an organic compound which is oxidisable into a colouring matter by the chromium di-oxide.

15 It is well known that by developing exposed films of halogen-silver in suitable solutions, monochrome pictures can be directly obtained, the exposed halogen-silver oxidising the substance in the solutions to an insoluble or comparatively insoluble coloring-matter which is precipitated on the reduced silver.

A familiar example of such colour development is found in the case where 20 an alkaline pyrogallol developer is employed without any preservative such as sodium sulphite. Amongst other substances which act in a similar manner may be mentioned indoxyl, thioindoxyl, hydrochinone and alpha-naphtol, paramidophenol and xylenol ($C_6H_3(CH_3)_3OH$), paramidophenol and alpha-naphtol, dimethyl paraphenylenediamine and alpha naphtol, dimethyl paraphenylene- 25 diamine and phenol, also toluylenediamine,

$$\underset{NH_2}{\overset{NH_2}{\bigcirc}} CH_3$$

diamidodiphenylamine ($NH_2.C_6H_4.NH.C_6H_4.NH_2.$) and other diphenylamine derivatives, and generally those bodies which while acting as developers also produce a more or less insoluble coloured oxidation product. Hereinafter this 30 mode of development will be termed "color development", and the substances causing the same "color formers".

According to my invention I utilise this stronger oxidation capacity of exposed halogen-silver as compared with that of unexposed halogen-silver for

[Price 8d.]

In this patent of 1912, Rudolf Fischer was first to use the terms 'color development' and 'color former'.

line screen, each time developing the resulting line image in a different colour developer. In the same patent it was proposed to obtain colour photographs by the subtractive process, either by superimposing three separate colour developed images, or by adding dye-forming substances (couplers) to three differently sensitive emulsions and then coating them in superimposition.

Fischer's description of a negative/positive colour printing procedure is quite clear, though he envisaged using a screen-plate negative as an original – as the Lumières had already suggested in 1907.

The relevant passage from the patent reads:

'Three emulsions are made, one being sensitive only to blue light, another only to green light, and a third only to red light. In these emulsions are incorporated the substances necessary for the formation of each color, i.e. the substances termed "color formers", the latter being so selected, for example, that the color formed at any time is complementary to the corresponding selective color-sensitization of the halogen-silver. Now when these three emulsions are poured out in three layers one on the other, there is formed, for instance under the action of blue light, a yellow color, and at places acted on by red and green light the corresponding complementary colors, cyan and magenta. When the colors are correctly chosen those places which white light strikes become nearly black, whilst at those places whereon no light strikes, for instance under the covered or dense parts of the negative, no coloration is formed at all, and consequently after fixing white results. By copying a screen negative on such a layer the correct colors and correct black and white values are obtained.'

Fischer was also well aware of most of the detailed requirements of a multi-layer colour material, for he explains that:

'When practising the process with three layers, I may use a yellow coloring matter mixed with a binder as an intermediate layer for the purpose of reducing the sensitiveness to blue in the halogen-silver layers sensitive to green and red.'

Furthermore, he foresaw the possibility, later pursued by both Agfa and Kodak, of realising a mixed-grain mono-layer colour material, saying:

'Instead of pouring the three emulsions, in three layers one on another, before pouring them I may treat them in a suitable manner, for instance by tanning, so that they can be mixed without the three compounds (halogen-silver and color-formers) uniting to form one homogenous layer or film.'

While Fischer's ideas would eventually be realised, their fulfilment was quite beyond the capabilities of any company at that time and the Neue Photographische Gesellschaft, had to settle for the production of a series of single image colour development papers called Chromal. Even this simple product proved unsatisfactory because the couplers incorporated in the emulsion tended to bleed out and ruin the developer.

LEONARD TROLAND

The most comprehensive patent on the subject of multi-layer materials for colour photography was granted to Leonard Troland in 1931, after he had applied for it ten years earlier. During that decade, Troland was director of research for the Technicolor Motion Picture Corporation, although the patent was eventually acquired by Eastman Kodak. Troland's remarkable specification contains the impressive total of 239 claims; none of them making any reference to the process of colour development.

In the preamble, the inventor said that his aim was to:

'simultaneously produce a plurality of separate superposed complemental images on a single film adapted to be used in an ordinary still picture or cinematographic camera.'

In reality, many of the claims are concerned with either two-colour photography or the use of a bi-pack of two films to provide three records for three-colour photography.

Very little information is given about the ways in which the integral separation records could be converted from silver into the necessary coloured images, although it is broadly made clear that the controlled penetration of processing solutions could provide a way of differentially treating images that have been formed at different depths within either a single or multi-layer emulsion.

On balance, Troland seems to have preferred using a single emulsion layer that had been differentially sensitized by controlled penetration of sensitizing dyes rather than a material requiring the superimposition of two or more emulsion coatings. No doubt this preference reflected doubts about the practicality and the economics of multi-layer coating in the 1920s.

In 1929, a couple of years before Troland's patent was made public, Emil Wolf-Heide obtained a patent protecting the idea of differentially sensitizing an emulsion layer by controlling the depth of penetration of the sensitizers. He would treat an ordinary emulsion layer in a solution of pinaflavol for a sufficient time to render the 'intermediate' portion of the layer sensitive to green light, and then, after drying, treat the plate in a solution of the red sensitizing dye pinacyanol for sufficient time to allow the dye to

penetrate only the surface layer of the emulsion. Such a plate or film would need to be exposed through its base, but there is no evidence that any materials of the kind described were ever produced.

LEOPOLD MANNES AND LEOPOLD GODOWSKY

In the preface to their book *Principles of Color Photography*, Ralph Evans and Wesley Hanson, both Eastman Kodak men, tell us that they joined the team under Mannes and Godowsky shortly after 1935 and they go on to say that – 'we persist in the view that the complexities of the interelations among the variables are so great that color photographic processes *must* be developed empirically.'

If empiricism means 'let's try it and see', then there can be no better proof of Evans' and Hanson's contentions than the joint efforts of Mannes and Godowsky in their search for a practicable colour process.

Frequently the work of the two musician/inventors is linked only with the development of the Kodachrome process. While this is understandable, it overlooks much of the work they did on other ideas and processes, both before and after joining Eastman Kodak in 1930.

It is said that the two friends, with their common interest in photography had been struck by the many imperfections of a film called *Our Navy* which they saw in New York in 1917. That film had been made with the Prisma process, an additive rotating filter system not unlike Kinemacolor, so it was not surprising that it had shortcomings. Mannes and Godowsky thought that they could do better, borrowed $800 from their parents, and did some work on a triple lens camera and projector which led to a private demonstration in the Rialto cinema in New York in 1921. The results were described as 'dark and fuzzy and as bad as ever'; so, just as Kalmus of Technicolor had already done,

Mannes and Godowsky abandoned the additive system.

Although they could not have been aware of Troland's ideas, their first attempt at a two-colour subtractive process resulted in a patent in 1923 which described the use of a film carrying two superposed emulsions. The one next to the support was sensitized to red light and the other sensitized to blue-green light. After exposure the negative was developed in a metol developer and bleached in potassium ferricyanide, after which the upper image was re-developed in amidol by careful control of its penetration. The lower image could then be toned blue with ferric chloride and the upper image treated with cupric ferricyanide to serve as a mordant for fuchsin (magenta) and a yellow dye.

This was the first indication of Mannes and Godowsky's belief in controlled penetration as a practical processing device.

Having exhausted the money initially provided by their parents, the two amateur experimenters were being advised by both family and friends to concentrate on their music, which they might well have done had it not been for an opportunity Leopold Mannes had, through the good offices of Professor Wood of John Hopkins University, to meet Dr. C. E. K. Mees of Eastman Kodak. In a letter to Mees, Wood wrote:

'This is to introduce to you my friend Leopold Mannes, who has worked out a system of color photography which appears to have some novel features which I think will interest you and your company. It occurred to me that you might offer him the facilities of your laboratory for a few days, for I feel sure that he can produce better results under better working conditions. He uses no color screens and can print colored positives from his color negatives.'

Mees, like George Eastman, believed in recruiting outside help whenever prospects seemed favourable. So, after listening to

Mannes' story and aspirations, he decided that it might prove worthwhile to support the two young men by providing them with the specially coated plates they required.

That conversation and agreement in 1922 was the start of 17 years of collaboration and perhaps on the strength of the promise of co-operation from Kodak, Mannes and Godowsky were able to raise a loan of $20,000 from a banking house in New York.

Up to that time the partners had somehow managed to carry out their experiments in the kitchens and bathrooms of their homes, even though they were often living on opposite sides of the country. With the new resources, they transferred their activities to rooms in the Alamac Hotel in New York.

INFLUENCE OF E. J. WALL

When it was published in 1925, Wall's *History of Three Color Photography* contained a reference to their 1923 patent and Mannes and Godowsky naturally bought a copy. Having read it thoroughly, they learned for the first time of Fischer and Siegrist's work in Germany in 1911/12 on colour couplers. Quickly recognizing the potential of colour development, they worked out a multi-layer process using colour couplers in three emulsion layers and obtained a patent for it in 1930.

At that time Mannes and Godowsky were looking for a process that could be used for motion pictures and consequently all their early ideas were intended to produce a colour negative from which release prints could be made. However, just as Fischer had found twenty years earlier, the only couplers available would not remain confined to their respective emulsion layers. Not only that, in the 1920s it was also difficult to prevent sensitizing dyes from wandering between layers.

One of Mannes' and Godowsky's patents, granted in 1927, warrants special mention because it included a description of a mono-layer mixed-grain emulsion and at the same time disclosed the idea of re-exposing such a material selectively by means of coloured light – thereby anticipating the method used for processing Kodachrome after the first few years during which the depth of penetration of successive processing solutions had to be precisely controlled.

In the 1920s there were few, if any, sensitizing dyes that would stay in position and remain unaffected by treatment in a developer. So it was probably the fact that towards the end of the decade, Kodak had discovered substantive sensitizers, that led Dr. Mees to propose to Mannes and Godowsky that they should throw in their lot with Eastman Kodak. In fact, Mees said as much in an address to his senior research staff in 1955 – 'In 1930 I reckoned that the new dyes that we could now make would solve the problem of making Mannes' and Godowsky's proposed color process work. So we asked them to join us here.'

Perhaps the terms of the three-year contract are still interesting. Kodak paid a lump sum of $30,000 ($20,000 of which went to repay the earlier loan) and salaries of $7,500 each, together with royalties on all patents filed prior to the agreement. Mannes and Godowsky accepted, and by November 1930 they were Kodak employees, although they continued to work in the improvised laboratory in the Alamac Hotel in New York City until the middle of 1931 when they moved to Rochester.

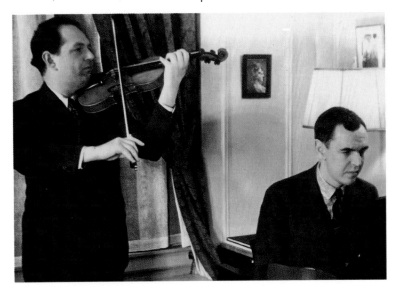

Leopold Godowsky was the violinist and Leopold Mannes the pianist when the two made music together.

THE KODACHROME STORY

It is convenient and reasonable to start the story of Kodachrome at the time when Leopold Mannes and Leopold Godowsky accepted Dr. Mees' invitation to join the research staff of the Eastman Kodak Company in Rochester. That was in 1930, some eleven years after the two musicians had first become fascinated by the problems of colour photography.

During those years Mannes and Godowsky had tried many different ways of achieving either two- or three-colour photography but by the time they went to Rochester they were quite sure that they would have to use some form of colour development to obtain a satisfactory result. They also knew quite a lot about controlling the rate of diffusion of various processing solutions into emulsion layers, so that superimposed emulsions could be treated individually to yield differently-coloured component images. These two factors probably persuaded Mees that the two amateurs were on the right track.

'MAN' AND 'GOD'

One must suppose that the arrival of two unqualified men who had been working on colour processes in a hotel room, caused a stir among the staff of the world's foremost photographic research laboratory. It has been acknowledged that at first the newcomers were considered to be 'little more than curiosities – two outsiders who admittedly considered photography a hobby and music their life's real calling.' However, 'Man' and 'God', as they were quickly dubbed, did have the advantage of being there at the invitation of Dr. Mees, who, years before, had not hesitated to import a number of British scientists to staff his new laboratory in Rochester.

It would seem from the patent literature that during the first few years after joining the Rochester laboratory, Mannes and Godowsky spent some time on mono-layer, mixed grain coatings in an attempt to avoid the problems of multi-layer coating. One of

their patents, granted in 1934, was summarized as follows:

'A photographic emulsion layer comprising a mixture of differently colour-sensitized grains is exposed to an object in colours, developed without fixing, re-exposed to light of a colour which affects only one set of grains, and colour developed to the minus colour, these exposure and development steps being repeated for the remaining set or sets of grains and the silver images produced being dissolved out, leaving a multi-colour image of dyed gelatine.'

If, as this patent suggests, sensitizers were then available that would retain their properties after first development, it is rather surprising that they were not used in the first multi-layer Kodachrome to avoid the necessity for controlled diffusion.

Since their initial contract was for three years, Mannes and Godowsky were quite concerned by 1933 that they had not yet delivered a workable process, particularly because this was the time of the Great Depression in the US and there was talk of abandoning research on new colour processes – especially research being done by a couple of musicians.

In the 1930s two-colour processes were still acceptable and very much used by the film industry. So rather than offer nothing, Mannes and Godowsky showed Dr. Mees samples of a two-layer colour development material that might be used as an amateur movie film. The fact that it would have to be returned to Kodak for processing did not worry anyone too much because they had been selling and processing black and white reversal cine film for amateurs ever since 1923.

Mees decided, perhaps because he too had a deadline, that the tests were good enough and that – 'This film will go on the market.' Mannes and Godowsky were somewhat taken aback and

THE KODACHROME STORY

pleaded for more time to convert the two-colour film into a three-colour process. Mees would not agree to further delay, but did promise to adopt a three-colour version as soon as it was ready.

As it happened, delays in the preparations for production of the new film enabled the extra research work to be done to produce a new three-colour process which Mees, true to his word, agreed to adopt. The new film was announced in the *Rochester Evening Journal* on April 15th, 1935 – a momentous day in the history of colour photography.

THE ORIGINAL PROCESS

Whether anyone other than Mannes and Godowsky themselves fully understood just how complicated the processing of the new film would be, is open to conjecture. Looking back, it was certainly a bold undertaking. W. T. Hanson, who worked for a while on the Kodachrome team and later became Director of Research at Rochester, described the original film and its processing:

'Kodachrome film consisted of five layers on a single support. The top emulsion layer was blue sensitive; to avoid exposing incorrectly the emulsions coated beneath, it contained a yellow dye to absorb all blue light that entered it. Below the blue-sensitive layer was a layer of clear gelatin. This was important. Below that was a blue- and green-sensitive layer, another gelatin interlayer, and finally a blue- and red-sensitive layer. Thus, three separation latent images were made when the film was exposed, blue in the top layer, green in the middle, and red in the bottom.

The processing followed from the film structure. First the silver negative images in all three sensitized layers were developed simultaneously, and the yellow filter dye was removed from the blue-sensitive top layer. The developed silver was then

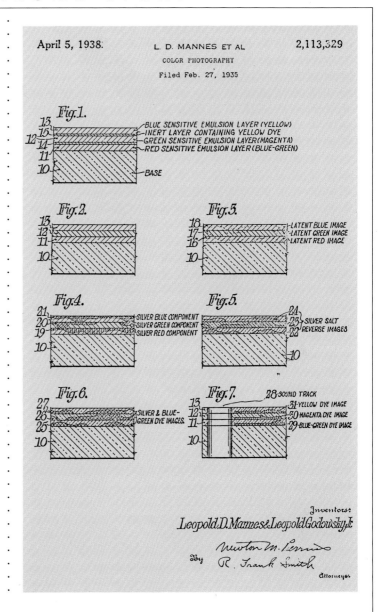

By 1935, Mannes and Godowsky were thinking in terms of a three colour process, but still using the controlled penetration of a bleaching solution. Fig. 7 indicates space for a sound track, because the inventors hoped to use the process for motion pictures.

THE KODACHROME STORY

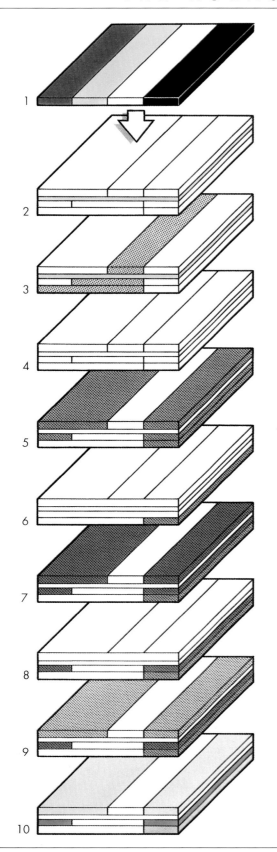

bleached and removed, and the remaining positive images in sensitive silver halide were exposed to light. All three layers were then developed in a cyan dye-forming color developer. With the cyan image completed, the film was dried, wound onto spools, and removed from the processor.

In another processor, the developed silver and cyan dye in the top two layers were bleached; the silver was rehalogenized and the dye destroyed. This was the key to the process and was known as controlled diffusion bleach. By timing it right and starting with dry film, Mannes and Godowsky were able to bleach the top layers completely without affecting the bottom layer. The gelatin interlayer that provided a margin for safety was one ten-thousandth of an inch thick (2.5 micrometers). After bleaching, the film was exposed and developed again. Silver images were developed in the top two layers, and the oxidized developer reacted with a coupler to form magenta dye. Again, the film was dried, spooled, and fed into another machine that repeated the process of bleaching, rehalogenizing, exposing, and developing to form yellow dye. Finally, all of the developed silver was removed. In all 28 steps were involved and the total time taken was 3½ hours!'

The colour formers cited in Mannes' and Godowsky's early patents protecting the process that became Kodachrome, were:

4-nitro acetoacetanilide

p-nitro phenyl aceto nitrile

m-hydroxy diphenyl

for creating yellow, magenta and cyan images respectively.

Mees must have known that he was taking a big risk by launching such a complex process within three months of receiving the go-ahead and without even having had a field trial. However, according to Peter Krause, writing in *Modern*

How early Kodachrome films were processed:
1. The original subject; 2. The red band is recorded only by bottom emulsion layer; yellow band by middle and bottom layers; white band by all three; 3. A black-and-white developer produces negative images in all three layers; 4. The silver images, together with the yellow filter layer are removed by bleaching; 5. The film is re-developed using a colour forming developer to produce combined silver and cyan dye images in each layer; 6. All silver and dye images are removed from the upper two layers by 'controlled penetration' of a bleaching solution; 7. The upper two layers are re-developed using a magenta dye-forming developer; 8. The silver and dye images are removed from the top layer by controlled bleaching; 9. Top layer is re-developed in a yellow dye-forming developer; 10. All silver images are removed to leave thre dye images to reproduce the original subject.

THE KODACHROME STORY

Photography, Kodak had a fall-back position:

'They made arrangements to introduce a substitute color film based on the established additive Dufaycolor system. The company even purchased bulk quantitities of film base rolls with Dufaycolor screen elements from the manufacturer, Ilford of England.'

In the event they were never needed. Ironically, it was the success of Kodachrome that led Ilford to sell their shares in Dufaycolor in 1938.

In 1935, despite the limited success they had achieved with their Kodacolor lenticular process, Kodak believed there was a worthwhile business to be won with a system of home-movies in colour. They had already established a world-wide reputation with their 16mm Cine-Kodak black and white films and cameras, but the rapid conversion of the commercial cinema to colour was leading the amateur to feel he was being left behind.

A FILM FOR HOME MOVIES

So it was that Kodachrome was first launched as a 16mm daylight film with a speed of Weston 8. An artificial light version and a daylight 8mm film followed early in 1936, but it was not until the second half of 1936 that the 35mm Kodachrome was introduced. It has to be remembered that the so-called 'miniature' still cameras using 35mm film were not yet well established outside Europe, where Kodak had just introduced the German made range of Retina cameras. In the US, two considerations probably led Kodak to offer a still film version of Kodachrome; one was that they were currently promoting a range of Bantam cameras which used a paper-backed 35mm film with a single perforation per frame, and the other was the very successful launch of the cheap Argus 35mm camera in 1936. At that time few people could have guessed that 35mm film yielding 36mm x 24mm images would eventually dominate almost all branches of photography.

At first, the processed spools of film shot in Bantam, Leica or Contax cameras were returned to the customers as uncut rolls.

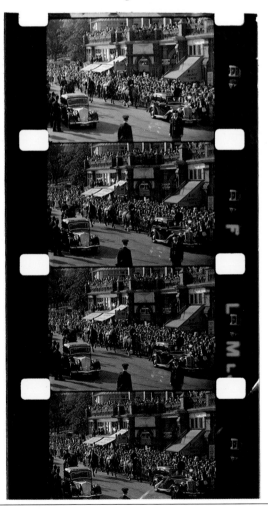

Some frames of 16mm Kodachrome that were exposed and processed between 1936 and 1938.

THE KODACHROME STORY

They either viewed the results by hand or wound them through one of the few projectors that were then available. It was Henry Staehle who did much of the design work required before Kodak introduced the world's first 35mm slide mounting service in 1939. At this distance, the introduction of such a service may not seem remarkable, but when it is remembered that the operation had to be highly mechanized if it was to be carried out without extra charge to the customer, then some idea of the difficulties will be appreciated.

Staehle tried several different kinds of mounts, made from brass, aluminium, plastic and cardboard. In the end he chose card, and the wisdom of the choice was confirmed by the fact that Kodachrome slides were returned to customers in cardboard ReadyMounts for almost another fifty years. A patent was granted protecting Staehle's mount, which was novel in that it provided a recessed area containing the frame of film with enough space allowed for expansion when heated up in a projector – thereby reducing the risk of buckling. Without a doubt, Kodak's decision to introduce a slide mounting service had a great deal to do with the subsequent popularity of 35mm colour photography.

BATCH PROCESSING

There is some evidence that early batches of Kodachrome film were segregated before being processed, so that any differences in their characteristics could be compensated by adjustments during processing. Bearing in mind that in the beginning, three successive machines were used to process the films, there were plenty of opportunities to ring the changes on development times.

However, as sales of Kodachrome expanded and new processing laboratories were established throughout the US and the rest of the world, (thirty of them by 1990) batch processing became impossible and was probably abandoned at the time the process was simplified in 1938.

(above) This type of card mount, with its recessed 'spacer', was patented by Henry Staehle in 1938 and was subsequently used by Kodak for almost fifty years.

(right) This Kodachrome film must have been processed after 1939, because it was returned in cardboard ReadyMounts. Reference to the Retina camera on the carton suggests that while the film was coated in Rochester, it was probably sold and processed in Europe, where Kodak's German made Retina cameras became very popular after their introduction in 1934.

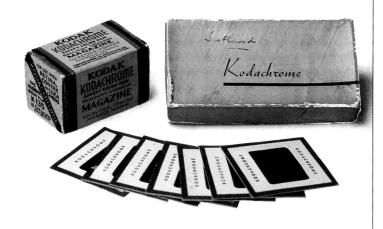

THE KODACHROME STORY

THE IMPACT OF KODACHROME

Kodachrome was so very different from all the earlier processes that its impact on some photographers was memorable. One of the first to use 35mm Kodachrome was Louis Marden, a young photographer working on the *National Geographic Magazine*, and he has told how sceptical some of the old hands were at the time.

Marden was a 'miniature' camera enthusiast with a Leica. After exposing his first cassette of Kodachrome he felt sure that it would revolutionize photography at the *Geographic* — if he could persuade his bosses to use it.

Having managed to get hold of a couple of cassettes even before the film was on the market, Marden exposed them on a wide variety of subjects, including some action shots that would have been impossible with an additive screen-plate process. When the rolls came back from Rochester, Marden separated them into individual frames and then bound them between lantern slide glasses before they were projected in a 2½in square projector. While Marden was delighted with the results and pointed out that the images showed no signs of any screen pattern and the whites were really white, his boss declared that – 'these things will never be worth a damn to the *National Geographic*.'

That judgement was soon reversed, because while the Geographic only used 62 Kodachrome exposures in 1938, the following year the total was 317. Not long after that the magazine decided to use Kodachrome exclusively and continued to do so for the next half a century.

CUT-SHEET KODACHROME

By no means were all photographers ready to convert to 35mm cameras in the 1930s, and it was to satisfy large-format users that in 1938 Kodak introduced Kodachrome in cut-sheet sizes.

A special automatic 'dip and dunk' processing machine must have been built at Rochester to handle Kodachrome in cut-sheet form. The films would have been clipped into individual frames before being transferred from one tank to the next by an automatically timed sequence of 'up and over' movements, a method that is still used for sheet and roll-film processing in many professional laboratories.

Cut-sheet Kodachrome was used by such famous photographers as Ansel Adams and Eliot Porter to produce some beautiful transparencies. However, over the years the difference between the superior image structure of Kodachrome and user-processed films like Ektachrome became less, particularly when judged in large formats, So, in 1955, production of cut-sheet Kodachrome ceased, because by that time, cut-sheet Ektachrome film, with its 'user processing' facility, was preferred by many professional photographers.

All 16mm and 35mm films were joined into long lengths before being processed in continuous machines of the kind used for motion picture processing.

SIMPLER PROCESSING

In 1938 a significant change in processing was introduced, because by then sensitizing dyes were available that would not only remain isolated in their respective layers, but would also retain their particular colour sensitizing properties after being through the first developer. This meant that instead of having to depend upon precisely controlled penetration of bleaching solutions, the red and the blue sensitive layers could be selectively re-exposed without re-drying the film, by using red and blue light followed by cyan and yellow colour development that could be allowed to penetrate the whole film. The middle, green-sensitive magenta image layer was made redevelopable by treating the film in a fogging agent such as borohydride.

Before 1938, Kodachrome transparencies were returned to the customer as uncut rolls, which were then viewed with projectors like this.

THE KODACHROME STORY

THE KODACHROME STORY

These important changes resulted in a reduction in the total number of steps from 28 to 18 and very probably improved the consistency of results.

In the mid 1930s, Karl Schinzel and his brother Ludwig, had patented the idea of selectively re-exposing individual layers of an integral tripack as well as many other aspects of manufacturing and processing multi-layer colour films. This group of patents, the rights to which the Schinzels assigned to Eastman Kodak, prompted the British Journal of Photography to make this comment in November 1939:

'A phenomenal event during the last few months has been the printing of forty specifications, comprising roughly 200 printed pages, on methods and materials for colour photography as proposed by Karl Schinzel, an Austrian (or so he thought) who has assigned his rights to Kodak. The specifications as a whole form an encyclopedia of information on materials for colour photography.'

Because of the extremely long time it took to process the original Kodachrome films, efforts were continually made to speed things up. Apart from the reduction in the number of steps made possible by the use of selective re-exposure, it was found possible in 1945 to halve treatment times simply by raising solution temperatures from 70°F to 80°F, although this change probably had to await improved hardeners for the film. Further changes were made in 1948 and again in 1961, when the film itself was redesigned and named Kodachrome II.

ANTI-TRUST ACTION

As more and more professional and amateur photographers came to use Kodachrome films, independent photo-finishers became increasingly concerned that all those films were being returned to and processed by laboratories established by Eastman Kodak and their companies throughout the world. Not unreasonably Kodak had thought that the processing of Kodachrome, with its dependence on the use of complex and expensive continuous machines, would be beyond the capabilities of the independent finisher. Nevertheless, the US Government thought otherwise, and in 1954 gave a judgement against Kodak, requiring them to cease selling Kodachrome films with the cost of processing included and to provide know-how and formulations to any bonafide photo-finisher. It has been estimated that about twenty companies took licences to process Kodachrome, including Pavelle Color in New York City.

Ten years later, when Kodak had nine Kodachrome processing stations in Europe, the corresponding British body, the Monopolies Commission, also ruled against both Kodak and Ilford, and those companies were required to release know-how to enable independent photo-finishers to process the films they manufactured. Only two British finishers ever undertook Kodachrome processing and they gave it up after only a few years. Even Kodak Limited ceased to process Kodachrome in England in 1985, sending customers' films by air either to a laboratory at Sevran in France or Stuttgart in West Germany.

However, in 1991, after much pressure from Kodachrome users in the UK, Kodak announced that they would re-establish a Kodachrome processing service in one of their subsidiary companies at Wimbledon near London.

IMPROVEMENTS IN SPEED AND IMAGE QUALITY

From the first, Kodachrome transparencies and amateur movie films were far superior to any of the earlier additive processes in almost all respects, yet they were by no means perfect. Perhaps

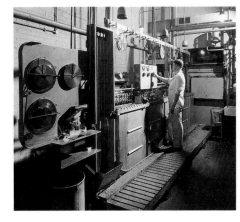
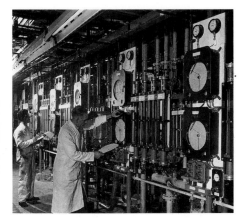

(left) John Hinde pioneered the use of colour photography for book illustration in the UK during the 1940s. His earliest books were a series entitled 'The Garden in Colour' for which he used cut-sheet Dufaycolor. There followed a series on 'British Ways of Life', which required pictures of live subjects, and for the first of these books – 'Exmoor Village' – Hinde used a Devin one-shot camera, but when it came to 'British Circus Life' he turned to cut-sheet Kodachrome.

(right) An early Kodachrome processing machine showing an operator adjusting the re-exposure lamps.

(far right) Rear of the machine showing solution controls.

THE KODACHROME STORY

the most serious shortcoming of early Kodachrome was the impermanence of the dyes which formed the images. In this respect the dyes chosen by the Lumières for their Autochrome plates were far superior, showing little sign of any change after three-quarters of a century.

However, after the Kodachrome process was changed in 1938, permanence was much improved and there are many examples of Kodachromes from the 1940s that are still in excellent condition. Throughout more than fifty years of production, many improvements were made to the quality of images recorded on Kodachrome films; starting with the use of two emulsion layers for each of the colour records. This change, which took place in 1961, was made possible by the use of an entirely new coating method invented by Russell and called multi-layer 'cascade' coating. Until that time, each of the three emulsion layers used for Kodachrome film was coated separately – a time-consuming and costly business. What Russell did was to make it possible to apply a number of very thin layers simultaneously.

The improved film was known as Kodachrome II and the necessary new process was designated K-12. Although the improvements were real, Kodak had a difficult time persuading users of Kodachrome I that they were better off with the new product, which now had a speed rating of ASA25 and produced sharper, more permanent and less grainy transparencies than the earlier product.

In 1962 an ASA64 version of Kodachrome was introduced – largely to fulfil the requirements of the relatively small aperture lenses used in the cheaper versions of Kodak's first 126 Instamatic cameras. This was not a particularly good film but twelve years later, in 1974, Kodachrome 25 and Kodachrome 64 were released and these did give better and more consistent results with a revised process called K-14.

PRINTS FROM KODACHROME TRANSPARENCIES

Although some keen amateurs were content to project their Kodachrome slides, there were many more who really wanted colour prints. Kodak was well aware of this requirement and worked out a reversal print material that would, in effect, yield Kodachrome images on an opaque base.

The new printing service was introduced in 1941 in two forms; Minicolor prints from 35mm slides and Kotavachrome prints from Kodachromes made on sheet film. Minicolor prints were either 2X (2¼in x 3¼in), or 5X (5in x 7½in) costing 75 cents and $3.50 dollars respectively. Kotavachrome prints could be any size between 8in x 10in and 30in x 40in, and these were made with the aid of a contrast mask to improve their quality. Both kinds of print were made on white pigmented acetate film base. Minicolor prints are still easily recognizable because they have round corners and no margins. Reversal printing normally results in black borders, so Kodak die-stamped all Minicolor prints and delivered then close-cropped. In 1945, three years after the introduction of Kodacolor, Mees estimated that some 4 million prints per annum were still being made from Kodachrome slides.

For a while early in the 1940s, Kodak seriously considered making a roll-film version of Kodachrome from which snap-shooters with box cameras could obtain colour prints from Kodak laboratories. Instead, Kodacolor negative roll-film was introduced two years later and neither Minicolor nor Kotavachrome prints were made after 1946, but similar prints, re-named Kodachrome prints and Kodachrome Professional prints, were produced until 1955.

KODACHROME AND THE MOTION PICTURE INDUSTRY

With the motion picture industry urgently seeking some way of dispensing with the expensive and unwieldly Technicolor three-strip camera, it was not surprising that in the 1940s many people

The image forming dyes in most early colour development films faded rather quickly, but great improvements in stability were subsequently made by all manufacturers.
(left) Anscocolor circa 1945 (Courtesy of Thomas T. Hill).
(centre) Early 1939 Kodachrome (Courtesy Library of Congress Collection).
(right) Agfacolor circa 1937 (Courtesy of Klaus B. Hendriks).

THE KODACHROME STORY

had high hopes that Kodachrome might provide the answer. Unfortunately, for a complete system at least three different films were required – a camera film, an intermediate film, and a release print film. It would also be necessary to sell the release prints at a price that would be competitive with Technicolor – 6 cents a foot at that time. With that requirement in mind, efforts were made to produce a mixed grain version of Kodachrome that would not involve multi-layer coating. Just how near the research departments of Rochester and Harrow ever came to a satisfactory mono-layer print film has not been reported and cannot be deduced from the patent literature.

In 1938, Dr. Herbert Kalmus, of Technicolor, was so sure that some form of single film would be used instead of the three-strip camera that he predicted — 'Within two years Technicolor will have done away with special cameras and be employing single strips of negative through any standard camera.' In 1944 Kodak did in fact make a special form of soft-gradation Kodachrome for Technicolor, who called it Monopack and processed it themselves. It was used for a film entitled *Thunderhead — Son of Flicka'* in the US, and another called *'Western Approaches'* in the UK.

However, all the films shot on Technicolor's Monopack (or ordinary Kodachrome) were invariably printed from separation negatives by Technicolor's dye-transfer process. In other words, using Kodachrome in any of its forms as a camera film made life easier, especially on location, but still provided no alternative to Technicolor for release printing. This remained the position, except in Germany, (see The Agfacolor Story p.152) until the introduction of Eastman Color in 1950.

16MM COMMERCIAL KODACHROME

In 1946 a soft-gradation 16mm version of Kodachrome, incorporating a silver mask, was introduced for commercial cinematography. The film was not intended for direct viewing, but only for the production of release prints. It remained in production until 1958.

OTHER KODACHROME-TYPE PROCESSES

After World War II, L.T. Troland's patent had expired and most of Mannes' and Godowsky's patents had very little time to run, so it was not long before several photographic film manufacturers began to produce Kodachrome-type films and processes. Some of them obtained licences from Eastman Kodak, while others simply proceeded independently. In Japan both Fuji and Konishiroku made 35mm versions of a selective re-exposure film as did Perutz in Germany and Dynacolor in the US. Gevaert in Belgium and Ansco in the US, produced Kodachrome-type films for the home-movie market under private labels, for processing by independent laboratories in the US.

'PROFESSIONAL' KODACHROME

In 1983, presumably as a result of some dissatisfaction with the stability of unexposed Kodachrome films, two 'Professional' versions of the film were introduced: one rated at ISO25 and the other ISO64. Kodak claimed that the two new films would be – 'as close to optimum color balance as possible when shipped, and will stay close to that "aim-point" as long as they are refrigerated and used by the expiration date.'

In 1986, an ISO200 35mm version of Kodachrome was introduced – some twenty-five times faster than the film launched in 1935.

It was announced in 1986 that Kodachrome would also be available in 120-size roll-film, something that had been considered and rejected as far back as 1940, although at that time it was the amateur rather than the professional whom Kodak had in mind.

Eastman Kodak introduced the world's first colour printing service using a multi-layer print material, when in 1941, they began to offer Minicolor prints from Kodachrome transparencies.

ILFORD COLOUR FILM 'D'

Ilford Limited, having been closely involved with the Dufaycolor additive process during most of the 1930s, decided in 1939 to sell their shareholding in Dufay Chromex Ltd. The commencement of World War II and demands for their aerial film prevented them from doing any further work on colour processes until 1946, by which time they had decided that they should attempt to devise a Kodachrome type reversal process rather than use the Agfacolor know-how that had become freely available. The film, introduced in 1948, was known as Ilford Colour 'D', and its distinguishing feature was the use of two 'barrier' layers between the three layers of emulsion. One of the barrier layers comprised colloidal silver and served as a yellow filter layer, while the other was formed from silver sulphide. Both layers were converted into silver in the first developer so that the outer and inner layers could be successively and separately re-exposed and colour developed to yellow and cyan images. The middle layer could then be re-exposed by using ultra-violet light. The procedure was protected by patents in the names of G.B. Harrison as well as C. Waller and H. Dickinson; although both Agfa and Kodak had been granted patents on the use of similar 'barrier' layers a few years earlier.

Like Kodachrome at that time, Ilford Colour 'D' had a speed of about ASA20 and it had to be returned to the manufacturer for processing. Because of slight manufacturing variations, it was necessary to segregate the film into batches and adjust the processing of each batch to yield optimum results. Quality was excellent, the image dyes were reasonably stable and for a while, the product achieved about 20% of the UK market.

ILFOCHROME

In 1962 the speed of Ilford Colour 'D' was increased to ASA32, its name was changed to Ilfochrome, and because the relevant Kodak patents had expired, the film could then be selectively re-exposed in the same way as Kodachrome. It was withdrawn in 1965.

AGFA'S WORK ON COLOUR FORMERS

It is likely that at least some people in the research laboratories of I. G. Farbenindustrie A. G. at Wolfen in Germany during the early 1930s were aware, from the patent literature and their Agfa-Ansco contacts at Binghampton in the US, that Eastman Kodak was working on a colour process that would depend upon some form of colour development. What they could not have known, because the decision was made only a few months before the Kodachrome process was announced, was that Kodak would choose to use a process of selective colour development by controlled diffusion, because they had found no way of anchoring colour couplers to individual emulsion layers.

In 1911/12 Rudolf Fischer had foreseen a multi-layer process using colour development. But he had left the Neue Photographische Gesellschaft and was operating his own photo-chemical company in Berlin by the time research staff of the Agfa Filmfabrik at Wolfen renewed work on colour development in the early 1930s.

(left) Ilford Colour Film 'D' was introduced in the UK by Ilford in 1948. The 35mm film differed from Kodachrome in that it incorporated 'barrier' layers that enabled the successive re-exposure of individual emulsion layers without the use of depth controlled development.

(right) Ilford changed the name and increased the speed of their colour film in 1962, calling it Ilfochrome 32.

THE AGFACOLOR STORY

As often happens with such discoveries, recognition of a possible way to immobilize a colour coupler within a layer of gelatine came by chance. Wilhelm Schneider was working on anti-halation dyes for the Agfa Filmfabrik at Wolfen when he discovered that the diffusion properties of the dyes he was testing depended more on their structure than on their molecular weight and that compounds with long, chain like structures were less likely to diffuse through a gelatine layer.

WILHELM SCHNEIDER AND GUSTAV WILMANNS

That was in 1935, at a time when Schneider was not supposed to concern himself with problems relating to colour photography. However, his boss, Gustav Wilmanns, encouraged him and together they patented ways of producing colour couplers that would 'stay-put' within an emulsion layer.

SUBSTANTIVE COLOUR FORMERS

The first public indication that the problem had been solved was seen in a patent issued in 1936 to I. G. Farbenindustrie Aktiengesellschaft, disclosing details of the structure of dye-forming compounds that would be fast to diffusion.

After acknowledging Fischer's work, the specification continued:

'For the production of faultless multi-coloured pictures it is necessary to fix the several dyestuff components each in its own layer and to prevent any diffusion into adjacent layers. The materials hitherto known do not fulfil this condition.

This invention is based on the observation that the diffusion of the dyestuff components may be minimized or completely suppressed by using as the component in the manufacture of the photographic silver halide emulsion a compound which has in the molecule an aliphatic carbon chain of more than 5 carbon atoms.'

According to Schneider, the organic chemical laboratories at Wolfen produced thousands of possible dye-forming couplers and made tens of thousands of trial emulsion coatings during the 1930s.

The first patent to disclose the use of a specific diffusion-fast colour former was issued in Britain and it referred only to a coupler forming the magenta image in the green-sensitive layer of an integral tri-pack. But by 1936 a complete multi-layer tri-pack was patented with couplers incorporating long chain molecules and stabilizing groups in all three emulsion layers. The couplers were specified as:

 para-capronly-amino-benzoyl-acetamino-salicylic acid

 1 hydroxy-2 carboxy-5 dodecoyl-amino napthalene

 and 1-(4' oxy-3 carboxy-phenyl)-3-(4' dodecoyl-amino)-
 phenyl-5 pyrazalone,

for the yellow, magenta and cyan images respectively.

COLOUR NEGATIVE

Just as Mannes and Godowsky worked on a multi-layer colour negative both before and after joining Eastman Kodak, Agfa were no doubt equally anxious to find an alternative to Technicolor, and they too obtained patents protecting a colour negative film that would use their new 'substantive' colour formers.

Agfa were well aware that simply to use a complementary coloured negative to print directly onto another, similar multi-layer material to produce a positive print would yield a rather unsatisfactory result because of the repeated use of the imperfect dyes that were available at that time. In order to minimize this problem, they proposed to use a 'false' colour negative; that is to say:

Wilhelm Schneider is generally considered to have been the main inventor of Agfacolor subtractive films, with colour couplers incorporated in their emulsions.

THE AGFACOLOR STORY

'a colour negative the colour of which deviates from the colour complementary to that of the object photographed and by suitable choice of copying conditions produces from this negative a copy in correct colour.'

No doubt there was some wishful thinking here, but the idea did recognize the fact that a colour negative, unlike a transparency, need not be a recognizable interpretation of what was photographed – a fact that made it possible for Kodak to utilize coloured couplers a decade later.

AGFACOLOR NEU

Although much work was necessary before an acceptable triad of substantive couplers was found, events moved extremely rapidly at Wolfen in 1935 and 1936. In 1935 alone, Agfa filed 450 patents relating to colour photography. Probably spurred on by the introduction of Kodachrome in the US in 1935, Agfa decided to introduce a multi-layer reversal film in 1936. They labelled it 'Neu' to distinguish it from the Agfacolor additive (screen-plate) product that was still on sale.

At the outset Agfacolor Neu was only available as a reversal film in 35mm cassettes, although a 16mm version was introduced in May 1937. Processing, which of course was much simpler than Kodachrome processing, was carried out by Agfa in laboratories

they established in Berlin, Prague and Vienna. Just before World War II, the film and processing became available in the UK, where a 36-exposure cassette of 35mm reversal film cost six shillings £0.30) including processing. In its original form Agfacolor Neu had a speed of 17° Scheiner – somewhat slower than Kodachrome at that time.

Agfacolor was officially launched by Professor J. Eggert in Berlin in October 1936 with Dr Rudolf Fischer present as the guest of honour. It was announced that besides the 35mm reversal film there would be Agfacolor films for the motion picture industry and Agfacolor paper for prints from colour negatives.

ANSCOCOLOR

Because there was close collaboration between I. G. Farben-industrie in Germany and Agfa-Ansco of Binghampton in the US, the American company was able to introduce Anscocolor, their version of Agfacolor Neu, in 1938. Production ceased on the outbreak of war in 1939 but recommenced when the company was taken over by the US Government in 1942.

AGFACOLOR AND THE MOTION PICTURE

It was clear from many of their early patents that Agfa intended to pursue the negative/positive route to motion picture release prints. However, there were many difficulties to be overcome before this

This early advertisement for Agfacolor 'Neu', stresses that the film requires no filters or special optics and the results can be projected with an ordinary projector.

THE AGFACOLOR STORY

aim could be realised. First, there was the problem of twice using imperfect dyes to obtain a print, disregarding the preferred practice of the industry to employ a third, intermediate negative, to permit the introduction of optical effects and protect the original camera negative.

Because it was not possible to make satisfactory intermediate negatives, it was the practice, whenever possible, to shoot each scene three times; one negative being stored for safety and the others serving to produce release prints. Dissolves and fades had to be made in the camera – in the same way as they had been in the earliest days of film production. Then there was the very real problem of producing long lengths of triple-coated film with the relatively slow and imprecise coating machines commonly used at that time.

A short film produced by the Agfacolor negative/positive process was shown at a conference of the German Society for Photographic Research in 1939 and soon after that UFA, the principal German motion picture production company, decided to adopt the system. They provided the necessary processing facilities by converting some of the black and white equipment already in their laboratories in Berlin. UFA produced a number of short advertising and documentary films for products such as 'Maggi' and '4711' Cologne; but wider use was inhibited by the very low speed of the negative material. After the speed of the camera material had been doubled with the aid of 'gold' sensitizing, a short feature film entitled *Ein Lied verklingt* was made and shown to an enthusiastic audience in Berlin in 1939. Bearing in mind that very few Technicolor films reached Germany after the outbreak of war, it was not surprising that the audience were ready to welcome a home-produced system. Other feature films followed, and perhaps the most famous of them was *'Munchausen'*: a production made on the instruction of Goebbels, the Minister of Propaganda.

These early Agfacolor motion pictures, the first to be made with multi-layer camera and print films, preceded Kodak's Eastman Color films by a decade and were therefore historic landmarks.

POST WAR INTELLIGENCE REPORTS

Immediately after the end of the War, parties of American and British experts visited the factories of the I. G. Farbenindustrie in Wolfen and Leverkusen and wrote a number of detailed reports on the production methods and formulas used in the manufacture of Agfa products in all their forms.

Two of these reports dealt specifically with Agfacolor films and Agfacolor papers, and from them it was learned that both films and papers required three passes through the coating machines and that the speed of coating was no more than 2 to 3 metres a minute for film, and 4 metres a minute for paper.

All of Agfa's early colour materials were coated on machines using the 'festoon' arrangement for drying either film or paper. This system, which dates from the earliest days of paper coating, automatically forms a continuous length of film or paper into a succession of loops that are suspended from 'sticks' which progress slowly through a drying chamber. This method of coating has the serious disadvantage that areas of slightly different sensitivity occur wherever a 'stick' causes a change in the rate of drying across the web of coated material. While these differences might not be too serious in black and white paper, they result in bands of colour changes when a multi-layer colour material is coated by means of three passes through such a machine.

Apart from 'stick' marks, the imprecise method of 'dip' coating used at that time inevitably led to colour balance differences between batches, which had to be compensated for at the time of release printing – a costly business. As a result, it was estimated that the yield of usable Agfacolor print film was no more than 70%.

"Munchausen", one of the most important films shot on Agfacolor negative material during World War II, was made in 1943, on the instructions of Goebbels, to celebrate the jubilee of the UFA film production company in Berlin.

THE AGFACOLOR STORY

Agfa technicians at Wolfen were well aware of these short-comings and towards the end of the War they constructed a coating machine with an entirely new drying system. the new design depended upon the film being rigidly supported by a large drum, so that hot air at high velocity could be used to cause rapid evaporation and so prevent re-melting of the emulsion. At the time the new machine was built, Agfa had no plans to coat more than one emulsion at a time and were simply concerned to make single layer coatings as quickly as possible.

At Binghampton in the US, Agfa-Ansco solved the problem by using a machine in which a web of coated material was transported horizontally in a 'straight-away' path through a drying box.

WOLFEN AND LEVERKUSEN

While the factory at Wolfen was mainly concerned during the War with the production of Agfacolor negative, positive and reversal films, work on Agfacolor paper was carried out at Leverkusen under Dr. Erwin Trabert. The first public evidence of the capabilities of the colour paper was seen in Dresden in 1942 during a conference of German Research Associations, when some very impressive 20in x 24in Agfacolor enlargements were exhibited.

After the War Wolfen found itself in the Russian-controlled zone, and eventually had to add colour paper production to complete its Agfacolor range. Conversely, Leverkusen had to turn its attention to producing Agfacolor films as well as colour paper.

After 1954 all Agfa products made at Wolfen were renamed ORWO (Original-Wolfen).

PRODUCT IMPROVEMENTS

The first Agfacolor negative film produced at Leverkusen was released in 1949, but it was not until 1952 that they produced their first reversal film.

Once the radical post-war reorganization had settled down, a steady flow of improvements were made to the whole range of Agfacolor films and papers. Speeds of the camera films were significantly increased, so that by 1956, Agfacolor Negative (CN17) had reached ASA40 – which was not far from the speed of a typical black and white film of that time. In the same year the speed of Agfacolor Reversal Film (CT18) was increased to ASA50. The reversal films for home movies were slightly slower at ASA16 and ASA32 for the daylight and artificial light versions.

The sharpness of prints made on Agfacolor paper was significantly improved by rearranging the relative positions of the three emulsion layers, so that the red-sensitive (cyan image-forming) layer was on top of the tri-pack with the blue-sensitive (yellow image-forming) layer next to the paper base. This idea had been patented by Schneider in 1939.

An Agfacolor Reversal paper, for prints from transparencies, was first introduced in 1962.

PROCESSING AND PRINTING ARRANGEMENTS

Although the processing of both Agfacolor negative and reversal films was relatively straightforward, there remained the problem of printing from colour negatives. Nowhere in the world, outside Eastman Kodak's laboratories in Rochester, was there any experience of making colour prints from colour negatives. For that reason Agfa felt able to release the processing of their reversal films (both 35mm and 16mm) before they were prepared to release colour paper and chemistry. Instead, they decided to appoint a limited number of processing stations until 1951, when it was decided to widen the circle of authorized processors to allow professional photographers to undertake their own processing and printing; but only after they had attended an approved course of instruction. In the UK the course was run by the International

Several teams of American and British scientists and technicians visited Leverkusen and Wolfen directly after World War II and wrote reports on Agfa's methods of film and paper production.

THE AGFACOLOR STORY

School of Colour Photography at Edenbridge in Kent. A limited number of photofinishers were also appointed in Europe, and five of them in the UK.

At that time Agfacolor negative films and the prints made from them were produced by methods and with equipment that were almost exactly the same as those used to make black and white prints. There were no continuous film or paper processing machines, and all the prints were made on separate sheets of paper exposed in ordinary enlargers fitted with some form of filter adjustment and processed in dishes or tanks.

SUBSTITUTE FORMULAE

In the early 1950s Agfacolor reversal films were still being sold with the cost of processing included and exposed films could be returned to Agfa's laboratories in Denmark, Holland, Germany, Switzerland or the UK. However, this did not alter the fact that in those days many photographers preferred to process their own films. Consequently a few keen experimenters, H. Gordon, E. Gehret and C. L. Thomson among them, devised formulations that could be made up and used by the amateur to produce quite satisfactory results.

The first collection of such substitute processing recommendations appeared in the *British Journal of Photography* in August 1953 and similar formulas became a regular feature in the *British Journal of Photography Almanacs* and *Annuals* thereafter.

UNION OF AGFA WITH GEVAERT

In 1964, after a decade of close co-operation, German Agfa and Belgian Gevaert, the two largest manufacturers of photo-materials in Europe, joined forces. Gevaert had already been producing colour paper based on Agfa formulations, but after the union they began to concentrate on films for the motion picture industry.

At first they produced Agfacolor CN5 negative film, but the success of Kodak's masked Eastman Color film (see section on Eastman Color) compelled Gevaert to devise a masked product of their own in 1968. However, it was not until 1969/70 that Gevaert was able to produce a print film that required the same processing as Eastman Color positive. The first Gevacolor negative film to be compatible with Eastman Color negative was ready in 1974 – some 30 years after Kodak had patented the idea of coloured masking couplers. After that neither Agfa nor Gevaert made materials with the kind of couplers Schneider and Wilmanns had discovered 40 years earlier.

OTHER MANUFACTURERS OF AGFACOLOR-TYPE PROCESSES

Publication of the several British and American Intelligence Reports based on visits to Wolfen and Leverkusen immediately after World War II meant that any photographic manufacturer was free to produce its own versions of Agfacolor products. Most of them opted to make a reversal film – probably because it could be sold without requiring a counterpart colour paper and some kind of printing service.

The companies that took advantage of Agfa's know-how included: GAF in the US; ICI in England; Ferrania in Italy; Valca in Spain; Tellko in Switzerland; and Fuji, Konishiroku and Oriental in Japan. What none of these organizations knew at the time was that all Agfa-type materials would eventually give way to films and papers using the type of coupler Eastman Kodak devised to compete with Agfacolor in the first place.

Although it is not history, it is tempting to speculate that had there been no World War II to bring about the separation and disruption of Wolfen and Leverkusen, it seems likely that an Agfacolor negative/positive print process would have been established in Europe before Kodacolor was ready in the US.

THE KODACOLOR STORY

Wesley T. Hanson, who worked for Eastman Kodak for 43 years and was in charge of research from 1972 until 1977, has said that around 1940, Kodak:

'Came very close to marketing Kodachrome roll-film and prints, but Kodacolor film and paper came along at just the right time; they provided much simpler processing, both for the negatives and the prints.'

Hanson was referring to a Kodachrome in its negative form, together with a silver masking image that would have added anothert 15 processing steps to make a total of 43!

Mannes and Godowsky had already obtained several patents on negative films that would be processed by the controlled penetration of a sequence of colour developers and then used to produce prints on a second, similarly processed positive material. But as Hanson also said – 'I shudder to think about the problems had we tried to market such a complex process.'

Kodak's research staff at Rochester were aware that Agfa had discovered long-chain diffusion-fast couplers in 1935, they nick-named them 'oily tails', but knew that an alternative way of incorporating couplers in emulsion layers would have to be found if they were to produce multi-layer colour materials that would be as easy to process as Agfa's colour films and papers.

According to Hanson, it was in 1939 that Paul Vittum and Edwin Jelly discovered that 'shorter chains of five carbon atoms each worked even better than Agfa's formulas.'

The relevant patent reads:

'Certain water-insoluble colour couplers are mixed with "oil formers" so that a liquid solution results which is then dispersed in a gelatine silver-salt emultion in the usual manner.'

A couple of years before Vittum and Jelly disclosed their ideas, Michael Martinez, whose tri-pack patents had led to the formation of Colour Photographs Limited in the UK back in 1928, obtained a quite different patent protecting the incorporation of a colour coupler in a resinous binder.

In brief, Martinez's 1937 patent read:

'In order to minimize the diffusion of a colour former from the emulsion layer in which it is incorporated into another layer or into the colour developer, it is localized by means of a natural or artificial resin not chemically combined but in intimate physical association. The mixture is prepared by dissolving the resin and the colour former in suitable organic solvents and incorporating the solution in an aqueous gelatine solution or directly in a silver halide emulsion.'

In 1940, while he was in an internment camp on the Isle of Man, Martinez was granted another patent for a mixed grain monolayer colour film, and Kodak must have considered that because the proposed procedures were sufficiently close to what they expected to do, they should obtain rights to the Martinez patents.

Also in 1940, D. J. Howe, a research chemist working for Elliott & Sons, a small British manufacturer of plates and films, was granted a patent covering the use of synthetic resins for the protection of colour couplers. Howe acknowledged Martinez's earlier patent and then described his own idea, which was to use either 'Glyptal' or 'Paralac', two synthetic resins made by ICI, to 'form a solution of the resin and colour former in a common solvent and precipitating therefrom a mixture of resin and colour former in intimate physical association but not combined.'

Barnet, Elliott & Sons' trading name, did produce some simple single-layer colour development papers rather like the Chromal

THE KODACOLOR STORY

papers made by the Neue Photographische Gesellschaft in 1913; but they never used their couplers in a multi-layer product.

Because it was similar to their own line of activity, Kodak also acquired the rights to Howe's patent.

With the patent situation tidied up, Kodak was ready to launch the Kodacolor process; the first complete system of colour photography to use the type of colour coupler that would one day become the norm throughout the photographic industry. In 1941 the vast majority of amateur photographers were still using roll-film cameras and they were the people for whom the new process was intended.

Kodacolor was announced in December 1941 and launched early in 1942. The press release was positive, claiming the new process to be 'the greatest achievement in photography since George Eastman pioneered and introduced roll film in 1889.'

Since no photofinishers in the US had any experience of handling colour negatives, exposed Kodacolor films had to be returned through a camera store to Rochester to be developed and printed, just as the first Kodak black and white films had been half a century earlier.

PHOTOFINISHING IN COLOUR

Kodak had already gained some experience of making large numbers of colour prints from Kodachrome transparencies, but the task of making prints from colour negatives was far more difficult. Special printers had to be designed and built to assess auto-matically both the amount and colour of light required to expose each negative so that an acceptable colour print would result. Kodacolor films were developed by a process known as C-22 which took about 50 minutes and remained in use until 1955. Customers were charged one dollar for processing a film and 30 cents for each print made on paper 3-1/2 inches wide – the other dimension

Full-Color Snapshots

OF YOUR FAVORITE SUBJECTS

WITH Kodacolor Film—the most important news in photography since Kodak introduced roll film—full-color snapshots are as simple and easy to take as ordinary pictures.

You load Kodacolor Film in any of the most popular size roll-film cameras*... expose it in bright sunlight ... and then send it back through your dealer for developing and printing ... all just as in black-and-white picture taking.

When your processed Kodacolor negatives and the Kodacolor Prints you order—are returned from Kodak's laboratories to your dealer for you, you will have pictures in full color—like those you have seen reproduced in books and magazines—of your own favorite subjects ... friends, family, landscapes, gardens, and activities. And these pictures will be big full-color photographic prints on paper—which you can place in albums...pass around ... or mail to those away in service. You can order extra prints, too. See your dealer for full details, and a roll of Kodacolor Film.

A 1946 advertisement for Kodacolor roll-film and prints. The small print at the end of the text reads: 'snapshots should be made under conditions of bright sunlight and with the largest lens opening.'

THE KODACOLOR STORY

depending upon negative format.

All these entirely new operations represented the beginnings of photofinishing in colour and are dealt with in a later section.

KODACOLOR NEGATIVE FILM

The speed of the original daylight Kodacolor film was ASA25. It was a basic three-layer material incorporating no colour or contrast correction masks and using couplers that resulted in unstable dyes and rather degraded colour prints. Nevertheless, Kodacolor was a success from the start and Kodak's research staff immediately set to work to find better couplers and faster emulsions. It has been reported, and the patent literature confirms, that a team under Arnold Weissberger made and tested thousands of different colour formers during the next few years in the search for better colour reproduction and more stable images.

CONTRAST MASKS

Because the early image dyes used for Kodacolor negative film were far from perfect, the contrast of the negatives had to be high in order to achieve reasonable colour saturation in the prints. The result was high tonal contrast leading to frequent loss of highlight and/or shadow detail. A partial solution to this problem was found by incorporating an additional black and white image layer in which a negative image was automatically generated during development. This kind of negative silver image mask was used in Kodacolor films from 1944 until 1949; after which coloured coupler masking was introduced.

Hanson was responsible for introducing coloured couplers in Kodacolor film and he has told how it came about:

'Lying in bed one night in February of 1943, I thought if you had a coupler itself colored and you destroyed that color when you made the dye, then you had an automatic mask right there. I got up the next morning and wrote down that idea, then I went into the labs and told Paul Vittum. He said, "I think we've got something on the shelf that might do it." So that same day we ran an experiment and, sure enough, it was colored and it was a coupler and it worked.'

Other people before Hanson had been aware of couplers that were themselves coloured. In 1938 R. B. Collins and J. D. Kendall of Ilford Limited had in fact patented coloured couplers, but their patent contained no suggestion that such couplers could be used to provide a masking image. R. W. G. Hunt, in his book *The Reproduction of Colour*, says of coloured couplers used for masking that – 'the credit for their introduction must be shared by the Research Laboratories of the Eastman Kodak Company and the General Analine and Film Corporation (GAF), who filed the first patents on the subject on the very same day!'

Hanson's basic patent has been summarized succinctly:

'To eliminate the necessity of using a separate mask for colour correction, at least one of the dye layers has incorporated in it a dye which cancels out the minor, unwanted colours absorbed. The dye is so chosen that, upon coupling, it changes to a complementary colour of the main colour former in the emulsion layer.'

In fact this represents an oversimplification of the system, as Hanson and Vittum made clear in another patent:

'In the use of coloured couplers whose original colour is destroyed during coupling, it is important that the light absorption of the uncoupled coloured coupler should be equal

THE KODACOLOR STORY

to the light absorption of the fully coupled colour coupler in the regions of the spectrum where correction is required. The present invention achieves this result by a suitable mixture of a coloured coupler and an uncoloured coupler, both of which give the same hue after coupling, the proportions of the mixture being chosen to obey the above requirements.'

The GAF patent, while having the same objective, reached it in a different way; it described a process:

'for producing negatives for colour photography in which there is uniformly distributed in at least one of the layers capable of forming the cyan and magenta negative images, an azo dye capable of producing a positive dye image in the layer by treating with a bleaching bath that does not affect in an irreversible manner, the dyes produced by colour development.'

In an address to the Society of Photographic Scientists and Engineers in 1984, Hanson outlined some of the work that was carried out in the 1950s and 1960s by the Research Departments at Rochester to improve the performance and quality of Kodacolor film and prints, as well as allied colour products.

He explained that:

'The quality of the photographic image results from dozens of interdependent qualities. One of the most intriguing is the simple issue of sharpness. One of the things that influences the sharpness of photographic images is the scatter of the light as it penetrates the emulsions. The thicker the emulsion, the more grains there are in it, the more light scatters, and the poorer the sharpness. Through the years sharpness has been increased tremendously by learning how to coat the layers more thinly. Not only did this involve the mechanics of coating but it also involved the structure of the couplers and their activity so that the smallest amount of coupler could be used. These advances and other developments made possible Eastman Color negative film and the Eastman Color motion picture system.'

Another shortcoming of early Kodacolor film was that, because of its high contrast and simple construction, it had hardly any

W. T. Hanson considered that the introduction of the Instamatic 126 camera and cartridge in 1963, did more than any other development to bring colour photography to the mass market.

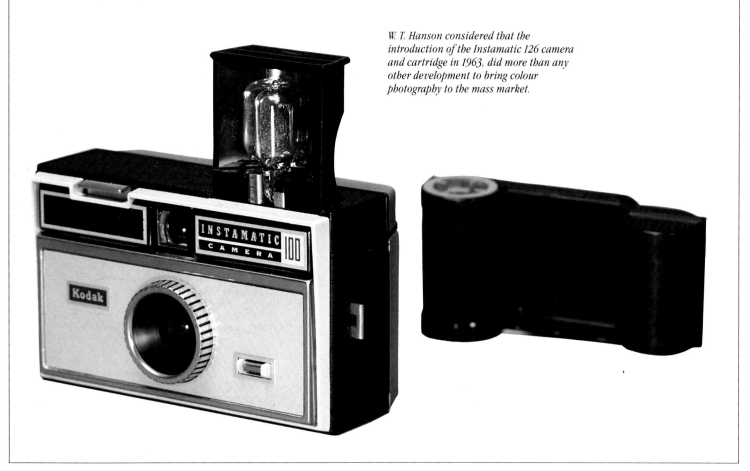

THE KODACOLOR STORY

more exposure latitude than Kodachrome. It was not until the 1950s that the introduction of new multi-layer coating techniques allowed the use of double-coating for each colour record, and both speed and latitude were improved.

35MM KODACOLOR

A 35mm version of Kodacolor did not appear until 1958, some sixteen years after it had been launched in roll-film sizes. There were probably two reasons for the delay. First, the graininess of the early films was too coarse to allow printing from 35mm negatives. Secondly, the colour printers in Rochester were designed to handle roll-film negatives after being cut into individual frames, a procedure that would not have been possible with strips of 35mm negatives.

INSTAMATIC 126

Hanson was undoubtedly correct in stating that the introduction of Instamatic 126 films in 1963 did more than any other marketing step to popularize the use of Kodacolor film throughout the world. The cameras were cheap, easy to load and easy to use, while the cartridge-loaded films were all rated at ASA64 – making it possible to obtain good results under a wide range of conditions.

ANTI-TRUST ACTIONS

Before the Instamatic landmark, an earlier event had changed the way in which people in the US had their Kodacolor films processed and printed. In 1954 the US Supreme Court ruled that Eastman Kodak could no longer sell any of their colour film with the cost of processing pre-paid. Prior to that time, most colour films had been sold together with a mailing bag in which the exposed spool was returned to one or other of Kodak's laboratories.

The Anti-Trust ruling also required Kodak to make processing formulas and know-how available to any bona-fide photofinisher who wanted to undertake the processing of Kodachrome or Kodacolor films. It was difficult for Kodak to comply quickly with the Anti-Trust ruling and the transfer of colour processing to independent laboratories took some time, but eventually it happened and while Kodak continued to offer processing services in most countries, their share of the business became relatively small, although there were 10 Kodak processing laboratories still operating in the US during the 1960s.

KODACOLOR II

The success of Instamatic cameras and films in the 126 format encouraged Kodak to launch another generation of Instamatic cameras using less film and a smaller image format. This step was taken in 1972, with the introduction of Instamatic 110 cameras and cartridges. It was made possible by a further significant improvement in the sharpness of Kodacolor film, which was then renamed Kodacolor II. Kodak reckoned that the 16mm wide film used in Instamatic 110 cameras permitted 7x enlargements to be made that were equal in quality to the 3x enlargements made from 126 Kodacolor X negatives on film 35mm wide. Kodacolor II required different processing so C-22 was phased out and the C-41 process soon became and is still the standard for colour negatives throughout the world. Processing time was reduced to 18 minutes – dry to dry.

DIR COUPLERS

The improved resolution and better colour reproduction of Kodacolor II came about after the discovery of the benefits that could result from using a new form of colour coupler. A development-inhibitor-releasing (DIR) coupler is one which, during the coupling reaction to form a dye, splits off a fragment that then acts to inhibit development. The early work on DIR

Cross sections (1100 X magnification) of a swollen Kodacolor II film, (right) before colour development and (far right) after removal of all silver. The slight pinkish colour of the bottom layer and the yellowishness of the middle layer are due to the presence of coloured masking couplers in those emulsion layers.

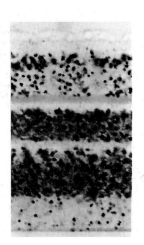
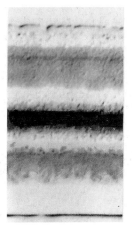

THE KODACOLOR STORY

couplers was done in Rochester by Charles Barr, who discovered that inhibitors could be released in proportion to image production, thereby providing a potential masking mechanism. He also found that they could be used to induce an edge enhancement effect, not unlike those previously seen with black and white negatives under certain conditions of development. But, as Hanson said, 'releasing such an active fragment during development plays havoc with the results. It took many years of research to get such couplers under control.'

KODACOLOR DISC FILM

In 1982, Kodak went a step further towards even smaller negative formats by introducing their Disc cameras with a range of Kodacolor HR films rated at ASA100, ASA200 and ASA400. Subsequent events showed that this was a step too far. The size of each negative image in a disc film was 11mm x 8mm – hardly more than one-tenth of the area of a standard 35mm frame – which meant that 10x enlargements had to be made to produce a print on 3-1/4 inch wide paper.

In an impressive presentation to the Photofinishing Industry early in 1983, Kodak Research and Marketing staff explained the philosophy of what they called 'decision-free' photography. But in the event, many disc films were exposed in cheap cameras and were processed and printed by independent finishers who did not have the six-element lenses that Kodak had specially designed for disc printing. Consequently many prints made from disc films were unsharp and people observed that even when prints were sharp, the 10x enlargement often revealed the grain of the negatives.

That such criticisms were probably justified was confirmed when Kodak announced in 1987 that they would be making no more disc cameras. Meanwhile, compact 35mm cameras had become available, so that the small size of the disc cameras was no longer important.

KODACOLOR PAPER

It would have been of little use continually improving the performance of Kodacolor films if the paper on which the negatives were printed was not improved at the same time. When roll-film Kodacolor was introduced in 1942, the negatives were printed on a simple three-layer colour paper with the red-sensitive (cyan image-forming) layer next to the paper base and the blue-sensitive (yellow image) layer on the outside. The trouble with this arrangement is that the cyan image, which has to provide much of the modelling in a picture, is relatively unsharp because image-forming light is scattered by the two emulsion layers above it. The answer was to rearrange the layer sequence so that the red-recording emulsion was on top and the blue record nearest the base. This was achieved by eliminating the yellow filter layer and ensuring that the blue sensitivity of the bottom emulsion, next to the paper base, greatly exceeded the native blue sensitivity of either of the other two layers. This change was made with the introduction of Kodacolor Type III paper in 1954.

Kodacolor Types I, II and III were used exclusively by Kodak for making prints from amateurs' negatives until 1955 when 'Type C' paper was made available to photographers using Ektacolor sheet film – a professional version of Kodacolor introduced in 1948 and

Kodak's Disc cameras and films were introduced in 1983. The area of a disc negative was little more than one tenth

the area of a standard 35mm frame. Production of the disc cameras ceased in 1987.

THE KODACOLOR STORY

originally intended to provide separation negatives for subsequent printing by the Dye-Transfer process. After 1959 Colour Print Type C became known as Ektacolor paper in accordance with a ruling laid down by Mees, that:

'The prefix "Koda" – is to be used for materials processed by the company and "Ekta" – for those to be processed by the user. The suffix – "chrome" is to be used for reversal materials and – "color" for non-reversal materials.'

This dictum could not be strictly observed because as the variety of their colour negative materials increased, Kodak films began to appear with names such as Vericolor and Ektapress, one version of which was rated at ISO1600 – some sixty times faster than Kodacolor in 1942.

R. L. Heldke, L. H. Feldman and C. B. Bard described the evolution of Kodak's colour negative print papers in a paper presented to the SPSE in July 1984. As well as explaining the improvements in colour reproduction, sharpness and image permanence that had been achieved during four decades of production, they also showed how processing had been shortened and simplified. In 1942 the original P-122 process required 7 solutions and took 50 minutes before the paper was ready for drying.

Resin coated paper (Ektacolor 20 RC) was introduced in 1968, after which wet processing time was reduced to 20 minutes and drying only added another minute or two.

In 1976, Kodak introduced the EP-2 process, requiring only 2 solutions (plus wash-water) and 8-1/2 minutes of wet processing. At the conclusion of their paper the authors took the opportunity to point out that 'the price of a 3R print from a Kodak Processing Laboratory has been held approximately constant in current dollar terms since 1942. This was achieved in face of inflation that has reduced the purchasing power of the dollar in real terms by more than a factor of six.'

EASTMAN COLOR MOTION PICTURE FILMS

In *'Journey: 75 Years of Kodak Research'*, the editors, writing about Dr. Wesley T. Hanson, say that 'when he returned to Rochester in May 1945 (after being seconded by Dr. Mees to work on the Manhattan Project), he resumed research on color motion picture processes and, working closely with Nick Groet, he eventually saw his invention of the colored coupler masking process reach fruition in Eastman color negative film.'

Before he had left Rochester to work at Berkeley and Oak Ridge, Hanson thought it might be possible to use Kodachrome as a professional motion-picture process, but he had met serious problems. Although original Kodachrome camera film was excellent, the contrast and colour reproduction of first and second generation copies were poor. Yet such duplicates were necessary in order to produce special effects and to protect the original film from wear and tear.

Hanson therefore concluded that it would be more satisfactory to use a motion-picture version of Kodacolor negative together with a film-based version of Kodacolor (Ektacolor) paper, for making release prints. The earliest experiments along these lines were made by Nick Groet, who in 1948, persuaded the laboratory studio to expose a length of 35mm Kodacolor negative film, which he then printed onto an Ektacolor type print film.

In terms of colour and tone reproduction the result was better than anything previously achieved, but sharpness and graininess were quite unacceptable. It was found that the poor resolution resulted from light being reflected from the coarse grain yellow image-producing layer at the bottom of the tri-pack, exposing the two upper layers a second time, causing a fuzzy double image.

THE KODACOLOR STORY

Groet, who then embarked on a single-minded crusade to solve this shortcoming, hit upon the idea of incorporating soluble magenta and cyan dyes in the two upper emulsion layers to absorb any reflected green or red light.

Another problem that Groet tackled and overcame, was the tendency of couplers to produce disproportionately large amounts of dye from a given amount of silver, thus making it impossible to use sufficiently high silver coating weights to produce fast films. To prevent the formation of excess dye, Groet introduced couplers that would compete for part of the available silver without producing dyes. This concept of 'coupler starvation', not only allowed the use of higher silver coating weights, but also made it possible to use pairs of fast and slow emulsions for each colour record, so improving speed and granularity still further.

There remained one other major problem – the cost of coating multi-layer films in the vast quantities required by the motion-picture industry. It was one thing to be able to make an adequate return on films sold to the professional or amateur photographer, but quite a different matter to produce millions of feet of both negative and positive colour films at prices that would be competitive with Technicolor. In fact, towards the end of the 1940s, one or two films were shot on Eastman Color negative and printed on Eastman Color positive stock; the first, entitled *Royal Journey*, was made by the National Film Board of Canada. Eastman Color negative film was also used by some production companies to produce camera records from which separation positives and then negatives could be made for subsequent printing by Technicolor's dye-transfer process.

It was the discovery by Theodore Russell of a way to coat multiple layers of emulsion simultaneously that really made possible the commercial production of Eastman Color films. Russell's invention is discussed in 'Coating Techniques' (p.173).

Eastman Color negative film began to be sold on a large scale in 1950, when it was designated Type 5247. Its speed was about ASA25 to tungsten light and ASA16 in daylight. That product was followed by a succession of improved versions until by 1972, Eastman Color Type 5257 had much improved sharpness, reduced graininess and a speed of ASA100 to tungsten light.

EASTMAN COLOR PRINT FILMS

From their inception, the print films intended for use with Eastman Color negatives had a layer arrangement that placed the green-sensitive (magenta image-forming) emulsion on top and the blue-sensitive (yellow image-forming) layer next to the film base. The original positive stock was known as Type 5281 and at that time Kodak claimed that better contrast and colour reproduction would be obtained if the film was exposed by additive red, green and blue light rather than filtered 'white' light. However, within three years an improved film (Type 5382) was introduced for printing with filtered tungsten light. Further improvements in speed, sharpness and colour rendering followed and, in 1974, Type 5383, with its greater emulsion hardness, allowed the introduction of higher processing temperatures and a shorter process.

INTERMEDIATE FILMS

The Eastman Color motion-picture system could not be said to be complete until an intermediate film was introduced in 1968. Only then did it become possible to produce a duplicate colour negative in a single printing and reversal processing operation.

From its introduction in 1950, the Eastman Color system of professional colour cinematography dominated the industry and, although several other manufacturers produced similar negative and positive motion picture films, they were all designed to be compatible with processes already established by Eastman Kodak.

ANSCO COLOR

Ansco Color Reversal film, made by Agfa-Ansco Inc., in Binghampton, NY, first appeaared in the US in 1938 and was the result of a pre-war link (formed in 1924) between the American I. G. Chemical Corp. and the I. G. Farbenindustrie in Germany. During the years immediately preceding the war, Ansco had been granted a number of key patents that effectively prevented any other US company from making Agfa type colour films or papers. In 1942, after America had entered the war, Agfa-Ansco was taken into the custody of the US Government, by which time it was known as the General Analine and Film Corporation (GAF). In 1943 the Ansco Color process was fully described in *The Ansconian*, but at the same time it was stated that – 'For the present, the entire production of Ansco Color film is being supplied to the United States Government, the armed forces and our allies, and the film is NOT available for civilian use.'

It was not until 1946 that Ansco Color reversal film was released to the public under the name Anscochrome. Alongside the reversal film, Ansco also introduced a reversal colour print material for making prints from transparencies. The new material was called Ansco Color Printon, and like Kodak's Minicolor prints, it used a white pigmented acetate base instead of paper. The base material was the only thing that was common to the Kodak and Ansco processes, since Minicolor prints were produced by a version of the Kodachrome process while Printon material could be processed by the user. Ansco's Printon process was subsequently adapted for large scale operation by Pavelle Color Inc. In New York and that enterprise is described in the section on photofinishing.

SUPER ANSCOCHROME

Super Anscochrome, with a speed rating of ASA200, was the fastest colour film available when it was introduced in 1957. The film was used during the first American space flight in 1963. But despite such achievements, by 1973 GAF brought an action against Eastman Kodak under the Anti-Trust laws, claiming that 'The amateur photography market had long been dominated by Eastman Kodak and it has become impossible to compete in the domestic market.' The suit was not heard until 1982, by which time

Ansco Color Film was launched in the US in 1946 and was the first subtractive type colour film to be made available in that country for 'user-processing'.

GAF had relinquished their consumer photographic businesses, but a settlement was reached and Kodak paid GAF $9.5 million while GAF assigned more than a hundred patents relating to photography to Eastman Kodak.

ANSCO PLENACOLOR

Although they achieved considerable success with the 'print from slide' service using Printon reversal material, Ansco must have recognized the greater potential of a colour negative system, because in 1949 they produced their answer to Kodacolor by launching Plenacolor. Like Kodacolor at that time, Plenacolor could not be processed by the user, but had to be returned to a specified laboratory – in this case Pavelle Color in New York where colour paper made by Ansco was used to produce the prints.

Although it owed much to Agfa's work in Germany, Ansco's Plenacolor was original in that it incorporated a colour masking system to correct the performance of the cyan and magenta dyes.

The masking images were formed by series of somewhat complex steps following colour development but preceding fixing and bleaching. With the three colour images formed, the film was exposed to blue light and then developed in a normal (not coupling) developer which resulted in silver being formed throughout the blue-sensitive layer. The film was then dyed in a yellow azo dye before being treated with a silver dye-bleach bath to remove the yellow dye wherever there was silver, that is wherever magenta or cyan images had been formed as well as the whole of the blue-record layer. Removal of the residual silver then left a combination of original and masking images.

Perhaps because its processing was complicated and difficult to control, Plenacolor did not achieve any sustained success and when Kodacolor processing and printing was released in 1954, Pavelle Color was one of the first independent laboratories to adopt it.

EKTACHROME

In 1946, four years after introducing Kodacolor roll-films to the amateur, Kodak launched Ektachrome, their first coupler-containing reversal film, for user processing. The new film, which had already been used and processed in the field by the US Air Force, was rated at ASA8 and it was processed to a positive in E-2 chemistry, involving 14 steps and 50 minutes of wet treatment at 75°F. In 1963 a new generation of ASA64 Ektachrome films, with the suffix 'X' was introduced together with the E-4 process. Further improvements were made in 1976, with the introduction of Ektachrome Professional films, requiring to be processed in the E-6 chemistry, thereafter used for all Ektachrome films and involving a sequence of 9 steps totalling about 30 minutes with both developers at 100°F.

By 1990 there were some nine different versions of Ektachrome films available, ranging in speeds from ISO50 to ISO1600.

ORWOCOLOR

East Germany and Russia should have found it easier than other countries to produce Agfacolor-type materials after World War II. They had the Wolfen plant and were able to utilize Agfa's know-how more quickly than any other manufacturer. Most of the colour film produced at Wolfen after the war was used by the East German film industry, particularly the production company DEFA which took over the UFA studios in Berlin.

By 1954 Wolfen was producing both reversal and colour negative films for use in still cameras. They were called ORWOchrom and ORWOcolor; ORWO standing for Original Wolfen. Orwo was still producing Agfa-type colour films in 1990, long after almost every other photographic manufacturer had accepted the necessity to produce colour films that would be compatible with the processing required for Kodacolor and Ektachrome.

(left) This photograph of the Earth was taken from the Apollo 17 spacecraft on special thin-base Ektachrome. The view extends from the Mediterranean to Antarctica.

(right) This action shot by Jack Eston of Pat Smythe riding 'Leona', in 1952 was remarkable at a time when the speed of Ektachrome was only ASA8.

FERRANIACOLOR

It is not widely known that Ferrania SpA was selling a 35mm colour reversal film in Italy before the end of World War II. Although that film seems to have been similar to Agfacolor, there is no evidence that the Italian company had any help from Germany before the Intelligence Reports were published in 1946.

Ferrania, like several other photographic manufacturers, undoubtedly benefited from information contained in the BIOS (British Intelligence Objectives Sub-Committee) and FIAT (Field Information Agency Technical) reports published in the UK and the USA, immediately after World War II. These reports dealt in great detail with the methods and materials used by Agfa in their Leverkusen and Wolfen factories to produce Agfacolor negative and positive materials. In 1949, Ferrania produced their first Agfacolor-type negative film. Like Agfa before them, Ferrania concentrated on the professional motion picture market and Ferraniacolor was used to shoot some 200 feature films between 1950 and 1966, after which the company made only Type HS positive film for release printing. In 1971 Ferrania was taken over by the 3M company of Minneapolis in the US and the names of all their colour products were changed accordingly. Furthermore, in 1974, the colour films that had been based on Agfa-type long-chain couplers were replaced by new products using Kodacolor-type protected couplers, making them compatible with Kodak's C-22 or C-41 processes.

DYNACOLOR

Before buying Ferrania, the 3M company had previously (1970) taken over the Dynacolor Corporation of Rochester, NY, a company that had rather audaciously made and processed a Kodachrome-type product in the same town as Eastman Kodak. They called the films Dynacolor from 1949 to 1955 and Dynachrome until 1970. No doubt because the task of marketing any colour film in direct competition with Kodak throughout the world was seen as being too formidable, 3M concentrated on selling their colour films to a wide variety of customers who had their own channels of distribution for what came to be known as 'private-label' films.

ICI COLOR

Several British companies availed themselves of the information provided in the BIOS and FIAT Reports. One of them, Dufay-Chromex Ltd., never managed to produce any multi-layer materials, but Imperial Chemical Industries, encouraged by the British Board of Trade, spent some years, at first alone and later with Ilford Ltd., on producing Agfacolor-type films and papers. A coating machine of the type used in Wolfen towards the end of the War was built and a pilot processing and printing laboratory was established at Blackley near Manchester.

ICI's original intention was to produce a roll film and colour print service for the amateur that would be comparable with Eastman Kodak's Kodacolor system in the US. Sensibly, ICI decided to run an internal field trial to test the performance of their film and paper as well as the processing and printing service they proposed to offer. The field trial must have caused ICI to reconsider their plans, because in 1957 they abandoned the amateur film and introduced a cut-sheet colour negative professional film called ICIcolor. Based on Agfacolor, and using long-chain couplers, the ICI film also incorporated a yellow styryl dye that served as a magenta coupler and, after suitable processing, also produced a masking image, the first of its kind in Europe. The idea was patented by P. Ganguin, one of the Agfa research chemists who left Wolfen to work for ICI. Despite two years of active marketing, ICIcolor film did not prove very successful and in 1959, ICI decided they would do better if they joined forces with Ilford Ltd., who at that time had no colour negative film or paper.

(right) This portrait by Cornel Lucas, was printed on ICI colour paper on an 8 x 10in ICIcolor negative. ICI, using mainly Agfa technology, produced a cut-sheet professional colour negative film in the UK in 1957, calling it ICIcolor. It was not successful commercially, but in 1959, ICI collaborated with Ilford Limited, leading to Ilfocolor film in 1960.

Suddenly Ilford Ltd. found themselves involved with five different colour materials: Ilford Colour 'D', Ilfochrome, the silver dye-bleach material used to make prints from transparencies as well as the colour negative film and colour paper transferred from ICI and renamed Ilfocolor.

The silver dye-bleach process had already been used in Europe during the 1930s by Gaspar for the production of motion picture prints and to a limited extent during the 1940s in the US for making prints from Kodachrome transparencies. The process is discussed fully in 'The Cibachrome Story'.

In order to provide the processing and printing services required for these products, Ilford built a new colour laboratory at Basildon in Essex. As it became more and more obvious that colour negative/positive processes were growing faster than reversal processes, they concentrated their research and marketing efforts on Ilfocolor films and paper, even though the processing was incompatible with any other company's products.

Although Kodacolor in roll film sizes was introduced to the UK market in 1957, a 35mm version was not made available until several years later and this gave Ilford an opportunity to launch Ilfocolor as a 35mm film together with a novel 'contact' or proof strip. The idea was quite successful but in the event, it sealed the fate of Ilford Limited in the amateur colour market because of a ruling by the Monopolies Commission in 1966. The Wholesale Photofinishers Association had already been complaining that its members were precluded from competing for the processing of reversal colour films such as Kodachrome and they now assumed that, because Ilford's contact proof strip had to be made on an expensive special printer, Ilford was trying to create a monopoly.

The real reason for the proof-strip was to help the amateur to

choose those negatives he wished to have enlarged, because at that time the yield of good negatives was still very low. Nevertheless, the Commission ruled, as the Supreme Court had done previously in the US, that colour films should not be sold inclusive of the cost of processing or printing.

By the end of the decade, Ilford had decided to pull out of the amateur colour market and concentrate on the production of Cibachrome – the story of which is told separately. (p. 183)

PAKOLOR

In 1952 the Photo Chemical Company, operated by Dr. K. Jacobson and Dr. White in the UK, launched the Pakolor negative-positive process in conjunction with Associated British Pathé, the motion-picture production company. Pakolor film, based on Agfa technology, was coated by Standard Photographics of Leamington, while the paper was produced by Kentmere at Staveley in the Lake District. The colour couplers and other special chemicals were supplied by the Photo Chemical Company and the film processing kits incorporated a combined bleach-fix for the first time.

TELCOLOR

Soon after the end of World War II, Wilhelm Schneider and Alfred Frölich left Agfa in Wolfen and joined the small Swiss firm of Tellko in Fribourg. With the help of these two ex-Agfa scientists, Tellko was able to introduce a colour negative film in 1951. The film, called Telcolor, was basically an Agfa-type product, but it did claim two novel characteristics. First, it could be exposed either in daylight or artificial light, and secondly, it incorporated a silver image mask.

In 1953 the negative film was followed by Telchrome, an Agfa-type reversal film with a speed of ASA50, which was considered quite fast at the time. In 1960 Tellko was taken over by CIBA, the large Swiss chemicals manufacturer who subsequently also purchased the Lumière company in France and Ilford Ltd. in England. After that, CIBA concentrated their efforts on the silver dye-bleach process.

THE JAPANESE MANUFACTURERS

The first Japanese company to produce colour transparency film was Konishiroku, who launched a Kodachrome-type product and a processing service in 1940. The project was suspended on the outbreak of war with the US, but restarted in 1946. The Fuji Photo Company followed suit by introducing their version of Kodachrome in 1948. After the end of the war in Europe, the availability of free information relating to Agfacolor films and papers tempted Japanese manufacturers to begin producing both films and papers based on the use of long-chain couplers.

First off the mark was a relatively small company, the Oriental Photo Industry Company, who were ready with colour negative and reversal films in 1953. Fuji launched their first Agfa-type film in 1958, while Sakura followed in 1959.

From the time patents began to appear in the mid-1930s, protecting Agfa's method of making couplers fast to diffusion, Eastman Kodak knew that films using such couplers could be processed far more easily than Kodachrome. In 1946, Agfa-Ansco boasted in the *Ansconian* that 'for those who have not yet discovered Ansco Color Film, a new experience is in store – that of taking color pictures and *'processing them in your own darkroom.'*

In 1962, Ilford introduced Ilfocolor negative films in both roll and 35mm formats. They also offered a unique proof-print service from 35mm negatives so that users could see which of their exposures were successful before ordering enlarged prints.

PROTECTED COUPLERS

Kodak needed colour films that could be processed by the user, but before they could be produced, a new way had to be found to prevent couplers from migrating between emulsion layers. The course of events and discoveries leading to 'protected' couplers has been described separately in 'The Kodacolor Story' (p.157), and here it will suffice to say that the solution proved to be so effective that it was eventually adopted by every manufacturer of colour films or papers, with the exception of ORWO, who were still producing Agfacolor-type films in 1991.

IMPROVEMENTS IN COUPLERS

The idea that Vittum and Jelly patented in 1940 was important not only because it revealed an alternative way of making a coupler fast to diffusion, but also because, unlike Agfa's long-chain couplers, couplers protected within oily droplets could be modified to adjust their characteristics in a number of useful ways.

For instance, in the late 1950s, Charles Barr and Keith Whitmore patented a class of couplers that would 'release mercaptan on colour development, thus being used for colour correction, control of contrast, grain size, sharpness and silver halide complexing.' In other words, development inhibiting or DIR couplers.

Another problem associated with early colour development processes was that too much dye was generated from a given amount of silver, so that coating weights had to be kept low, with a consequent limitation of speed. It was Nick Groet of the Kodak Research Laboratories in Rochester who had the idea of using a second, non-image forming coupler, to compete with the colour forming coupler and so allow the use of normal silver coating weights and even twin emulsion layers when necessary. The competing coupler produced a soluble dye that could be washed out of the film during normal processing.

The principal reason for Kodachrome remaining the only colour film to be processed by 'external' colour development, was the better resolution that resulted from not having couplers in the emulsions. This advantage in sharpness was challenged in 1990 by the introduction of Fuji's Velvia, an ASA50, coupler-containing film for processing in E-6 chemistry. Transparencies made on the new film displayed much the same sharpness as Kodachrome film of the same speed. The improvement was said to result from thinner emulsion layers, made possible by using smaller amounts of oil to disperse the colour couplers. Fuji claimed that their 'solvent-free coupler dispersion technology produced multiple layers that are highly saturated with coupler, but the thickness of the film's 17 layers has been reduced by 15%'.

IMPROVEMENTS IN COATING

To reduce the combined thickness of the emulsion, filter and separating layers of colour film while increasing their total number, has been one of the most remarkable achievements in the history of colour photography and is discussed in the section under 'Coating Techniques' (p.173).

Kodachrome, the simplest of colour films in terms of coating requirements, originally used only three emulsion layers but it was not long after Russell's discovery of cascade coating in 1950, that double coating of each of the three recording layers was adopted.

LAYER SEQUENCE

Many integral multi-layer films departed from the orthodox sequence of emulsion layers. For example, a film such as Kodacolor VR1000 used a fast red-sensitive layer coated above a slow green-sensitive emulsion to increase speed. The commonly used yellow filter layer could be omitted because the 'T' grain

emulsions used to record green and red light were so sensitive to those colours that their sensitivity to blue could be disregarded.

PROCESSING COMPATIBILITY

By 1980, almost every manufacturer had accepted that if they planned to compete in world markets against Kodak, they would have to offer colour films and papers requiring the same processing as Kodak's coupler-containing products. For Agfa, the decision must have been particularly difficult, since they had been producing their long-chain coupler products ever since 1936. The switch was probably not so difficult for Japanese companies because they only started to produce coupler-containing materials after the war when German know-how became freely available. As it happened they spent only a few years and no great investment on marketing Agfacolor-type materials before redirecting their attention to products containing protected couplers of the Kodak type.

Although they did have to make their films compatible with Kodacolor (C-22 then C-41) and Ektachrome (E-4 then E-6) processing, Japanese manufacturers did not remain content to simulate Kodak's products and, during the 1980s they introduced several significant improvements in speed and image quality.

In 1987 Konica, who in 1940 had produced a Kodachrome-type film with a speed of ASA10, introduced a Konica Color negative film with a speed of ASA3200 – the world's fastest at that time.

Towards the end of the same decade, Fuji introduced Velvia, an ASA50 film, that set new standards of sharpness for an E-6 process compatible transparency film.

IMPROVEMENTS IN PROCESSING

The first process to be released for Kodacolor films was known as C-22, originally involving 8 steps and requiring some 53 minutes of wet processing at 75°F. When Kodacolor II films were introduced in 1973, processing was changed radically and re-named C-41. The number of steps was reduced to 6 and the wet processing time to 24 minutes at 100°F. As mini-labs became popular in the 1980s, Kodak introduced additional versions of the standard C-41 process, calling them C41BNP and C-41RA. NP stood for 'non-plumbed' or 'washless processing', while RA stood for 'rapid access', a 6½ minute process intended for mini-labs.

The time required for print processing was also reduced when Kodak introduced their Ektacolor 2001 paper and RA-4 chemistry in 1986, after which a colour print could be processed and dried in a little over 4 minutes.

The introduction of very fast colour films (ISO 1000 and more) in the early 1980s, made it possible for fast action such as this to be stopped by exposures of 1/1000th second even in late afternoon sunlight. This shot was taken on Kodak Ektar 1000.

COATING TECHNIQUES

'Early coating machines laid down one emulsion at a time. The task of designing a multi-layer coating hopper that could put down as many as six layers at a time, without those layers affecting one another, was an awesome technical achievement. Yet, if manufacturing technology hadn't been able to match the science of color photography, we would have needed coating machines that were miles long to handle the quantities of color films we produce today.'

W. T. HANSON JR., 'FORTY YEARS OF COLOR PHOTOGRAPHY '1977

'I am unable to explain why two or more layers of coating composition when simultaneously coated onto a web in accordance with the present invention do not mix but maintain a layer relationship as distinct and as free of mixing and contamination at the interface of the layers as when the same compositions are coated successively with a complete drying of each coating before the next one is applied thereto.'

THEODORE A. RUSSELL. (US PATENT NO. 2,761,791. 1956.)

In 1935 while describing the make-up of the first Kodachrome multi-layer film, Mees said:

'Kodachrome has four coatings – nearest the base is an emulsion coating which is strongly red-sensitive; on to this is coated a green-sensitive emulsion overcoated with a yellow layer to act as a filter. Finally there is applied a top coat which is blue-sensitive.'

At about the same time in Germany, Agfa were coating the first Agfacolor subtractive films by successively applying single layers of emulsion, the thicknesses of which were given in FIAT Final Report No. 271 as:

LAYER	THICKNESS
Top	6 micro-metres
Filter layer	2 micro-metres
Middle	6 micro-metres
Bottom	6 micro-metres
Film Base	130 micro-metres
Anti-halo	2-3 micro-metres

'FESTOON' MACHINES

One of the earliest methods of coating long lengths of film or paper with emulsion was by 'dip' application and 'festoon' drying. The festoon dryer was invented by A. J. Boult in 1887 and he sold the rights to George Eastman. The same method was undoubtedly used by Lumière and Agfa to coat their additive colour films in the 1930s. Dufaycolor film, the reseau for which was printed on film

An early paper coating machine with a 'kiss' coating roller and a festoon dryer.

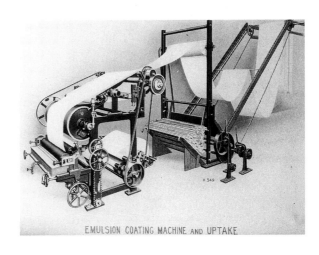

EMULSION COATING MACHINE AND UPTAKE

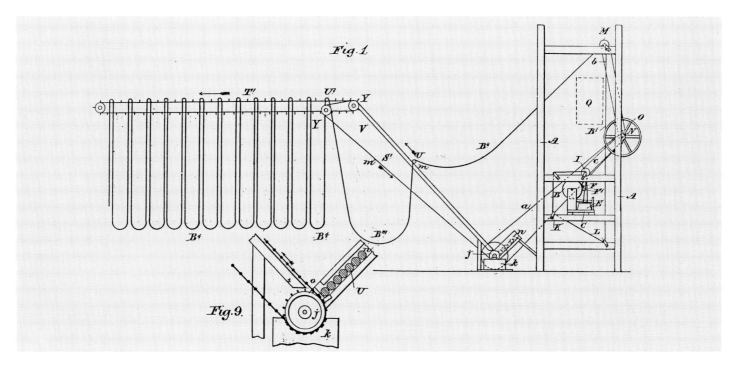

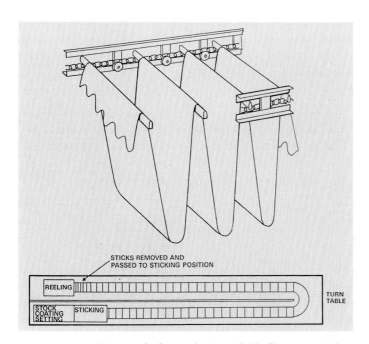

A schematic drawing from Mason's 1887 patent for a 'festoon' dryer linked to an emulsion coating device.

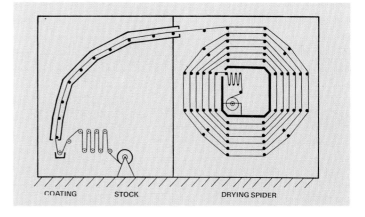

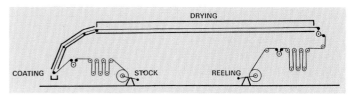

Diagram of a festoon drying track. The film or paper is hung in loops over poles which are carried by a track through the drying chamber.

(top) Diagram of a spider dryer. From the coating point, on the left, the film was fed into a large spiral in the drying chamber, finally being reeled up in a room within the hub of the spiral. This was a highly economical method of drying film.

(above) Diagram of a single-coat flat-bed drying system.

base by Spicer-Dufay at Sawston in Cambridgeshire, England, was subsequently coated by Ilford Limited at their Brentwood factory on a 'spider' machine. This method of transporting the film spiral fashion through a coating and drying machine avoided the 'stick' marks that were characteristic of film or paper coated on a festoon machine.

Early Kodachrome, Kodacolor and Anscocolor films were coated on machines incorporating a 'straightaway' or 'flat-bed' section that ensured uniform drying.

Agfa were aware of the problems of coating colour films on machines using festoon dryers, and towards the end of World War II they built a high-speed, single layer, coating machine at Wolfen based on the use of a large drum on which a web of film could be supported while high velocity hot air was blown across it counter to its direction of travel. Such a machine, besides avoiding stick marks, made it possible to coat single layers of emulsion more quickly.

Dip coating, involving the immersion of one side of a moving web of film or paper in a liquid emulsion, gave way to 'kiss' coating, whereby a rotating roller picked up emulsion from a trough and transferred it to a moving web. Neither of these methods was conducive to accurate coating weights and some improvement was made by using an air-knife to limit the amount of emulsion left to dry on the film or paper by controlling the amount of 'run-back'.

SLOT COATING

Much more precise coatings became possible with the introduction of 'slot' coating which ensured that a predetermined volume of emulsion was pumped through a slot onto the web to be coated. However, it was found that there was a limit to the speed at which the web could move past the bead of emulsion beyond which the bead would be broken. Furthermore, the passage of a splice in the web of film or paper would disturb the bead and cause considerable wastage of both base and emulsion.

SLOT COATING WITH SUCTION

Albert Bequin of Eastman Kodak obtained a patent in 1951 that went a long way towards removing the limitation of coating speed and the necessity to remove the coating head from the web to allow a splice to pass. His patent described a method of holding a coating bead constant at speeds as high as 500 feet per minute by using suction to reduce the pressure on the underside of the bead. This invention originally related to single layer coatings, but proved to be equally important a few years later when Russell discovered his method of multi-layer slide hopper, or cascade coating.

A side-elevation drawing of the machine made by Agfa at Wolfen during World War II, for high-speed single-layer coating.

A replica of this machine was built by ICI in 1958 and installed at Burn Hall, near Blackpool, England.

SLIDE HOPPER COATING

Hanson has told how:

'A multi-layer (Eastmancolor) print film was going to be expensive to manufacture. So, we kept working on mono-layer film for motion picture prints. If we could get a color negative, then make a positive intermediate and then print on a mono-layer, we thought that would be the ideal system. We were working very hard on that when another invention came along and, within a month, the whole programme was stopped.'

The possibility of applying two or more layers simultaneously occurred to Theodore Russell while he was still working on mixed 'packet' emulsions and encountered difficulty in blending emulsions homogenously. He reasoned that it might prove possible to coat one emulsion on top of another without the two mixing.

A small, experimental coating machine was made with two coating slots. The hopper was constructed from a transparent plastic material and differently coloured solutions were used so that their behaviour could be watched. When the combined layers of solutions reached the coating point between the lips of the hopper and the web, a distinct layer relationship was maintained despite apparent deformation of the bead. An enlarged cross-section of the coated web after being dried, showed that the two layers were distinct and free from contamination or mixing.

In a later patent Russell described the way in which:

'The conventional slide-hopper performs its coating operation by metering a first coating liquid from a supply through a narrow distributing slot which distributes the liquid uniformly across the top of a downwardly inclined slide surface. This layer of liquid moved down the slide surface by gravity so as to supply an evened out and steady supply to a coating bead, across and in contact with which the web to be coated is moved to pick up a layer of liquid therefrom. If the simultaneous coating of two liquids is desired, a second liquid is supplied to, and distributed by a second distributing slot which in turn directs a uniform layer of the liquid onto the top of a second slide surface so as to flow down to the coating bead, first alone on its own slide surface, and then onto the top of the layer of liquid issuing from the first distributing slot and then down to the coating bead in superposed relation with the layer of first coating liquid. Subsequent liquids may be coated simultaneously by equipping the hopper with the appropriate number of distributing slots and slide surfaces.'

Sceptics thought that even if the superimposed emulsions did not mix with each other, the combined coating weight of several layers would present formidable drying problems. In the event it was found that once a coating bead had been established with the lowermost emulsion, the layers above it could be made thinner and more concentrated thereby reducing the drying load to a manageable level. The radically new coating head was nicknamed 'Joe Hopper' by Cyril Staud, who said it reminded him of 'Joseph's coat of many colours.'

EXTRUSION COATING

During the 1980s, Fuji were particularly active in patenting methods of coating the underside of a moving web by extruding emulsion from a slot. The extrusion method does not depend upon the formation of a bead at the coating point; instead, all of the emulsion emerging from the slot is continuously transferred to the moving web. Most of Fuji's patents described single layer extrusions, although in a specification published in 1989, it was

Drawings from the patent granted to Beguin of Kodak, protecting a method of applying reduced pressure on the underside of an emulsion bead to hold it in contact with the web at high coating speeds.

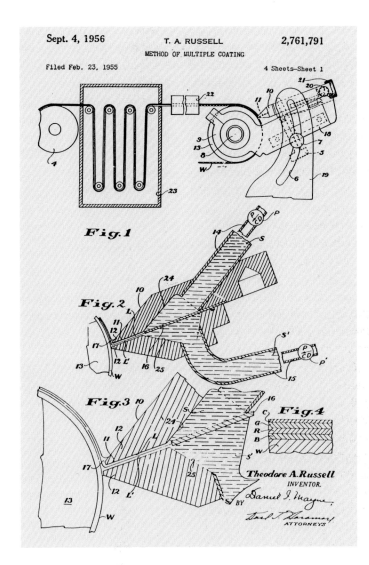

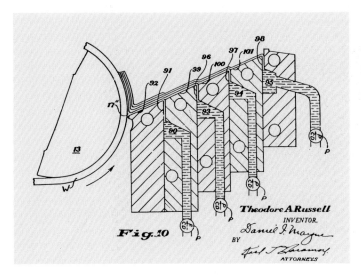

(above left) Russell's first multi-layer coating head (Figs. 1, 2 and 3), combined only two emulsions in one pass; but his patent also described slide-hoppers designed to coat as many as four emulsions simultaneously.

(left) Fig. 10 from Russell's patent illustrates the way a multiple feed slide-hopper would be used to apply four emulsion layers simultaneously.

(above) This experimental machine was used to prove the practicability of Russell's revolutionary method of multi-layer emulsion coating.

claimed that at least two layers could be simultaneously applied in this way.

Manufacturers seldom disclose just how many emulsion layers they coat at one time or what coating speeds they achieve; but in his original 1956 patent, Russell claimed that:

'these hoppers have been successfully used to coat webs 44 inches wide at speeds of coating ranging all the way from 24 feet per minute and 100 feet per minute.'

Several film and paper manufacturers took licences from Kodak to use Russell's method of cascade coating during the 1960s and '70s, while others obtained know-how from an ex-Kodak man turned consultant, named Olzewski.

By 1985, long after the Russell patent had expired, Geoffrey Crawley, writing in the *British Journal of Photography*, reported that:

'In place of twelve coating machines of the former type at Leverkusen, Agfa-Gevaert have just two coating machines for film and one very big and fast machine which coats a 1.6m (72in) web of colour paper at speeds of up to 200m (660ft) per minute, putting on seven layers at one pass.'

Despite the obvious advantages of multi-layer cascade coating, the method did have some disadvantages. For example, because the gap between the web and the lip of the hopper must be kept small – probably no more than 0.25 to 0.5mm – there is always a risk that bubbles, slugs of gelatine, or even unusually large silver grains will become lodged in the bead and cause longditudinal 'pencil' lines on the coated film or paper. A way round these problems was found by introducing a system of coating that allowed a pre-formed 'sandwich' of emulsions to fall freely in the form of a curtain before reaching the web to be coated.

CURTAIN COATING

In 1968, J. F. Greiller of Kodak Limited at Harrow, applied for a patent in which he described a method of:

'forming a free-falling vertical curtain of liquid photographic coating composition in such a manner that the curtain is stable and has a uniform flow rate across its width.'

Greiller's patent referred to a single layer curtain, but in 1970, Hughes of Eastman Kodak in Rochester was granted a patent in which he would use 'a plurality of distinct superposed layers –

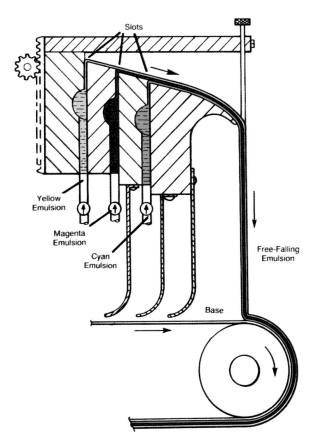

Slots

Yellow Emulsion

Magenta Emulsion

Cyan Emulsion

Free-Falling Emulsion

Base

This schematic representation of a multi-layer coating head is not strictly applicable to a colour development material, since the cyan, magenta and yellow dyes are not present in their colour form at the time of coating. However, actual dyes are used in the emulsions coated on Cibachrome material.

applied to the surface of an object by forming a stable multi-layer free-falling vertical curtain.'

Curtain coating, while offering the important advantages of very high speed coating, coupled with freedom from pencil lines and the ability to coat over splices, has its own problems. A free-falling curtain of emulsion – perhaps 80 inches wide with a fall of about 6 inches – can be disturbed by the slightest movement of surrounding air. Furthermore, there is a tendency for the edges of the curtain to shrink inwards and a number of patents have been granted on methods to prevent this.

Another snag that became the more serious as coating speeds were increased, was the waste of base and emulsion that inevitably occurred during the start of a coating run. In this respect multi-layer curtain coating might be compared with the start-up procedure for the float-glass process; in both cases large quantities of basic materials are inevitably scrapped before good product is obtained.

COATING HEADS

Coating heads, which can be 80 inches long, are usually built up from sections of stainless steel bolted together. Ducts are provided within the sections through which warm water is circulated to keep emulsions in the liquid state. Obviously, the slots through which the emulsions emerge must be perfectly uniform, since any variations will affect the performance of a multi-layer colour film. To ensure rigidity and freedom from distortion, substantial blocks of metal are essential, and the assembled head becomes very heavy and cumbersome to handle and clean. Although stainless steel is often used, it has been suggested that titanium or a titanium/aluminium alloy, is a preferable material for construction because of its greater resistance to thermal shock and its compatibility with photographic emulsions.

In 1989, Fuji patented the use of a sintered ceramic material as a substitute for metal, claiming that the ceramic is both lighter and has a lower coefficient of thermal expansion. In the patent, Fuji included a number of cross-sectional drawings to illustrate the different ways in which emulsions can be fed onto a moving web.

Just how many different emulsion, filter and separating layers are applied during a single coating pass is known only to individual manufacturers, although, in a patent granted to Hughes of Eastman Kodak in 1970, the inventor claimed that his particular method of curtain coating was capable of producing ten or more individual layers.

In one of the cited examples, Hughes also claimed that he was able to apply six layers at 1,000 feet per minute.

The fluid mechanics of cascade and curtain coating have been studied by L. E. Scriven, S. F. Kistler and others at the University of Minnesota.

By the 1980s, all the major manufacturers were regularly coating colour products requiring as many as fourteen or fifteen different layers with an average thickness of 0.001mm, and when it is remembered that such complex multi-layer coatings add up to no more than the thickness of emulsion coated on a simple black and white film, it will be realised how precise the coating operation must be. By way of a comparison, the thickness of a page of this book is probably about 0.1mm while the total dry emulsion thickness of a typical colour negative film is likely to be about 0.01mm. This means that it would require some 10 composite emulsion layers from a colour negative film to equal the thickness of this page.

When all of these factors are taken into consideration, the coating of multi-layer colour materials in the 1980s must be seen as an engineering achievement of the first order.

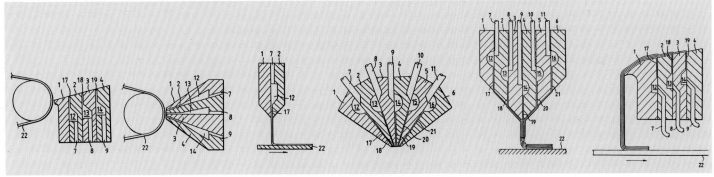

Fig. 1 A vertical cross-sectional view of a multi-slide hopper.

Fig. 2 A vertical cross-sectional view of a multi-extrusion hopper.

Fig. 3 A vertical cross-sectional view of curtain hopper.

Fig. 4 A vertical cross-sectional view of a multi-extrusion curtain hopper.

Fig. 5 A vertical cross-sectional view of a multi-extrusion slide-type curtain hopper.

Fig. 6 A vertical cross-sectional view of a slide-type curtain hopper.

PRINTING
FROM COLOUR
TRANSPARENCIES

'Often what is wanted, is not the single film that was exposed to the subject but either a copy of it, or one or more reflection photographs rather than a transparency'.

RALPH M. EVANS: ' EYE, FILM AND CAMERA IN COLOR PHOTOGRAPHY'.

The advent of colour transparency films such as Kodachrome and Ansco Color in the US and Ilford Colour 'D' in the UK, led to the establishment of colour print-making services that marked the beginning of photo-finishing in colour.

For a while it seemed to a number of manufacturers that the route to the colour snapshot would be via the colour transparency. Eastman Kodak, faced with an increasing demand for prints from Kodachrome slides by an easier and cheaper method than making separation negatives and dye-transfer prints, launched the Minicolor and Kotavachrome print service in 1941. Very little was ever disclosed about the printing and processing that was involved except that the print material was comparable with Kodachrome film but with the emulsions coated on a white pigmented acetate base. Paper was tried as a support but difficulty was encountered with stain and mottle.

Other manufacturers including Ansco, Ilford and Ciba, also used white pigmented acetate as their base material until papers coated on both sides with a layer of polyethylene were introduced around 1970. Although in France, Kodak Pathé did manage to produce a paper-based, coupler containing, reversal print material that was used by Kodak laboratories in Europe in the late 1950s, but not in the US. In fact for a while, in Rochester Eastman Kodak decided to produce prints from Kodachrome transparencies by making internegatives that could then be used to obtain Kodacolor prints. This internegative procedure was made acceptable with the aid of coloured coupler masking, but once reversal Ektachrome-type print materials were introduced on resin coated paper, Kodak reverted to direct reversal printing.

WHICH WAY TO THE COLOUR PRINT
There must have been mixed opinions within Eastman Kodak during the early 1940s about the best way to obtain colour prints.

On the one hand the company had just launched the Minicolor and Kotavachrome services for prints from Kodachrome transparencies and on the other hand, in 1942, they began to promote Kodacolor, their negative/positive system.

It was not until 1955 that Eastman Kodak introduced a user-processed reversal paper called Kodak Color Print 'Type R', later called Ektachrome Type 1993, which was used by professionals and photofinishers, who continued to refer to the results as 'Type R' prints.

ANSCO COLOR PRINTS

Ansco's Printon, introduced in the US in 1943, was the first direct reversal print material to be based on Agfa's long-chain couplers. Unlike Minicolor (Kodachrome) print material, Printon could be processed by individual photographers or by independent photo-finishing laboratories.

Ansco decided not to set up a printing service of their own, but instead, to provide technical assistance to help Pavelle Color Incorporated to establish and operate a Printon laboratory in New York.

In 1946 Ansco also began to offer Printon material and processing chemicals to individual professional and amateur photographers. This was a notable landmark because it was the first time a multi-layer colour print material could be purchased by a photographer for processing in his own darkroom.

Ansco's processing instructions were quite straightforward, and the total wet treatment time amounted to 42 minutes at 68°F. The first developer was a simple metol-hydroquinone formulation, while the colour developer contained Ansco's Dicolamine. Prints were processed either in trays or in tanks using sheet film hangers while re-exposure involved two minutes fogging with a No. 1 Photoflood lamp held at a distance of 3 feet.

Ansco's Printon process, launched in the US in 1946, made it possible for the first time for the individual photographer to make colour prints from his transparencies.

The colour balance of prints could be adjusted by inserting suitable combinations of low density yellow, magenta or cyan gelatine filters into the printing beam – usually in the lamphouse of the enlarger; there were no special colour heads for enlargers at that time.

GASPARCOLOR OPAQUE

For a short while between 1949 and 1952, Bela Gaspar operated a reveral print making service from a laboratory in Hollywood, using a silver dye-bleach material made to his specification by DuPont and called Gasparcolor Opaque. An earlier version of this material had been made by Ansco during World War II, for the USA Air Force at Wright Field, Dayton, Ohio.

Gaspar also entered into an arrangement with the French manufacturer Bauchet, who made a dye-bleach material for a short period in the early 1950s. An attempt was made to sell the process to individual users for use in their own darkrooms, but there were a number of difficulties, particularly the very long exposures required when printing, and the idea had little success.

ILFORD COLOUR PRINTS

There was no large scale colour print making service available in the UK before Ilford established their print from slide laboratory at Richmond, near London in 1952. Unlike Kodak and Ansco, Ilford decided to use a silver-dye-bleach material for the prints and although they did have some preliminary discussions with Gaspar, they eventually decided to go it alone, obtaining a number of patents between 1945 and 1960.

In 1963, CIBA acquired an interest in Ilford Limited, and revealed that they too had been working on the silver-dye-bleach process. The extent to which their work had improved the process was seen in the Cibachrome prints they exhibited at Photokina that year. The events leading to the subsequent range of Cibachrome materials and processes are considered sufficiently interesting to be told separately.

In 1952 Ilford Limited introduced a service by which photographers could obtain colour prints from their Ilford Colour 'D' or Kodachrome transparencies. The print process was based on a direct reversal silver-dye bleach material coated on a white pigmented film base.

THE CIBACHROME STORY

CIBA'S decision to undertake the development work that resulted in the Cibachrome process was made in the spring of 1958, although an interesting series of events preceded it.

Robert Kappeli and Edgar Gretener had been at school together and Kappeli turned out to be an excellent manager, eventually becoming President of CIBA for many years, while Gretener studied physics and became head of a research section at Siemens in Berlin, where he worked on Berthon's additive lenticular process in collaboration with Perutz in Munich.

At the outbreak of war in 1939, Gretener returned to Switzerland and formed a small company devoted to optical and electronic projects including some ideas he had for improving the light efficiency of the lenticular process, and for large-screen projection television. Financial help for the work was organized by Kappeli.

Apart from poor light efficiency, the lenticular process also suffered from degradation of colours resulting from light-scatter within the banded images formed behind each tiny lenticulation.

Dr. Armin Meyer, whose name like Gaspar's, became synonymous with the silver dye-bleach (SDB) process, has described how, after joining CIBA in 1951, he found an answer to light scatter in lenticular films by using a yellow dye image formed by the silver dye-bleach process:

'It was not feasible to get saturated colours. I found that the reason was light scattering of the separation films. (It should be explained that he was using silver-image positives made from Technicolor separation negatives). Two ways allowed correction; contact-printing of the separations on physically developed, ultra-fine grain film, or on ordinary movie printing film and transform these images into monochrome SDB images. A yellow azo dye was applied to the black and white developed film and fixed in the layer.

An SDB bleach solution converted the silver image to a yellow image, yellow because it was later printed with near UV light. These intermediate separations showed very low light-scattering effect and excellent lenticular images could be obtained. It was our first application of the SDB technique.'

In greatly simplified terms, the unwanted negative dye image in a silver dye-bleach material is destroyed by local reduction of any dye adjacent to the negative silver image, which results in the splitting of the azo molecules into colourless compounds that are subsequently washed out of the layer, together with the residual silver complexes formed by bleaching and fixing.

Dr. Paul Dreyfuss, a dye-chemist who had worked with Gaspar in Germany, joined CIBA in 1952, by which time many of Gaspar's early patents had expired, while some of those remaining in force were circumvented with the aid of Dreyfuss and other members of a research team that included Carlo Rossi, Armin Meyer and R. V. von Wartburg. In the summer of 1955 Gretener's lenticular system was demonstrated to the Technicolor Corporation, who had been supporting the research. The outcome was that light efficiency was still not acceptable and the process was complicated in comparison with the colour development systems, such as Eastman Color, that were in use by then.

Dr. Gretener died in 1958 but CIBA decided to continue the work on the silver dye-bleach process and to diversify into the photographic industry in a substantial way. Their first acquisition, made in 1960, was Tellko AG, a small Swiss manufacturer at Friburg near Berne. In the folowing year they bought Lumière, the long established French company in Lyon. Contacts with Ilford Limited in England started in 1963 and by 1967, CIBA had taken over that company.

THE CIBACHROME STORY

THE FIRST CIBACHROME PRINT

Meyer records that the first Cibachrome print he ever made was produced in March 1959 using positives printed from Technicolor (16mm x 22mm) separation negatives. The three layers containing the dyes were coated on triacetate film and after a process taking two hours, the back of the film was painted white with gelatine containing barium sulphate. By 1962, white pigmented triacetate film was being used and the first public exhibition of Cibachrome prints was at Photokina in 1963.

For several years before the company was acquired by CIBA, Ilford Limited had been operating a print-from-slide service based on their version of the silver dye-bleach process and as it happened, they had been obtaining the necessary azo dyes from Geigy, who at that time were a competitor of CIBA in Switzerland. After the union of CIBA and Ilford, it was decided that all further research work would be carried out in Switzerland, at first in Basle, and later in a new research centre at Marly near Friburg.

The research team from Basle moved to Marly in 1966 and were joined by some members of the original Tellko staff. Their task was to synthesize dyes, sensitizers, hardeners and above all, bleach catalysts. From the thousands of azo dyes already made by CIBA none was suitable for use in a silver dye-bleach material. At first,

This is reproduced from the first Cibachrome print made in 1959 by Dr. Armin Meyer, who was largely responsible for the research on which the process was based. The print was made by successive exposures to three colour-separation negatives.

THE CIBACHROME STORY

CIBA used bleach catalysts of the kind proposed by Gaspar – 'a dark brown mixture of more than 20 compounds', but later they developed more efficient colourless quinoxalin catalysts.

For a short while after the successful exhibition of the first Cibachrome prints at Photokina in 1963, the process was made available in Switzerland to the amateur via a service not unlike that offered by Ilford in the UK.

An attempt was made to link the printing service with the use of Tellko's 35mm Agfacolor-type reversal film, but that project only ran for one year. The special printers were designed and built by Gretag AG, who by then were owned by CIBA.

After that, the decision was made to concentrate on the professional and commercial markets and to arrange for a limited number of authorized laboratories throughout most countries of the world to process Cibachrome Print material.

PROCESS P-7A
Initially, the process required some 45 minutes of treatment; usually carried out either in tanks or on a rotating drum machine of the type introduced by the Holmuller Company in Germany. The developer contained phenidone and hydroquinone and the sequence of steps required separate dye and silver bleaching stages.

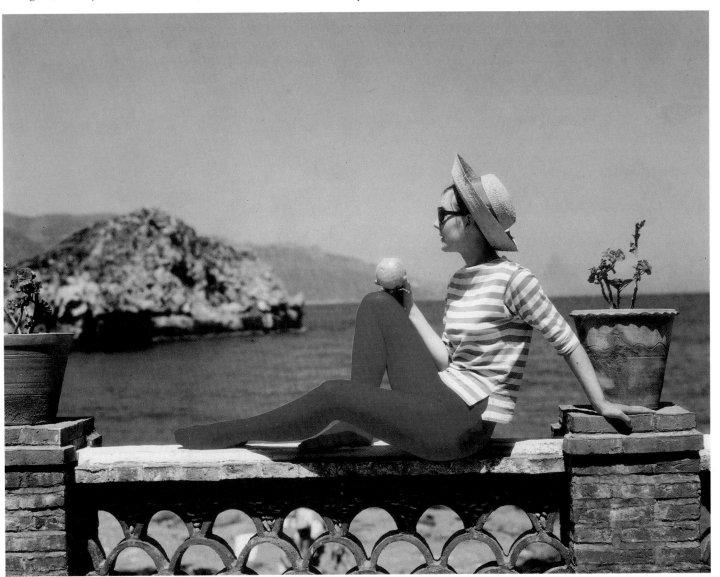

Ciba-Geigy, who had been working on their version of the silver-dye bleach process for some years caused a stir at Photokina, at Cologne in 1963 by exhibiting many large Cibachrome prints, including this one.

THE CIBACHROME STORY

Processing was carried out under amber safelight illumination (Wratten 10 or equivalent) or in complete darkness until after the first wash step; thereafter, normal room lighting could be used.

The fact that processing could be carried out under safelight is a reminder that the first Cibachrome materials were extremely slow – a characteristic of all silver dye-bleach materials until ways were found of solving that problem.

In 1965, Meyer published a paper in which he outlined the distinctive features of a silver dye-bleach process at that time, viz:
1. The advantages of having dyes in the emulsion layers was that sharpness was improved. The dyes limit the scatering of light that is inevitable in silver halide emulsions. Meyer claimed that the MTF for Cibachrome Print material was comparable with black and white enlarging paper.
2. The light fastness of the azo dyes used in a silver dye-bleach material is far better than that of any dyes formed by colour development.
3. The silver dye-bleach process is capable of producing colours of high purity, since no coloured by-products arise in processing.

It was acknowledged that there were some disadvantages; including:
1. Having dyes in the emulsion layers meant that the sensitivity of the material was reduced. Meyer indicated the causes of the losses in a table:

Sensitivity Losses in a Cyan Dyed Layer	
Optical Loss (absorption)	0.80 log E units
Chemical desensitization	0.18 log E units
Desorption of sensitizing dye	0.26 log E units
Total	1.24 log E units

Such losses in speed, although greatly reduced by the subsequent use of dual-recording layers (as explained below), show why it has never been possible to produce a camera speed SDB film.
2. Reduction (bleaching) of the dyes required the use of hydrochloric acid at a pH value between 0 and 1, and although subsequent bleach formulations used sulphamic acid, this aspect of the SDB process remained a disadvantage.

While Cibachrome Print material was being coated in the old Tellko plant in Friburg, it remained a simple three-layer product, but when production was transferred to a new unit in Marly, simultaneous multi-layer coating became possible because CIBA had obtained a licence to use the slide-hopper coating system invented by Russell of Eastman Kodak. This meant that the dye layers could be separate from the associated silver-halide recording layers so that both light efficiency and gradation were improved. At that time Cibachrome Print material carried nine distinct dye, emulsion and separating layers.

In 1969 a version of Cibachrome, known as Cibachrome Transparent (CCT), was introduced to satisfy a market for large display transparencies that would not fade appreciably under the adverse conditions of back-lighting that are necessarily involved. At that time all other colour print materials were based on colour development and yielded dyes that were notoriously unstable to light.

During the 1970s, several further significant improvements were made to the print materials and their processing. Because printing is done from positive transparencies, it was difficult to keep the contrast of the print materials low enough. Low contrast emulsion layers have low speed – already a problem with any silver dye-bleach material, but Meyer found that contrast could be reduced if the bleach catalyst was added to the developer rather than to the

THE CIBACHROME STORY

dye-bleach solution itself. That way a limited amount of catalyst was absorbed by the layers and lower contrast resulted.

An additional, possibly unexpected, benefit came from combining the catalyst with the developer, because in strongly coloured areas only one or two of the three dye layers were bleached and these same areas obtained additional catalyst from the adjacent unexposed layers and were therefore bleached more fully, thereby producing a self-masking effect.

PHOTO-ME

By 1976, Cibachrome Print Type D-182 could be processed in P-10 chemistry in 36 minutes, but this was still much too long for the process to be used in 'while-you-wait' kiosks of the kind operated by PhotoMe, who were interested in using a Cibachrome print material for making colour portraits directly. PhotoMe were not too worried about the low speed of the material since they could increase the power of their electronic flash lamps to suit any reasonable requirement. But they did need a process that would require no more than four minutes to produce a touch-dry print. Remarkably, the research department at Marly came up with entirely new chemistry that fulfilled PhotoMe's requirements, and

the company was able to offer 'while-you-wait' colour portraits from their chain of kiosks throughout the world.

P-18 PROCESS

With processing time reduced and chemistry simplified (the P-18 process with its combined dye and silver bleach required only six steps lasting 15 minutes) the time was ripe to introduce a version of Cibachrome for the hobbyist.

CIBACHROME-A

Ilford Inc., in the US, led by their chief executive, Peter Krause, introduced Cibachrome-A in the autumn of 1974. Krause was not new to the amateur colour print business since he had worked at Pavelle Color in New York while they were operating Ansco's Printon service in the late 1940s.

The Cibachrome-A kit included a small developing drum, a packet of print material, a set of colour correction filters, a set of P-30 chemicals and an instruction book. Processing time was reduced to 12 minutes and there were only three solutions, all of which were discarded after use to avoid the need for replenishment. The new process was extremely successful and after

(right) A typical strip of four 'while you wait' portraits made in a PhotoMe Kiosk, and delivered in a few minutes.

(far right) There are PhotoMe kiosks in most countries of the world using Cibachrome direct reversal colour print material. (top left) United Kingdom; (top right) France; (bottom left) Italy and (bottom right) Spain.

THE CIBACHROME STORY

the launch in the US, it was quickly made available in other countries. In Europe, two specially equipped railway carriages travelled through W. Germany, Austria and Switzerland, giving practical demonstrations of the process.

Although not without problems, making colour prints from transparencies was a great deal easier for the amateur than printing from colour negatives, and the Cibachrome-A process enabled tens of thousands of hobbyists to experience the thrill of making their own colour prints for the first time.

There has probably never been a simpler colour print making process than Cibachrome-A; the only problem with it was the difficulty in achieving perfectly correct colour balance, a difficulty that applies to all colour printing processes. Any colour print material, whether intended for printing from colour negatives or transparencies, will vary slightly from batch to batch so that a correction must be made whenever a different batch is used. Cibachrome-A print materials were tested before being released for sale and the filtration recommended to produce a satisfactory print from a correctly balanced transparency was indicated on each packet or box of material. However, several other variables, including the colour balance of the original transparency, the type of film it was made on, the illumination of the enlarger, the condition and use of the processing solutions, all conspired to make it almost impossible to obtain a perfectly balanced colour print without first making one or more test prints.

It was largely because of its novelty that the Cibachrome-A process gained widespread popularity during the late 1970s and early 1980s. After that, interest gradually waned.

No doubt the improvements in colour negative films and photofinishing services, including the introduction of mini-labs, also hastened amateurs' swing to the colour negative process rather than making prints from colour transparencies.

CIBACHROME COPY

The Cibachrome Copy System was launched at Photokina in 1978. Copies, either in the form of prints or transparencies, were made on a daylight opeating camera/processor with a processing cycle of 6 minutes.

CIBACHROME II MASKED MATERIAL

In 1980, a new series of print and transparency materials was introduced under the name Cibachrome II, together with P-3, a new process requiring 18 minutes at 30°C. The major improvements were that the print materials incorporated a silver masking layer and required new chemistry. The P-3 process, like P-18, involved only three solutions – one of them being a combined dye and silver bleach.

For the first time Cibachrome print materials could be supplied either on a plastic or a polythene-coated (RC) paper base. The introduction of a silver mask meant that first development became more critical than it had been with earlier versions of Cibachrome and consequently Cibachrome II materials were intended for use by laboratories using either continuous roller processors with automatic solution replenishment or drum processors from which solutions were discarded after a single use.

The net result of this automatic, self-masking system was a marked improvement in the reproduction of most colors – especially blues, purples, yellows, browns and greens. Flesh-tone rendition also was better than in unmasked Cibachrome prints.

CIBACHROME RE-NAMED

After being committed to the silver dye-bleach process for more than 30 years, Ciba-Geigy sold their photographic interests to the International Paper Company in 1989. Shortly after that, it was announced that their SDB products would be renamed Ilfochrome:

Besides the necessary print material and processing chemicals, 'Cibachrome A' kit included printing filters, a processing drum, a thermometer and an instruction manual.

In 1953, a year or so after the introduction of Ilford's reversal colour printing service in the UK, Kodak Pathé in France and Kodak Limited in Britain, launched a similar service; using a paper-based colour development material made by the French company. But, unlike Ansco in the US, Kodak did not make their reversal paper available to independent photofinishers or professional laboratories. In Germany in 1958, Agfa produced their first reversal colour print material, calling it Agfacolor Reversal Paper CT, while a later product was known as Reversal paper CU. Both papers were made available to photofinishers.

INTERNEGATIVE

As an alternative way of working, Eastman Kodak in the US offered a colour internegative material with which masked colour intermediate negatives could be made from transparencies before being used to produce colour prints on a negative/positive paper. To many photofinishers and some hobbyists, the advantages of using internegatives were considerable, because the exposed film could be processed in the well established C-22 chemistry before being printed on a negative/positive paper and processed together with normal production prints.

Nevertheless, the theoretical benefits of using a masked colour internegative material were only fully realised if the negatives were carefully exposed and processed – conditions that were not always fulfilled in those days.

The growing popularity of Cibachrome prints during the 1960s and '70s, no doubt caused many manufacturers to consider the possibility of making a silver dye-bleach material of their own. Between 1950 and 1970, Agfa, Fuji, GAF (Ansco), Ilford and Kodak were all granted patents relating to the silver dye-bleach process. Only Ciba and Agfa produced SDB products commercially and an Agfa product, known as CU-420, was only made available to a few photofinishers in Germany between 1970 and 1976.

In the British Journal of Photography Annual for 1978, the editor, Geoffrey Crawley, wrote:

'The positive/positive photographic print process has long remained a poor relation, compared with the negative/positive. Mainly used by the professional, who works it via the expedient of an internegative or even through colour separations (Dye-Transfer), it was not within the reach of the average amateur. The breakthrough of Cibachrome and the very warm welcome which colour photographers gave it, certainly contributed to taking the mystery out of positive/positive, a development which did not succeed at that time in giving an impulse to the vintage Kodak Ektachrome paper, already known for more than a decade.'

Between 1930 and 1970 all the major photographic film and paper manufacturers obtained patents on aspects of the silver-dye bleach process.

Legend:
- Gaspar
- Agfa
- Kodak
- Ilford
- Ciba
- Geigy
- Fuji
- Dupont
- Gaf

1930-35 1936-40 1941-45 1946-50 1951-55 1956-60 1961-65 1966-70

EKTACHROME 14 RC

In 1976, Kodak Limited and Kodak Pathé introduced the French-made Ektachrome 14 RC, a resin-coated paper that could be processed in about 14 minutes at 38°C (100°F). The next generation of Kodak's direct reversal print materials, known as Ektachrome 22, was introduced in 1983 and that in turn was replaced in 1990 with Ektachrome 'Radiance' requiring only 10 minutes processing in R-3 chemistry.

By the 1980s, Agfa, Fuji and Sakura were also producing reversal colour print material requiring R-3 or equivalent processing and all of them had come closer to the purity and permanence of the dyes used in Cibachrome print materials. Fuji in particular were claiming that their Fujichrome Type 34 paper incorporated a new magenta dye that resulted in the improved reproduction of reds, scarlet, pink, purple and blue and that the 'newly developed magenta coupler and a new low-fade type cyan coupler are used so that the highest possible image stability is maintained.'

Despite the improvements claimed by Fuji, a survey carried out by Henry Wilhelm and published in 1990, showed that a Cibachrome print was significantly more resistant to fading than a print made on any chromogenic material. Wilhelm found that Cibachrome image would require 28 years exposure to 450 lux (42 foot candles) for 12 hours a day before any objectionable loss of dye density would occur, whereas it would take 19 years for the same amount of change to become apparent with a print made on Fuji's Type 34 material.

AGFACHROME SPEED

In 1983, Agfa introduced a diffusion transfer print making process they named Agfachrome Speed, thereby indicating that the product was intended for printing from slides rather than colour negatives. Kodak's previously introduced Ektaflex process was initially negative-positive working, although they later introduced a reversal product.

Agfachrome Speed was no more successful than Ektaflex, and both Agfa and Kodak were guilty of making claims for the two processes that were misleading. For example, Kodak said – 'If you know how to make black and white prints, color printing will be easy'; while Agfa went even further, claiming that – 'Agfacolor Speed does away with all the problems which have so far limited the fun of making your own colour prints.'

(right) Cibachrome print from an
Ektachrome transparency by Tim Brown.

PRINTING FROM COLOUR NEGATIVES

'When the final goal is a reflection photograph there is no need for the camera original to be satisfactory as a projected picture. Because there is considerable photographic advantage in developing the original to a negative rather than reversing it, there have gradually evolved the negative-positive color processes in which both the negative and the positive are in color but the first is printed onto the second to get the desired final picture'.

RALPH M. EVANS: 'EYE, FILM, AND CAMERA IN COLOR PHOTOGRAPHY'.

There was a profound difference between the approach taken by Eastman Kodak in the U.S. and Agfa in Germany when those two companies began to promote the use of their colour negative films. In Kodak's case, they had no doubt that it would be necessary for them to provide a Kodacolor processing and printing service and accordingly they established a very large photo-finishing plant in Rochester and later in other locations, to do just that. (See chapter on Photofinishing).

In 1949, when Agfa began to produce both colour negative films and papers at Leverkusen, they decided to operate a kind of licensing system based on a selected number of independent photo-finishers throughout Europe and the UK.

These different commercial practices were matched by differences in technical approach. Kodak designed and constructed highly specialised printing and processing equipment while Agfa tended to leave photo-finishers to adapt the equipment they were using for their black and white work.

PROCESSING

In fact there was not much difference between the methods used by Kodak and the Agfacolor finishers to process their exposed colour negative films. In both cases the films were handled on 'dunking' machines that transferred them automatically from one tank to the next in much the same way as black and white films. The real differences came at the print exposing and processing stages. Kodak designed special printers on which they made large numbers of print exposures using long rolls of paper that were processed continuously before being separated into individual prints. Agfacolor laboratories made their prints on ordinary englargers, using separate sheets of paper that were subsequently developed in trays or tanks.

(right) The Agfa Varioscop 60 enlarger complete with colour head. This was the first enlarger to incorporate continuously adjustable colour filters.

(far right) In the early days of colour printing, Agfa produced coloured charts from which the additional exposure required when using any combination of correction filters, could be derived.

Filter factors

PRINTING

Mosaic filters incorporating small areas of all practical filter combinations were placed in contact with colour paper to produce after a single exposure a test print from which suitable filtration could be chosen. Corresponding colour correction was made by introducing subtractive coloured gelatine filters into the enlarging beam, either above or below the lens. In 1958, Agfacolor negative/positive materials were released for user processing and after that it was not long before improved methods of print exposure and processing were devised. First, Agfa designed a special colour lamphouse or 'head' for use with their Variscop enlargers. The colour of the illumination provided by the Agfacolor head was adjusted by three knobs which in turn operated a set of cams to move cyan, magenta or yellow filters more or less completely across the beam of light from a projection lamp. The effective density of each of the three coloured glass filters depended upon the extent to which it interrupted the light beam. Heavy diffusion was used to mix the light before it reached the negative. Because the introduction of filters in the beam directly affected the time of exposure required for different negatives, tables of filter factors were published so that the necessary adjustments could be made.

An important advance in colour printing came with an invention granted to Keith Aston in 1969. Aston's idea was to introduce small dichroic (interference) filters between a focused quartz-halogen lamp and a light mixing chamber. This arrangement, which was used by Pavelle (later Durst) in the UK,

proved so compact and efficient that it was not long before other enlarger manufacturers began to use dichroic filters in their colour heads and enlargers.

ADDITIVE PRINTING

During the early years of printing from colour negatives, it was believed that with the colour papers then available, more saturated colours would be obtained if prints were exposed by suitable proportions of red, green and blue light rather than by white light modulated by the introduction of low density subtrative filters. Additive printing with filtered red, green and blue light was inconvenient because it meant either making three successive exposures for each print or using a lamphouse containing three sources of light.

Kodak in Rochester supported the principle of additive printing and designed printers that made a sequence of red, green and blue exposures for each print they made from Kodacolor negatives. In order to eliminate the effects of reciprocity failure in the colour paper of that time, their additive printers also made exposures of the same duration, the intensity of the exposing sources being varied automatically to compensate for differences in density and colour balance between negatives.

Some enlargers were also designed to make a sequence of exposures through a rotating filter wheel, or by incorporating three lamps in a common lamphouse so that red, green and blue exposures could be made simultaneously.

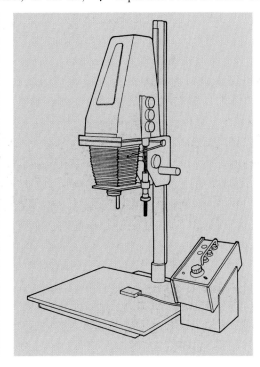

FIG. 1.

(far left) In 1969, Aston patented the use of moveable yellow, magenta and cyan dichroic filters to adjust the colour of the exposing light in an enlarger.

The lamphouse of the Model 400 Pavelle enlarger uses two lamps, the light from which is directed into a white polystyrene-lined box. Two sheets of opal Perspex are used just above the negative to ensure diffusion. Dichroic interference filters are located between the lamps and the diffusing box. These filters are moved in or out of the beam as necessary to produce the required filtration.

SUBTRACTIVE PRINTING

R. W. G. Hunt, who worked in Kodak's Research Laboratory at Harrow in the UK, considered that satisfactory colour reproduction could be obtained by using a single 'white' light exposure and in 1959 he designed and patented a 'subtractive' lamphouse that could be fitted to the Kodak Precision enlarger.

The novelty of Hunt's design lay in the use of a pair of sliding filter holders which could be moved across the beam of light from a Truflector lamp. One of the filter slides contained a yellow and a cyan sector to control the relative amounts of blue and red light, while the second slide held magenta and green sectors to modulate the amount of green light reaching the negative. Between the magenta and green sectors there was a pale orange filter intended to compensate for the unavoidable absorption of blue light by the magenta filter.

In use, the positions of the two filter slides were adjusted so that the output from a set of photo-cells housed in the bellows of the enlarger, indicated that a predetermined colour balance had been obtained. As with any other system of colour printing, the enlarger and measuring unit had to be set up initially by making test prints from a reference or standard negative.

MOTION PICTURE PRINTING

Much of the earliest Agfacolor negative film was used by the motion picture industry and means had to be found to introduce rapid changes in colour correction between scenes on a continuous motion picture printer. Agfa devised a filter band made up from opaque 35mm perforated film in which a series of 20mm diameter holes were punched and covered with gelatine filters to provide the colour correction required by the sequence of scenes contained in the film being printed. The filter band, positioned between the light source and the printer gate, was automatically moved from one filter to the next whenever a change of scene required a different colour correction. The signals came from notches cut in the edges of the negative being printed. This method of changing the colour of the printing light was not very satisfactory, if only because of the fading and damage that inevitably occurred to the filters after repeated use.

A better method was introduced by Bell and Howell in the US in the late 1950s, when they decided to use additive printing with a single lamp and a set of dichroic filters to split the beam into separate red, green and blue secondary light sources. The Bell and Howell printer also incorporated three 'light valves' with which the amounts of red, green or blue could be rapidly adjusted and then mixed before reaching the printing aperture. The response of the light-valves was so quick that a change between scenes could be made in less than a quarter of an inch of film while the printer was running at 180 feet a minute.

Grading or evaluating the individual scenes of a negative used to produce release prints of a motion picture can be done by trial and error, often with the aid of a video translator, because the cost of such preliminary testing is spread over the large number of prints usually required. Such empirical methods were obviously not suitable when single prints had to be made from vast numbers of amateurs' colour negatives.

INTEGRATION TO GREY

An almost, but not quite, complete answer to the problem sprang from some work carried out by F. H. G. Pitt and E. W. H. Selwyn of the Kodak Research Laboratory at Harrow in 1938. They observed that the overall colour of the average outdoor subject is very nearly grey and that different subjects do not depart markedly from the average.

In 1946, Ralph Evans of Eastman Kodak patented the concept of

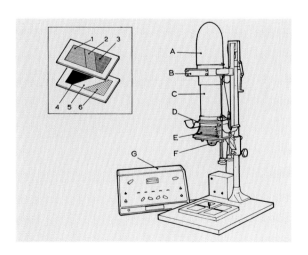

*In the colour enlarger designed by Hunt lamphouse **A** contains a Truflector type lamp throwing light via a mirror downwards on to two sliding filter carriers in housing **B**. Each filter comprises three sectors, in the one case magenta (1), orange (2) and green (3), and the other cyan (4), clear (5), and yellow (6). Moving the one sector of the filter across the light beam changes the ratio of red to blue light reaching the negative. Adjustment of the other slide changes the ratio of green to blue light. The purpose of the orange sector of the first filter slide is to offset the unwanted absorption of blue light by the magenta filter. Representative light transmitted by the negative is received by a series of photocells located inside the bellows **E** and directed toward the negative from a position around the lens **F**. Current from these cells is fed to the Control Unit **G**.*

arranging for the same doses of red, green and blue light to reach the print material whatever the density of colour balance of the negative being printed. Claim 1 of the Evans patent reads:

'The method of printing a multi-color transparency on to a photographic printing material whose sensitivity lies in three different regions of the spectrum which comprises uniformly illuminating said transparency with light which contains energy in said three regions of the spectrum, integrating the light transmitted through the transparency, measuring the color of said integrated light, determining the color and amount by which said integrated light departs from light which will print grey on said printing material, adjusting the intensity of the printing light so that when integrally passed through said transparency which has the same printing characteristics as light which prints substantially grey and then focusing and printing said transparency on to said printing material with the said last mentioned light.'

It is not clear whether Evans was aware of Pitt and Sewyn's work, since he never referred to the paper they published in the Photographic Journal in 1938 entitled 'The Colour of Outdoor Photographic Subjects'.

KODAK'S 1599 PRINTER
Evans' ideas were incorporated in a patent granted to C. M. Tuttle and T. B. Brown in 1947, describing what came to be known as the Kodak 1599 printer.

VARIABLE TIME EXPOSURES
All of the patents relating to Kodak's 1599 printer were confined to the use of constant-time variable intensity printing. In 1955, Agfa patented an alternative method of integrated colour printing by means of variable time exposures. In their patent, Agfa described a printer with three separate light sources to be used to make three simultaneous, but not necessarily equal, exposures through red, green and blue filters. This was the method used when they introduced their Agfa Colormator printer in 1960.

SUBJECT ANOMALIES
The concept of integration to grey was known to fail in varying degree with abnormality of colour distribution in the subject. This meant that when full colour correction was applied, some 10 to 20 per cent of the resulting prints might be unacceptable because the printer had been misled by some unusual distribution of colours in the negative. The classic example of a 'subject failure' or 'subject anomaly' as C. J. Bartleson and R. W. Huboi more correctly described it, is the white cat on a red carpet. A more frequent cause of failure was any landscape scene with a large area of bright green grass in the foreground, giving rise to clouds tinted with magenta.

Several solutions to the problem were proposed, all of them dependent upon reducing the level of correction called for by the integrating system and therefore dependent in turn upon a reduction in the correction for the variables that can influence the printing exposure required for a particular negative. Certainly as manufacturing and processing consistency improved, and cameras with automatic exposure control became more common, it did become possible to reduce the level of printer correction so that subject anomalies became less serious.

SLOPE CONTROL
If subject anomalies were number one on the list of problems related to automatic methods of colour printing, then slope control must be number two.

The form of printer adjustment known as slope control was first described by V. R. Pieronek, W. L. Syverud and W. F. Vogelsong in 1956, with particular reference to the Kodak Type IVC printer that was supplied to independent finishers in the US following settlement of the Anti-Trust suit against Eastman Kodak in 1955.

Hunt, in a paper dealing with 'Slope Control in Colour Printing', explained the effects that lead to the necessity for slope control adjustments on an automatic colour printer, saying:

'The prints produced by an automatic printer may vary systematically in density level and in colour balance as functions of the densities of the negatives. These variations are usually functions of reciprocity failure of the paper, and of spectral sensitivity differences between paper and monitoring photocells. Slope control provides means for attaining high quality prints from negative of widely differing densities in spite of inherent printer and paper limitations'.

In his paper, Hunt dealt specifically with the slope control provided on the Kodak S-1 printer, which he designed.

PROFESSIONAL PRINTING

The principle of integration to grey was also used for professional or 'custom' printing. Colour enlargers could be linked to electronic analyzers that were used to evaluate a colour negative before it was printed. Macbeth, Speedmaster, Lektra and Melico were among the many companies producing analysers that could be used to assess the integrated colour of the light transmitted by a negative and an enlarger lens so that the result could be compared and filtration adjusted to match some predetermined values. In all cases the analyzer could only be set up after test prints had been made to show what filtration was required to produce a correctly balanced print from a standard or reference negative.

Another method of exposure determination depended upon the measurement of some local area of a known colour – such as a flesh tone – that needed to be matched. This was known as 'on-easel' evaluation and it involved the use of a movable probe to collect light exclusively from a selected area of the projected image.

SELF-MONITORING COLOUR HEADS

The use of dichroic filters in conjunction with quartz-halogen lamps greatly improved the performance of colour heads for enlargers. The output of tungsten-halogen lamps changed less during their life than ordinary tungsten filament lamps and the interference filters were both heat resistant and stable to light. Nevertheless, variations due to voltage fluctuations and discoloration of the interior of the light mixing boxes, caused problems when colour prints were being made to high standards of accuracy and reproducability. It therefore became necessary to introduce some form of feed-back to ensure that any changes in light output were automatically detected and immediately corrected.

This was achieved by locating a set of three colour sensors in the lamp-house itself, so that any changes in brightness or colour would be detected immediately and corrected by means of electronically connected servo motors linked with the dichroic filters. The Bremson Dyna-Lite system was typical.

VIDEO ANALYZERS

The Hazeltine Color-Film Analyzer was first described in 1958 and was intended to enable a motion picture colour film grader – 'to see instantaneously the effect of various printing light adjustments on the printed positive and allow him to choose the adjustment which gives the desired color balance and printing density.' It was claimed that the Analyzer 'will frequently give a high-quality print at the first attempt, and in any case the number of trial prints will be substantially reduced.'

The Bremsons CVIS, Digital Video Analyzer allows four different reference images to be presented at the same time.

To use a video analyzer, a negative is placed in the pick-up gate, where a scanner produces signals that are electronically modified to reflect accurately the characteristics of the printing material and the effect of the printing and processing operations. The signals are then applied to a colour television tube with the appropriate polarity to produce a positive image.

Three graduated control knobs enable the grader to vary the colour balance and brightness (density) of the video image, until he is satisfied with the result. The final scale settings then indicate the filtration required to make the print.

At first, the Hazeltine Video Analyzer was used by motion picture laboratories; in due course professional laboratories began to use a model specially designed for them. In 1969, Eastman Kodak introduced a Video Color Analyzer (VCNA), based on a design by Alex Dreyfoos, and this too was used by motion picture and professional laboratories to grade individual colour negatives. After that, the use of video analyzers became widespread and quite often they were incorporated in automatic roll-printers intended for the large scale production of colour enlargements from amateurs' negatives.

PRINT PROCESSING

The early stages of colour print processing must be carried out in complete darkness, and there was little point therefore in developing colour prints in the trays and dishes that were commonly used to develop black and white prints by inspection. Instead, it soon became usual to develop cut-sheets or short rolls of paper in racks or reels that would be immersed in solutions contained in a sequence of tanks. For a while some finishers, particularly in Europe, used rotating drum processors in which a variety of print sizes could be automatically treated in an appropriate sequence of temperature controlled solutions.

DRUM PROCESSORS

The earliest commercially available drum processor was made in Germany by Holmuller, to a design by Gall. A number of other rotary processors quickly followed, some of them, like the Holmuller, automated so that the required sequence of processing steps was determined by a programme card. Others needed the attention of an operator to tip out solutions and replace them at appropriate intervals. Some machines, including the Autopan, Meteor and Colenta, operated with prints attached to the outside surface of the drum while others used a hollow cylinder, inside which the prints were placed for processing. Examples of the latter type were Kodak's Model 30 Rapid Processor and the machines designed by Peter Wilkinson and originally sold by Agfa Gevaert.

Another, smaller form of processing drum was invented by two Canadians – Simon Restowsky and Douglas Rickard – who called it the Simmard drum. The drums were made in Canada and in the US under licence, where they were known as the Unidrum.

Small processing drums or tubes, provided a simple and cheap answer to the problems of small-scale colour print processing. They could be loaded in the dark and then used in white-light, they required very small volumes of solution and agitation could be achieved simply by rolling the drum back and forth on a bench or table or by using a motorized drum roller. The Simmard drum incorporated a pair of eccentric flanges which ensured that as the drum rolled, the solution inside moved laterally as well as in a rotational direction.

In the early 1970s, Eastman Kodak introduced a slightly more elaborate form of processing machine they called the Rapid Color Processor. This time the print was located, with its emulsion surface facing inwards, on the outside of a dimpled stainless steel drum. The print was prevented from rotating with the drum by means of flexible sheet of plastic mesh and the drum collected

If rolling a print-drum by hand became too boring, an electrically driven drum roller could be used.

The Wilkinson film or paper processor could handle prints up to 24" x 20" and was originally distributed jointly by Wilkinson and Agfa-Gevaert.

In the 1970s, Kodak introduced the Rapid Color Processor, incorporating a stainless steel drum with a dimpled surface. The print to be processed was placed face down on the drum and prevented from rotating by a mesh blanket placed over it. Continuously changing solution, picked up by the drum, moved across the emulsion surface of the print.

solution from a tray and carried it up into contact with the emulsion surface of the print as it rotated.

When, around 1960, the hobbyist was able to buy Agfacolor or Ektacolor papers to make prints from colour negatives, it took him some 30 to 40 minutes to process a print, which then had to be dried – often by glazing. Gradually the number of solutions and steps were reduced while their working temperatures were increased, until by 1975, it was possible to process an Ektacolor 74RC print in the Kodak Rapid Color Processor in 4-1/2 minutes by using the developer at 100°F. Drying the print could be speeded up by using a hair dryer, but in any case, drying only took a few minutes because by that time all colour papers were coated on resin coated paper, both sides of which were protected by a layer of polyethylene leaving only the emulsion layers to absorb water.

ROLLER PROCESSING MACHINES

Machines through which sheets of film or paper were moved from solution to solution while being constrained by a series of closely spaced rotating rollers, were originally introduced by Kodak for processing X-Ray films.

It was Russell, the man who discovered that it is possible to apply multiple layers of emulsion simultaneously, who also invented the X-Omat roller processor.

When resin-coated papers became available it was not long before roller processors began to be used for processing colour prints. Some of the early machines, made for professional laboratories by such manufacturers as Hostert, Hope, Kreonite and others, were large enough to handle paper up to 70 inches wide. Smaller, much more compact bench-top machines began to appear in the 1980s and were used for the small-scale processing of prints made from either colour negative or transparencies.

A typical example of such processors was Ilford's CAP-40, which would produce processed (wet) Cibachrome prints up to 20″ x 16″ in 6 minutes.

EKTAFLEX

In 1980 colour print processing of negative/positive prints was made even easier when Kodak introduced their Ektaflex process. Ektaflex, which was a diffusion transfer process, owed much to the work that Kodak did in developing their alternative to Polaroid's 'instant' colour processes. The only piece of equipment required to process an Ektaflex print was the Printmaker, described by Kodak as 'just a sophisticated tray with a ramp at one end and a set of rollers at the other.'

In use, a sheet of exposed Ektaflex PCT (photo color transfer) film is run through an activator contained in the Printmaker before being laminated to a sheet of transfer paper. After lamination white light could be used. The activator was strongly alkaline but its temperature was not critical and the time the film and transfer paper remained in contact was not important. In 1982, a reversal Ektaflex film was introduced for making prints from slides.

Despite the extreme simplicity of its processing, Ektaflex achieved only limited popularity. It was not print processing that inhibited the hobbyist when making colour prints, but the difficulty he faced in arriving at the correct exposure and filtration without making excessive numbers of test prints. This problem remained the same whatever method he used to process the print, and was made worse by the fact that small test strips or prints could not be used in the Ektaflex process.

ENLARGEMENT CENTRES

At an SPSE Symposium on Photofinishing Technology in 1982, Jack Coote presented a paper in which he described a daylight operating enlarger/processor that could be sited in photo-outlets and used by

(far left) The Ektaflex process, was based on technology developed by Kodak during research carried out on a 'peel-apart' process to compete with Polaroid.

(mid-left) The Ektaflex Printmaker was simply a tray with a ramp at one end and a set of rollers at the other.

(left) The Kodak Create-a-Print centre, with its built-in paper processor, enables a customer to compose the enlarged image from a colour negative by adjusting an electronically reversed positive image on a video screen.

photographers requiring selective 8 x 10in enlargements from their colour slides.

The print material was Cibachrome, and the enlarger/processor, equipped with a zoom lens to facilitate cropping, was made by Durst. Machines were installed in the US, the UK, and Europe.

In 1988, Kodak introduced the Create-a-Print Centre: a stand-alone, rapid-access enlarger/processor, intended for producing selectively composed 5 x 7in, 8 x 10in or 11 x 14in enlargements from 35mm colour negatives using a 17x enlargement zoom lens. Both the composition and the colour balance of each print could be adjusted by examination of a CRT Monitor and only when the video image appeared satisfactory was the print exposure initiated. Using the RA-4 process and Ektacolor 2001 paper, without running water, finished prints could be delivered in four minutes.

In 1982, Ilford Limited, in collaboration with Durst in Italy, introduced the Cibachrome Print Centre, which enabled the user to visit his local photo-dealer and while there, make selective enlargements from his own colour transparencies. The time required was 10 minutes.

PHOTOFINISHING
IN COLOUR

'To imagine that dividends can be paid to shareholders in a process that seeks to supply the public with snapshots or portraits in colour is extreme foolishness.'

PENROSE ANNUAL; 1930

'In face of all warnings, we still, unfortunately, continue to receive Colour Films for processing. Will you please note that we do not process colour films. They should be sent to the makers to be treated as instructed on each roll.'

A PHOTOFINISHER'S WARNING NOTE TO HIS CUSTOMERS; PUBLISHED IN 'THE BRITISH JOURNAL OF PHOTOGRAPHY'; JANUARY 1947.

From about the 1960s in the USA and in the 1970s in much of the rest of the world, most people came to think of colour photography in terms of the prints they obtained from photofinishers – small local companies at first, then large-scale central laboratories often operating by mail-order, and then, after 1980, from the mini-labs that appeared in the high streets and shopping malls of the world.

However, if the processing of amateur movie films is accepted as part of photofinishing, then colour finishing really began in 1935 with the launch of Kodachrome film in 16mm size for use in amateur movie cameras. Because the Kodachrome process was so complex in its original form, there was no possible alternative for Kodak but to undertake to process the film themselves.

Similarly, because the print material used to produce their Minicolor and Kotavachrome prints from Kodachrome transparencies had to be processed in the same complicated way as Kodachrome films, Eastman Kodak knew that the printing service would have to be restricted to their own laboratories.

When they launched Kodacolor film in 1942, Kodak still felt that they had to undertake the necessary processing and printing, since photofinishers at that time had no idea of the problems involved in printing from colour negatives. Consequently, all Kodacolor films were returned to Kodak processing laboratories until, in 1955, Eastman Kodak was obliged to sign a Consent Decree under the Anti-Trust Law. This required them to sell Kodachrome films without the cost of processing included and to release both Kodachrome and Kodacolor processing formulas and know-how to bona-fide photofinishers.

THE MONOPOLIES COMMISSION

A decade later, the Wholesale Photofinishers Association appealed to the Monopolies Commission in the UK to instruct Kodak Limited

to release the processing of Kodachrome to British finishers. In their report the Commission not only complied with the request of the WPFA but also recommended that both the film manufacturers and the photographic dealers should reduce their margins of profit. In the event only two British independent photofinishers installed a Kodachrome processing line and, after 1970, neither was operating.

COLOUR TRANSPARENCIES

Although colour reversal films preceded colour negative films and were popular with enthusiastic amateur photographers for several decades, the era of the subtractive colour transparency must now be seen as something of an anachronism in the history of popular amateur colour photography.

To the snapshot photographer, photography has always meant prints, whether in black and white or colour but the problems that had to be solved before a reasonably good colour print could be made reliably enough and cheaply enough were many. That is why the colour transparency achieved such popularity with the hobbyist after the introduction of Kodachrome and Agfacolor in 1936. At that time it was a great deal easier for a manufacturer to produce a 35mm reversal transparency film than to devise both colour negative and colour papers and the intermediate printing systems that must link the two products.

From the manufacturer's point of view, the advantage to them of making a reversal rather than a colour negative film outweighed the fact that they were offering the amateur a film with a very restricted exposure latitude as a substitute for the much more tolerant black and white film he had been using. In fact, relatively few snapshot photographers made the change, and it was not until the introduction of Kodacolor in 1942 that colour photography really began to reach the mass market.

THE MONOPOLIES COMMISSION

Colour Film

A Report on the Supply and Processing of Colour Film

Presented to Parliament in pursuance of
Section 9 of the Monopolies and Restrictive Practices
(Inquiry and Control) Act, 1948

Ordered by The House of Commons *to be printed*
21st April 1966

LONDON
HER MAJESTY'S STATIONERY OFFICE
Reprinted 1970
12s. 6d. [62½p] net

1

Following representations by the Wholesale Photofinishers Association, the Monopolies Commission published a Report on the Supply and Processing of Colour Film, in 1966. Besides recommending the release of Kodachrome and Kodacolor processing to independent photofinishers, the Report also required the price of colour film to be reduced.

Fig. 2.

(above) This printer, patented by Eastman Kodak in 1940, was used for making Minicolor prints from Kodachrome transparencies.
The main novelty of the design was the provision of a 'white' light surround to a projected image of the transparency to be printed. The idea was to provide a neutral reference field against which the colour balance of each transparency could be judged and then modified by the introduction of correction filters.

(right) In 1954, Pavelle Color Inc., in New York, were using a pre-grading system to determine correct exposures from colour transparencies onto Ansco's direct reversal Printon material.

Nevertheless, there were short periods in the US and the UK when it was only possible for the amateur photographer to obtain colour prints at acceptable prices by having them made from 35mm colour transparencies.

PRINTS FROM TRANSPARENCIES

Around 1940 a version of the Kodachrome process was used by Eastman Kodak for making colour prints on white-pigmented acetate film base. These prints, called Minicolor or Kotavachrome according to their size, and were recognizable by rounded corners.

In 1940 Kodak patented a projection printer of a type that was probably used to make Minicolor prints. It incorporated a two-position swinging mirror that could be used to direct an image of the transparency, either to the eye of the operator or to the focal plane of the print material.

The novelty of the patent lay in the provision of a 'white' light border round the projected image of the transparency, against which the overall colour balance of each transparency could be more accurately judged. Any colour correction considered necessary was made by introducing one of more of a range of low density subtractive colour filters into the projection beam.

Exposures were made on a roll of print material wide enough to accommodate three rows of images that were slit and chopped into individual prints after being processed.

ANSCO PRINTS

In 1943 Ansco produced a reversal colour print material called Printon, the emulsions of which were coated on white-pigmented film base just like Kodak's Minicolor and Kotavachrome prints.

Film base was often used for early direct reversal print materials in order to minimize the risk of mottle arising from the lower image forming layer recording the unevenness of a paper surface.

PAVELLE COLOR

Unlike Kodak, Ansco decided not to establish a processing service under their direct control, but to assist the Pavelle brothers, who ran a black and white photofinishing laboratory in New York, to establish and operate a colour laboratory called Pavelle Color Incorporated. Thus, Pavelle became the first independent colour photofinisher, with a modern laboratory equipped with special purpose colour printers and large, high-speed continuous print processing machines.

The Pavelle colour printers have been described by Lloyd Varden and Peter Krause. They were used in conjunction with a grading and coding system by which each transparency was rated in terms of the ratio between total light transmitted and the light transmitted by a small but important area. The two readings were fed into a zero-centre meter and any defection was translated into 'plus or minus' density corrections. The printers had no means of assessing colour balance or necessary corrections, which were determined after visual examination by a grader.

After exposure the Printon material was processed on a continuous machine running at twenty feet a minute and taking two strands. Glazing was unnecessary because the prints dried with a glossy surface reflecting the film base on which the emulsions were coated.

ILFORD COLOUR PRINTS

In Britain, Ilford Limited, who had been making a non-substantive 35mm colour reversal film called Ilford Colour D since 1948, entered the amateur colour print field in 1952, some three years before Kodacolor film reached the UK. They decided to use a silver dye-bleach print material and to offer a print making service of their own.

A feature of any silver dye-bleach material of that time was its

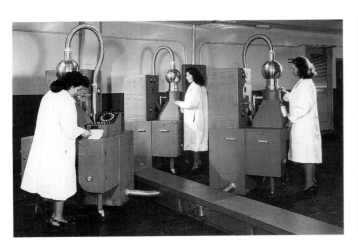

(far left) The Pavelle Color printers were operated in white light and they incorporated automatic density integration. Pavelle Color Inc., was the first large-scale independent colour processing laboratory.

(left) Re-exposure before colour development of the Printon material was made in an overhead light-box located between the dark and light sections of the print processing machine.

extremely low sensitivity and in order to achieve reasonable rates of production, a printer was designed around a 2-1/4 kW Xenon arc lamp.

A useful bonus came from the use of a Xenon arc as a printer light source, because Ilford was able to use a novel method of introducing colour corrections to compensate either for batch to batch differences in the print material – of which there were many – or for differences between individual transparencies.

The idea was patented by Jack Coote and Philip Jenkins and depended upon the adjustment of the phase relationship between the pulses of light from the lamp and a rotating sectored filter wheel, driven from the same power supply. When the phase relationship between the light source and the filter disc was altered (by rotating the body of the motor) different clear or coloured areas would be present in the light beam during the peak output of each pulse from the lamp.

The Minicolor prints made by Kodak in the US, and the prints made on Printon material by Pavelle Inc., were trimmed flush to the picture area and had rounded corners. This was done in order to avoid delivering prints with black borders – a characteristic of any direct reversal print making process. Ilford decided to produce their prints with white borders and this was done by giving a second exposure during which an opaque metallized glass protected the image area while allowing the surrounding borders to receive a flash exposure sufficient to completely fog all three emulsion layers.

The Ilford printer was worked by two operators, one of them feeding card-mounted transparencies and information into the printer and the other removing the printed transparencies and replacing them in their individual envelopes. By these means more than 1,000 exposures an hour could be made, despite the extremely low speed of the print material.

Ilford continued to operate their print-from-slide service for a decade, often producing a million prints in a year.

KODAK REVERSAL COLOUR PRINTS

In Europe, Kodak did not introduce colour prints from transparencies until 1955, when they used a paper-based colour development material employing colour couplers of the Ektachrome type. This was the first reversal colour print material to be made on a paper base and the research leading to its production was mainly carried out by Kodak Pathé in France.

None of the colour printers used by Kodak, Pavelle or Ilford for printing from slides, incorporated any form of electronic control of colour balance.

THE LAUNCH OF KODACOLOR

The processing of amateurs' colour negatives was first carried out by Eastman Kodak in 1942, when the Kodacolor process was launched in the US. The machines used by Kodak to process the exposed films, were of the rack and tank type, or what came to be known as 'dunking' machines. These were used because Kodacolor was available in all roll-film sizes but not in 35mm cassettes and the use of continuous processing machines would not have been possible.

PRINTING KODACOLOR NEGATIVES

After some preliminary work on printers involving visual comparisons by the printer operator, Kodak began to introduce greater control and automation of the printing process. First came the 1598 printer with which variations due to film speed and colour balance together with negative processing, were monitored by exposing a standard reference patch on the end of each customer's film before it was processed. After processing, the

A Kodak Minicolor print (far left) and a print made by Pavelle Color on Ansco Printon material (mid left). Both prints were made in 1954. The reproduction with the square corners was made directly from the original Kodachrome transparency.

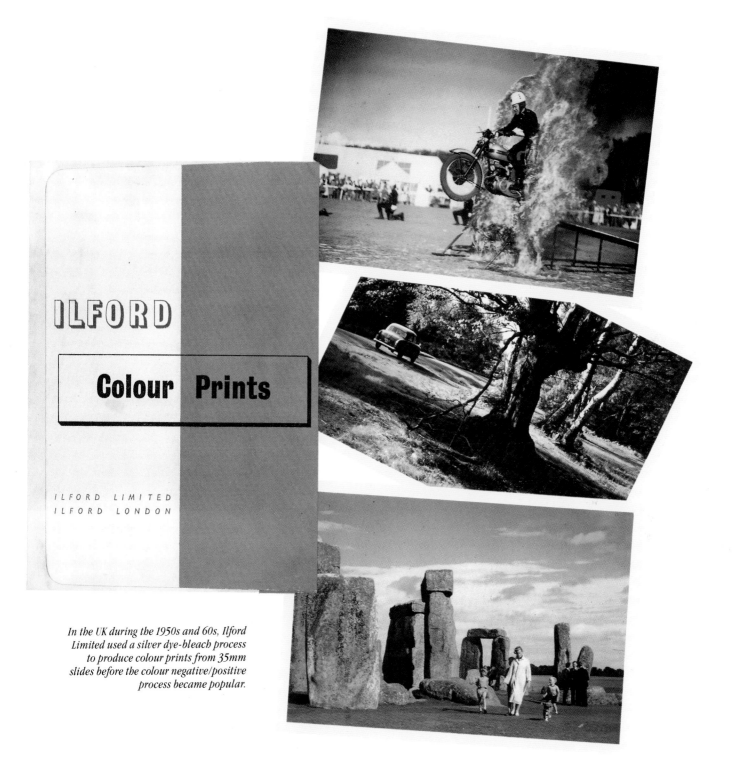

In the UK during the 1950s and 60s, Ilford Limited used a silver dye-bleach process to produce colour prints from 35mm slides before the colour negative/positive process became popular.

colour densities of this reference patch could be measured and then each negative on the film was punched with a series of small holes along the edge, the size and location of the holes indicating the direction and degree of colour correction required to adjust the transmitted colour of any particular negative to a standard. When each negative was printed, coded perforations automatically determined the correction filters that were required in the printing beam, while the response from a photo-cell was used to adjust the intensity of the printing beam by means of a neutral continuous wedge so that a uniform time of exposure would result.

EASTMAN KODAK 1599 PRINTER

Kodak's next printer, the Type 1599, was based on the Evans disclosure, and it was protected by a patent issued in 1947 to C. M. Tuttle and T. B. Brown, who explained that:

The customary methods of making colour prints in a multi-layer printing material from an integral tri-pack color negative involves the following steps. First, a processed negative is sent to an expert for judging and this step requires the services of an expert who can judge color negatives and tell what combinations of filters is required in a color printer to correct for discrepancies in the color balance or overall hue of the negative in order to obtain a color print having colors rendered correctly therein. The expert puts a code on the margin of each negative judged and each code informs the printer operator what combination of filters to insert into the printing beam in the exposure. Since this judging step is time consuming and fatiguing it is customary to judge only one negative, usually the first, on each roll of film and the code applying to this negative is used for printing the entire roll.

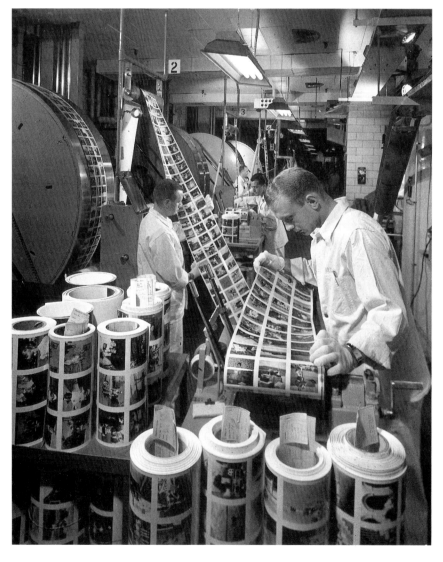

'The practicability of this procedure is dependent on the fact that all pictures on the roll are exposed at approximately the same time, or at least under the same lighting conditions, so that any deficiency as to correct color balance or overall hue, which might appear in one picture due to improper exposure, should apply to all pictures on the roll. While this condition might be true on average, it will be obvious that it does not hold true for all pictures and it is quite possible that different pictures on the same roll will be exposed on different days and under quite different exposure conditions.

'According to the present invention, the total negative transmission for each of the three primary colours (red, green and blue), is integrated and measured individually and the printing source is adjusted until the intensity of each of the transmitted primary colors is equal to a pre-selected value. The color-sensitive printing material is then exposed for a given time to each of the transmitted primary colors with the intensities so adjusted. While the exposures with the three primary colors is preferably made successively right after integration, measurement and adjustment as to intensity to the transmitted printing beam, the three could be integrated, measured and adjusted as to intensity individually and then the exposure by the three could be made simultaneously. This of course, would necessitate using three separate printing sources. It will thus be seen that by the preceding method each and every color negative is integrated and measured rather than only one on each roll as is commonly done with previously known methods.'

The 1599 printer exposed three rows of prints along an eleven inch web of paper. Each print was the product of three consecutive exposures – one each through red, green and blue filters – a procedure that became known as additive printing.

In order to avoid the complications that could result from reciprocity failure in the emulsion layers of the colour paper of that time, the 1599 printer used filtered exposures that were always of the same duration, because the intensity of the light at the paper plane was automatically adjusted to a predetermined level. That the 1599 printer was extremely successful was shown by the fact that at one time something like a hundred of them were in use at Rochester.

In any constant-time printer a thin negative must take as long to print as a dense one, which can often result in lowered output. No doubt this was why the 1599 printer incorporated triple negative carriers so that the operator could be loading or changing negatives while the printer continued to make exposures from another negative in the gate. This system required the printer operator to be working on three different customer orders at the same time.

THE TECHNICOLOR PRINTER

Technicolor, who entered the photofinishing field in 1957 by buying Pavelle Color Incorporated, designed and constructed a constant-time additive printer with a very high operating speed. The printer, which may have owed something to the Bell and Howell additive motion picture printer, was described by A. M. Gundelfinger, E. A. Taylor and R. W. Yancey. In order to avoid the loss of time involved in making consecutive exposures, each print was exposed concurrently through red, green and blue interference filters. The exposure time for any negative was 0.5 secs.

The printer accepted two 500ft rolls of encoded roll film negatives and was loaded with a supply of 7 inch wide paper. The Technicolor printer operated at the rate of 5,000 prints an hour without the attention of an operator – a remarkable achievement at that time.

(left) Prints made from roll-film Kodacolor negatives in Eastman Kodak's Rochester laboratory during the 1940s and 50s, were printed in three rows on 11 inch wide paper.

(right) The Type 1599 printers used by Kodak for printing 120 size Kodacolor negatives, used the additive form of exposure. The operator could apply both colour and density corrections if necessary.

(far right) Between 1942 and 1955, all the Kodacolor films exposed in the US were processed in Kodak laboratories and printed on batteries of Type 1599 printers.

THE KODAK IVC PRINTER

At the time of the Anti-Trust ruling in 1955, very few photofinishers understood anything of the problems related to the printing of colour negatives and no colour printing equipment whatsoever was available to them. The 1599 printer was far too complex and expensive to be suitable for the outside finisher, although it was offered for sale. Eastman Kodak's answer to the problem was to convert their existing Type IV Velox Rapid Roll-Head black and white printer into a variable-time additive colour printer.

The reciprocity characteristics of their colour paper had improved sufficiently by then to allow the use of exposures of different duration.

The IVC conversion was so successful that it became standard equipment in the US.

Although they used Type IVC printers supplied from the US in their Kodacolor processing laboratory at Hemel Hempstead, Kodak Limited, like Eastman Kodak, needed to have a colour printer available for independent finishers who wished to start processing and printing Kodacolor films, following the ruling of the Monopolies Commission in 1966.

The IVC printer had a very limited rate of printing and Kodak Limited solved this problem by adopting a printer designed by R. W. G. Hunt. The S1 was the first colour printer to be made generally available in the UK and it departed from the principle of additive exposure that had been established in Rochester.

With the S1, and most of the other printers that followed, exposure commenced with unfiltered light from a 'white' (tungsten) source that allowed all three red, green and blue exposures to proceed at the same time. The predetermined amounts of each of the three component exposures were obtained by the automatic insertion of subtractive (minus) filters at the appropriate times. When the required amount of red light had reached the print material, a cyan (minus red) filter was inserted into the exposing beam so that only green and blue light continued to reach the exposure plane. When the green exposure was sufficient, then a magenta (minus green) filter was inserted into the beam as well. Similarly, when the channel monitoring blue light was satisfied, a yellow (minus blue) filter was used to terminate the blue exposure and a capping shutter then completed the exposure of the print.

Not long after the S1 printer appeared in Britain, two subtractive printers were launched in the US: Pako's Pakotronic 5C in 1958 and Eastman Kodak's 5S in 1959.

GEVAERT

In 1958, the Belgian company Gevaert, who had not yet amalgamated with Agfa, began selling Pako processing and printing equipment in Europe to support the sale of Gevacolor paper, an Agfacolor-type product they had been making since 1951.

THE KODAK 5S PRINTER

The 5S printer differed from the S1 in one important respect; its terminating filters were positioned after the measuring photo-cells, whereas in the S1, the terminating filters were located before the photo-cells.

In a patent granted to E. K. Letzer of Eastman Kodak in 1959, the problem of print wastage due to colour anomalies was addressed once again and the solution proposed was to locate the measuring cells of a printer, such as the 5S, before the terminating filters. By these means Letzer made use of the non-image absorbencies of the subtractive filters in order to:

'provide where necessary, a lowered color correction level while maintaining a nearly full correction for overall density

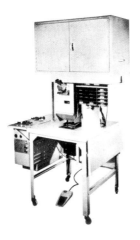

In 1955, following their signing of a Consent Decree requiring them to release Kodacolor processing and printing to independent finishers, Kodak quickly converted their Velox Rapid black and white printer to an additive colour printer they called the IVC.

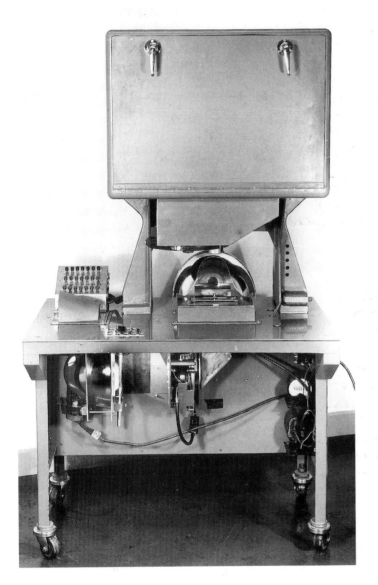

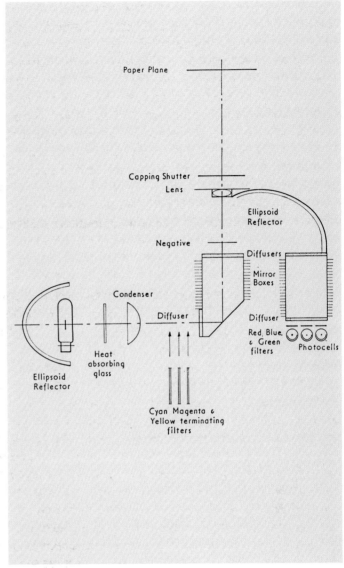

The Kodak Type S1 colour printer was designed by Dr R. W. G. Hunt and introduced on the UK market in 1967. It was the first printer to use a single 'white' light exposure rather than successive exposures through red, green and blue filters.

Schematic diagram of Kodak S1 printer. White light printing with subtractive termination. Light for the photocells is collected by a large ellipsoid reflector and diffused by a secondary mirror-box. The main mirror-box provides diffused light at the negative plane. The terminating filters are in the lamphouse, so are effective on both the printing paper and the reading cells.

variation of a population of negatives to be printed. This desired result can be accomplished with a variable time subtractive printer modified so that the monitoring cells are placed in the system ahead of the subtractive filters and therefore do not compensate for the non-image absorbencies of the filters.'

GRETAG PRINTER

Gretag AC of Zurich were owned by CIBA and became involved with photofinishing when in 1955, they were asked to design and build a colour printer for Tellko to use for making prints from slides at Friburg. When CIBA acquired Ilford Limited, it was decided to concentrate group photofinishing activities in the UK and the Tellko operation ceased. Gretag, having decided to remain active in the photofinishing field, began to concentrate on the production of printers for colour negatives. Their first design, shown at Photokina in 1963, was known as the EC2, but in 1964, this was replaced by the 3000 series, of which the 3116 became the best known. The success of the 3116 was largely due to its stability and reproducibility. A constant intensity circuit included a control amplifier linked to a photo-resistor located in the lamphouse to hold the printing lamp at a predetermined brightness. The system was effective enough for illumination to remain constant even after replacing a lamp.

FILM SIZES AND FORMATS

Before 1958 the colour films used by amateurs were available only in roll-film sizes. There were probably two reasons for the belated marketing of Kodacolor in the 35mm format; one of them being the relatively grainy emulsions of that time, and the other, the large number of exposures, normally twenty or thirty-six, made on each roll. At that time, because of the low film speed and limited exposure latitude, the chances of obtaining good colour prints

from every exposure made by an amateur were very slight and the photofinisher was faced with a serious problem, since he had to decide on behalf of the customer, which negatives should be printed. In making these decisions he had to weigh on the one hand, the reluctance of the customer to pay for a poor print from a technically deficient negative, against his natural desire to have some return for the money spent on the film and its processing.

ILFOCOLOR PROOF-PRINTER

Ilford Limited, who had introduced their Ilfocolor (Agfacolor-type) negative films in 1960, decided in 1961/62 to deal with this problem by producing a proof-print from every 35mm film before asking the customer to decide which frames he wanted enlarged. The principal features of the system were:

1) After processing the 35mm film, one-to-one 'contact' prints were made from every exposed negative. The strip of prints was returned to the customer so he could decide for himself from which negatives he would have enlargements made.

2) Negatives were cut and card mounted and the mounts were numbered to correspond with numbers on the proof print.

3) Proof prints and the negatives were returned by post to the customer, who subsequently returned selected negatives for enlargement printing. Customers tended to select only the better negatives for re-printing and often confidently ordered several prints from each negative.

The Ilfocolor proof printing handled 35mm negatives that had been joined into 250ft lengths before being processed on a continuous processing machine – probably the first time that amateur colour negatives had been handled in that way. Notches were cut in the edge of the films to indicate the positions of individual pictures and other notches were cut in the opposite edge of the film to mark the start of each new order. The so-called

The Gretag 3116 colour printer was introduced in 1964 and was the first printer to use fully transistorised electronics to control exposures. The printer could handle 126 and 135 films and produce prints up to 8 inches wide. It incorporated two independent paper reels.

'contact' prints were in fact one-to-one prints made by optical projection.

After proof printing, the negative roll was passed to an automatic mounting machine in which the film was cut into individual frames and sealed in 2 x 2 card mounts, the mounts being numbered to correspond with the numbers already printed on the proof print strip.

An automatic enlarger/printer was used to print customers' re-orders and the mechanical feed of the printer was based on the design of the card-mounted transparency printer previously used by Ilford and described by Jack Coote and Philip Jenkins. The proof prints and mounted negatives proved very popular and the system may have become established practice in the UK had the Monopolies Commission not ruled that both Ilford and Kodak must reduce the prices of their colour films. Ilford were unable to comply and still make adequate profit. So, in 1968 they decided to withdraw from the amateur colour market, thereafter selling their colour negative films to high-volume, private-label mail order outlets in the US, to whom the special processing requirements were seen as an exclusive advantage.

PROCESSING COMPATIBILITY

The fact that the processing of Agfacolor films and papers had been established in Europe before Kodacolor film was available, meant that finishers were often expected to operate two different colour negative processing lines and to set up printers to suit the very different characteristics of Agfacolor and Kodacolor films. This problem of non-compatibility remained a serious one for European photofinishers for many years and was not resolved until, in 1978, Agfa decided to make only colour films and papers that required processing in the C-41, E-6 and EP-2 chemistries established by Kodak throughout the world.

INSTAMATIC 126

A few days before the Photokina exhibition of 1963, Kodak announced that they were introducing an entirely new cartridge loading system of snapshot photography. The concept had been a well-kept secret and photofinishers had been given no opportunity of making plans to handle this entirely new film and format. Yet within a short while it became obvious that 126 Instamatic films incorporated a number of features that could greatly facilitate their processing and printing.

Several of the frequent causes of failure with roll-films were completely eliminated with 126 cartridge films. For example, there was no risk of fogged film edges due to loosely wound spools, no risk of overlapping frames or double exposures, and little risk of physical damage due to faulty film transport.

Although Instamatic 126 cartridges were made available loaded with Kodachrome-X, Ektachrome-X, Kodacolor-X and Verichrome-X films, the success of the system was undoubtedly based on the sales of Kodacolor film. It is probable that the introduction of the Instamatic 126 system did more to popularize colour negative films than any other marketing scheme.

The finisher also benefited directly from several features of the 126 cartridge film. First, when the numbers of the films justified the investment, he could process them on a continuous processing machine – together with 35mm cassette films if necessary. Second, because each frame was associated with a single perforation, the processed negatives could be transported automatically through a printer with the certainty that each exposure would be correctly framed. Rather surprisingly, Kodak had little equipment ready to enable finishers to take full advantage of the new film and format, but a number of independent equipment manufacturers quickly filled the gap.

By the late 1960s, new printers became available that made it

(far left) When in 1962 Ilford Limited launched Ilfocolor in 35mm cassettes, they sold the film inclusive of processing cost and provision of a proof-print from every negative. The images on the proof strip were numbered to correspond with the negatives.

(left) The proof prints made from Ilfocolor 35mm negatives were made on an optical printer which produced images that were the same size as the negatives, in two rows on 70mm paper.

possible to produce more than 2,000 prints an hour from rolls of 126 negatives. Kodak had their 2620, Gretag the Model 3115, and Pako the Mach 1. These printers could also handle joined-up rolls of double perforated 35mm film, but then the negative transport could only be automatic if the films had been pre-notched to ensure correct framing. In Europe, Agfa was busy opposing the Instamatic system and promoting their Rapid cassettes and cameras as an alternative.

110 AND DISC FILM

When, in 1975, Kodak introduced their Pocket Instamatic Cameras and 110 cartridge films, they reduced the size of the Kodacolor negatives to 13 x 17mm. For the most part, photofinishers were able to adapt existing 126 and 135 processing and printing equipment to deal with 110 films, but when in February 1982, Kodak announced their disc cameras and films, photofinishers throughout the world were seriously inconvenienced. Neither processing nor printing disc films could be done on existing equipment and this time the equipment could not be modified. The result was that many small finishers were forced to sub-contract their disc film orders and the system became unpopular with them from the outset.

There were several other reasons for the limited acceptance of disc cameras and films, but the most frequently reported cause of

dissatisfaction was the relative unsharpness and graininess of the resulting prints. Despite the expenditure of enormous amounts of money on both research and marketing, Kodak had no way of ensuring that some disc films were not exposed in cameras with less than perfect lenses or that the processed films would always be printed on printers equipped with the special lenses they had devised. Consequently, quality standards were not always maintained, the disc system never achieved the targets Kodak had set for it, and in 1987 they announced that they would make no more disc cameras.

SCANNING PRINTERS

Kodak's 2610 printer incorporated a scanning device to determine the correct overall exposure required by a negative, but the assessment of the colour of the negative and ratio of red, green and blue exposures required, were still based on large area transmittance density, or LATD. In 1974, Gretag introduced the first colour scanner, although initially it was used as a stand-alone unit producing a magnetic tape that was then used to control a 3114 printer. By 1976, Gretag had incorporated a colour scanner in the 3140 printer, designed by Walter Grossman and capable of exposing some 5,000 prints an hour.

Gretag's first scanner and scanner printer used a rotating aperture disc in conjunction with three filtered silicon photo-cells to traverse a moving negative to provide approximately 100 density

After 1976, Gretag produced their Types 3140 and 3141 printers, incorporating a colour scanning system designed by Walter Grossman. These printers were capable of making some 5000 prints an hour from 35mm negatives.

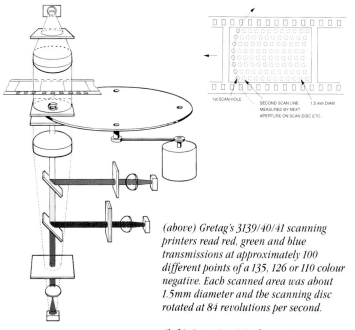

(above) Gretag's 3139/40/41 scanning printers read red, green and blue transmissions at approximately 100 different points of a 135, 126 or 110 colour negative. Each scanned area was about 1.5mm diameter and the scanning disc rotated at 84 revolutions per second.

(left) Gretag's original scanning system used a rotating aperture disc in conjunction with stepped movement of the negative.

measurements. Later, a fixed array of fibre-optic detectors was used in place of the rotating disc.

The introduction of image scanning as a means of assessing the exposure required for a particular negative, made it possible to operate printers at very high speeds without any attention from an operator except to supply rolls of negative and colour paper.

Essentially, an automatic scanning printer depends upon two units:

1) A scanning system that will assess the density of a colour negative in terms of red, green and blue at many different parts of the image.

2) An evaluation station at which a computer analyses the density measurements and compares them with algorithms before determining the exposure required.

In 1983, Agfa, Fuji and Kodak all introduced new scanning printers.

The Agfa MSP printer read 420 scanning points per 35mm frame and also used a 'total film scan' system. This latter innovation involved scanning the whole length of each film before dealing with its individual frames, thereby obtaining information that enabled different colour film types to be printed without the need for preliminary sorting or coding. The MSP was also able to detect and reject unsharp negatives.

Agfa had obtained a patent for their multi-scanning idea in 1972 and in the preamble of the specification the problem of waste due to subject anomalies was outlined once again:

'In a relatively high percentage of cases, irrespective of the subject this type of correction (integration to grey) produces satisfactory prints but with subjects in which one colour predominates this type of correction produces colour shifts which in many cases are unacceptable.

'In order to overcome this, printing methods have previously been proposed in which only partial compensation is made for colour ratio differences in the originals being printed that differ from the normal ratio. In this way a compromise is achieved which is in fact satisfactory for some of the cases that would otherwise have been unsatisfactory but, essentially, one error is only reduced by this method at the expense of an increase in another.'

'The invention provides a process for the reproduction of photographic originals which comprise transilluminating plurality of coloured originals, measuring for the plurality of originals the average intensities of the light transmitted in each of three primary colours, and for the purpose of making reproductions of the originals illuminating each original in turn with printing light in which the ratio of the quantities in each of the said three primary colours is adjusted as a function of the ratios of the said averages.'

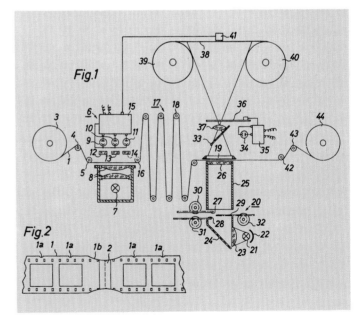

The novelty of Agfa's Multi Scanning printer lay in the fact that the whole length of each customer's film was scanned to detect any overall deviation, before the individual frames were printed.

This schematic drawing from a patent protecting Agfa's multi-scanning idea, shows how each film was first passed through a scanning station (6) before being printed, frame by frame at an exposing position (26).

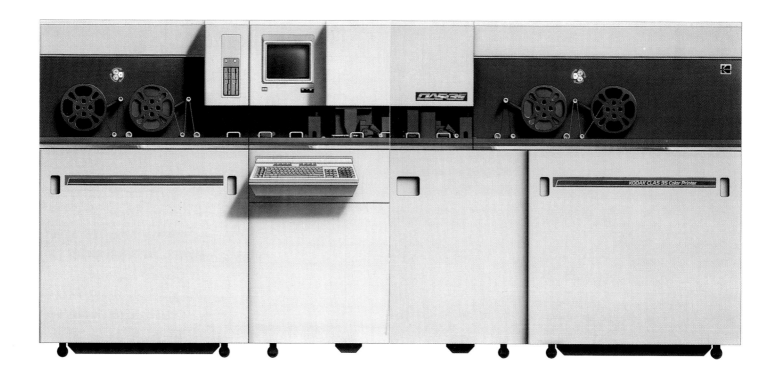

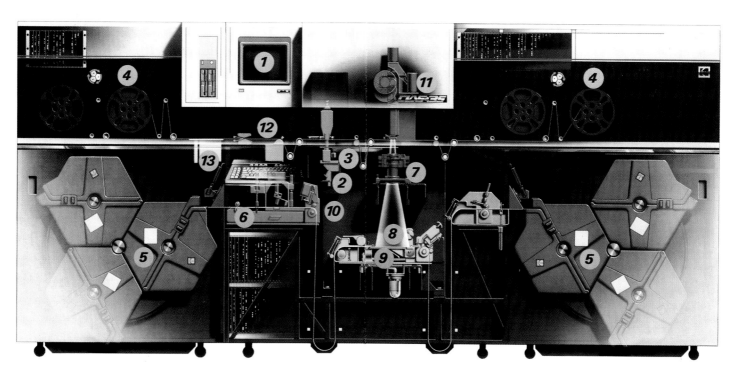

Eastman Kodak's CLAS 35 printer was designed for use by very large photo-finishing laboratories, able to utilise an output of some 20,000 prints per hour. To achieve such rates of production, 'down-time' was reduced by using dual film-supply and take-up reels and a triple paper roll supply together with automatic paper splicing and roll change-over.

In other words, before any negative is printed, all the negatives on the roll were scanned together, so that the peculiarities of that particular film, including the effects of any manufacturing differences, storage conditions, processing errors, were detected and used to automatically adjust the reference standards against which the printer then operated.

At first, multi scanning was used only with large scale high-speed printers, but later the principle was incorporated in the much smaller printers used by mini-labs.

Fuji's Advance Computerized Color Scanner (ACCS) was the first to use a charge coupled device (CCD) as an 'area sensor'. Fuji explained:

'ACCS relies on two types of specially developed software to perform scanning operations and recognize patterns. One inspects and reads CCD-derived image information. The other calculates the proper exposure and sets the lights accordingly. To determine the main subject in the photo, the ACCS software programme consults a host of simulated image patterns.'

Some of the early Kodak scanning printer read each negative at 100 points, but in Eastman Kodak's CLAS 35 printer, each negative is read at points spaced at 1mm intervals, that is, 24 x 36 points per frame, making a total of 864 pixels.

Printing exposures are made using a constant-time, variable-intensity, additive light source, reminiscent of the old 1599 printer, with the difference that the exposures are made concurrently. The CLAS 35 printer was designed to reduce 'down-time' resulting from paper and negative roll changes. By using three 1,800ft paper supply and take-up cassettes with automatic splicing, paper roll changeover time was reduced to 25 seconds. Dual slide-over negative film tracks enabled negative roll changes to be made in 15 seconds. At the extremely high operating speeds achieved with this printer (Kodak claimed 20,000 exposures per hour), it was necessary to use a vacuum platen to ensure that the paper lay flat and stationary even though it was moved some six or seven times a second.

Their investment in such a large and expensive printer during the 1980s, was an indication that Kodak foresaw a continuation of some very large photofinishing operations, even though by that time they, like the rest of the industry, were fully aware of the growing importance of what came to be called the mini-lab.

CRT SCANNER/PRINTER

At Photokina in 1986, Agfa demonstrated an experimental digital print system based on a high definition scanner to convert colour transparencies (or negatives) into digital form so that the output could be manipulated before being 'written' by a three colour cathode ray onto multi-layer colour paper. When used for printing from slides, electronic reversal and contrast control allowed the use of colour negative paper with its shorter processing cycle. Agfa claimed and subsequently demonstrated that 9 x 12cm prints could be made at a rate of 1000 per hour; although that level of production would certainly preclude manipulation of any individual image.

Agfa's Digital Print System used a CCD line scanner with 2048 pixels coupled with a vertical scan of 1028 lines, thereby producing 3 x 2,000,000 picture elements per frame. To use so much information, it was necessary to develop a special cathode ray tube with enhanced definition and a flat screen, from which prints as large as 20cm x 30cm could be generated.

LARGE SCALE PHOTOFINISHING

Throughout the 1970s and '80s, the numbers of 35mm cameras, particularly 'compact' versions, increased dramatically so that more than half the films used by amateur photographers were in

(far left) When, during the 1970s and 80s, the numbers of 35mm films to be processed exceeded all other sizes, most photofinishers installed continuous film processing machines on which joined up films could be processed at high speeds. The Agfa C35/16 machine was typical and it could handle either 35mm or Instamatic 126 films.

(left) As many as six strands of colour paper could be processed simultaneously on a continuous processor such as the Agfa Labomator H machine.

(above) In some large photofinishing plants, joined up rolls of 35mm negatives are fed into printing machines from which the exposed rolls of paper are transferred continuously to paper processing machines and thence directly to an inspection station, where the prints are separated before being re-united with the negatives from which they were made. This system of working was introduced by the Italian company G.P.E., who called it Maxilab.

(left) The 'mini-lab' exhibited and operated by Noritsu at the PMA Convention in Chicago in 1978, comprised four separate units: a film processor, a printer, a paper processor and a print cutter.

35mm cassettes. This meant that any large photofinisher could join up the exposed negatives into long rolls before processing them on continuous film processing machines. After processing, the rolls could be passed through an automatic notching machine so that the notches cut in the edges of the films would serve to locate automatically each negative image correctly in the gate of an automatic printer. Prints were exposed, on long rolls of colour paper, which again were processed in continuous machines.

With so much of the photofinishing process being conducted with continuous rolls of film and paper, it seemed sensible to the Italian company, Maxilab, to link together printers, paper processors and print examining stations to provide a continuous flow of work. The idea was first tried in a Fuqua laboratory in the US and, in 1990, Colourcare installed a Maxilab system at Park Royal in the UK.

MINI-LABS

By the mid-1970s, it seemed that the future of colour photofinishing would lie in the hands of very large organizations, able to invest in complex and expensive processing and printing equipment that would produce enormous numbers of prints at low prices. To many, it appeared that the technical complexity of colour processing and printing put it beyond the reach of small operators.

But then, at the Photo Marketing Association's exhibition in Chicago in 1978, the old-established Japanese equipment manufacturer, Noritsu, exhibited and actively demonstrated a complete laboratory that was able to accept 35mm films and deliver prints from them in just 45 minutes. Noritsu called the system QSS – the Quick Service System.

In fact, Noritsu were not first to have the idea of an on-the-spot photofinishing service, because, in 1961, Kurt Jacobson of Pavelle Limited in the UK, had patented a printer/processor:

'for making enlarged photographic prints from negatives comprising an enlarger and a processing tank, said enlarger including a printing station, means for holding a supply of printing paper and for presenting said paper at the printing station, and means for feeding individual exposed frames of printing paper from the printing station to the said processing tank including two or more compartments for the processing solutions, and means of feeding and guiding such individual frames of printing paper through said compartments and to an exit of said apparatus, said apparatus being enclosed in a light-proof or substantially light-proof manner so as to be operable under normal or subdued light conditions.'

The machine, known as the Pavelle P-100 Automatic Daylight Color Printer-Processor, was compact enough to be used on the counter of a photo-shop. The unit had been designed by Alex Dreyfoos and George Mergens in the UK, while the processing chemistry was worked out by Jacobson in the UK. The colour print material was coated on a white-pigmented acetate base, and produced by the Pavelle Company in the US. By combining the bleaching and fixing steps and raising solution temperatures to 90°F, processing time was reduced to 10 minutes or less, according to the amount of washing given to the prints. Print exposure was said to be controlled by 'an analog computer which accurately determines color balance and exposure in seconds.'

At about the same time, in Switzerland, a combined printer/processor called the Automagnifier, was used at skiing resorts to produce black and white prints on the spot. Then, at Photokina in 1972, the Swiss company, Gretag, showed a printer/processor for producing prints from colour negatives.

The Pavelle Automatic Daylight Color Printer/Processor was designed by Dreyfoos and Mergens and based on a patent granted to Kurt Jacobson in 1961.

Although the unit did not include means for processing negatives, it was the first time that a colour printer had been linked directly to a roller paper processor.

The Pavelle and the Gretag propositions were based on the assumption that many amateurs wanted re-prints from colour negatives that had already been processed and printed. Noritsu believed that the whole photofinishing cycle could be carried out on-the-spot, and what made this possible was the steady reduction there had been in the time required to process colour films and papers, as well as significant improvements in the automatic assessment of print exposure from colour negatives.

PROCESSING TIMES

When first released for general use in 1955, Kodak's C-22 process for developing Kodacolor films required some 50 minutes. When they introduced the C-41 process in 1972, the dry to dry time was reduced to 30 minutes with a four-bath process. Still further reductions in the time followed, until by the late 1980s, a Kodacolor film could be processed in less than 15 minutes.

In 1942 when Kodacolor was launched, the Type 1 Ektacolor paper used by Eastman Kodak in their Rochester plant, required approximately 50 minutes wet processing time, development alone taking 12 minutes at 75°F. Ektacolor Type 1384, used by finishers in the 1960s, still required about 25 minutes wet processing followed by two-stage drying on a hot drum and a high-pressure ferrotyper.

It was not until the early 1970s, after resin-coated papers had been introduced and glazing became unnecessary, that colour paper processing could be completed in less than 10 minutes.

In 1968, a typical continuous paper processing machine would have been working at 8-10 feet per minute with solutions at 85°F

but by the end of the 1980s, colour papers were being processed in RA-4 chemistry at speeds of 50-60 feet per minute, with solutions at 100°F and a processing cycle of about four minutes.

'WASHLESS' PAPER PROCESSING

In 1984 S. Kobishi and M. Kurematsu presented a paper to an SPSE Symposium on Photofinishing, in which they described a 'washless' system of processing colour paper that Konishiroku subsequently incorporated in their Nice Print mini-lab. A patent was granted protecting a method of processing colour papers in which washing is replaced by a treatment with a stabilizing solution. The solution being used to remove most of the entrained developing and bleach/fixing chemicals, in a sequence of tanks in counter-current arrangement. The composition of the stabilizer solution also improved the stability of the print.

The patent could not have been all that effective because within a short while almost every manufacturer of mini-labs was offering 'washless' or 'waterless' processing as an option. Besides making it possible for mini-labs to operate on sites where there could be no connection to a sewer, 'waterless' processing was attractive to other photofinishers who were becoming increasingly aware of the cost of running water.

GRETAG MASTER LAB

In 1989 Gretag produced the first fully integrated mini-lab and called it the Master Lab. It incorporated film processor, printer and paper processor in a single free-standing unit requiring no more than one square metre of floor space.

Before resin coated paper colour paper became available in 1968, glossy prints were made by re-wetting dried prints before passing them through high-pressure ferrotyping units.

The Gretag Master micro lab was the first mini-lab to combine a film-processor, colour-printer and print-processor in a single unit, requiring a floor-space of only one square metre and no connections to running water or a drain.

ONE STEP COLOUR PHOTOGRAPHY

'The story is by now well known and too good not to be true. Apparently, Land, an amateur photographer, was taking family snaps at a picnic in 1943 when his young daughter demanded to know why she couldn't see the pictures – "now". She had picked on the right father to confront with that question.'

GEOFFREY CRAWLEY, 'THE BRITISH JOURNAL OF PHOTOGRAPHY' APRIL 1968.

In March 1839, the Frenchman Hippolyte Bayard produced the first direct positive images within a camera and exhibited prints at an exhibition in Paris in June of that year.

Gernsheim, in his *History of Photography* considers that because Bayard was persuaded by Arago to delay publishing details of his method until February 1840, he effectively lost the right to – 'a more prominent position as an independent inventor of photography.'

Bayard divulged his process to the Acadèmie des Sciences in these terms – 'Ordinary letter paper having been prepared following Mr Talbot's method, and blackened by light, I soak it for some seconds in a solution of potassium iodide, then laying the paper upon a slate, I place it in the camera obscura. When the image is formed, I wash the paper in a solution of hyposulphite of soda and then in pure water, and dry it in the dark.'

The prints exhibited in Paris gave rise to favourable comment by *Le Moniteur* which reported that – 'These specimens are a good augury; if they do not reproduce the colours of the objects, if they leave something to desire in the matter of perspective, they indicate at least that the reflecting operation invented by M. Bayard should be susceptible to rapid improvement.'

Although Bayard's method did not require the use of solutions within the camera it could not be described as a 'dry' process because of the processing required subsequent to exposure. The first person to devise a way of dispensing with processing solutions was Edwin Land, who hit upon the idea of containing necessary chemicals in viscous form within a 'pod' that could be ruptured to allow an extremely thin layer of reagents to be spread between the surfaces of an exposed emulsion layer and an image receiving layer. The result was a practically dry process.

The first Polaroid process, of 1948, used Type 40 material and yielded a sepia monochrome print within about 60 seconds.

Early attempts by Polaroid to obtain 'instant' colour prints. (far left) Using a dye-developer in conjunction with a 'striped' three colour negative record. (left) Using a dye-developer in conjunction with a three colour multi-layer negative record.

THE POLAROID STORY

It must be supposed that Edwin Land's daughter had in mind a photograph in colour, since that was how she saw the scene around her. The fulfillment of that expectation took Land rather longer than it did to achieve 'instant' photography in monochrome. Nevertheless, Land himself must have recognised the importance of colour because the work that eventually led to the first Polacolor process in 1963, began in 1948.

ADDITIVE POSSIBILITIES

At first Land experimented with additive processes, one of which involved the use of a lenticulated film for use in conjunction with the usual banded colour filter on the camera lens. The exposed film was processed to yield a positive image in a receiving layer; but since the result could only be viewed by projection through another banded filter, the process would have had little appeal. Other attempts were made to produce additive screen-plate transparencies that could be processed immediately and viewed in the hand.

A number of different approaches were then made towards solving the more complex problems involved in producing three separate subtractive colour images which would be simultaneously formed within or transferred to a single reflecting layer without interfering with one another.

In one of the earliest attempts, colour images were formed by an exhausted coupler process in which development of the exposed grains of emulsion with a colour developer in the presence of a colour-forming coupler formed insoluble dye and silver images in the emulsion, while in unexposed areas unoxidized developer and unused coupler transferred to a receiving layer, where oxidization led to formation of a positive dye image.

Attempts were also made to use a negative element that did not involve superposed emulsion layers, but instead comprised a pattern of either side by side or crossed stripes – not unlike some of the arrangements previously used for additive screen-plate processes. The elements proposed would be small enough to ensure that during transfer to the receiving surface the separate cyan, magenta and yellow images would merge to form a continuous subtractive colour picture. Manufacture of such a film would have been extremely difficult, and Polaroid must have been relieved when Howard C. Rogers, Head of their Color Research, came up with an entirely new and much better proposition.

POLACOLOR

Rogers' idea was to use a novel type of molecule, linking a developer, usually hydroquinone, with an azo dye. Before oxidation, such a dye/developer was insoluble in water, but readily soluble in the alkaline solution released from a pod. Dye/developer oxidized as the result of developing exposed silver halide, remained stationary, but the remaining, unoxidized dye/developer would migrate to the receiving layer to yield a positive subtractive dye image.

The negative image-forming element of Polacolor was made up of eight emulsion, dye/developer and separating layers; the blue, green and red recording layers being coated adjacent to yellow,

Polacolor, Polaroid's first colour system, required a 'receiving' sheet bearing the final image, to be peeled away from the film on which the original camera image had been recorded.

THE POLAROID STORY

magenta and cyan dye/developer layers and those pairs being separated by thin gelatine spacing layers. The receiving sheet carried three layers, the uppermost being a polymer coating containing a mordant to fix the dyes. Below that was a timing layer and a polymeric acid layer to neutralize the residual alkali; the timing layer was there to regulate the rate of neutralization.

This kind of receiving sheet made it possible to dispense with the after-coating that had been necessary with black and white Polaroid prints.

Polacolor was a 'peel-apart' system that could be used in most of the then existing Polaroid cameras. The time required before separation of the negative and receiving layers was about ninety seconds and the print dried quite quickly with a glossy surface. The effective speed of the film was dependent upon ambient temperature, but in temperate climates was about 64ASA, going up to 100ASA in the tropics.

Describing the Polacolor process in the *British Journal of Photography* in 1963, Geoffrey Crawley said:

'This process is without doubt the most outstanding advance to be made during this century in photography, and must be considered one of the major steps in the advance of photographic science.'

In retrospect this may be seen as a somewhat exaggerated claim; nevertheless, commercial success quickly followed the introduction of the process and resulted in a 19 per cent increase in Polaroid's sales during its first year of production and a further 13 per cent increase in the following year. By that time the photographic part of Polaroid's business represented 97 per cent of their £140 million annual sales, making them the second largest photographic company in the world.

POLAROID 20 x 24 CAMERA

In 1976, John McCann of Polaroid designed a very large camera with which to produce 20 x 24 inch Polacolor reproductions of paintings, tapestries and other works of art. Three cameras were built and were also used for life-size portraits of famous people.

The sensitive material was basically the same as that used for 'peel-apart' Polacolor prints, except that the film and the receiving sheet material were fed from rolls as required.

KODAK'S INVOLVEMENT

Eastman Kodak, who had co-operated in the manufacture of Polaroid materials since Land's early days of polarizing filters, made the multi-layer negative elements of the Polacolor system, while the receiving sheets were made by Polaroid themselves.

As Eastman Kodak shareholders became aware of the success of the Polacolor process and the money it was making for Polaroid, they began to ask why Kodak did not have an 'instant' process of their own.

Although they never made use of it, Kodak had an agreement with Polaroid, which cost a quarter of a million dollars, that would have allowed them to produce and sell Type 108 film packs for use

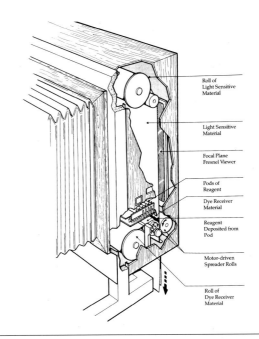

A schematic drawing of the motorised back of the Polaroid 20 x 24 inch camera. The roll of sensitive material allowed 45 exposures, while the roll of receiving sheet material and the supply of chemical pods were sufficient for 15 prints. The sensitive material was wound back temporarily onto its parent roll while focusing took place. The camera weighed some 200 pounds.

Roll of Light Sensitive Material

Light Sensitive Material

Focal Plane Fresnel Viewer

Pods of Reagent

Dye Receiver Material

Reagent Deposited from Pod

Motor-driven Spreader Rolls

Roll of Dye Receiver Material

THE POLAROID STORY

in Polaroid cameras. Instead, in 1969, Eastman Kodak announced that they would be entering the 'instant' picture market themselves. Few Kodak executives could have foreseen the consequences of that decision.

But they must have realised that it would force Polaroid to make other arrangements to safeguard the supply of negative film – which they did by taking the characteristically bold step of building a plant to do the job themselves.

At first Kodak intended to produce a peel-apart process similar to Polacolor, but just before their marketing date in 1972, Polaroid forestalled them by announcing the entirely new SX-70 system which Land himself described as: 'Absolute One-Step Photography.' Kodak's response was to cancel plans to produce a peel-apart process and promise a one-step system that would compete head-on with SX-70.

SX-70 CAMERA

Land described the SX-70 camera, film and process at a lecture he gave to the Society of Photographic Scientists and Engineers in San Francisco on May 10th 1972, and some of his remarks are worth quoting by way of explaining how the system worked.

First, what happens:

'The photographer, after composing and focusing through a new kind of single-lens-reflex viewer, touches an electric trigger.

Within 0.4 second of the shutter closing, from the front of the camera the picture emerges; it is hard, dry, shiny, flat and invisible. Initially the region within the border is a uniform pale green; over the next minute or two, an image materializes with enough colour and definition for judgement of its merit; the materialization continues over the next two minutes to provide the final full-color picture.'

The prints were rectangular with one border wider than the others and an image area of 8cm x 8cm. The filmpack contained 10 exposure units together with its own disposable battery – the camera itself requiring no batteries.

SX-70 FILM

'Then the film itself: at the time of exposure the film unit consists of an integral structure of about 17 layers, the outer two comprising most of the thickness – one of these two outer sheets is transparent so that the light for exposure can penetrate – to enter the image-forming layers. That wide margin contains a very thin version of the conventional Polaroid pod. The film packet is so beautifully self-contained, both before and after processing, that it is a primary contributor to the success of the whole project. We had to learn precision in filling the pods far beyond what we had previously regarded as precision; we had to learn to

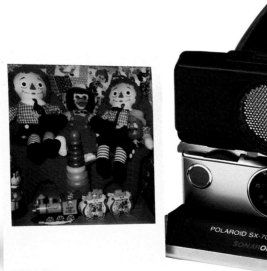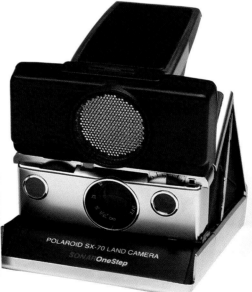

Polaroid's SX-70 camera, introduced in 1972, revolutionized 'instant' photography by using one sheet of film to yield colour prints in full daylight. The SX-70 was remarkable for a number of reasons. Its optical system had to produce a correctly oriented print when viewed from the same side as that which received the image. The SX-70 was also the first camera to be powered by a battery contained in each film pack. The camera could be purchased with auto-focus facility, the first of its kind.

THE POLAROID STORY

make a thin spread between layers already in place – to keep the residue at the end of the spread miniscule and to conceal this miniscule residue.

'What is within the integral structure? Let us start from the outside of the transparent heavy sheet. Keep in mind that there are no air spaces from front to back, either before or after processing – in a typical one of our new structures, on its inner surface would be a layer of a polymeric acid plus layers of what we call a timing polymer, mordant, polymer, gelatine, blue sensitive silver halide, our new metallized dye developer, then the subsequent series of layers with appropriate emulsions and magenta and cyan metallized dye developers. Finally, there is the heavy opaque supporting layer to complete the integral structure. This whole inner structure within the two heavy layers has a total thickness of less than 0.002in, of which the negative, as we make it, is less than half. The pod is sealed to this structure in such a way that, as it passes through the rollers, the small quantity of viscous reagent are alkali and titanium dioxide, so there is immediately formed a new integral structure with a layer of white pigment as a central stratum. The alkali which permeates the layers of dye developer dissolves them. The exposed silver halide leads to the oxidation of the developer moiety and the capture of the dye developer in the region of exposure. The unoxidized dye developer passes through the titania to the mordant and is captured there; this dye is then seen against a background of the white titanium pigment.'

Land left till last his explanation of the remarkable fact that the SX-70 film emerged from the camera into 'several hundred million times as much light as was used to expose it' and yet produced a full colour picture under the gaze of the photographer. He admitted that the camera was designed as if they had solved this problem, while they continued the basic research on the chemical task of bringing the picture directly into the light.

'We synthesized new kinds of indicator dyes designed to be stable at very high pH values, having high absorption coefficient, becoming colorless and remaining colorless at predetermined lower pH values. We then planned to include these dyes in the viscous reagent, rendering it opaque when first spread. Shortly after spreading, the alkali ions would be captured in the polymeric acid layer and the indicator dyes would become colorless.'

The density of the opacifying layer was 6.5 at the commencement of the processing cycle, which normally took between 5 and 10 minutes to reach completion. Because processing took place outside the camera, additional exposures could be made at intervals of less than 2 seconds. In 1969, 'Time-Zero' film was introduced, halving the time required for completion of an image.

The SX-70 camera incorporated a number of unusual features, including a hinged Fresnel viewing mirror that automatically swung into a second position, where its underside served as a reflecting surface for the exposing beam. This reflection provided the correct optical orientation for the print, since viewing and taking were both from the same direction. The first SX-70 camera had an aperture range from f/8 to f/96 with speeds between 14 seconds and $1/175$th second from an electronic shutter.

The new system was an immediate success and Polaroid's sales for 1973 showed an increase of 23 per cent over the previous year. Such results must have spurred Kodak on to complete the research and development on their process, and with some 1600 Polaroid patents to skirt around, some of which ran to more than 100 claims, this was no easy task.

KODAK'S 'INSTANT' PROCESS

The urgency was considered to be so great for Kodak that three different approaches were pursued simultaneously and internationally. Evidently the researchers eventually narrowed the choice to three imaging chemistries. The French laboratory produced a promising technique, but it might take some time to develop. The Rochester laboratories worked on a chemical process which they thought could be commercialized quickly. But the chosen approach was the result of a joint effort by Eastman Kodak researchers in Rochester and Kodak Limited at Harrow in England, resulting in a new reversal imaging process.

In fact the ideas sprang from work done at Harrow in the 1940s by E. B. Knott and G. W. Stevens, and Knott and J. B. Davey, when they patented adaptations of a 'Burton'-type, internal latent-image forming emulsion. When such an emulsion and process was used to prepare and develop a multi-layer colour film, a positive image in colour could be obtained with fewer processing steps than are required with normal films and methods.

Hanson described the new process in a paper entitled *A Fundamentally New Imaging Technology for Instant Photography* which he presented at the Annual Conference of the Society of Photographic Scientists and Engineers in New York on May 27th 1976. When the paper was published, the editor of the *SPS&E Journal* found it necessary to append the following footnote:

'This paper was accepted and prompt publication arranged on account of its timeliness and general interest. This was accompanied with reduced reviewing procedures. The effect of this is particularly evident in the limited literature citations which leave somewhat obscure the relationship of the work reported and other systems existing in the field.'

The film comprised three parts:
1) The *integral image receiver*, containing an image forming section, consisting of emulsion layers and dye releasing layers, and an image-receiving layer coated on an Estar support;
2) the *pod*, consisting of the activator fluid and an opacifier; and
3) the *cover sheet* to effect process stabilization and reaction termination consisting of timing layers, one of which contained a development inhibitor precursor, and an acid layer coated on an Estar support.

The film was exposed through the transparent cover sheet and the black alkaline activator fluid from the pod, started the reactions that released dyes to form the image which was viewed in correct orientation through the support of the imaging receiver.

IMAGING CHEMISTRY

Hanson explained the chemical reactions involved:

'The color image of this instant print film is produced from dyes released as a consequence of redox reactions and hydrolysis. The developing agent is an electron transfer agent, which supplies electrons to the developing silver halide emulsion and is regenerated as it removes electrons from a dye releasing compound called a dye-releaser (DR). The electron transfer agent (ETA), is developing the silver image, becomes oxidized. The latter oxidizes the dye releaser, while ETA is regenerated. Since the ETA can then reduce more silver ions it, in effect, transfers electrons from the dye releaser to the developing emulsion. While this is going on the oxidized dye releaser is being hydrolysed by the alkali in the activator fluid to yield a mobile dye. The released dye is relatively inactive photographically; the by-product of the hydrolysis is immobile and, therefore, also effectively inactive.'

The image on Polaroid Spectra film exposed in an SX-70 camera, begins to appear about a minute after the print emerges, but does not reach completion until some five or six minutes later.

1 minute *2 minutes* *3 minutes* *4 minutes* *completed print*

Hanson went on to explain how the positive working emulsions behaved:

A halide conversion emulsion is an internal latent image emulsion in which internal sensitivity is built into the grain by a catastrophic precipitation technique. First, a silver chloride emulsion is precipitated and then a halide exchange is effected by introducing bromide and iodide salts in such a manner that a mixed halide emulsion with severe internal crystal disruption is obtained. A typical halide conversion emulsion shows virtually no surface sensitivity in the primitive state but reasonably good internal sensitivity when processed with an internal developer, ie. a developer containing a silver halide solvent that makes the internal latent image accessible. The original halide conversion emulsions were deficient in photographic speed, but further research led to considerably faster internally sensitive emulsions and the new film is rated at EI 150.'

With these emulsions, the unexposed grains could be developed instead of the exposed grains, thus making it possible to produce positive images directly.

As part of the system, Kodak offered two cameras, the EK4 and the EK6, the one manually operated and the other with motorized print delivery. The image formed by a 137mm f/11 plastic lens was twice reflected inside the camera to make it more compact, but because the finished print was viewed from what was the back of the film at the time of exposure, orientation appeared correct.

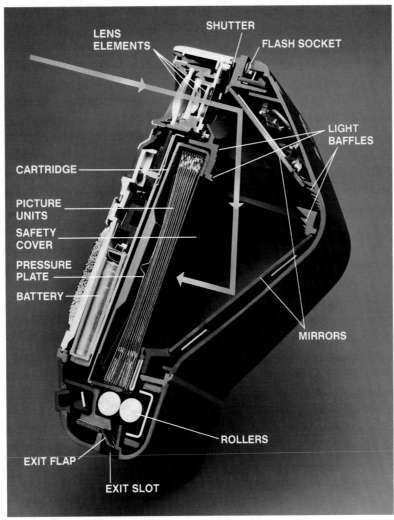

Because a Kodak Instant Print had to be viewed from the opposite side to that which faced the lens during exposure, Kodak Instant cameras incorporated two mirrors so that the double reflection produced an image that was correctly oriented.

Unlike Polaroid, Kodak decided to have a battery in the camera rather than in each film pack. Kodak's literature on the process was reluctant to refer to the time taken for a print to be fully developed, but initially it was about 8 to 10 minutes, much the same as for a print from the SX-70 camera. Later, the time required for a Kodak print was reduced, but there was some evidence that their product was more sensitive to variation in ambient temperature than the Polaroid film.

After internal trials in 1975, Kodak launched the process in the US in April 1976.

LEGAL ACTIONS

Six days later, Polaroid filed an action claiming $12 billion, to compensate for loss of revenue during the period when Kodak cameras competed for sales, and for royalty payments that would have been due under a licensing agreement. Polaroid alleged infringement of 10 of their patents; four involving the SX-70 camera and six relating to SX-70 film.

For their part, Walter Fallon, Kodak's chief executive, responded: 'We still believe our patent position is sound. We don't knowingly infringe anybody else's valid patents.' Kodak then proceeded to bring a counter action, seeking annulment of certain Polaroid patents. Ten years later, a preliminary ruling forced Kodak to withdraw their instant cameras from the market and compensate purchasers with a cash repayment; but another four years were to pass before the dispute was settled.

In October 1990, Federal Judge Mazzone ordered Eastman Kodak to pay $454.2 million in lost profit and royalties for bringing out instant cameras in 1976 that infringed on seven Polaroid patents, plus $455.3 million in interest. This was one of the largest settlements in American legal history, albeit smaller than Eastman Kodak had feared.

FUJI INSTANT COLOR FILMS

In 1968 Polaroid entered the ordinary colour film market by introducing a Professional reversal film in the 4″ x 5″ format. The film, made for Polaroid by Fuji, was intended for processing in E-6 chemistry and was sold in 'packets' suitable for loading into Polaroid's Model 454 camera backs.

This collaboration between Polaroid and Fuji was extended when Fuji began to sell their version of a peel-apart instant film in Japan. By 1991, when many of the original Polacolor patents had expired, Fuji began selling their FP100C (ASA100) film in Europe; starting in Spain.

For a time, Fuji had produced a 'mono-sheet' film under licence from Eastman Kodak, until Kodak's 'instant' cameras had to be withdrawn from the market in 1986.

During the 1970s and 1980s Polaroid introduced several improvements to the basic SX-70 cameras and process; among them Time-Zero film which reduced development time significantly and allowed a completed image to be obtained in just over a minute.

POLAVISION

It was Land's habit to demonstrate some new development or project to the shareholders during their annual meetings. In 1976, one such demonstration was devoted to Polavision, the first 'instant' movie system. Land believed that there was a market for an 8mm movie film that could be processed immediately and then displayed in a compact viewer/projector. Subsequent events proved him wrong, but the ways in which the Polavision system was made to work are nonetheless interesting.

Land had always been intrigued by additive processes and with Polavision he took some of the old principles of the screen-plate processes much further than had been possible fifty years earlier.

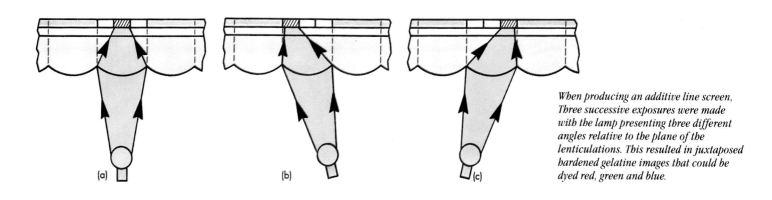

When producing an additive line screen, Three successive exposures were made with the lamp presenting three different angles relative to the plane of the lenticulations. This resulted in juxtaposed hardened gelatine images that could be dyed red, green and blue.

There were two basic problems: first, to produce a much finer additive filter screen than had previously been achieved, and second, to find a way of converting a negative image into a positive *in situ*.

Land decided to use a filter screen comprising parallel lines – just as Joly had done in 1894 – but this time the lines would be spaced at 4,500 per inch against Joly's 200. To obtain such a screen, Land did not use a ruling engine as Joly had done, but instead he made a clever use of a lenticulated film; not to obtain a final colour image, but as a means of forming optically the very fine lines he wanted. One side of a web of clear film base was embossed with parallel lenticulations that were used in conjunction with carefully positioned sources of UV light to expose a thin layer of bichromated gelatine on the other side of the base. In this way line images were formed that could be dyed red and green after successive removal of the unhardened gelatine. Having obtained the red and green lines, the lenticulated surface was softened by solvents and calendered to produce a perfectly smooth surface. The film was again coated with bichromated gelatine and the clear spaces between the red and green lines, hardened by exposure to UV light and dyed blue to complete the job.

The Polavision linemaking process was patented and Land reported that production speeds of 80ft per minute were possible with line spacings of up to 4,500 per inch.

Neither the peel-apart procedure of the early Polaroid processes nor the opaque layers of the SX-70 system could be used to dispose of the unwanted negative image formed in the Polavision movie film process. The trick employed was to ensure that the negative image formed by the camera exposure had such a low density and covering power that it could be left in place, while the subsequently formed positive image had good covering power and a maximum density of 3.0. The ratio of positive to negative covering power was between 8:1 and 10:1, while the single layer of the negative was almost as thin as its constituent grains so that the total weight of silver used for each 2½ minute film was less than 100mg.

The active photographic layers of Polavision film included an anti-halation layer, an emulsion layer and an image-receiving layer and, of course, the emulsion layer was exposed through the film base and the striped filter.

PROCESSING

Processing was initiated by the application of a 10 micro-metres layer of reagent to the surface of the film as it rewound at 400ft per minute past a nozzle in the cassette. Within seconds the exposed grains would begin to develop to form a low density negative image while the unexposed grains began to dissolve. The soluble silver complex then migrated to the positive image receiving layer where it developed into a thin but high density image.

After development of the negative and positive images, the dyes in the anti-halation layer had to be bleached and the stabilizer had to move through the outer layers to the two silver images. Finally, no residue of developer could remain to cause subsequent staining.

VIEWER/PROJECTOR

Any additive process suffers from the fact that some two thirds of the available viewing or projection light is absorbed by the necessary red, green and blue filters. In the case of Polavision, matters were made worse by the fact that the silver of the negative image – removed in all other additive processes – had to remain in place. Recognising this problem, Land ensured that the density of the negative image never exceeded 0.3. He also designed a very efficient light source for the projector/viewer, which used a 150 watt lamp in conjunction with a Fresnel lens and a lenticulated screen that together resulted in a bright, evenly illuminated 12 x 10 inch viewing screen.

(far left) A photomicrograph of the Polavision screen (1500 triplets per inch) (centre and right) photomicrograph of Dufaycolor and Autochrome screen at the same magnification.

Polavision cameras and projectors were made for Polaroid by the Austrian company, Eumig, and their involvement with the project may well have led indirectly to their demise in 1980.

Despite its ingenuity, Polavision was not a commercial success. With a playing time of only 2½ minutes, a Photo-tape cassette was seen as poor value when compared with either conventional Super 8 movie films, or the new video systems being introduced by JVC and Sony.

But because Polavision was seen as Land's personal brain child,

it led to him being criticized within Polaroid and eventually caused him to relinquish the post of Chief Executive in 1980.

POLACHROME

Eight years after the introduction and failure of Polavision, Polaroid again launched a colour process based on additive principles. This time the process, called PolaChrome, produced 35mm colour transparencies ready for projection, in less than 5 minutes after exposure.

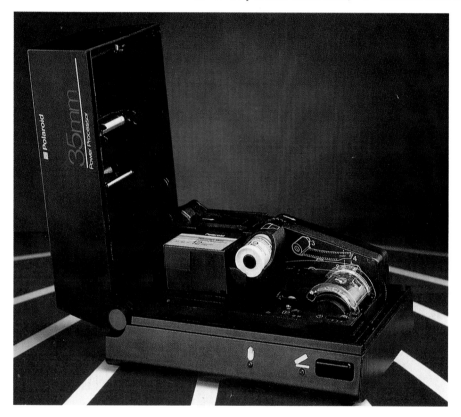

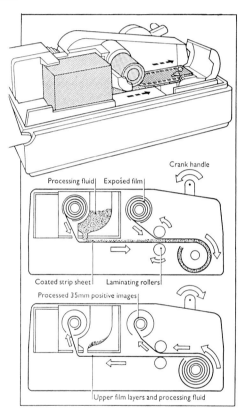

Polaroid AutoProcessors can either be hand-cranked or motor driven, like the model illustrated. In use, the exposed film and a processing pack are loaded with the two leaders attached to a take-up spool. The motor (or crank handle) is then operated to bring the film into contact with the developer saturated processing web. After 60 seconds, the film and the web are rewound and the processed film is separated from the web, which also carries the unwanted negative image layer.

The filter screen used for PolaChrome was created in just the same way as it had been for Polavision, using temporary lenticulations to successively expose and dye stripes of hardened gelatine. At 3000 per inch, the frequency of the lines was slightly lower than Land had claimed for Polavision, but many times higher than had ever been achieved before.

W. Andrews and D. L. Miller have described the manner in which 6000ft rolls of 21in wide film were prepared before being coated with a panchromatic emulsion that gave Polachrome an effective speed of ASA40:

'The polyester base is first softened and then passed over an embossed cylinder which creates minute lenticles of lenses running the length of the roll, 1000 per inch. The colour stripes are then applied photographically by a photo resist method. The embossed film is coated with bichromated gelatin which, when exposed to ultraviolet light, becomes hardened and insoluble in water. The Polachrome film is then exposed, through the lenticular surface, to a bank of ultraviolet lights at an angle, so that the lenticles cause only one third of the film to be exposed, forming hardened gelatine stripes one third of the lenticle's width. The unhardened gelatine is then washed away and the hardened gelatine dyed in a red dye bath. The process is then repeated, with the film being exposed at the opposite angle in preparation for the green dye. Following this the lenticles are removed and the photo-resist process is repeated on the remaining surface for the application of the blue dye. The result: alternating stripes of red, green and blue. The film has now travelled a third of a mile at 85ft per minute.'

EXPOSURE AND PROCESSING

PolaChrome film was balanced for exposure in daylight and could be used in any 35mm camera, although focusing had to take account of the film being exposed through its base. Unlike Polavision, where processing was carried out while the film remained in the cassette, exposed PolaChrome film, after rewinding, was transferred together with a processing pack, into a small, hand-operated table-top machine called an AutoProcessor. The machine could also be used to process PolaPan CT (Continuous Tone) and PolaPan HC (High Contrast) black and white films that formed part of the 35mm AutoProcess system.

After attaching a special perforation in the protruding tongue of an exposed film to a hook on the take-up spool in the AutoProcessor, turning a hand-crank (a later model of the processor was motor driven) caused an even layer of processing fluid to feed by gravity from a chemical pack onto the moving film. The processing fluid then diffused through the outer layers of the film immediately to reduce the exposed silver halide in the panchromatic emulsion layer, thereby producing a low density silver image negative. The unexposed silver halide formed a soluble complex and migrated to the receiving layer to form a positive image. After about a minute in the AutoProcessor, the film was rewound into its cassette, while at the same time the outer layers of the film including the negative image layer together with the applicator band were peeled off and wound into the disposable processing pack.

The positive colour images are usually mounted for projection in the same way as any other slide film, but because the base density of a PolaChrome slide is about 0.7, a powerful projector lamp is required to achieve normal screen brightness. While certainly not the equal of subtractive colour transparency films in quality, PolaChrome offered the possibility of producing finished colour slides in under 5 minutes, and, where necessary, under conditions of complete confidentiality.

ELECTRONIC METHODS OF COLOUR REPRODUCTION

'We all know it won't be long before we can take pictures on a disc tape and view them straight away on a TV screen. There will be no need for processing. You will be able to enlarge or reduce the size of the image, change the colour, add special effects – all at the touch of a button.

'And if you want "hard-copy" prints – simply connect a special box to produce as many as you want – instantly.

'If you think this is light years away, let me assure you it isn't. The technology, as regular AP readers will be aware, is available. Within two or three years, at least one system will be available, if not more.'

EDITOR: 'AMATEUR PHOTOGRAPHER' JULY 13TH 1985.

*'Kodak announced many new silver halide films at Photokina, but did **not** announce an electronic imaging system.*

'According to Prezzano, they have the technology – including a new 1.4 million pixel image sensor. That said, this sensor still has 15 times less information storage capacity than a single frame of 35mm film.

'Mr Prezzano said: "We believe that silver halide has a long and healthy life ahead of it. Meanwhile electronic imaging will begin to grow. By the year 2000 each will have its place." So don't rush to sell your current hardware or worry about what to buy next.'

EDITOR: 'AMATEUR PHOTOGRAPHER' SEPTEMBER 27TH 1986.

The editor of *Amateur Photographer* was right both times. It was not long after he wrote his 1985 editorial that Sony launched a colour video printer that could produce 3in x 4in prints within about a minute from selected frames in their 8mm video camera.

On the other hand, what Prezzano said during Photokina in 1986 remained entirely valid at the end of the decade.

VIDEO RECORDING

When video tape recording was introduced around 1950, the necessary electron beam cameras with their beam-splitters and triple pick-up tubes were used almost exclusively for broadcast television; their size, complexity and cost making them quite unsuitable for any other use.

SOLID STATE IMAGING

It was the invention of the charge-coupled semi-conductor device by W. S. Boyle and G. E. Smith of the Bell Laboratories that showed the way to capture scenes electronically with much smaller cameras requiring far less power. The discovery was made in 1969, the same year in which F. Sangster disclosed his idea for a 'bucket-brigade' delay circuit, the general principle of which is that the signal to be delayed is sampled and stored in a cascade of capacitors interconnected by switches operated at the same frequency as the signal sampler.

In April 1972, the *British Journal of Photography* reported on the work of the Bell Systems scientists, who explained their CCD in these terms:

The charge-coupled device operates by manipulating small packets of electrical charge within a solid slice of silicon. Light incident upon the silicon is absorbed, creating an electrical charge which is stored locally at the surface of the silicon under

(right) In 1991 Sony introduced the Mavica MVC7000P electronic still camera, incorporating three separate CCDs and an optical beam-splitting arrangement.

the metal electrodes. The amount of stored charge is proportional to the incident light flux. Charge coupling makes it possible to move these packets along a well-defined path to an output electrode, where the charge becomes an analogue electrical signal which represents light variations along the scanned line. The charge packets are moved very precisely within the silicon by varying the voltages on the extremely fine electrodes on the surface of an oxide covering the silicon.

The original model camera made by Bell used an array of 128 x 106 light sensitive elements, but ten years later, Sony made a CCD incorporating 490 x 470 pixels.

THE MAVICA CAMERA

Sony caused a furore in 1981 by demonstrating their Mavica 'filmless' still camera; thereby causing many people to conclude that this new form of photographic recording would quickly replace all those methods depending upon silver halides.

But making CCD chips for video recording requires extreme precision and cleanliness, since to provide just acceptable resolution the array of sensors for still video recording must comprise at least the quarter of a million pixels used by Sony in the Mavica camera. But in the case of a single CCD colour camera the array of sensors must be shared between red, green and blue recording elements. Some of the problems involved in achieving colour separation with a CCD are similar to those faced by the inventors of the early additive screen-plate processes. A choice has to be made between stripes and checkerboard filter patterns, but whatever arrangement is chosen (Sony used tricolour stripes), division of the photosensitive surface into red, green and blue components inevitably reduces the resolution of the system, even if electronic compromises are made. Michael Kris assessed some of these difficulties in a paper entitled 'Film and Electronics: a Synergistic Combination', presented at the 3rd SPSE International

Symposium on Photofinishing Technology in 1984.

It is possible to use three separate CCDs behind red, green and blue filters in conjunction with some form of optical beam splitter of the kind used on 'one-shot' colour cameras of earlier days. This is done with professional video cameras and in the Mavica MVC-7000P still camera announced in 1991. Sony also made a single reflector still video camera, the MVC-5000, in which two images are recorded on one CCD and a third on the other. This arrangement can be compared with Technicolor's 'bi-pack and one' combination of films in their famous three-strip cameras.

Either of the above solutions leads to a larger and more complicated camera and sometimes to problems in accommodating wide-angle lenses.

Manufacturers do not disclose the yields of usable CCDs they achieve, but it is known that they do grade their production in terms of the numbers of defects that are considered to be acceptable by professional and amateur users.

RECORDING MEANS

Video movie cameras use magnetic tape to store the information received from a CCD, but most still video cameras use a 50mm floppy disc with a capacity of either 25 or 50 images. This format was agreed as a standard by twenty Japanese companies in 1983. Nevertheless, in 1988, Fuji announced a motorless camera using a 'memory card' on which ten images could be stored.

As it happened with film sizes and formats, a number of different video recording formats were introduced and these differences were further complicated by the fact that while Japan and the US used a 525 line television system, most of Europe used 625 lines.

The first still video cameras to comply with the PAL 625 line system was the Canon ION, introduced in 1990 and intended for direct connection with a television set.

In their publicity, Canon made it clear that: 'the camera is to be considered for viewing images on-screen only. Although hard copy prints can be made, the quality is certainly nowhere near the quality needed as an alternative to conventional prints.'

This recognition by Canon of the quality difference between still-video and silver halide imaging had been anticipated by Wilbur J. Prezzano, Vice-President of Eastman Kodak, when in 1986 he pointed out that:

A solid state sensor's speed and dynamic range – or latitude in film terminology – are limited by the ratio of signal to noise. In this case the signal is the intended message, while noise is the equivalent of graininess in photography, or "snow" in television. If we try to increase resolution by making the sensor elements smaller, we get reduced signal per element and poorer signal-to-noise ratio. This lowers the dynamic range and speed. If, on the other hand, we increase the element size, we increase speed, but decrease resolution. In other words, solid state physics faces the same type of challenges that photographic scientists have been battling with for many years.'

During the same presentation, Prezzano also expressed some views on the relative convenience of prints and video displays, saying:

The convenience advantages of the electronic still camera appear at first, to be so obvious as to scarcely be worth addressing. A consumer presses a button and moments later – or even in real time if the system is configured that way – an image of the subject appears on a television screen. There is no trip to the photofinisher, no wait, no apparent cost. On the face of

it, this is a very convenient way to look at a photographic image. But the convenience of instant TV display may carry with it some hidden penalties.

'One hidden barrier may come from the need to go to the TV set to see the picture at all. I know that in the Prezzano household, the vacation prints are left on the kitchen table. We glance through them as we happen to pass through the room. We look at them individually at our own convenience and at our own pace. When we look at prints together, we like to pass them round. Here we still move at our own pace, each person obviously "reading" different pictures in different ways. Perhaps the most important point is simply that paper is one of the most perfect devices ever invented from a human engineering standpoint.'

Despite these thoughts, Kodak announced in 1990 that in collaboration with Philips, they would introduce a Photo CD system by means of which an amateur would be able to take his colour negatives or slides to a photofinisher for transfer in digital form onto a compact disc. The resulting CD would then be used, either to view any of its 100 images on a TV screen, or to provide prints via a thermal transfer printer.

Kodak had previously made an attempt to provide the amateur with means to display his snapshots on a TV set. In 1982, when they launched the ill-fated disc film system, Kodak demonstrated, but did not market, a video system that would enable colour negatives made on disc film to be automatically selected and viewed on a domestic television screen.

VIDEO PRINTERS

There are a number of ways in which a colour print can be obtained via electrical signals without the aid of a silver-based print material. Among them are ink-jet printing, electrostatic printing and the thermal transfer process. The heart of a thermal printer is the heater head, usually consisting of some 500 elements arranged in a line. By controlling the amount of heat generated by each element the size of the transferred dot and therefore the relative density of each colour can be modulated. The three subtractive dyes plus a black to enhance resolution, are transferred from separate colour sheets to a plastic-coated paper receptor. This means that because four passes are required to assemble the component image, it takes at least a minute to produce a single print, which is of course, very much slower than using a multi-layer colour paper with a high speed photofinishing printer requiring no more than 0.2 sec. exposures per print. The quality of a video print will depend partly upon the method employed, but also upon the amount of information contained in the original electronic record and as Prezzano pointed out in 1986, even a 1.4 million pixel image sensor still has 15 times less information storage capacity than a single frame of 35mm film.

CONCLUSION

Perhaps it is apposite to end this section and this history by quoting from a paper presented by Geoffrey Crawley to the SPSE Symposium on Photofinishing Technology in 1982:

'It is difficult to understand what the recent fuss has been about, just because a prototype camera not using film has been demonstrated. Technically aware people should have known for years that it was going to happen . . . Progress is going to be gradual enough for any eventual takeover of areas in which film is now used, to occur in a slow orderly fashion with plenty of time for adjustments and no major financial losses on equipment or systems.'

By 1990 it was possible to use a video camera recording to play back scenes on a TV screen or to obtain colour prints via a video printer.

1722 Le Blon discloses his method of three-colour mezzotint printing.

1801 Young propounds his theory of three-colour vision.

1839 Herschel experiments with direct process of colour photography.

1848 Becquerel records spectrum on layer of silver chloride.

1851 Rev. Hill claims to have discovered process of direct Heliochromy.

1861 Clerk-Maxwell demonstrates additive three-colour photography at Royal Institution.
 Chevreul demonstrates that many colours can be reproduced by mixtures of three subtractive primary colours.

1863 Vogel extends the colour sensitivity of silver halide by optical sensitization.

1864 Swan patents 'chromo-gelatine' printing process.

1868 Du Hauron obtains French Patent describing both additive and subtractive methods of colour photography.

1869 Cros describes methods similar to du Hauron's.

1878 Alcide du Hauron writes: *La Triplice Photographique et l'Imprimeur.*

1891 Lippmann announces interference process based on work of Zenker.

1892 McDonough patents (but does not use) random pattern mosaic of filter elements for additive screen-plate.

1894 Joly obtains patent for additive screen-plate, using ruled lines.

1895 Ives invents and produces the Kromscop camera and viewer.

1896 White patents a three-plate single exposure colour camera.

1897 Bennetto and Butler both patent single-exposure cameras.

1898 Lanchester patents micro-spectrum dispersion process.

1899 Turner and Lee patent their additive system of three-colour cinematography.

1900 Lumière brothers exhibit colour prints made by bichromated glue process.

1903 Miethe and Traube patent use of ethyl-red as a sensitizer and Perutz produce first panchromatic plates.
 Didier introduces Pinatype printing process.

1904 Lumière brothers obtain patent for use of dyed starch grains to form a mosaic screen-plate.
 Smith introduces Utocolor bleach-out paper.

1905 Schinzel describes an integral tripack film.
 Manly patents the Ozobrome printing process.

1906 Sanger-Shepherd introduces a dye-transfer printing process.
 St. James' colour portrait studio opens in London.

1907 Lumière market the Autochrome screen-plate process.
 DuHauron and Bercegol introduce the Omnicolore plate.
 Homolka shows that a coloured image can be produced in conjunction with one of silver.

1908 First public demonstration of Kinemacolor.
 Dufay patents a screen-plate using geometric pattern of filter elements.
 Finlay patents use of separate taking and viewing screens for additive process.

1909 Berthon patents lenticular system of additive projection.

1911 Fischer and Siegrist patent a process of colour development.

1911 Fischer and Siegrist patent a process of colour development.

1913 Raydex (carbro) process introduced.

1914 Eastman Kodak introduce Kodachrome two-colour process invented by Capstaff.
 Keller-Dorian patents means for producing continuous lengths of lenticulated film base.

1916 Two-colour Kodachrome process used to make short film in Rochester.
 Agfacolor screen-plate introduced in Germany.

1917 Technicolor produces two-colour feature film — *The Gulf Between.*

1923 Mannes and Godowsky granted US Patent for a two-colour subtractive process.

1924 Jos-Pe colour camera and printing process introduced in Germany.

1928 Kodacolor 16mm lenticular system launched.
 Colour Snapshots (1928) Ltd., attempt to produce colour prints from amateur tri-pack negatives in UK.
 Technicolor patents process and equipment for producing motion picture prints by imbibition transfer.

1929 Finlaycolor separable screen-plate introduced.

1930 Vivex colour print service established in UK.
 Reckmeier patents use of pellicle reflectors in a colour camera.

1931 Ball of Technicolor patents 'three-strip' camera with prism block.

1932 Technicolor's first three-colour production – the Disney cartoon: *The Flowers and the Trees.*
Agfa introduces 35mm lenticular film in Germany.
Ives discloses his Polychrome ($2^1/_2$ colour) process.
Lumière Autochrome glass plates replaced by Filmcolor.

1933 Gasparcolor silver-dye bleach process used for motion picture film in Germany.

1934 First live film in three-colour Technicolor: *La Cucaracha.*

1935 Kodak launch Mannes and Godowsky's Kodachrome process as amateur 16mm movie film.
Wash-Off Relief process introduced in US.
Defender introduce Chromatone (metallic toning) print process.

1936 Agfacolor Neu introduced in Germany as 16mm movie and 35mm still film.
Kodachrome available in 35mm cassettes.
Dufaycolor roll, sheet and movie films available in UK.

1937 Martinez patents use of 'resin protected' colour couplers.

1938 Anscocolor introduced in US (Discontinued in 1939).
Eastman Kodak starts to mount Kodachrome slides in Readymounts.
Kodachrome process simplified.

1939 Agfacolor negative-positive process used to produce short film entitled – *Ein Lied verklingt.*
Jelly and Vittum patent 'oil-soluble' colour couplers.

1940 Konisiroku produce Kodachrome type film in Japan.

1941 Minicolor and Kotavachrome prints made by Eastman Kodak from Kodachrome slides.

1942 Kodacolor roll-film and printing service introduced in US.

1943 Pavelle Color in New York produces prints from slides on Ansco's Printon material.

1945 Kodak's Dye-Transfer process replaces Wash-Off Relief.

1946 Ektachrome (ASA 8) film released in US.
Anscochrome made generally available in US.

1948 Hanson patents coloured coupler masking.
Ilford introduce Ilford Colour 'D' Film in UK.

1949 Ansco introduce Plenacolor negative film in US.

1950 Kodak introduces Eastman Color negative-positive process for motion pictures.

1954 Eastman Kodak signs Consent Decree after Anti-Trust Action by US Government.

1955 Kodak releases their colour processes to photofinishers in US.
Russell patents multi-layer 'slide-hopper' coating head.

1957 Super Anscochrome (ASA 200), introduced in US.
IClcolor masked colour negative film launched in UK.

1958 Kodacolor film available in 35mm cassettes.
Fuji introduces Agfa type colour negative film in Japan.

1961 Kodachrome II (ASA 25) film introduced.
Ilford offers contact strip-prints from 35mm Ilfocolor negatives in UK.

1963 Instamatic 126 cameras and Kodacolor-X film introduced world-wide.
Polaroid launch Polacolor 'peel-apart' film and camera.
Cibachrome prints exhibited at Photokina.

1964 Monopolies Commission Report on Colour Film and Processing in UK.

1965 3Ms announce Electrocolor process.

1968 Kodak offer photofinishers Ektacolor 20 paper on resin coated base.

1969 Boyle and Smith of Bell Laboratories invent the charge-coupled device (CCD).

1972 Polaroid launch the SX-70 'one-step' process.

1973 Kodacolor processing changed to C-41.

1976 Kodak launch their 'instant-print' system.
Gretag introduce colour scanning printer for photofinishing.
Land demonstrates the Polavision amateur movie system.

1978 Noritsu's live demonstration of a mini-lab in US.

1981 Sony demonstrates Mavica electronic still camera.

1982 Kodak's Disc camera introduced with Kodacolor VR (T-Grain) film.

1984 Konishiroku introduces 'washless' paper processing for mini-labs.
Polaroid launches Polachrome 35mm additive colour process.

1989 Fuji introduce Velvia (ASA 50) E-6 compatible high-resolution film.

1991 Sony demonstrates the Mavica MVC7000P still camera, with three CCDs.

BARRET, A. and GENARD, P. **Lumière: Les Premieres Photographies en Couleurs,** *Andre Barret, Paris, (1974).*

BASTEN, F. E. **Glorious Technicolor,** *A. S. Barnes & Co. Inc. New York, (1980).*

BAYLEY, R. C. **Photography in Colours, London, 1900. Real Colour Photography,** *London, 1907.*

BERGER, H. **Agfacolor,** *W. Girardet. Wuppertal, Germany, (1950).*

BERTHIER, A. **Manuel de Photochromie Interferentialle,** *Paris, 1895.*

BOLAS, T., TALLENT, A. and SENIOR, E. **A Handbook of Photography in Colours,** *Marion & Co., London, 1900.*

BOMBACK, G. E. **Encyclopedia of Colour Photography,** *Fountain Press Ltd., London, 1963.*

BROWN, G. E. **Color Photography, Photo Miniature No. 128,** *Tarrant & Ward, New York, 1913.*

BROWN, G. E. and PIPER, W. **'Colour Photography with the Lumière Autochrome Plate',** *London, 1907.*

COE, B. **Colour Photography: The First 100 Years,** *Ash & Grant Ltd., London, 1978.*

COOTE, J. H. **Making Colour Prints,** *Focal Press Ltd., London, 1938.* **Colour Prints,** *Focal Press Ltd., London, 1956.*

CORNWELL-CLYNE, A. **Colour Cinematography (3rd Ed.),** *Chapman & Hall Ltd., London, 1951.*

DUNN, C. E. **Natural Color Processes,** *American Publishing Co., Boston, 1940.*

EVANS, R. M. **Eye, Film and Camera in Color Photography,** *John Wiley & Sons Inc., New York, 1959.*

EVANS, R. M., HANSON, W. T., and LYLE, W. **Principles of Colour Photography,** *John Wiley & Sons Inc., New York, 1953.*

EYNARD, R. A. (Ed.) **Color: Theory and Imaging Systems,** *Society of Photographic Scientists and Engineers, Washington DC, 1973.*

FRAPRIE, F. R. **How to make prints in colors,** *Boston, 1916.*

FRIEDMAN, J. S. **History of Color Photography (1st Ed.)** *American Photographic Publishing Co., Boston, 1944.* **(2nd Ed.)** *Focal Press Ltd., London, 1968. (The second edition contains a preface and a useful appendix by Lloyd Varden).*

GAMBLE, W. **Color Photography, a list of references in New York Public Library,** *New York, 1924.*

HUBL, A. von. **Die Dreifarbenphotographie,** *Halle, 1897, 1902, 1912 and 1922.* **Three-Colour Photography, Translation, H. O. Klein,** *London, 1915.*

HUNT, R. W. G. **The Reproduction of Colour (4th Ed.),** *Fountain Press Ltd., London, 1987.*

IVES, F. E. **Handbook of the Photochromoscope,** *London, 1894.* **Kromskop Color Photography,** *London, 1898.*

JENKINS, R. V. **Images and Enterprise,** *John Hopkins University Press, Baltimore 1975.*

JOHNSON, G. L. **Photography in Colours,** *Ward & Co., London, 1910, 1914, 1917 and 1922.*

KEPPLER, V. **The Eighth Art,** *William Morrow & Co., New York, 1938. Chapman and Hall Ltd., London, 1939.*

KONIG, E. **Natural Colour Photography (Translation, E. J. Wall),** *Dawbarn & Ward, London, 1906.*

KOSHOFER, G. **Farbfotographie (3 Vols.)** *Lanterna Magica, Munich, 1981.* **Color Die Farben Des Films,** *Volker Speiss GmbH, Berlin, 1988.*

KRAUSE, P. and SCHULL, H. **The Complete Guide to Cibachrome Printing,** *Ziff-Davis Pub. Co., New York, (1980).*

LIBERMAN, A. (Ed.) **The Art of Color Photography,** *Simon & Schuster, New York, 1951.*

LIMBACHER, J. L. **A Historical Study of the Color Motion Picture,** *(Mimeographed) Dearborn, Michigan, 1963.*

LIMMER, F. **Bleach-out Process and Uto-color Paper,** *Paris, 1912.*

MARDEN, L. **Color Photography with a Miniature Camera,** *Fomo Pub. Co., Ohio, USA, 1934.*

MEES, C. E. K. **Color Photography, Photo Miniature No. 183,** *Tarrant & Ward, New York, 1921.*

MIETHE, A. **Dreifarbenphotographie nach der Natur,** *Halle, 1904.*

NEUHAUSS, R. **Die Farbenphotographie nach Lippmann's,** *Verfahren, Halle, 1898.*

NEWENS, F. R. **The Technique of Colour Printing,** *Blackie & Son, London, (1931).*

RAMSAYE, T. **A Million and One Nights,** *Simon & Schuster Inc. New York, (1926).*

RICHTER, S. **The Art of the Daguerrotype,** *Viking, London and Rizzoli, Milan, 1989.*

RYAN, R. T. **A History of Motion Picture Color Technology,** *Focal Press, London, 1977.*

SCHULTZE, W. **Farbenphotographie und Farben Film,** *Springer Verlag, Berlin, 1953.*

SIPLEY, L. W. **A Half Century of Color,** *The Macmillan Co., New York, 1951.*

SPENCER, D. A. **Colour Photography in Practice,** *Pitman & Sons Ltd., London, 1938.*

TRAUBE, A. and AUERBACH, H. **Photographie und Farbenphotographie,** *Berlin, 1920.*

VIDAL, L. **Photographie des Couleurs,** *Paris, 1897.*

WALL, E. J. **History of Three-Color Photography,** *American Photographic Publishing Co., Boston, 1925.* **Practical Color Photography,** *American Photographic Publishing Co., Boston, 1928.*

WALLACE, R. J. **Color Photography, Photo Miniature No. 38,** *New York, 1902.*

WHEELER, O. W. **Colour Photography,** *Pitman & Sons, London, 1929.*

The following literature references include many from the Colour Supplements that at one time formed part of the 'British Journal of Photography'. These Supplements were published in the first week's issue of each month from January 1897 until April 1934. Subsequently, starting in November 1938, 'The British Journal of Photography' included regular articles under the heading 'Colour News' or 'Progress in Colour'. Although never attributed, these contributions were written by Alan Tull, who worked for some years at Technicolor in the UK. Similarly, Joseph Friedman, who also worked for Technicolor at one time, contributed regular articles on colour processes to the 'American Photographer' during the 1940s under the heading 'Photographic Reviews'.

Most authors have designated patents issued by the Patent Office before the 1920s as E.P.s, but because of the risk of confusion with the more recent European Patents, the abbreviation B.P., has been used for all British Patents.

CHAPTER 1

ANON. **Practical Application of Interference Colour Photography** Brit. J. Phot. (Col. Supp.) pp. 83-86, (4 Nov 1910).

EDER, J. M. **History of Photography (Trans. Epstean), Chapter XCV,** Columbia University Press, New York (1945).

HERSCHEL, J. **On the Chemical Actions of the Rays of the Silver Spectrum on Preparations of Silver and Other Substances, and on Some Photographic Processes,** Philosophical, Transactions of the Royal Society, CLXXXIV (1840).

HILL, L. L. **A Treatise on Heliochromy,** Robinson & Caswell, New York (1856).

LANCHESTER, F. M. **B. P. 16,548 (1895).**

LIPPMANN, G. **Photography in Colour,** The American Journal of Photography 12: pp. 180-183, 14th Feb. (1891) (Translated from La Nature). **Coloured Photographs of the Prismatic Dispersion,** Brit. J. Phot. 53: pp. 644-645, (1906).

Prismatic Dispersion, Brit. J. Phot. 53: p. 644-645, (1906).

NAREID, H. **A Review of the Lippmann Process,** J. Phot. Sci. 32, pp. 158-169, (1984).

NEUHAUSS, R. **Die Farbenphotographie nach Lippmanns Verfahren,** Willhelm Knapp, (1898).

PHILLIPS, M. J., HEYWORTH, H. and HARE, T. **On Lippman's Photography,** J. Phot. Sci. 32: pp. 158-169, (1984).

WALL, E. J. **A Forgotten Page in the History of Colour Photography,** Brit. J. Phot. (Col. Supp.) pp. 1-3, (Jan 1921).

CHAPTER 2

ANON. **An Interview with M. Louis Ducos du Hauron,** Brit. J. Phot. (Col. Supp.), pp. 1-2, (1907).

COOTE, J. H. **Photography in Colours in 1876,** Brit. J. Phot. 85: p. 179, (1938).

CROS, C. **Solution generale du Probleme de la Photographie des Couleurs,** Bulletin de la Societe Francaise de Photographie, 15: pp. 185-195, (1869).

CLAUDY, C. H. **An Appreciation of Mr. F. E. Ives,** Brit. J. Phot. (Col. Supp.) pp. 34-36, (1920).

DU HAURON, Louis, Ducos, **Les Couleurs en Photographie, Solution du Probleme,** Le Gers. (March and April 1969).

DU HAURON, Louis, Ducos and Bercegol, **B.P. 2973 (1876), B.P. 194 (1907).**

DU HAURON, Alcide, Ducos, **Photography in Colours by the Method of Ducos du Hauron,** Penrose's Annual, pp. 105-110, (1908).

EPSTEAN, E. and TENNANT, J. **The History of Colour Photography,** Photo Engraver's Bulletin, pp. 18-29, (Feb 1939).

EVANS, R. M. **Some Notes on Maxwell's Colour Photograph,** J. Phot. Sci. pp. 243-246, (July/Aug 1961).

FARMER, H. **Clerk Maxwell's Gifts to Photography,** Brit. J. Phot. 49: pp. 556-569, (1902).

IVES, F. E. **Practical Demonstration of Additive Projection,** J. Franklin Inst. p. 58,

(1889). **A New System of Trichromatic Photography,** *Brit. J. Phot. (Col. Supp.) pp. 49-51, (July 1910).* **Autobiography of an Amateur Inventor,** *Innes & Sons, Philadelphia, (1928).* **Handbook to the Photochromoscope,** *Simpkin Marshall, London, (1894).* **U.S.P. 432,530 (1890), U.S.P. 475,084 (1892).**

KLEIN, H. O. **A Review of Colour Photography,** *Penrose's Annual, pp. 137-139, (1907).*

LE BLON, J. C. **Il Coloritto or The harmony of colouring in painting reduced to mechanical practice,** *Pub. London, (1722).*

MAXWELL, James Clerk, **On the Theory of the Three Primary Colours,** *Proc. Royal Inst. Vol. 111, (1858-1862).*

POTONNIÉE, G. **Louis Ducos du Hauron: His Life and Work (Translated by Edward Epstean),** *Photo-Engravers Bulletin, 28: pp. 18-29, (1939).*

PROKUDIN-GORSKII, S. M. **Photographs for the Tsar (Ed. R. H. Allshouse),** *Sidgewick & Jackson, London, (1980).*

SPENCER, D. A. **The First Colour Photograph,** *Penrose Annual, pp. 99-100, (1940).* **The First Hundred Years of Colour Photography, (Maxwell Centenary Discourse),** *Phot. J. pp. 265-272, (Sept. 1961).*

SUTTON, T. **Photographic Notes,** *Phot. News, 6: p. 169, (1861).*

WALL, E. J. **A Chronology of the Photochromoscope,** *Brit. J. Phot. (Col. Supp.), (April 1992).*

WATERHOUSE, J. **The Late Prof. H. W. Vogel,** *Photography, pp. 3-4, (Jan. 1899).*

YOUNG, T. **On the Theory of Light and Colours,** *Trans. Royal Soc. XCII, pp. 12-48, (1802).*

CHAPTER 3

ANON. **The Evolution of Screen-Plate Colour Photography,** *Brit. J. Phot. (Col. Supp.) (Oct. 2, 1914).*

BERTHON, R. **A Suggested New Method of Colour Photography Direct at One Exposure,** *Brit. J. Phot. (Col. Supp.) p. 15, (1910).* **B.P. 10,611, (1909).**

BULL, A. J. **On Three Colour Additive Photography,** *Phot. J. 75: pp. 67-71, (1935).*

CAPSTAFF, J. and SEYMOUR, M. **The Kodacolor Process for Amateur Color Cinematography,** *Trans. Soc. Mot. Pict. Eng. XII: pp. 940-7, (1928).*

CHRISTENSEN, J. H. **B.P. 20,097 (1908), B.P. 216,698 (1923).**

DUFAY, M. L. **B.P. 11,698 (1908), B.P. 18,744 (1908), B.P. 217,557 (1923), U.S.P. 217,557 (1923).**

FINLAY, C. **The Finlay Colour Process,** *Phot. J. 54: p. 76, (Feb 1930).*

HARRISON, G. B. and HORNER, R. G. **The Theory of Additive Three-Colour Photography,** *Phot. J. 77: pp. 706-713, (1937).* **The Principles of Dufaycolor Printing,** *Phot. J. 79: pp. 320-9, (1939).*

JOLY, J. **On Colour Photography,** *Brit. J. Phot., July 20, (1894).* **B.P. 7,743 (1893), B.P. 17,900 (1897).**

KELLER-DORIAN, A. **B.P. 24,698 (1914), B.P. 207,836 (1922).**

KLEIN, H. O. **Colour Photography Today,** *Brit. J. Phot. Almanac, pp. 172-185, (1936).*

LUMIÈRE, A. and L. **A New Method for the Production of Photographs in Colours,** *Brit. J. Phot., July 8, (1904).*

LUMIÈRE, A. and L. et ses Fils, **B.P. 22,988 (1904), B.P. 20,111 (1908).**

McDONOUGH, J. W. **Improvements in the Art of Producing Coloured Photographs,** *Brit. J. Phot. 39: p. 651, (1892).* **B.P. 5,597 (1892).**

MEES, C. E. K. and PLEDGE, J. H. **On Some Experimental Methods Employed in the Examination of Screen-Plates,** *Phot. J. 50: p. 197, (1910).*

PLEDGE, J. H. **The Agfa Colour Plate,** *Brit. J. Phot. (Col. Supp.) p. 48, (1923).*

REICHER, L. T. **Making Agfa Colour Films,** *Brit. J. Phot. (Col. Supp.) pp. 43-4, (Nov. 1927).*

RENWICK, F. F. **The Dufaycolor Process,** *Phot. J. 75: p. 28, (1935).*

SMITH, R. C. **Colour Photography in the Nineties,** *Brit. J. Phot. pp. 1122-24, (Dec. 1967).*

THORNE-BAKER, T. **The Spicer-Dufay Colour Film Process,** *Phot. J. 72: p. 109. (1932).*

WELFORD, S. F. **Dufaycolor,** *History of Photography, 12: pp. 31-39, (1988).*

WALL, E. J. **Screen-Plate Colour Photography,** *Phot. Annual, 6: p. 9, (1910).*

WALLON, E. **The Work of Louis Lumière,** *Bull. Soc. Franc. Phot. 8: pp. 225-249, (1921).*

WEIL, F. **The Optical-Photographic Principles of the Agfacolor Process,** *J. Soc. Mot. Pict. Eng. 20: No. 4, (1933).*

CHAPTER 4

BUCHANAN-TAYLOR, W. **B.P. 12,469 (1914).**

COOTE, J. H. **Progress Report on Colour Kinematography,** *J. Brit. Kin. Soc., Vol. 16. pp. 83-90, (March 1950).*

FRIESE-GREENE, C. H. **The Friese-Greene Colour Process,** *Phot. J. 49: p. 487, (1925).*

KALMUS, H. T. **Technicolor Adventures in Cinemaland,** *J. Soc. Mot. Pict. Eng. pp. 564-584, (Dec 1938).*

KELLY, W. V. D. **Color Photography Patents,** *Trans. Soc. Mot. Pict. Eng. Nos. 21 & 24, (1925).*

LIMBACHER, J. L. **A Historical Study of the Color Motion Picture,** *Dearborn, Michigan, (1963).*

MEES, C. E. K. **Three-Colour Kinematography,** *Nature, 87, p. 556, (Oct. 1911).*

SMITH, G. A. **Animated Photographs in Natural Colours,** *J. Roy. Soc. Arts. LVII: pp. 70-76, (Dec. 1908).*

SZEPANK, J. **Kinematography in Natural Colours,** *Kinotech, pp. 293-297 & 322-329, (1924).*

THOMAS, D. B. **The First Colour Motion Pictures,** *H.M.S.O., London, (1969).*

TURNER, E. R. and LEE, F. M. **B.P. 6,202 (1899), U.S.P. 645,477.**

SZEPANK, J. **Kinematography in Natural Colours,** Kinotech, pp. 293-297 & 322-329, (1924).

THOMAS, D. B. **The First Colour Motion Pictures,** H.M.S.O., London, (1969).

TURNER, E. R. and LEE, F. M. **B.P. 6,202 (1899), U.S.P. 645,477.**

CHAPTER 5

ANON. **Coloured Prints by the Jos-Pe Process,** Phot. Ind. pp. 435-438 (1924).

ANON. **Colour Photography Commercialised,** Brit. J. Phot. (Col. Supp.) pp. 21-22, (June 1928).

ANON. **Colour Photography in 1930,** Brit. J. Phot. (Col. Supp.) pp. 5-6, (Jan 1930).

ANON. **How Colour Snapshots are Made,** Brit. J. Phot. pp. 273-5, (May 1929).

ANON. **Professional Colour Photography (a Report on the St. James Studio),** Brit. J. Phot. pp. 366-8, (1906).

ANON. **The Tri-Tone Colour Print Service,** Brit. J. Phot. p. 185, (April 1940).

BUTEMENT, C. **Chromatone: A New Method of Making Three-Colour Prints,** Brit. J. Phot. pp. 113-14, (Feb. 1937).

COLTON, H. C. **Dyes for Imbibition Printing,** Photo Technique, 2, pp. 54-8, (1940).

COOTE, J. H., **Making Colour Prints,** Phot. J. pp. 381-85, (1943).

COPPIN, F. W. and SPENCER, D. A. **Basic Features of the 'Vivex' Process,** Phot. J. 88b: pp. 78-83, (1948).

DU HAURON, L. Ducos. **B.P. 2,973 (1876).**

IVES, F. E. **Polychrome Process of Photography,** Photo Engravers Bulletin, pp. 99-100, (Sept. 1934).

JASMATZI, A. **B.P. 402,619 (1933), B.P. 3,730 (1903).**

JUMEAUX, B. and DAVIDSON, W. N. **B.P. 3,730 (1903).**

LEIGHTON, C. **A Contribution to the Theory and Practice of the Carbro Process,** Phot. J. 67: pp. 362-73 & 409-15, (1927).

MANLEY, T. **B.P. 17,007 (1905).**

MEYER, D. K., OSTREM, A. G. and POLLMAN, G. J. **U.S.P. 3,130,655 (1964), B.P. 990,971 (1961).**

MILLER, H. **B.P. 100,098 (1915).**

OLIVER, L. W. and CLARE, G. W. **B.P. 357,548 (3930.**

PHILLIPS, A. H. **Practical Colour Print Making,** Brit. J. Phot. pp. 696-99 and 708-711, (Nov. 1938).

PILKINGTON, W. **Cellophane Stripping for Colour Prints on Paper,** Brit. J. Phot. pp. 114-15, (March 1941).

RANGER, R. H. **Duxochrome Photo Color Prints,** F.I.A.T. Report No. 891. H.M.S.O. London, (1948).

RENDALL, H. F. **A Review of Colour Photography,** Brit. J. Phot. (Col. Supp.), pp. 31-34, (Aug. 1919).

SHEPHERD, F. S. and BARTLETT, O. M. **B.P. 24,234 (1902).**

SHEPHERD, J. F. **B.P. 175,003 (1920).**

SNYDER, F. H. and RIMBACH, H. W. **B.P. 469,133 (1937).**

SPENCER, D. A. **Some Fundamental Problems in Three-Colour Photography,** Phot. J. pp. 9-16, (Jan. 1931). **B.P. 340,605 (1929).**

SWAN, J. (Sir). **B.P. 503 (1864).**

TAGUCHI, S. et. al. **U.S.P. 3,756,817 (1973).**

TRAUBE, W. **Three-Colour Prints by the Traube Iodide Process,** Brit. J. Phot. (Col. Supp.) pp. 26-28, (1907).

TRITTON, F. J. **Three Colour Carbro,** Phot. J. 52: pp. 159-61, (1928). **Practical Points on the Three Colour Carbro Process,** Phot. J. 53: p. 281, (1929).

TROLAND, L. T. and EATON, R. D. **B.P. 392,785 (1932).**

WALL, E. J. **The Present Status of Colour Photography,** Brit. J. Phot. pp. 588-592, (July 1906).

CHAPTER 6

BENNETTO, J. W. **B.P. 2,973 (1897).**

BUTLER, E. T. **B.P. 4,290 (1905).**

COOTE, J. H. **A Survey of Available 'One-Shot' Colour Cameras,** Brit. J. Phot. pp. 659-661, (Oct. 1938). **The Evolution of the Single-Exposure Colour Camera,** Phot. J. pp. 293-302, (June 1941).

CLIFFORD, T. W. **B.P. 445,799 (1934).**

CROS, A. H. **B.P. 9,012 (1889).**

DU HAURON, Louis, Ducos. **B.P. 2,973 (1876).**

GEISLER, L. **B.P. 24,244 (1910).**

IVES, F. E. **U.S.P. 475,084 (1892), B.P. 4,606 (1892), B.P. 28,920 (1897), B.P. 12,181 (1900).**

KLEIN, H. O. **Pellicle Mirrors,** Brit. J. Phot. p. 225, (Nov. 1938).

MIKUT, O. **G.P. 631,676 (1933).**

PFENNINGER, O. **Trichromatic One-Exposure Cameras,** Phot. News. pp. 308-9, (April 1906).

RECKMEIER, E. **B.P. 357,372 (1929), B.P. 436,014 (1934), B.P. 440,006 (1935).**

RENDALL, H. E. **Tri-Colour One-Exposure Cameras,** Phot. J. pp. 390-96, (Sept. 1924). **One-Exposure Tricolour Cameras,** Proc. 7th Internat. Congress of Photography, London, 1928, pp. 436-449.

SPENCER, D. A. **A New One-Exposure Three-Colour Camera,** Phot. J. pp. 103-5, (March 1934).

CHAPTER 7

ANON. **A New Material for Colour Photography (Defender Tri-Pack),** Brit. J. Phot. p. 148, (March 1937).

ANON. **How Colour Snapshots are Made**, *Brit. J. Phot. pp. 273-4, (May 1929).*

ANON. **'Monopack': A New Colour Separation Material**, *Brit. J. Phot. pp. 601-2, (Sept. 1938).*

ANON. **Tri-Folium Colour Packs, Colour Snapshots (1928) Ltd.**, *Brit. J. Phot. (Col. Supp.) pp. 39-40, (Oct. 1928).*

BAKER, T. T. **B.P. 326,559 (1928).**

CAPSTAFF, J. G. **An Experimental 35mm Multilayer Stripping Negative Film**, *J. Soc. Mot. Pic. Eng. 54: pp. 445-453, (April 1950).*

COOTE, J. H. **How 'Monopack' Separation Works**, *Photography, p. 24, (Oct. 1938).*

DU HAURON, **B.P. 250,862 (1865).**

FRIEDMAN, J. S. **U.S.P. 2,047,022 (1935).**

IVES, F. E. **The Ives Tripack Process of Colour Photography**, *Brit. J. Phot. (Col. Supp.) pp. 41-2, (June 1911).* **B.P. 14,243 (1909).**

KLEIN, A. B. **B.P. 326,559 (1928).**

OLIVER, L. W. **The New Colour Process of Colour Photographs (British and Foreign) Ltd.**, *Photo. J. 69: pp. 14-21 (1929).*

TARBIN, W. T. **B.P. 283,765 (1927).**

CHAPTER 8

ANON. **Thornton's Colour-Cinematograph Process**, *Brit. J. Phot. (Col. Supp.) pp. 10-11, (March 1925).*

BALL, J. A. **The Technicolor Process of 3-Colour Cinematography**, *J. Soc. Mot. Pic. Eng. 25: pp. 127-138, (1935).* **B.P. 373,429 (1931).**

CAPSTAFF, J. G. **U.S.P. 1,273,457 (1918).**

CATLING, D. **Shooting in Monopack**, *Brit. J. Phot. pp. 282-4, (Aug. 1944).*

COMSTOCK, D. F. **U.S.P. 1,231,710 (1917), B.P. 188,329 (1921), B.P. 307,659 (1928).**

COOTE, J. H. **Progress Report on Colour Kinematography**, *J. Brit. Kin. Soc. 16: pp. 83-90 (March 1950).*

CORNWELL-CLYNE, A. **Colour Cinematography (3rd ed.)**, *Chapman & Hall, London, (1951).*

GASPAR, B. **B.P. 397,159 (1931), B.P. 415,040 (1931).**

GUNDELFINGER, A. M. **Cinecolor Three-Color Process**, *J. Soc. Mot. Pic. Eng. pp. 74-86, (Jan. 1950).*

HAPPÉ, B. **80 Years of Colour Cinematography**, *J. Brit. Kin. Soc. 67: (1985).*

HERNANDEZ-MEJIA, A. **The Colorgraph Process of Cinematography**, *Brit. J. Phot. pp. 805-7, (Oct. 1912).*

IVES, F. E. **Subtractive Color Motion Pictures on Single Coated Film**, *Trans. Soc. Mot. Pic. Eng. No. 25, p. 24, (1926).*

KALMUS, H. T. **Technicolor Adventures in Cinemaland**, *J. Soc. Mot. Pic. Eng. pp,. 564-584, (Dec. 1938).*

KELLY, W. V. D. **Imbibition Coloring of Motion Picture Films**, *Trans. Soc. Mot. Pic. Eng. No. 28. pp. 238-42, (1926).*

KOSHOFER, G. **50 Jahre Technicolor**, *Kino-Technik, 21: pp. 258-262, (1967).*

LIMBACHER, J. L. **A Historical Study of the Color Motion Picture**, *Dearborn, Michigan, (1963).*

MATTHEWS, G. E. **A Motion Picture Made in 1916**, *J. Soc. Mot. Pic. Eng. pp. 624-26, (1930).*

OTIS, R. M. **The Multicolor Process**, *J. Soc. Mot. Pic. Eng. pp. 5-10, (July 1931).*

THORNTON, J. E. **B.P. 9,324 (1912), B.P. 16,899 (1914).**

TROLAND, L. T. **B.P. 204,035 (1922), B.P. 392,785 (1932).**

WALL, E. J. **Notes on Processes of Cinematography in Colour**, *Brit. J. Phot. (Col. Supp.) pp. 23-24, (June 1916).* **Relief Processrd for Colour Work**, *Brit. J. Phot. (Col. Supp.) pp. 30-34, (Aug. 1921).*

CHAPTER 9

ANON. **Agfacolor and Anscocolor Compared**, *Brit. J. Phot. pp. 236-8, (July 1946).*

ANON. **Ansco Color Film and Ansco Color Printon**, *The Ansconian, (Sept-Oct. 1943).*

ANON. **The New Agfacolor Process**, *Brit. J. Phot. p. 709, (Nov. 1936).*

ASHTON, G. **50 Years of Kodachrome**, *Brit. J. Phot. pp. 418-423, (April 1985).*

BARR, C. R., THIRTLE, J. R. and VITTUM, P. W. **Development Inhibitor-Releasing (DIR) Couplers in Color Photography**, *Phot. Sci. Eng. 13: pp. 74-77 and 214-217, (1969).*

BECKETT, C., HARRIS, R. A., SCHAFER, R. K. and SEEMAN, J. M. **Preparation of Duplicate Negatives Using Eastman Color Reversal Intermediate Films**, *J. Soc. Mot. Pic. Tel. Eng. pp. 1053-56, (Oct. 1968).*

BELLO, H. J. **Color Negative and Positive Silver Halide Systems, Color: Theory and Imaging Systems**, *Phot. Sci. Eng. Washington DC, (1973).*

CHILTON, L.V. **Further Investigation of Agfa Filmfabrik, Wolfen**, *B.I.O.S. Final Report, No. 1355, H.M.S.O., (1946).*

COLLINS, R. B. **Ilford Colour Processes**, *Phot. J. pp. 173-4, (June 1960).*

DAVIES, E. R. **The Kodachrome Process of 16mm Colour Kinematography**, *Phot. J. 76: p. 248, (1936).*

DUERR, H. K. **The Ansco Color Negative-Positive Process**, *J. Soc. Mot. Pic. Tel. Eng. pp. 465-79, (June 1952).*

FIELD, G. T. J. and JOHN, H. O. **Processing Ektachrome Film with Genochrome**, *Brit. J. Phot. p. 253, (June 1949).*

FISCHER, R. **Toning Bromide Prints**, *Brit. J. Phot. 60: p. 712, (1913).* **B.P. 2,562 (1913).**

FISCHER, R. and SIEGRIST, **B.P. 15,055 (1912).**

FLORSTEDT, J. **Colour Photography – International Developments**, *Brit. J. Phot. pp. 94-98 and 111-115, (Jan. 1970).*

FOREST, J. L. and KING, F. M. **The New Agfacolor Process,** J. Soc. Mot. Pic. Eng. 29: p.248, (1937).

FRIEDMAN, J. S. **Colour Correction by Masking,** Proc. R.P.S., Centenary Conference, London, 1953, pp. 269-274.

GANGUIN, K. O. and MACDONALD, E. **Chemical Background of Some Masking Techniques,** J. Phot. Sci. 14: pp. 260-177, (1966).

GLUCK, B. **The Manufacture of Agfacolor Material,** F.I.A.T. Final Report No. 943, H.M.S.O., (1947).

HANSON, W. T. **Color Correction with Colored Couplers,** J. Opt. Soc. Amer. pp. 166-171, (March 1950). **Color Negative and Color Positive Film for Motion Picture Use,** J. Soc. Mot. Pic. Tel. Eng. p. 223, (March 1952). **Forty Years of Color Photography,** J. Phot. Sci. Eng. 21: pp. 293-296, (1977). **Chemical Research in Color Photography,** J. Soc. Phot. Sci. Eng. 10: pp. 130-134, (June 1984).

HANSON, W. T. and VITTUM, P. W. **Colored Dye-Forming Couplers in Subtractive Color Photography,** J. Phot. Soc. Amer. 13: pp. 94-96, (1947).

HARRISON, G. B. **B.P. 626,724 (1947).**

HEIDKE, R. L., FELDMAN, L. H. and CHARLTON, C. B. **Evolution of Kodak Photographic Color Negative Print Papers,** J. Imag. Tech. 11: pp. 93-97, (June 1985).

HOMOLKA, B. **Experiments on the Development of the Latent Image with Indoxyl Compounds,** Brit. J. Phot. 54: p. 216, (1907).

JELLY, E. E. and VITTUM, P. W. **B.P. 541,589 (1941).**

JENNINGS, A. B., STANTON, W. A. and WEISS, J. P. **Synthetic Color-Forming Binders for Photographic Emulsions,** J. Soc. Mot. Pic. Tel. Eng. pp. 455-476, (1950).

JUDKINS, S. L. and VARDEN, L. **The Ansco Color Process,** J. Phot. Soc. Amer. 10: p. 533, (1944).

KOSHOFER, G. **Thirty Years of Modern Colour Photography,** Brit. J. Phot. (July, Aug, Sept. and Oct. 1966).

TULL, A. G. **Notes on the Chemistry of Colour Development,** Brit. J. Phot. pp. 627-29 and 647-48, (Oct. 1938). **Colour Development: Its History, Chemistry and Characteristics,** Phot. J. 85B: p. 13-24, (Jan/Feb 1945).

VITTUM, P. W. **Chemistry and Color Photography,** J. Soc. Mot. Pic. Tel. Eng. 71: p. 937, (1962).

VITTUM, P. W. and WEISSBERGER, A. **Recent Advances in the Chemistry of Dye-Forming Color Development,** J. Phot. Sci. 6: p. 157, (1958).

WOLFE-HEIDE, E. **B.P. 340,278 (1929).**

CHAPTER 10

BEGUIN, A. E. **U.S.P. 2,681,294 (1954).**

BOULT, A. J. (assigned to George Eastman) **B.P. 3530 (1887).**

CHILTON, L. V. **Further Investigation of Agfa Filmfabrik, Wolfen,** B.I.O.S. Final Report No. 1355, H.M.S.O., (1947).

FRANZ, D. **Photographic Paper Coating,** Phot. Lab. Management, pp. 6-9, (Nov./Dec. 1982).

GREILLER, J. F. **U.S.P. 3,632,374 (1968).**

HUGHES, D. J. **U.S.P. 3,508,947 (1970).**

OZAKI, K. **E.P.O. 361,167A1 (1989).**

RUSSELL, T. A. **U.S.P. 2,761,791 (1956). B.P. 834,528 (1956).**

RUSSELL, T. A. and MERCIA, J. A. **U.S.P. 2,761,419 (1956).**

CHAPTER 11

ANON. **Anscolor Printon,** The Ansconian, p. 12, (May/June 1948).

ASHTON, G. **Colour Prints from Reversal Transparencies,** Leica Photography, pp. 108-111, (May/June 1956).

BERGER, H. **Agfacolor (pp. 167-9),** W. Giradet, W. Germany, (1950).

COOTE, J. H. **Dye-Bleach Processes,** Proc. R.P.S. Symposium on Photographic Processing, pp. 151-58, Academic Press, London, (1973).

FRIEDMAN, J. S. **Silver-Dye Bleach Processes,** Amer. Phot. 36: (2), p. 38, (1942). **Gasparcolor,** Amer. Phot. 36: (3), p. 30, (1942).

GEHRET, F. C. **Cibachrome Print Type 216 and Ektachrome R. C. Improved,** Brit. J. Almanac 1978, pp. 214-216.

JACOBSON, K. **The Gaspar Process of Colour Photography,** Brit. J. Phot. (Col. Supp.), pp. 29-31, (Aug 4, 1933).

MEYER, A. **Some Features of the Silver-Dye Bleach Process,** J. Phot. Sci. 13: p. 90, (1965). **Practical Aspects of Silver-Dye Bleach Processing,** J. Phot. Sci. 20: p. 81, (1972).

PETERS, M. **Agfachrome-Speed, A Novel Dye-Diffusion Material for Prints from Color Slides,** J. Imag. Tech. 11: pp. 101-104, (1985).

SCHULTZE, D. F. **Historical and Recent Applications of Silver-Dye Bleach Color Copy Materials,** Color: Theory and Imaging Systems, (pp. 228-299), Soc. Phot. Sci. and Eng., Washington D.C., (1973).

WILHELM, H. **The Great Fade Test,** Pop. Phot. pp. 40-46, (June 1990).

CHAPTER 12

BARTELSON, C. J. and HUBOI, R. W. **Exposure Determination Methods for Color Printing,** J. Soc. Mot. Pic. Tel. Eng. 65: pp. 205-215, (1956).

BERGER, H. **Agfacolor (pp. 149-166),** W. Gerardet, W. Germany, (1950).

DREYFUSS, A. W., WAZ, E. M. and WOODLIEF, T. **Design Aspects of a New Video Color Analyser,** J. Brit. Kin. Soc. 52: p. 202, (1970).

HAZELTINE CORP, **B.P. 841,125 (1958).**

HUNT, R. W. G. **Printing Colour Negatives,** J. Phot. Sci. 11: pp. 109-120, (1963). **Slope Control in Colour Printing,** J. Phot. Sci. 8: pp. 212-219, (1960).

JACOBSON, K. **Improved Method of Grading Colour Negatives,** Proc. R.P.S., Centenary Conf. pp. 274-77, London, (1953).

LAUFER, C. **The Development of Enlarger Light Sources,** Phot. Lab. Management, pp. 8-9 and 38 (Oct. 1985).

PITT, F. H. G. and SELWYN, E. W. H. **The Colour of Outdoor Photographic Subjects,** Phot. J. 78: pp. 115-121, (March 1938).

CHAPTER 13

AGFA-GEVAERT **B.P. 1,300,843 (1972).**

COOTE, J. H. **Landmarks in the History of Photofinishing,** J. Imag. Tech. 11: pp. 87-92, (1985). **Photofinishing Techniques and Equipment,** Focal Press Ltd., London, (1970).

COOTE, J. H. and JENKINS, P. **A Machine for High-Speed Printing from 35mm Colour Transparencies,** J. Phot. Sci. 8: pp. 102-5, (1960).

EVANS, R. M. **U.S.P. 2,571,697 (1946).**

GUNDELFINGER, A., TAYLOR, E. and YANCEY, R. **A High-Speed Color Printer,** Phot. Sci. Eng. 4: pp. 141-150, (1960).

KAHN, M. **Washless System Technology,** Phot. Lab. Management, pp. 6-8 and 10-12, (Sept. 1985).

KOBOSHI, S. and KUREMATSO, M. **A New Stabilization Process for Color Films and Prints,** Soc. Phot. Sci. Eng. Symposium, Ottowa, 1984. **U.S.P. 4,336,324 (1982).**

PAVELLE, L. and VARDEN, L. **Ten Years Experience in Color Photofinishing,** Photo Developments, pp. 25-27, (Oct. 1956).

ROSKILL. **A Report on the Supply and Processing of Colour Films,** The Monopolies Commission, H.M.S.O., London, 1966.

CHAPTER 14

ANON. **Patents Case: Kodak Cries All The Way To The Bank,** Brit. J. Phot. p. 7, (25 Oct. 1990).

CRAWLEY, G. **The Polacolor Process,** Brit. J. Phot. Almanac, pp. 133-140, (1963). **SX-70 Camera and Film,** Brit. J. Phot. pp. 998-90, (Nov. 1973). **Polaroid: The First 50 Years,** Brit. J. Phot. (April 7, 14, 21, 28 and May 5, 1988).

HANSEN, W. T. **A Fundamentally New Imaging Technology for Instant Photography,** Phot. Sci. Eng. 20: pp. 155-174, (July/Aug. 1976).

LAND, E. H. **An Introduction to Polavision,** Phot. Sci. Eng. 21: pp. 225-236, (Sept./ Oct. 1977). **Absolute One-Step Photography,** Brit. J. Phot. pp. 872-864, (6 Oct. 1972).

ROGERS, H. G. and WALWORTH, V. K. **One-Step Photography,** 7th Ed. Neblette's Handbook of Photography and Reprography, pp. 258-330, Van Nostrand, (1977).

MAUDE, N. **Those Instant Systems,** Phot. J. Phot. pp. 776-7, (16 Sept. 1977).

WESTON, A. and MILLER, D. L. **Polachrome,** Modern Phot. (March 1985).

CHAPTER 15

ALLBRIGHT, G. S. **Physics and Photography,** Phot. J. pp. 234-238, (May 1990).

CRAWLEY, G. **The Solid State Still Camera and the Future,** Brit. J. Phot. pp. 1112-1115 and 1122, (Oct. 1981).

KRIS, M. A. **Film and Electronics: A Synergistic Combination?** Paper presented at Soc. Phot. Sci. Eng., Symposium on Photofinishing, Las Vegas, (1984).

LOHMANN, J. **Photochemical and Electronic Processes,** Brit. J. Phot. pp. 800-803, (July 1986).

SHELDON, I. **An Introduction to CCD Technology,** Sony Broadcast Ltd., Basingstoke, U.K. (1990).

UEDA, H. **The Impact of Technology on Tomorrow's Photofinishing,** J. Imag. Tech. 11: pp. 98-101, (June 1985).

WEST, P. **Still Video Photography,** Brit. J. Phot. (Jan. 9, 16, 23, 30, Feb. 13, 20, 1987).

During the two years it took me to write this history, I also wrote hundreds of letters and made many phone calls, seeking information and assistance from people all over the world. Some of those I wrote or spoke to, I knew, others I have never met, yet almost without exception they provided the help I needed and now is the time for me to thank them all.

To include all of their names would make a very long list, but because some gave me far more help than I had any right to expect, I would like to thank them especially.

Dr. Robert Hunt, Author of 'The Reproduction of Colour', with his vast knowledge of colour in general and of Kodak's processes in particular, not only read a draft of the book and made valuable suggestions, but also wrote the foreword. Robert Nowak, friend and former colleague, died in Switzerland towards the end of 1991, but I believe he knew how much I valued his support and encouragement. Dr. Armin Meyer, also from Switzerland, told me about the early days of the Cibachrome process.

Peter Krause, whose involvement with colour photography spans almost as long a period as mine, always answered my questions promptly and more completely than I expected. Dr. Leo Acklin gave me specialized information on coating techniques and Dai Jones of Ilford Limited provided me with valuable patent references on that same subject.

Chris Roberts of Kodak Limited went to considerable trouble to obtain the photograph of Russell's experimental multi-layer coating machine from Rochester.

Paul Goetschy of Ilford SA in Lyon, provided contacts that enabled me to complete the Autochrome story. One of them was M. Bernard Chardère of the Institut Lumière, who supplied me with some rare photographs of Autochrome production equipment.

Jean-Luc Dufay was kind enough to send me a copy of the history he had written of his grandfather's work on the Dioptichrome, Versicolor and Dufaycolor process.

Ron Collins, a colleague from the time when Ilford Limited made colour films, jogged my memory and corrected some of my recollections. George Duffin, another ex-Ilford man, obtained a 3Ms Electrocolor print for me.

Tadao Sakai sent me a Fuji Dyecolor print from Tokyo and Simon Bell, one of the few remaining exponents of the dye-transfer process, managed to make a print from a set of pre-war separation negatives I exposed in a Mikut camera.

Kate Rouse photographed the Devin and Hamburger cameras from the R.P.S. collection in Bath. Michael Pritchard of Christies put me in touch with Fred Spira in New York, who arranged the photography of several items from his unique collection of colour cameras and viewers.

Roger Taylor, Curator of the National Museum of Photography, Film and Television, kindly located a photograph of the Technicolor camera they have at Bradford.

Reg Smith, whose firsthand knowledge of colour photography pre-dates mine by a few years, generously lent me his collection of lecture slides and several photographs of Ives additive viewers.

Ron Callender knew Dr. Douglas Spencer well and could therefore tell me things about the Vivex colour printing service that helped me to complete that story.

Pat Wallace kindly obtained transparencies from the Polaroid archives in the US.

Chris Dickie, editor of the British Journal of Photography and Geoffrey Crawley, Technical Manager, both provided welcome encouragement as well as allowing me frequent access to their complete set of Journals. Hugh John, long-time editor of Photographic Abstracts cheerfully looked up numerous references for me. I also had several useful meetings with Sam Welford, an active member of the RPS Historical Group. Brian Coe, who has himself written a history of colour photography, was always willing to help. Alan Tull, who worked for Technicolor for many years and also wrote extensively, often anonymously, on colour photography during the 1930s and '40s, put me in touch with Ron Corke, one-time Chief Engineer at the Technicolor plant in the UK.

The staff of Southend-on-Sea Library proved just how good our public library service can be, by obtaining every book I requested.

I must also acknowledge the courtesy of those who granted permission to use certain drawings and photographs. They include the Comptroller of HMSO for allowing the reproduction of text and drawings from a number of British patent specifications; Edita SA for permission to re-use some of the colour photographs from 'The Illustrated History of the Camera'; the Amon Carter Museum for allowing the use of one of Eliot Porter's photographs; the Royal Photographic Society for use of the Autochrome of Bernard Shaw and Henry Wilhelm for his photograph of Charles Berger. John Hinde, probably best known for his view-cards, kindly let me use an illustration from his 'British Circus Life', for which he had used cut-sheet Kodachrome.

Many publishers take a long time before giving an author their decision, but Harry Ricketts of Fountain Press needed only a few days before agreeing to publish this work. Perhaps he was influenced by Peter Wilkinson, his friend and mine, who supported the project from the beginning.

When it came to the tasks involved in preparing my efforts for the printer, my daughter Janet Harber, deserves thanks for cleaning up an untidy typescript and getting it safely onto disc. The final, all important job of design, fell to Nigel Osborne, to whom I presented a complex mix of text, photos and drawings from which, to my great satisfaction, he and Sally Stockwell produced this book.